The Economics of American Art

The Economics
of American Art

Issues, Artists, and
Market Institutions

ROBERT B. EKELUND, JR.,
JOHN D. JACKSON, AND
ROBERT D. TOLLISON

OXFORD
UNIVERSITY PRESS

Oxford University Press is a department of the University of Oxford. It furthers the University's objective of excellence in research, scholarship, and education by publishing worldwide. Oxford is a registered trade mark of Oxford University Press in the UK and in certain other countries.

Published in the United States of America by Oxford University Press
198 Madison Avenue, New York, NY 10016, United States of America.

Library of Congress Cataloging-in-Publication Data
Names: Ekelund, Robert B. (Robert Burton), 1940– author,
Jackson, John D., Tollison, Robert D.
Title: The economics of American art : issues, artists and market
institutions / Robert B. Ekelund, Jr., John D. Jackson, Robert D. Tollison.
Description: New York : Oxford University Press, 2017. |
Includes bibliographical references.
Identifiers: LCCN 2016052819 | ISBN 9780190657895 (hardback : alk. paper) |
ISBN 9780190657901 (upub)
Subjects: LCSH: Art—Economic aspects—United States.
Classification: LCC N8600 .E39 2017 | DDC 707—dc23
LC record available at https://lccn.loc.gov/2016052819

9 8 7 6 5 4 3 2 1
Printed by Sheridan Books, Inc., United States of America

For Mark, Martha Gale, and Anna
and
For the late Bob Tollison, whose love, dedication to
economics, and influence endure

Contents

Preface

A RAPIDLY CHANGING and evolving art market would appear to be chaotic to the casual observer, with new highs, potential lows, and tastes and fashions changing from season to season. Economists, however, view the actions of buyers and sellers as constituting an identifiable market. They have, for some decades, studied such issues as artistic productivity and "death effects" on prices, investment returns on art, and estimated prices in auction markets.

Our book, using simple economics and both narrative and statistical economic tools, presents, in easily readable style, an analysis of these and many more issues such as art crime and possible art "bubbles." This book, however, is uniquely applied to the entire spectrum of *American art* rather than "art" as a homogeneous category. Further, our approach follows the accepted academic tradition of the study of art by economists over the past three or four decades. While American art has influenced world art in the post-1950 era, it was clearly a distinct market prior to that, a fact demonstrated in Chapter 5. American art was created and bought, almost exclusively, by Americans pre-1950. The reader is thus provided with a background in the marketing of that art and a basis for understanding today's "hot" Contemporary art traded at astronomical prices. We aim at readership in the community of "cultural economists," dealers, collectors, auctioneers, regulators, museum directors, curators, and the artistic community at large.

These applications of economics to "treasures" may seem strange to many in the art world, especially art historians. Many may tend to view it as an exercise in what is often termed "economic imperialism"—that is, the use of economics as a tool to study history, politics, religion, marriage, the family, and many other areas, outside the normal range of economics. But the study of cultural economics generally and the economics of art markets in particular does not rely on "implicit commodities," such as religious belief or love or marriage. Naturally there is return to art that is beyond a monetary price. It includes the pleasure we receive from holding and viewing it, or making

friends jealous. However, art is undeniably a physical good that is always traded at a monetary price. Naturally economists do not avoid the difficult-to-price aspects of buying art—such as the pleasure we get from looking at it—but these are in addition to the observable prices at auction or in dealer sales.

This study has had a long history. Almost two decades ago, along with growing interests in the application of economics to religion and culture, an initial inquiry into the "efficiency" of auction estimates and a possible "death effect" was conducted using a small sample of Mexican art (Ekelund, Ressler, and Watson 1998, 2000). Interest in museums and their functioning was stimulated by a number of factors: by the planning and opening of a university museum at Auburn University in 2003; by research into museum attendance (Skinner, Jackson, and Ekelund 2009); and by one of the present authors (Ekelund) serving as acting co-director of the Jule Collins Smith Museum of Fine Art at Auburn University. These factors and the advice of the Museum's initial director, Dr. Michael DeMarshe, together with the sage advice of Curator Dr. Catherine Walsh, noted collectors Noel and Kathy Wadsworth of Atlanta, Georgia, as well as friends Nancy Hartsfield, Kay DeMarsche, and Dr. Taylor Littleton, led us to economic studies relating to American Art. We recognized, even at this early date, that issues such as investment return, auction evaluations, productivity, and "bubbles" were being analyzed for "art" as a *homogeneous* entity, but that little work had been directed specifically to the market for American art. Thus began a multiyear and ongoing odyssey into these and many other aspects, including the history, of the American art market.

Our technical analysis (Ekelund, Jackson, Tollison 2013, 2015; Anderson, Ekelund, Jackson, and Tollison 2015) began with small samples of early (pre-1950) artists, some of them grouped into "schools" (e.g., the ashcan school of the early twentieth century). Those studies evolved into a full-scale analysis of eighty major American artists from the nineteenth and twentieth centuries and a sample of more than 14,000 observations. However, the "story" of the American art market cannot be told or even approximated with technical analysis alone, however interesting. A narrative of the history and development of that market, as we find it today, must provide a centerpiece for discussion of the evolution of markets for American art. The result is this book, which we hope will give both the economist and many in the art community (experts, dealers, museum curators, and so on) an initial window into the functioning of and ongoing developments in the art market.

No work of this magnitude and coverage could exist without the critical inputs of experts in its chief subject. We have benefited in critical ways by associations and interviews with art experts based in New York City. Betty Krulik, owner and director of Krulik Fine Arts, recent president of the

American Art Appraisers Association and an authority on American art, was unstinting in providing information on the nature of the historical and present market. No less helpful was Katherine Dehn, director of the revered Krushaar Gallery in New York City. Their vast personal knowledge of the artists and the market that comprises American art is reflected in this book from beginning to end. This group certainly includes Jean Belt, art appraiser extraordinaire, who helped keep us abreast of art market functioning on a regular basis over the years of this book's development. The input, suggestions, and references provided by Tom Butler, two-decade director of the Columbus Art Museum in Columbus, Georgia, have been extremely important. In addition, American art collectors Dr. Philip and Lorraine Brewer and Thornton and Sue Jordan of Columbus, Georgia, stimulated our interest in American art with discussion and analysis. Brief conversations (Ekelund's) with the late Thomas Hoving, former director of the Metropolitan Museum of Art, and Phillipe de Montebello, also a former director of that Museum, both visitors to the university museum at Auburn, helped stimulate many ideas found in our book. Conversations with Serge Guilbaut at the Jule Collins Smith Museum, an authority on the move of the center of the art market from Paris to New York City, were also helpful. Similarly, we are extremely grateful to Dr. Katherine Graddy, editor of the *Journal of Cultural Economics*, for encouraging and helpful comments on our work. Professors Mark Thornton of Auburn University, William Shughart of Utah State University, Mark Crain of Lafayette College, Professors Sarah Skinner and Keith Watson of The University of Louisiana at Lafayette, Professor Rand Ressler of Georgia Southern University, Professor Seth Anderson and Professors William Dougan and Howard Bodenhorn of Clemson University read large portions of our manuscript and made helpful comments. Discussions with the late Joseph Ansell, David Braly, and over the years with John and Mary Jane Roper and Dr. Ed Hayes, M.D. have been extremely helpful. We thank all of them.

Two individuals were most critical in orienting our view of American art for this study, as well as for sage inputs on so many of the aspects of the market discussed in this book. These two individuals are Dr. Marilyn Laufer, director of the Jule Collins Smith Museum of Art at Auburn University, and Dennis Harper, chief curator of that museum. Their guidance and suggestions as we traveled through this extensive project were invaluable. Their knowledge and love for art generally, and American art specifically—and their willingness to spend time in countless informal interviews—were central to the concepts and completion of this book. We cannot thank them enough. Despite all this wonderful help and advice, they and the rest of our advisors are innocent of what we chose to include or exclude here.

A book with three authors naturally follows some specialization and some explanation of division of labor. Ekelund and the late Bob Tollison were working partners in applied microeconomics and economic history for four decades. They developed many of the topical and theoretical scenarios of economics applied to American art. But many of these topics have become operational only with statistical testing. These tests required sophisticated expert input, and no one filled that bill better than John D. Jackson, Ekelund's colleague at Auburn University, whose matchless expertise created most of the original technical extensions of theory into new results based solely on American art data. His superlative work and intuition are reflected in the entire book. Data gathering for our "tests" was tedious and time-consuming. We wish to thank Josh Griffin, Dr. Jonathan Newman, and Dr. Sarah Seals for many hundred hours of steady and accurate work. The editing skills of Harry David and Dr. Richard Ault helped us avoid many grammatical and literary mistakes in our presentation. We are also grateful to the *Southern Economic Journal, Applied Economics*, and the *Journal of Cultural Economics* for formal permission to use portions of earlier papers in this book.

The shocking and unexpected passing of Robert Tollison in October 2016, just as this book entered the production phase, in no way lessens his critical input into his last of many works. Bob was and will continue to be an inspiration to generations of economists as a result of both his teaching and his extensive research. Best known as the one of the principal exemplars of public choice and areas of applied economics, such as sports economics and the economics of religion, Bob was nothing less than a creative genius in the application of economics to many areas of life. Many of the ideas in this book owe their origin to Tollison. As grateful as we are for his life as an economist, we and so many are even more grateful for his unmatched friendship and generosity of spirit. We are all poorer for his passing.

Finally, one thing we have learned in executing this project must be emphasized. Unlike the well-known and established painters considered in this book—those who have so obviously "made it" by being included in the secondary (auction) markets on a routine basis—there are thousands (perhaps more than several hundred thousand) of artists who must live modestly, must take "day jobs," with extremely limited incomes. The same is sadly true for musicians, actors, athletes, and others over time. Waiting tables, parking cars, and engaging in jobs unrelated to art do not appear to be permanent impediments to perform the activity that they love. There is always that unlikely chance that luck will find them, that they will be discovered by a major gallery, appear regularly at auction, and that they will find success in enlightened

self-expression. We dedicate this book to Bob Tollison and to all artists (and those in all other human activities, including economics) who, often at great cost, persist and persevere in doing what they love.

Robert B. Ekelund, Jr.
John D. Jackson
(The late) Robert D. Tollison

Chapter 1

Markets, Culture, and American Art

Vita brevis,
Ars longa.

—HIPPOCRATES, *Aphorismi*

MARKETS FOR ART—BUYING and selling through individuals, dealers, and per-haps even auctions—may be traced to Greek and Roman and even earlier civilizations. We find art or effigies, whatever their function, to be the product of human beings fifty thousand years or more ago. Human civilization would be largely unintelligible without art or writing. Much of what we know about the life of the ancients of our kind may be read from pictorial depictions of historical events. Our knowledge of Egyptian, Greek, the earliest North and South American, and so many other ancient cultures would be impoverished without the often exquisite reliefs depicting everyday as well as royal life in those places. Art, we must admit from the beginning, is fundamentally of a historical, aesthetic, and spiritual nature, playing a fundamental role in cul-ture and society. But art has an *economic component* that stands in possible relationships to the other fundamental attributes, and these relationships may help provide insight into this glorious aspect of human nature.

Artists and markets have always been entwined, no matter the status of the artist as workshop apprentice (in the Leonardo da Vinci–Verocchio, student-master model), "isolated genius," spiritual conduit, professional, or entrepre-neur. Perhaps an artist is all of these things. But while art is clearly an aesthetic or spiritual experience and the nature of the artist may be fashioned by the kind of art she engages in and many other factors, there is a *necessity to exist* for the artist—that necessity involves some kind of commerce, be it patronage or direct or indirect links to markets where things are bought and sold. That is the case for all artists at all times. That issue was and is no less important

for *American artists* as they have lived, evolved, and are evolving through the nineteenth, twentieth, and twenty-first centuries.

Art, in addition to its cultural and spiritual significance, has taken on an additional economic aspect as well in modern times—some would say that it has been "commoditized"—and there are arguments pro and con for this clear trend. These functions go well beyond simply looking at the price of materials to produce art or to the price that art brings in markets. In 2015 global art auction sales reached more than $63.8 billion, down from 2014, but with the United States leading the way. Many auction houses, Christie's and Sotheby's chief among them, are opening offices and facilities around the world. Christie's and Sotheby's alone sold more than $25 billion, with postwar and contemporary art on the front lines. Art auction markets in Asia are booming, and reports are that sales at both galleries and auction houses are meeting and exceeding their all-time highs. (Of course all international art sales, including gallery, individual, and auction sales, reach into the billions of dollars annually.)

Record prices for individual pieces of art are being broken almost every year. British artist Francis Bacon's triptych (*Three Studies of Lucien Freud*) depicting Freud, his friend and fellow artist, sold in November 2013 for $142.2 million, and a Picasso painting (*Women of Algiers [Version O]*) sold at Christie's in New York City on May 11, 2015, in excess of $179 million, with an Amadeo Modigliani reaching $170 million later that year.[1] A private sale of a Paul Cézanne work was reported to have traded for more than a quarter of a billion dollars and, as noted earlier, billionaires compete both at auction and in private transactions for the "best of the best."[2] While much of the "big dollar" art historically has been created by Europeans, American art is very much in the game, certainly in Contemporary (post-1950) art (Warhol, Rothko, etc.), but also more recently in art produced by Americans in earlier periods (pre-1950). (Note that we designate contemporary American art produced post-1950 with an uppercase "Contemporary.") Georgia O'Keeffe's $44 million painting *Jimson Weed/White Flower No. 1*, for example, sold in November 2014, bested by a Norman Rockwell at $46 million in 2013.[3] Seventeen paintings at Sotheby's in New York, several of them by American artists, topped $10 million in one week in November 2015.

It is fair to say that interest in American art, especially post-1950 art, is at an all-time high, and the sheer size and breadth of the international art market could not fail to attract the attention of investors, collectors, museums, galleries, and auction houses, as well as organized crime. Fine art and other collectibles and valuable items such as gold, stamps, and coins typically become investment repositories, especially during periods of economic turmoil

and expected inflation. These so-called passion investments are tracked by the press—for example, the *Financial Times* provides discussion of the Knights Frank Passion Index—and by specialists in particular areas. Academicians Jianping Mai and Michael Moses, who have produced important academic research on returns to art investment (2002, 2005), established a subscription service called Beautiful Asset Advisors (ArtasanAsset.com) to help investors make decisions concerning fine art as an element in their investment portfolios.[4] The Fine Art Fund, a private equity firm in London, advises investors in the global art market. A number of other organizations have arisen for that purpose and for other "treasure assets." "Art advisors" are growing in number, and some major investment houses (such as Morgan Stanley) are offering special units and advisory services to their top clients in the arena of portfolio analysis.[5] Perhaps such interest through the financial markets is unsurprising—there is an enormous amount of money in art markets—but the burgeoning activity in this rapidly expanding market has enlivened the interest of academic economists, as well as the ire of some art professionals.[6]

We must underline the fact that art and culture studies are not chiefly a subject about "dollars" for most of the world, including the art world, although money and prices are important. At the most fundamental level of thought, art concerns aesthetics—a record of human achievement, spirituality, culture, and the changing of lives and the world about us. It is not, to many art historians, art lovers, and some in the art community, about commerce. But those interested in aesthetics and art appreciation cannot avoid the fact that a good deal of information may be gleaned from considering economic concepts and culture—first and foremost, the culture and operation of art markets. Far from studying simple "commoditization" of art and culture, modern studies involving economic tools, both statistical and narrative, relate art to such matters. Some of these questions and issues, plus the location where they are deliberated in this book, are as follows:

- How, historically, a market for American art developed, along with marketing and technology, and whether that art was (as is often supposed) completely derivative of European (especially French) influences (Chapter 2);
- How the politics of the postwar era shaped, at least in large part, the direction of American art, a direction that continues into Contemporary art today (Chapter 2);
- Whether age and "type" of artist—traditional or "innovative"—are related and, if so, how age is related to productivity. Writers on this subject have had primary recourse to anecdotal evidence. We evaluate this position with the use of a statistical test of American artists. Further, we query whether

the undeniably "innovative" art being produced in the United States today is partially related to marketing and modern selling techniques (Chapter 3) rather than the age-related link most often offered as explanation for this phenomenon. These factors contribute mightily to the potential success or failure of American artists;[7]

- How the credence of both buyers and sellers is particularly central to the art market and how the authenticity of a piece of art is established in art transactions sold through auction houses and other venues. Further, can "no-sales" at auction be predicted? The manner in which an art seller's painting might be "burned" by failing to sell when it first goes to auction and returns to auction at a later date is also examined (Chapter 4);

- Is investment in American art (categorized as that produced pre- and post-1950) a remunerative endeavor compared to other investment possibilities? In this analysis, for the first time, both buyers and sellers' premiums are brought to bear in calculating returns showing a range of possible outcomes (Chapter 5);

- Do economic insights provide understanding of fakes, fraud, and theft of art, particularly American art? Does that include, given the opaque nature of the market, why more of it might be expected in the future? Interestingly, art theft remains (and we predict will remain) the third most high-valued crime on a global basis (Chapter 6);[8]

- Whether the death of the American artists in our sample who died prior to 2013 has affected their price paths at auction, identifying precisely what a "death effect" is composed of (Chapter 7);

- Is there is a boom (or a bust) in the market for Contemporary American art as might be found, for example, in the real estate or stock markets. We conclude that, depending upon how a "bubble" is defined, there is certainly a boom in the art markets, particularly for Contemporary American art (Chapter 7), understanding that all markets rise and fall over time.

- We conclude that the ongoing evolution of American art is attended by a massive number of influences, some of them economic in nature. Specifically, in Chapter 8, we summarize how the technology of buying and selling art, the distribution of income favoring bidders and buyers at the highest income levels, the drive to innovation, and rising international art theft and fakery, among other factors—the marketplace—are creating a force upon which American art evolves.

In short, the use of economic and statistical concepts to analyze art is not a substitute for connoisseurship or for an analysis of the artists to be included or excluded in the "pantheon" of art movements. That is the business of art

professionals such as art historians. But there is an economic component to each of the points enumerated in the preceding, and this book is written on the premise that the use of economic concepts merely *complements* these critical and important "cultural" studies of art. *Does economics have anything to contribute to our understanding of one of the greatest human activities beyond what long-standing art-historical investigations have created?* We hope, focusing on American art, to at least partially answer some of these questions and to extend the studies of others into the realm of American art. Our book is designed to be both "academic" and "practical," aiming at use by collectors, auction houses, American art experts of all kinds, museums, gallery owners, advisors, sellers, and buyers of art (particularly American art) and, not least, by economists with continuing scholarly interests in these matters.[9]

Finally, as is fairly obvious, asking and answering these questions regarding American art requires *some* technical as well as narrative analysis. While we have attempted to keep the former to a minimum, those readers untrained in statistics (or econometrics) who are interested in better understanding the issues outlined in the preceding are provided with *complete narrative descriptions* of our findings when using technical methods to investigate issues. While we are not always able to provide definitive answers to questions posed, we seek to provide readers with a sound understanding of issues relating to the American art market and why some of them are important for those interested in the many facets of that study. Thus our book focuses on American art and on a primary institution—the auction house—through which the art is handled.

Economics as a Conduit for Analyzing Culture and Art?

Economics, despite its reputation among some as a "dismal science," was, at the end of the eighteenth century , the queen of the social sciences. Brief perusal of the index to Adam Smith's *Wealth of Nations*, written in 1776, conveys its enormous initial scope. There we find Smith's opinions and evaluations of history, politics, literature, religion, geography, culture, and opulence, in addition to his analyses of supply and demand and the usual topics of a contemporary elementary economics textbook (markets, labor, rents, prices, and so on). Subsequent writers up to the present day focused on the economic theory in Smith's book and developed an ongoing mathematical and highly technical treatment of Smith's initial statements. But the purely technical aspects of economics have met a backlash within an important subset of the economics

profession. Though there has been some determined resistance from other social scientists, a concerted effort is underway to reintegrate the social sciences to include—as well as economics—history, sociology (particularly marriage and the family), anthropology, archaeology, and politics (Becker 1976). Those applications coming under the greatest fire often deal with intangibles (e.g., children as a product, utility produced by religion). It would seem that art, both visual and performing arts, would come under similar attack, but that is not so. Visual art, in addition to possessing value not easily measured in money, is most often a physical item that is bought and sold. The artist produces a product, just as the automaker produces motor transportation, and a money price is arrived at for the painting, whatever the other aspects of well-being there are to the buyer and seller. The economics of art markets, including the nominal money price of a piece of art, are in this sense easier to grasp and study than the "price of children" or the "price of religion."

Economists have been dealing with art and culture for about three decades. Simple neoclassical models of the art market (Grampp 1989) have been fodder for those who resist the inclusion of an economic component for art (Horowitz 2011: 21), but this view is off the mark. Modern economists do not argue that prices expressed in money are the only things that matter in determining "value." The aesthetic and spiritual nature of art is seen as being reflected in values that include price—price is but a reflection of some of the values buyers place on art, but it is a good indicator of the many reasons that individuals buy art.[10] Far from introducing a "dismal science," the modern marriage of economics and other social sciences has been interesting, informative, and exhilarating. The marketplace for art is but a companion and a complement to the philosophical and culture-related studies of art. This union has produced a brilliant and fecund new direction that includes art and culture.

The interface is both political and cultural with respect to art. Many aspects of the relation between culture and economics, including the study of particular markets themselves and the relation between the arts and government, caught the interest of economists decades ago. Throughout American history there has been a relation, albeit sometimes indirect, between governments at all levels and "art." In the United States, the National Endowment for the Arts was founded in 1965, and states and local governments have expanded into contributions to the arts at all levels. Economists and scholars from other disciplines have weighed in on many aspects of these developments.

While interest in "treasure goods" and their production and consumption is many centuries old, the variety and academic nature of studies expanded in the second half of the twentieth century and into the twenty-first. The acknowledged founders of research in performing-art markets and economics

are William Baumol and William Bowen (1966), who identified a "cost disease," at least in the performing arts.[11] Later studies by Baumol expanded our understanding of aspects of the art market (Baumol 1986) and were then somewhat continuously elaborated on by a growing number of investigators (Frey and Pommerehne 1989, and many others). Studies on the many facets of culture and the arts led to a gathering cascade of literature, continuing into the present. There were those relating to art museums (Feldstein 1991), art and culture broadly considered (Goetzmann 1993; Heilbrun and Gray 2001), theoretical problems encountered in cultural economics research (Ginsburgh and Menger 1996), artists, art markets, and the history of art markets (De Marchi and Goodwin 1999; Grampp 1989), and subsidies to the arts (Peacock 1969), which together set the stage for an explosion of interest by economists in markets relating to art, culture, and economics before the end of the last century. Important analyses of the performing and visual arts, including motion pictures, dance, music, and theater have been analyzed in important books and compendia such as Caves (2003) and Throsby (2001) and in handbooks from several publishers containing myriad essays on aspects of culture and art (see in particular those essays contained in Ginsburgh and Throsby 2006, 2013; and Towse 2015). Works making important contributions to our understanding of the overall history of the art markets are De Marchi and Van Miegroet (1994, 2006). This widespread interest was further exemplified in the establishment of both societies relating to the economics of the arts, specifically the International Association of Cultural Economics, and a journal, the *Journal of Cultural Economics*, before the end of the twentieth century, devoted exclusively to these topics.[12] Finally, see the book by David Throsby (1994) that established cultural economics (which includes the economics of art markets) in the hierarchy of the American Economic Association index of topics considered "economics."

Frey (1997a) analogized, correctly in our view, the progress of the study of art history and social science to that of art history itself. First there are the founders of a movement, then "followers of significant achievement," and then a third phase following "the main stream art movements" (1997: 163). Frey is, of course, quick to emphasize that stellar contributions may be made as art (or social science) progresses through time. Economist Frey and others have been in the vanguard of those concerned with the interpretation of "value." Obviously the purchase of art, if not immediately for resale as investment, brings ongoing satisfaction or utility to the buyer. Prices are therefore not alone in determining value. There have been important discussions of this issue and how to deal with it (see Hutter and Frey 2010; Hutter and Throsby 2008; and Throsby and Zednik 2013), as well as the large research study on

assessing the value of cultural goods for the United Kingdom (Crossick and Kaszynska 2016).

Economists have perhaps arrived at the third phase—one in which particular issues and streams of issues have dominated undertakings. An international coterie of economists has developed and are developing technical tools to study interesting aspects of the art market. As the flow of literature on art, culture, and economics has been growing, there has been a necessary reliance on auction data in the case of fine art, as noted earlier. Auctions and auction theory have garnered the principal interest of cultural economists, but it is important to recognize at the outset that at least half of fine art in the United States is transferred through galleries and at hundreds of art fairs and private individual sales, of which little is known. Such activities are by their very nature proprietary and private, leaving no data trail from which investigators might glean information concerning transactions. Thus, most formal studies of these markets have been limited principally to the use of auction data, supplemented of course by anecdotal materials, since data on gallery or other sales are not generally available. In fact, auction data have thus formed the basis of most economic research on art markets, and it does in this book as well.

A wide range of work has been undertaken by a growing number of economists in a number of countries. One of the most comprehensive and useful surveys of contemporary topics linking art and economics is the survey by Ashenfelter and Graddy (2003), and the literature continues to grow (Towse 2005, 2013). An expanding body of research runs a range from rates of return and investment (Mei and Moses 2002; 2005), to supply-side effects including "death effects" on art prices (Ekelund, Ressler, and Watson 2000; Itaya and Ursprung 2007; Ursprung and Wiermann 2011), to auction estimates and realized prices (Ekelund, Ressler, and Watson 1998; McAndrew, Thompson and Smith 2012), to values related to artistic productivity and "types" of artists and age (Galenson 2009; Galenson and Weinberg 2000, 2001; Ginsburgh and Weyers 2006), to "anchoring" (Beggs and Graddy 2009), to economics and aesthetics (Spaenjers, Goetzmann, and Mamonova 2015). Such contributions have all served to answer questions or pose new problems and issues in this interesting area of applying economics to culture. The literature has become truly international and expansive. But there is perhaps only one constant: issues are primarily related to auction markets because of the assumed "objective" nature of statistics when art comes to auction. That "objectivity," despite the fact that roughly half of the art bought and sold in the United States and elsewhere goes through artists themselves or galleries or art fairs, has encouraged and enabled researchers to examine a number of matters, some mentioned earlier. It has

formed the fundamental (though not the only) basis upon which conclusions have been drawn concerning world art and world auction activity.

Why a Book on the American Art Market?

Works, both formal and otherwise, examining economics and the art market have been concerned, with few exceptions, with international art in multiple international auction settings. American art as a segmented class of art has not been isolated to any degree, although there are several exceptions (e.g., Agnello 2002; Agnello and Pierce 1996; Anderson et al. 2015, 2016; Ekelund, Jackson, and Tollison 2013, 2015;). There has been little intensive study of the sweep of American art from both a formal (statistical) and narrative-anecdotal perspective. The purpose of this book is to do just that. We seek to isolate and explore both formal and informal issues regarding American art, an emphasis that, to the best of our knowledge, is unique. We hope to help fill that gap by developing a new set of auction data on eighty important American artists from the nineteenth and twentieth centuries for formal (statistical) studies, with the full realization that fully half of art sales are made in galleries, for which little hard information exists. Our sample includes artist representatives from many of the "schools" that developed from the beginnings of the republic.[13] The eighty artists are chosen on two bases: (1) to obtain representative members of particular schools; and (2) to include those who had significant observations—that is, paintings listed in askART, an Internet source recording the sales of all American (and other) paintings—over the 1987–2013 period at auction, enough to meet statistical requirements.[14] In general, the number of observations in our sample reaches approximately fourteen thousand. Matters relating to fakes, fraud, theft, and other critical issues related to the market—those not readily amenable to formal analysis such as art crime, fakes, and fraud—will not be neglected. Thus, both *statistical tools* and *narrative exposition* suffuse our studies.

One of the reasons we have chosen this topic is that American art, over the past twenty or so years, has come into its own for US and *international* collectors. In the nineteenth and much of the twentieth centuries, European, mainly French, art trumped most American work in the minds of many important collectors, including American collectors, as we explain in Chapter 2. After World War II, New York "stole the art market from Paris" (Guilbaut 1985, 1992) with abstract expressionism and its contemporary offshoots. The tide clearly turned at this point. The availability and value of Contemporary art has soared in the past decade, the art becoming an object of investment and even rampant speculation.[15] The great interest in US contemporary art has

spilled over into American art produced before World War II to a significant degree, back into the first half of the twentieth century and reaching into the nineteenth century. While this interest has quickened, the modern and contemporary market for (post–World War II) American works has exploded. Of the sixteen of the highest-priced artworks ever sold at auction (as of November 2013), four were by Americans (one by Andy Warhol and three by Mark Rothko), but that has been a recent development (all were purchased since 2007). This activity has been a twenty-first-century development. American creativity, spurring the explosion of the contemporary art market, has been a vital force in world markets since the innovative developments of the 1970s. The major auction houses began offering separate auctions for contemporary art (including artists from around the world, as well as American artists) and for "American art," chiefly that produced by artists prior to 1950. And in 1988, for example, the primary auction houses, including Sotheby's, Christie's, Bonhams, Phillips and other houses in New York, London, Beijing, and elsewhere, began selling contemporary works by American artists in *midcareer or earlier*, many of them long prior to death. These developments spread to other markets, underpinning the contemporary boom in the highly innovative art and sculpture venues. Despite these developments, however, American art produced earlier than 1950 has been a far more contained geographic market wherein Americans, until recently, have almost exclusively been the purchasers and sellers of that art.[16] This suggests that a book on the American art market, except for post-1950 "Contemporary" American art, is able to consider a more contained market for much of the last two hundred years than for "art" generally.[17]

Credence: A Central Issue Relating Economics to Art

A critical point to remember when considering the art market or any market is one simply based on common sense linking economic concepts and art dealings of all kinds. We all buy (or sell) products and services every day. We buy or sell different kinds of products—tacos, refrigerators, used cars, new cars, psychiatric services, or an Edward Hopper drawing. Trade of all kinds, however, is related to information, and the acquisition of information is costly in terms of time, money, or both. And information about products is supplied in many forms.

This economic idea—that we are willing to use resources as buyers or sellers to determine the quality of goods—is *particularly applicable to the art*

market, as we will see throughout this book. Indeed, it is at the very *heart* of the market. Any art, American or otherwise, carries a credence factor with it. Is the work of art—a Winslow Homer oil or a John Singer Sargent watercolor— what it is represented to be? Is it authentic—that is, a work by the artist whose name appears on it, or what it is represented to be? Is it a fake, a work by another hand than is represented on the canvas or paper? Is it a copy of an existing work by a particular artist? Is it a work in the style of a particular artist that is not by that artist's hand? What are the factors that provide credence to a piece of art? Who are the experts on particular artists or genres of art, and how do they get to be experts? What is the chain of ownership from artist to seller, or the picture's *provenance*, a concept we will encounter many times?[18] These questions and their answers all involve a degree of credence that is provided in various ways in art markets. The issue of art fakes and frauds will be analyzed in detail in this book, but the issue of credence pervades virtually *all* trades in art or anything else. A sound introduction to the issue is critical from the beginning of our analysis (see Chapter 2), and the nature of credence in the art market is discussed many times throughout this book.

It is clear that art authentication has created the rise of the "expert." It also opens the door to debate and legal wrangling over who qualifies as an "expert" at the date of sale or at the date of the claim made by the buyer. Further, what is a "generally accepted" expert? Where experts disagree or refuse to proffer an opinion for legal reasons, can a piece of art ever be verified as authentic with complete credence?[19] All this is not to suggest that the vast majority of work sold at auction or by galleries and individuals is not genuine; it is to better describe the artistic product. Art is fundamentally a "credence good" that has created the rise of the "experts": art advisors and a burgeoning industry in the appraisal of art, schools of art, and individual artists. These individuals provide a necessary role in a functioning market and credence of authenticity in American art and indeed art of all kinds. Private, non-auction estimates are available through galleries and through independent appraisers. Specialization emerges to support the functioning of a market by providing information. As a rule, however, asymmetric information exists in such markets. One party to an exchange, usually the seller, has more information concerning a piece of art than the buyer.[20] Thus, with a mass of exceptions, the art market is one in which credence for buyers might be formed either through the reputation of a seller, by a post-purchase buy-back agreement, by provenance, or by an acknowledged expert's opinion as to the authenticity of a given piece of art. Whether this takes place or not may be problematic, and some economists believe that the art market is, to a large extent, characterized

by fraud, even in the presence of these supposed "safeguards." It is not too much to say that credence is the glue that holds markets, including the art market, together.

Interesting Questions Posed in the American Art Marketplace

This book is roughly divided into topics that use both formal statistics and anecdotal analysis, on the one hand, and those that are, fundamentally, only amenable to anecdotal narrative, on the other. In all cases, the results of our technical analysis are explained in narratives on the problems and issues at hand. In Chapter 2 we briefly outline the development of the market for American art from before the nineteenth century through the present. Additionally, several important issues are developed, including the means through which the American (and all) art market functions, particularly the auction process. Chapter 2 will expand on how credence is a *fundamental* aspect of the market for art and how institutions have arisen to provide it. Additionally, we there present some preliminary details of our new database on eighty American artists born before 1960 whose paintings sold at auction between 1987 and 2013.

Age and creativity have been of interest to psychologists and other scholars for literally hundreds of years. Do American artists produce their most creative and/or innovative works at younger or older ages (as is said to be a question relevant for poets, physicists, and others)? Artistic creativity has become the subject of research. Economist David Galenson, using both statistical and anecdotal methods, divides artists into two types, innovative and experimental, to investigate how age is related to creativity. In doing so, he also suggests links between age and artistic productivity. We apply these interesting ideas and other methods to our sample of eighty American artists born prior to 1960 in Chapter 3 and consider the impact of being associated with a "school" on the value of art. There the use of anecdotal evidence in the age-creativity relationship is also evaluated in this regard by examining two famous American artists—Georgia O'Keeffe and Jackson Pollock. Our results indicate that a number of factors must be considered to link or investigate the relation of age to artistic creativity.

The auction house is a primary institution through which art is exchanged. Chapter 4 investigates a number of aspects of this institution vis-à-vis American art. If a piece of art is not examined physically, the representation of a third party either at an auction house or at a gallery serves to provide a level of credence to buyers. Then there are credence issues when a piece of art may

not be "right"—art-market parlance for "genuine." All of this has created a market for "experts" on particular artists, genres of art, or American art in general. Auction houses hire experts both for types or styles of art and for a complete category of art (say, American art or Chinese art). Auction-house experts also routinely ask known "experts" on an artist or style for their opinion on the authenticity of particular works of art.

Economists, in this vein, are interested in a number of questions regarding the market for evaluators of art. First, are the estimates provided by auction houses "efficient" or "unbiased"? For example, if a piece of art by a particular American artist is given a catalogue estimate that the hammer price will fall between $10,000 and $20,000, is that expectation realized at the mean ($15,000)? If so, and if this mean hammer price is realized over many estimates, economists would call the estimates "efficient" or "unbiased" in an economic sense. This chapter uses a sample of eighty American artists and provides statistical analyses as to whether the estimates given by auction experts are unbiased—that is, not systematically over- or underestimated. The question of the rise of "experts" and the issue of credence are also raised here (and at several other places in the book).

A second interesting question, analyzed in Chapter 4, arises when a piece fails to sell. Either the demand for the object was insufficient to reach the reserve price, or the seller and/or the "auction-house expert" set the reserve too high. (The reserve price is that price below which the seller with not sell.) So it is interesting to examine no-sales in our data set. First, we look at the number of no-sales in the data and then see what factors might lead to an explanation or, in statistical parlance, "predicted." Second, since reserves are thought to be 70–75 percent of the low estimate and the reserve is negotiable, the least willing sellers will set the reserve higher (in no case can it be higher than the low estimate in New York, according to law). Thus, the "expert" may be influenced to reduce the gap between low and high estimates (not increasing the high estimate but increasing the low). So no-sales might be predicted by the narrowness of the "spread" between estimates. A statistical test is possible. If a painting doesn't sell, in other words, how good are the auction "experts" at providing estimates on resale? If a buyer attempts to sell the piece again, is the item "burned"—that is, does it receive a lower price on second (or greater) offering?

Art is one of the precious things that is collected for its beauty and enjoyment. It may be increasingly used as a substitute for money, as a hedge against inflation, as a means of "laundering" money, or simply as a substitute for alternative investments yielding a return. How well does art (and specifically American art) serve this function? A number of investigations

using different methods and alternative data sets have asked this question. In Chapter 5 we summarize the two basic methods and the results of earlier studies. Our model tackles such questions as whether a particular American artistic "school" or "style/subject/genre" makes a difference as to return; whether American-art investment returns are related to financial-investment returns; whether it pays to "buy the best art you can afford"; and whether there are psychic factors in art investment and, if so, how they are calculated.

Some of these issues are of a semi-technical nature, but economists have much to say concerning art markets that does not involve formal statistical analysis. There are other economic issues that, by their nature, are narrative or anecdotal. In particular, the art market in America (as opposed to the American-art market) has been punctuated with issues less amenable to formal economic analysis due, in part, to a lack of data. Tantalizing tales of fraud (Salander-O'Reilly Gallery in New York), fakes (the recent Knoedler Gallery case of selling fakes to the tune of $80 million, Knoedler having been the *oldest* gallery in the United States!), money laundering by drug dealers, and other interesting matters fill the popular press. Skyrocketing prices suggest bubbles in the contemporary market as well, not unlike that occurring in the housing market prior to the crash of 2008. Some of these issues may seem far from the formal concerns of economics, but all of these matters have significant economic implications for the art market, especially as they affect credence and market information. Next to money laundering and drugs, art theft and fraud, in value terms, are often cited as the third-highest-value crime in international markets. Chapter 6 investigates, from an economic perspective, the modes and methods of theft and fakery. Covering both older and more recent examples, we examine the fundamental reasons that art crime is so prevalent. While artists, museums, and galleries are affected greatly, such crime has a low rate of discovery and punishment. Our discussion has particular applicability to the American art market and the economic consequences of this ever more popular crime.

Do the values of American artists' works rise when they die or when death approaches? Chapter 7 entertains that question with a sample of American artists who were born after 1900 and who died over our sample period 1987–2013 to attempt to identify and analyze a so-called death effect. Our tests indicate a death effect to be clearly operative, which supports a clear definition of the phenomenon. Finally, we examine some recent trends in the market for contemporary American art to ask and at least partially answer the question of whether "bubbles" are being experienced.

These discussions, which comprise our book, clearly touch at the interface between art, artists, marketing, and economics. But there are deeper and

more profound relations and analogies between art markets and *all* markets. It is axiomatic in modern economics that economic growth and progress are related to technology and its absorption by producers and competitors. Perhaps the greatest exponent of this view is economist Joel Mokyr (1992), who has argued that a new technology or invention succeeds in promoting growth if demander-firms are unfettered in either adopting or rejecting the innovation. The analogy is extremely apt in describing art markets. Artists (single-person "firms") freely innovate with new concepts, new experiments, and new materials. They offer collector-museum-gallery buyers (demanders) their wares and innovations. These works may be accepted or rejected. When accepted, these new technologies create artistic progress. This does not mean that art is simply a commodity. It is far more in aesthetic and cultural terms. It does not mean that artists simply "paint to make a living"—the goals of the vast majority of artists are far loftier than the fruits of commerce. It does mean, however, that there is an economic component and an important analogy between art and all other markets, one that may importantly augment the non-commercial aspects of this part of culture.

The disparate market for American Art, especially Contemporary American art, poses many interesting questions relating art and markets that can only be touched on in this book. It would be impossible to deal with every issue facing the American art market. As such, we must regard our effort as a preliminary excursion into the complexities of that marketplace—but a trip that, it is hoped, will stimulate additional research in this particular and fascinating area of cultural economics.

Chapter 2

Dimensions of the American Art Market

THE PROFILE AND dimensions of the market for American art developed, if in fits and starts, from the beginnings of the republic to the present. The pace quickened from about the second decade of the nineteenth century, blossoming in the twentieth, further reaching for apogee in the present day. Appreciation for the functioning and organization of that market is essential to understanding the buying and selling of art, as well as discernible and useful trends in the heady days of art trading today, with some paintings selling for many millions of dollars. That market has primarily consisted of art sold through galleries in New York City (principally), Boston, Philadelphia, and elsewhere and, later in the twentieth century, through the expansion of large New York City houses (such as Sotheby's and Christie's) to locales across the United States. Independent auction venues selling art and other items now number in the hundreds in widely dispersed locations in the United States.

Our study of marketing of American art and its evolution through time is discussed throughout this book. It takes us on an introductory tour of the primary methods of selling American and other art in the nineteenth through twenty-first centuries. It also provides an opportunity to introduce the reader to some of the major trends and schools of art that the United States has produced. The introduction will be brief, as the tale of American art history has become like any other major tradition—lengthy, complex, and filled with numerous interrelations and connections. Many volumes have been written on American art from artistic perspectives, and the interested reader will find excellent surveys and volumes on individual artists and schools of artists.[1] Our aim is not to produce a history of American art or an art history text, as noted in our preface, but it is necessary to underscore, at least in cursory

fashion, the nature of that art. It is especially important to understand the nature of the type of art developed in the United States in the post–World War II era—art styles that signaled not only a "new art" but (simultaneously) a *new kind* of marketing from that time onward. We have even witnessed, for example, an "internationalization" of American art created post-1950, although, for the most part, *pre*-1950 American art was and is collected and assembled by *American* collectors and museums.[2]

Today, approximately half of American art sales are made through auction houses and half through galleries, many of which participate in art "fairs." About 10 percent is sculpture, with the remaining 90 percent composed of paintings in all media (oils, watercolors, pastels, and so on) and prints and drawings. The present chapter explores the critical issues of the methods of buying and selling American art through the centuries, as well as providing, along the way, a thumbnail and loosely organized survey of some of the major schools associated with American creativity. But it does more, by introducing readers to the sample of American artists that we have chosen for empirical/ statistical study, and by discussing the common-sense terms of the primary economic issues we will analyze. One of the issues we will discuss more fully is the centrality of credence in market dealings and the way credence problems are wholly or partially overcome in art markets of all kinds, including American art.[3] We begin at the beginning.

The Marketplace of American Art: Early Period

Markets for art of one kind or another have always existed in America and internationally throughout history.[4] Individuals migrating from England and elsewhere to the British North American colonies surely included painters who recorded the existence of the people who lived in New England and elsewhere, including native peoples. English and other immigrants also brought art with them to the colonies. The wealthy likely bought pictures, with a large proportion of them probably portraits, to decorate their abodes. Painters, perhaps with no formal outlet for their wares, took commissions from wealthier clients. There were no "galleries" as we now know them, but, as reported by Goldstein (2000: 1–3), works of art (including paintings) were sold in shops, along with glassware, supplies, frames, and materials.[5] Great artists were born and worked in the colonies—for example, Benjamin West, born in Springfield, Pennsylvania, in 1738, and John Singleton Copley in Boston in the same year—and their works were purchased and appreciated by well-heeled collectors. Portraits, by these and a wide variety of other fine artists in pre-Revolutionary days as well, were commissioned.

American artists, at least some of them, did manage to make a living in colonial times and during the republic, but there were few, if any, specialized dealers or galleries over this period. The first "stand-alone" galleries appeared in Boston, New York, and Philadelphia over the first two decades of the nineteenth century. While early dealers sometimes offered American works, the largest market for wealthy Americans was in the "Old Masters" obtained in Europe. These works were imported to the United States, and many were of uncertain provenance and authenticity (Goldstein 2000: 10).

Art academies formed in Philadelphia and New York to promote the interests of art and artists. (Collections associated with wealthy collectors and the academies themselves became the basis of many art museums in America.) Early attempts at the formation of art associations were made in these cities. An early one, founded by Charles Wilson Peale in Philadelphia in 1795, though short-lived, served as a venue for artistic activity and exhibitions.[6] Among these early associations was the American Academy of the Fine Arts in New York City. While this academy achieved some benefits for artists, such as the exhibition of new works, the system did not break down the social gulf between wealthy patrons and the artists themselves. Its treatment of artists regarding space for drawing sessions and classes led to the establishment of a new organization—the National Academy of Design. Again, according to Goldstein (2000: 17),

> With Samuel F. B. Morse [artist as well as inventor] as its first president, the National Academy soon became the stronger of the two societies. Only artists and architects were elected to membership. In 1841 the American Academy, its membership having sharply declined, was dissolved. . . . The National Academy meanwhile had moved from strength to strength. Firmly established in the art community long before the older society had given up the ghost, it drew the attention of the press with annual exhibitions of its members' work.

Meanwhile, American artists were receiving attention in shops, often dedicated to selling all types of merchandise. Framers, carvers, gilders, furniture dealers, and other tradespeople carried the works of seminal and important American landscape artists, such as Thomas Cole and Asher B. Durand.[7] But artists and entrepreneurs found other ways to create income. Some shops carried quantities of art, American and otherwise, and charged "admission" to see the wares, a policy that made sense in days when museums were not readily available to the general public, if at all.

Several marketing tools advanced the interests of American artists and provided additional sources of income and outlets for American art exhibitions: (a) the "traveling exhibits" or studio exhibits of monumental landscapes, often of the untamed Western landscape and other subjects; and (b) the use of a lottery to sell American paintings. The traveling exhibit was a means of collecting income for artists and impresarios in America and abroad. Examples abound: the artist John Trumbull painted four large canvases depicting scenes of American independence for the Capitol rotunda in Washington. In addition to the commission earned, the paintings went on the road and earned Turnbull a handsome fee. The exhibition of Frederic Edwin Church's *The Heart of the Andes* brought in thousands of viewers (at twenty-five cents per view) and that painting, along with his panoramic *Niagara*, went on tour to London and elsewhere, with large financial rewards. This tradition of putting "exotic" landscapes on tour continued throughout the nineteenth century. Such tours and exhibitions of the new "American paradise" made perfect sense in a world without television, photography, motion pictures, or readily available outlets of information on world or American geography. (Not all were successful, of course.)

An innovative marketing scheme was a serious boost for American art and artists. One James Herring, an artist, secretary of the American Academy and sponsor of a lending library for books, opened the Apollo gallery at 410 Broadway in New York City in 1838. According to Goldstein (2000: 20), Herring "had no trouble gathering examples of the work of leading artists; clearly they saw his invitation as the answer to a long-felt need. Missing at first were pictures by Cole, Durand, and Morse, but Herring secured works by J. W. Casilear, Thomas Doughty, Rembrandt and Raphaelle Peale, Hiram Powers, Thomas Sully, and many others, for a total of 260 items by ninety-six artists." Monetary arrangements proved a problem since Herring charged only admission fees, with no commission fees to the artists who sold their work in his gallery. Herring then imitated a system used in Edinburgh and other cities abroad. He organized a group of eminent citizens and art patrons to pledge subscriptions of five dollars each, with the art to be distributed by an annual lottery. The artists had a new market for their work, and the subscriber-public would have a chance of acquiring high-quality art at reasonable prices. The marketing plan thrived for sixteen years (under the titles "Apollo Art-Union" and, in 1844, the "American Art-Union"). Exhibitions and sales of paintings continued, and engravings of the great American artists were made and distributed. But, as Goldstein notes (2000: 22), the big attraction was the lottery—the chance to obtain a first-rate painting by a recognized American

artist for a low price. According to Goldstein, "off to a promising start, the Art-Union attracted 814 subscribers in its first year and distributed thirty-six paintings, chosen from among those not sold at the exhibitions. In its peak year, 1849, the numbers climbed to 18,960 subscribers and 460 paintings along with 550 statuettes, models, and prints."

The turning point in the market for American art was, in many respects, the emergence of the lottery system in New York, in addition to an increase in the number of galleries and businesses catering to American artists. Prominent figures, for no charge, managed the lottery of the Art-Union, and they did it to promote American culture. The art was of American subjects, including landscapes, genre paintings of the many aspects of American life, as well as portraits.[8] The Art-Union, which ultimately faltered due to public criticism of and legal dissolution of the lottery as "gambling," was perhaps the major reason for the growth of the American art market over this period. It supported Americans in their quest to excel in art. It had many imitators. Goldstein (2000: 23–26) reports the emergence of a "Free Gallery" in 1844 with subscription arrangements for American art in Philadelphia, with similar unions in Cincinnati, Newark, and San Francisco. Thus, a huge impetus was growing in the interests of artists, dealers, collectors, and those interested in establishing a cultural base in the large cities of the United States. Economically, this momentum was furthered by an interesting credence factor, one that is inherent in all art markets to this day (as we explained in Chapter 1 and as elaborated later in the present chapter). The taste for then-contemporary American art was accompanied by the growing realization among art unions, nascent museums, and collectors that there was a serious credence problem in most of the "Old Master" art that was for sale. Fakes proliferated. That, together with the undeniable quality in the work of American painters, helped push the market into the second half of the nineteenth century.

Shifting Demand Parameters

We are today quite aware of the largely unpredictable, mischievous taste parameter concerning fashions in art, both international and domestic.[9] (In contemporary art, demand appears to change quickly for innovative artistic genres and styles.) French academic art of the late nineteenth century, once all but totally out of vogue, has returned as desirable to collectors. Contemporary art, both American and international, is the subject of quite rapid taste change. Most economic models treat taste change as exogenous or outside the model

of explaining behavior, but the source of some taste change in art may be identified. Specifically, taste change may stem from critical reviews, gallery exhibitions, and hype among important purveyors of art, and from demonstration effects among wealthy collectors, where "keeping up with competitors" becomes critical. Taste change may be fairly rapid, as in a shift in taste from French (or American) academic art to the French or American impressionists, or as in the taste change from one innovative style to another, such as was experienced with post–World War II Contemporary art. A less recognized taste change was the impact of shifting tastes for American versus European art in the nineteenth century.

The market for American art was well underway in the large cities of the United States by the time of the Civil War. The wealth generated by the war helped make the collection of art fashionable among the rich. But collections shifted somewhat from Old Masters, such as Rembrandt and Raphael, to American painters in the early nineteenth century due to authentication and credence problems relating to classic European works. The emergence of art "unions" and design academies to foster the exhibition and support of American artists, together with the emergence of galleries and dealers in American art, all served to support an emerging market in art produced by Americans.

A number of signals led to a taste change in favor of American work in addition to the credence problems attached to Old Master painting. Support came from many quarters. For example, Goldstein (2000: 30–31) reports the construction of an art studio building in 1857 in New York City (and imitated in Boston) that housed art exhibitions, artists' quarters, and working space. Artists such as Frederic Edwin Church, John F. Kensett, Albert Bierstadt, William Merritt Chase, and Worthington Whittredge used the facility. Studio space was made available elsewhere as well. Galleries selling both American and European art proliferated in the pre– and post–Civil War periods. An international interest in selling art (European only at first) in the United States (New York City) developed as well. The Goupil Gallery of Paris, sponsoring artists and printmakers there, established a business in New York City under the leadership of Michael Knoedler, dealing in European art. Knoedler bought out Goupil's US operations in 1857 and began dealing in both European and American paintings purchased directly from the artists. The sale of American art in the major urban centers was successful. Knoedler acquired such an inventory of American art that he and other dealers held periodic auctions of artists such as Jasper Francis Cropsey, William Sidney Mount, and Church to make room for the acquisition of new American works. Galleries in general charged artists a 10–14 percent commission on works sold to cover expenses

and make profits, although some galleries continued to act as de facto museums and charged an entry fee.

Tastes in art, however, are malleable and ever changing. An event took place, with art as only one element, which changed the course of collecting tastes and of American art for the remainder of the nineteenth century. A World's Fair was held in Paris in April 1867.[10] Naturally, the American galleries, collectors of American art, and American artists themselves wanted to put their best foot forward at the fair. A committee of American art dealers and connoisseurs, including Samuel P. Avery, a preeminent collector and dealer, and Michael Knoedler, selected forty-eight paintings and sculptures, plus etchings by James Abbott McNeill Whistler, to be shown in Paris. Works were lent by galleries and collectors that included the cream of the crop of American artists of the time—Francis Church, Albert Bierstadt, Jasper Cropsey, Asher Durand, George Inness, John Frederick Kensett, Winslow Homer, and others. But the expected triumph did not materialize in Paris. French and English critics and some American critics as well bathed the display with faint praise. Only one picture (Frederic Church's monumental and spectacular *Niagara*, reproduced as Figure 2.1), won any award, and it was a second-place, silver award to boot.

The impact of this event cannot be overestimated. An art-buying frenzy was underway in the wake of wealth increases in the big cities of the Northern United States in the post–Civil War period. But the results on collector acquisitions were altered by exposure to the contemporary European art and the tepid reaction to the American work shown at the fair. A taste change was

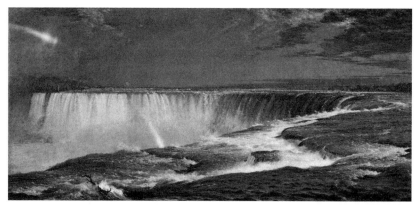

FIGURE 2.1 Frederic Edwin Church, 1826–1900, American, *Niagara*, 1857. Oil on canvas, National Gallery of Art, Corcoran Collection (Museum Purchase, Gallery Fund). Open Access Image; Copyright, public domain.

underway favoring contemporary (in addition to Old Master) *European* art against home-grown paintings. According to Goldstein (2000: 48–49),

> disappointment was general, and in consequence well-to-do American cognoscenti, who had already been treated to displays of European art in Knoedler's and Schaus's galleries and in the exhibitions staged in New York by Ernest Gambart, began to look with heightened appreciation at what those and other dealers offered in the latest fashions from the Continental art centers and from England.

Thus, a taste change was underway, and the market responded. Purchases and holdings of American art by US collectors were reduced relative to imports by the 1880s. French romanticist and Barbizon paintings began to replace the works of the Hudson River school and their followers.

Disappointments relating to the reception of American art created by the fair had yet another and much longer-lasting effect. *American artists* themselves became interested in European styles, a romance that lasted until the post–World War II period. It is not that some American artists and art promoters discounted the quality of American art or that, at a somewhat later period, they did not attempt to establish a uniquely "American" art. Rather, American artists were genuinely impressed by the new styles and accomplishments of their European counterparts. They, and collectors and gallerists generally, began to make an art education in Europe a *foundation* for being an artist. American artists in the following generations, with some exceptions, made study trips abroad in Paris, Munich, and elsewhere the sine qua non of learning to produce "quality work." That practice lasted well into the twentieth century.

Stylistically, American artists evolved from the careful, "tight," and meticulously painted Hudson River school to looser productions suggestive of European styles. Tonalism and luminism, where dark or light neutral colors were used chiefly in landscape painting, as in many works by George Inness, were related to impressionism. (A beautiful example of American tonalism is Inness's *Home of the Heron*, Figure 2.2.) These styles and an American Impressionism, together with realism of various kinds, were *all* in vogue in the closing decades of the nineteenth century in the United States.[11] The works of George Inness (1825–1894), Winslow Homer (1836–1910), James McNeill Whistler (1834–1903), William Merritt Chase (1849–1916), and John Singer Sargent (1856–1925) were extremely popular. These artists studied in Paris or elsewhere in Europe. Whistler and Sargent, though American, in effect became English-speaking "Europeans." Few American artists were untouched by European influences, and American artists found numerous collectors and

FIGURE 2.2 George Inness, American, 1825–1894. *Home of the Heron*, 1893. Oil on Canvas, Edward B. Butler Collection, Image Permission Licensed by The Art Institute of Chicago. Copyright, public domain.

galleries that gave exclusive representation to a number of them. Over the late nineteenth century, galleries selling American art sprang up in Chicago, San Francisco, and elsewhere, with new galleries arising in New York, Boston, and Philadelphia.[12]

Despite positive developments in the American art market, the taste shift to European art in collections continued into the closing decades of the nineteenth century. (The demand for all art was dampened by a series of economic "panics" and recessions in 1873, 1893, and other years, as it is today.) At home, American artists and collectors had long asked for protection that would be afforded by new and higher tariffs against imported art in the wave of a taste change brought on, in part, by the Paris Exposition of 1867. Perhaps in anticipation of the taste change, agitation started before the exposition. Artists were not rewarded until 1883, however, when the price of all imported art (except for reproductions) was raised by 30 percent. Galleries specializing in American art (or primarily American art) continued to exist. The fin de siècle emphasis on art influences from abroad continued, however, for collectors of the "newly discovered" impressionists, but that did not stop the progress of American work. In short, the quest for a "truly American art" did not end and was revitalized at the opening of the new century.

The American Art Market at the
Opening of the Twentieth Century

Although the quest for a unique art did not keep Americans from traveling to Europe for study, it did produce two important movements in the early twentieth century: the so-called ashcan school and the modernists, the latter heavily influenced by European, particularly French, art. Artists returned home to adapt their learning to American subjects. The search for a distinctly American art began at this time, under the leadership of Robert Henri (1865–1929), an artist and teacher who himself had studied and painted in France. A group of artists known as the "Eight" exhibited a new art at the Macbeth Gallery in New York City.

While these artists were pioneers in every sense, they have been the subject of some misconceptions. The first, mentioned earlier, is that the Eight were ashcan artists or "the" ashcan artists. Five of them (Glackens, Shinn, Luks, Sloan, and Henri) certainly dealt with urban or social realism (hence the term "ashcan")—or as Henri, the great teacher of all of them (and plenty of other artists, including George Bellows and Edward Hopper) put it, they were painters "of our time" (Milroy 1991: 121). A fine example of the ashcan style is Luk's *Tenements* (ca. 1899), shown as Figure 2.3. But there were many other artists who were "ashcanners" both contemporaneously and following the great 1908 exhibition.[13] And the subject matter of the eight painters could hardly be more diverse, as aptly described by Milroy (Milroy: 16):

> Certainly George Luks, John Sloan, and Everett Shinn made pictures of New York slums and trash-filled alleys. But William Glackens, Robert Henri, and Maurice Prendergast preferred parks and avenues. Ernest Lawson found pure landscape, not social commentary, in Manhattan and the Bronx. Arthur Davies found dreams. Nor were Prendergast, Lawson, and Davies eccentric adjuncts to an "urban" core headed by Henri and Sloan, but rather equal members of a carefully assembled coalition.

Each of these artists, within their own styles and approaches to art, embodied a uniquely "American" perspective (Glackens 1957; Homer 1988; Perlman 1979). Acknowledging that "we've come together because we're so unalike," (Milroy: 27) the Eight were powered by an impetus to declare their independence from a system that was rooted in traditionalism. In particular, the proximate cause of the revolt of the Eight came from the great teacher Robert Henri.

FIGURE 2.3 George Luks, American, 1867–1933. *Tenements*, ca. 1900. Ink with grey washes and dry brush on paper. Robert B. Ekelund, Jr. and Mark Thornton Collection, by permission. Copyright, public domain.

Henri's target was New York's National Academy of Design, which, even though it was not a government-sponsored school such as the École des Beaux-Arts in France, exercised strong influence over the direction of fine art in the United States. Indeed, several of the eight artists, including Henri, had shown their work with and had associations with the academy. Henri, however, disputed the academy's jury system and its treatment of his students and

in 1907 withdrew a picture from an academy exhibit, among other matters, causing a public controversy in the art community of New York. A successful idea was born among the eight artists, promulgated by Henri. They pooled funds to rent the Macbeth gallery, from 1892 the first gallery to specialize in American art, for their breakthrough exhibit.

The Eight's striving for a uniquely American art was perhaps the earliest, best organized, and most representative force in the new drive for independence from tradition and Eurocentric culture in the United States. Most important, as Elizabeth Kennedy (2009: 13, our emphasis) expressed the matter, "each [of the Eight artists] dedicated himself to continuous creative *experimentation* as a necessity of his artistic philosophy" and embodied "artistic individuality as a collective experience." Proof of the force of the Eight's collaboration is that they *remained* grouped together in exhibits (Kennedy 2009; Milroy 1991) and in American art more than a century after their first and only show as a group. The truth is, however, that not even these artists could completely divorce themselves from European influence. All of them exhibited both before and after 1908, and, by the time of the iconic Armory Show of 1913, where European modernists such as Pablo Picasso and Henri Matisse were shown alongside the Americans, the Eight, for the most part, had gone their separate ways.

The Armory Show 1913, Stieglitz, and American Modernism

An adverse reaction to the traditional art in both France and the United States produced a generation of artists who sought to detach themselves from the establishments and academies that represented such styles. The ashcan exhibit at the Macbeth Gallery was one example. But an even more avant-garde movement was afoot with the establishment of the Exhibition of Independent Artists in 1910 and with American artists Arthur Davies and Walt Kuhn's drive to present the new currents of art at what has been labeled the Armory Show. At that show three hundred artists, including Europeans and Americans, showed an enormous number of exciting works showing new cutting-edge styles (some of it was of a more traditional vein as well). (Marcel Duchamp's famous *Nude Descending a Staircase* was shown at the show, receiving mixed reviews.) The Armory Show was a watershed in the market for American art in particular. It traveled, after New York, to Boston and Chicago and was viewed by tens of thousands of people a day after a shaky start (Watson 1992: 181). However, a development leading to the creation of a uniquely American art (though one melding indigenous and imported influences) or "American modernism"

preceded it.[14] That development owed its origin principally to one man—
Alfred Stieglitz (1864–1946).

Stieglitz, originally joined by fellow photographer Edward Steichen, one
of the great American photographers of the twentieth century, began showing
his own and others' photographs early in the first decade of the new century.
Additionally, between 1905 and 1910 he began showing modern art, including
modern American art *before* the Armory Show. In a succession of galleries
(Little Galleries of the Photo Secession at 291 Fifth Avenue, known as "291";
the Intimate Gallery; and An American Place) Stieglitz pioneered the introduc-
tion of European and American modernism with the buying public, including
the first showings of Matisse and Picasso in the United States. Before the
Armory Show, Stieglitz showed non-figurative and abstract art by Americans
John Marin, Arthur Dove, Marsden Hartley, Max Weber, Abraham Walkowitz,
and Arthur B. Carles. More than any other individual, Stieglitz worked to-
ward a "uniquely American art" via promotion throughout the period. Some
of these artists brought elements of European modernism into their work.
Cubism, for example, figured prominently in the art of Max Weber (1881–
1961) (see Figure 2.4, *Seated Nude* [1910], where the influence of Pablo Picasso
and cubism is obvious). In addition to the artists mentioned here, Stiglitz
sponsored others as well, including Oscar Blumner, Elie Nadelman, Stanton
McDonald-Wright, and, of course, though not famous at the time, an artist
who became his wife, Georgia O'Keeffe. Not only did he represent them, in
some cases he financed their living expenses and artistic excursions to Europe
to study and paint (in return for canvases or first picks of canvases).[15]

The Armory Show of 1913, however, tended to benefit European post-
impressionists. There was indeed a major market in art sales in Europe
and New York over the entire period between the Civil War and World War
I for impressionist and post-impressionist European art among many of the
wealthy scions of the big cities of the Northeast. But that is not the whole
story. As Denis Michael Hall (2001) argues, that generalization neglects some
important facts. There were galleries that sold American art from the second
half of the nineteenth century onward, as mentioned earlier in this chapter.
Interruptions in the American art sales resulting from a change in taste
occurred at the Paris Exposition of 1867, but tariff impositions on art of "for-
eign origin" were lobbied for and approved, benefiting American artists of the
period. A natural barrier to imports of foreign art occurred when commodi-
ties, including art, were embargoed during World War I.

Hall (2001) presents a wonderfully balanced picture of the situation in the
market for American art over the crucial period between the Armory Show
of 1913 and the advent of World War II. In a masterful anecdotal empirical

FIGURE 2.4 Max Weber, American, 1881–1961. *Seated Nude* (1910–1912). Pen on tan paper. Robert B. Ekelund, Jr. and Mark Thornton Collection, by permission. Copyright, public domain.

study, Hall analyzes the number and primary artistic character of two hundred galleries, four hundred collections, and numerous artists, selecting five of each to study in detail. He finds that of the approximately two hundred galleries, about sixty of them specialized in selling American art, many of them representing particular artists and artists' ateliers. A number of these galleries (e.g., Krushaar) continue doing so to the present day. Hall also

comments presciently on the "sociology" of art collecting in an environment such as New York City. By 1900 more than a third of the population was foreign-born, making the city a rich mix of old and new traditions, a mix that enlivened innovation in the arts and sciences. As Hall put the matter, "indeed New York became a magnet for artists and writers and many of the nation's most creative and ambitious prime movers in every field from the last decades of the nineteenth century onwards, bringing vibrancy, a sense of optimism and in some cases a sense of urgency for change to the flourishing metropolis" (2001: 20).

Top-level collectors continued to pursue European art, including Old Masters, European impressionists, and German art, old and new, but American art flourished nonetheless. Rising wealth, particularly in the Northeast, fueled a demand for art in a fashion described by Thorstein Veblen (1899)—that is, as "conspicuous consumption." Women of the rising upper classes pushed American art along as art became a signal of wealth and class. The newly opulent involvement with the arts was a symbol then, as today, of status in the community. The new and wealthy nation sought a national identity in all things, including art. Museums, without substantial acquisitions budgets, depended on gifts, and some American art was included. Still, museums in America, always with some exceptions, remained traditional in their collecting and in the 1910s and 1920s avoided "modernist" art. There were exceptions, as Hall (2001: 35–36) notes:

> The outstanding exceptions to this during the twenties ... were the Newark Museum, the Phillips Collection and the foundling Whitney Museum which all, in different ways, did much to support modern American art.... The overall climate was to change within a decade, however, as museums established purchasing budgets during the thirties and increasingly received gifts of modern American painting from patrons, or from the Government-funded Federal Art Projects; all signs of the growing call to support the development of both a distinct history as well as the future of American art.

The character of New Yorkers of the period explains the burst of interest in American art. Again in the words of Hall (2001: 39–40), New York

> had a distinctiveness from other American cities in its multiple elites, which allowed for both conformity and distinction; its lion's share of America's millionaires living in a dynamic, mobile population of wealthy people and a flow of ambitious incomers whose tradition was

more European-American than one of Anglo-American conformity. Hence the huge expansion in the numbers of the wealthy along with the unprecedented levels of disposable income, when married with the optimism of the twenties, were the key catalysts for the development of the New York market for modern American painting.

Thus the real shift to collecting American art occurred in the 1920s, and while the depression of the 1930s created a downturn in the market for American and other art, two developments helped buttress the market. First, as noted earlier, museums were developing collecting budgets, in addition to donor gifts. The second support came from the US government, which established the Federal Art Project (FAP) as an adjunct of the New Deal's Works Progress Administration (WPA). With government support, between 1935 and 1943, the FAP subsidized American artists (and some foreign-born artists working in America, such as Mexican artist Rufino Tamayo) to paint murals, posters, paintings, and decorations of public buildings across the United States. The subsidized included many prominent American artists, including modernists and realists, painting in different styles—American scene subjects, abstract and representational.[16] Most of the members of the abstract expressionist school, including Jackson Pollock, also participated in the WPA/FAP program, painting in a *social realist* style.

Despite the interruption of the Depression, American art was firmly established as a major art form by the advent of World War II. Entrepreneurial promotion, with more than sixty galleries dedicated to selling American art in New York City alone (see statistics later in the chapter), an artist-dealer system whereby contracts were made with artists for exclusive representation, important collectors of American art, and a thriving art community in many diverse areas of artistic style all combined to produce nothing less than the "national identity" of "American artists" by the advent of World War II that had been longed for since the opening of the twentieth century. But a major shift in the world art center to New York City (from more traditional European locales) was yet to come.

Postwar Ascendance of American Art

World War II brought émigré artists to the United States, but something more fundamental changed the face of American art in the postwar era, leading it to steal the mantle of "modernism" from Europe in general and France in particular. Although Marcel Duchamp and many other artists had enlivened a type of modernism in American art as far back as the Armory Show, a group

of Americans, many of whom were socialists and communists who had participated in New Deal art projects, broke away completely from traditions then prevalent in American art. Serge Guilbaut, the authority on this period and the emergence of modern-contemporary art in America, put the matter as follows (1985: 3):

> Avant-garde art succeeded because the work and the ideology that supported it, articulated in the painters' writings as well as conveyed in images, coincided fairly closely with the ideology that came to dominate American political life after the 1948 presidential elections. This was the "new liberalism" ... an ideology that, unlike the ideologies of the conservative right and the Communist left, not only made room for avant-garde dissidence but accorded to such dissidence a position of paramount importance.

While many "modern" American artists of the period continued to paint in their received styles, some artists in particular—Adolph Gottlieb, Mark Rothko, Barnett Newman, and others—broke all tradition by creating a kind of abstraction called, unsurprisingly, abstract expressionism. These artists eschewed "propaganda" and illustration—an art typified in the 1930s and early 1940s by a realist style, some containing a "socialist" element. The new art explored the worlds of the unconscious, myth, primitive symbols, and the imagination of the artist. Barnett Newman exhibited this kind of abstraction as early as 1943, and Jackson Pollock was shown at Peggy Guggenheim's gallery Art of this Century in New York in 1944. Pollock, with his "drip paintings," was a symbol of this movement toward a new American art (Guilbaut 1985: 85; DeZayas 1996), an art that came to be promoted by galleries—with Guggenheim in the forefront—and by critics. Most famous of these critics defending the new style were Clement Greenberg, Harold Rosenberg, and Leo Steinberg. The end of WPA subsidies led to a new wave of competition between artists, and the abstract-expressionist style expanded.

The market for this new art was energized by a number of factors: the postwar period of inflation and the pent-up demand and incomes from the war led to a new cascade of collectors. Additionally, French art was no longer imported after 1944, and the European art market had been devastated by the war. Subsequently, the market for American art entered a boom period that continues to this day. According to Guilbaut (1985: 91),

> The art "boom" followed the "economic boom." All of a sudden the country seemed to have developed an insatiable appetite for the arts.

All the sources agree: the art scene was ebullient and the art market was going full steam. The number of art galleries in New York grew from 40 at the beginning of the war to 150 by 1946. Parke-Bernet's [now Sotheby's] public sales (private sales are not recorded) increased from $2,500,000 in 1939 to $4,000,000 in 1942 and by 1945 stood at a record $6,500,000. Private gallery sales for 1945 were up forty to three hundred percent compared with sales for 1944. In order to attract a broader clientele [rather than aristocratic-plutocratic clients], art dealers developed new sales methods, emphasizing simplified trans-actions, advertising, democratization of the market, direct sales, sales through artists' cooperatives, and even buy-by-mail arrangements.

Art, Politics, and Then-Contemporary Art

The interface between politics and art played, albeit indirectly, an important role in establishing the avant-garde in the latter half of the twentieth century, leading to the multiplicity of innovative genres of art, many of which we con-tinue to enjoy. In 1946, in the realization that an American century in cul-ture lay ahead, the US State Department and government, eager to advertise American supremacy in the arts, organized a collection of then-contemporary American paintings, sometimes called "Advancing American Art."[17] These works—oils and works on paper chosen by Joseph LeRoy Davidson, arts spe-cialist at the State Department—were to tour Europe, Latin America, and Asia. (The competition was clearly a ploy to compete with the Soviets in the emerging Cold War.) Seventy-nine oils and seventy-three watercolors were purchased to tour Eastern Europe, Latin America, China, and the Far East. Some of the abstract expressionists, including Jackson Pollock and Bernard Newman, had major exhibitions as early as 1943, but were excluded from these "Advancing American Art" tours. However, many of the most renowned contemporary artists, including Stuart Davis, Georgia O'Keeffe, John Marin, and Marsden Hartley, were not excluded.[18] Representational (realist) and tra-ditional artists were represented as well—Edward Hopper and Walt Kuhn, for example—but were a small portion of the total. The pre-abstract expressionist avant-garde of experimental and innovative American artists were the bulk of the shows, which included a melting pot of artists with international heritage (Japanese, German, Italian) painting in a variety of styles—expressionist, cub-ist, surrealist, and representative works.

The paintings were shown in Prague and parts of Latin America in 1948 before the program was abolished. Naturally, artists who were left out com-plained. These included a number of realist regional artists who, perhaps,

resented the successes of "foreigners" and "homosexuals" who worked mainly in New York City. But many of the artists represented had participated in the New Deal program and were proponents of "American scene" art. Some of these artists depicted social concerns relating to poverty in the United States, fascism, and an actual or perceived repression by US conservatives who branded their work "socialist." Such work unleashed an avalanche of conservative critics, led by the likes of William Randolph Hearst. The art was called "lunatics delight" (Harper 2012: 20) and the paintings dismissed as "left-wing propaganda."

Republicans took back Congress in 1946, and the watchword of the day was "anti-communism." Senator Joseph McCarthy's witch hunt, including the House Un-American Activities Committee which pre-dated McCarthyism, was in full swing by 1948–1949 in its focus on art and culture. Blacklisting and liberal purges were the order of the day, and the State Department's art tours were under the microscope. Pressure was put on Secretary of State George C. Marshall to end the program, and President Harry S. Truman even joined in the chorus against what was increasingly perceived as a New Deal communist plot. About Yasao Kunioshi's *Circus Girl Resting* in the traveling collection, shown in Figure 2.5, Truman was said to have remarked that "if this is art, I am a Hottentot." The solution became clear as politics dominated modern art: Davidson's job at the State Department was eliminated and by mid-1948 the art had been recalled and put up for sale as government surplus by the War Assets Administration. Politics, at least for the moment, had triumphed over free artistic expression. Unfortunately, the "Advancing American Art" episode of that triumph would not be the last. Despite the anti-communist purges of free expression in the United States, or perhaps because of it, by 1948 or so, abstract expressionism had won the battle of becoming the avant-garde style of world art.[19] Although the particular style of Pollock ("drip painting") and some others was largely passé by the mid-to-late 1950s, it was the impetus for artists to become individualists, exemplifying a storied "alienation from society"—symbols of innovation, detached from the world and, often, representations of it. Pure abstraction became largely "apolitical," insulating it from the kind of dire criticisms exemplified by McCarthy and right-wing conservatives.[20] A variety of styles were spawned by "action painting," another phrase describing abstract expressionism. The 1960s, 1970s, and 1980s saw the development of color-field painting, minimalism, hard-edge painting, and pop art (as exemplified in Andy Warhol's many works). These streams of artistic endeavor and their offshoots have become what is termed "contemporary" or "modern" painting from the twentieth into the twenty-first century in the United States and around the world. Such contemporary painting appears to

FIGURE 2.5 Yasao Kunioshi, American, 1889–1953. *Circus Girl Resting*, 1925. Oil on canvas. Jule Collins Smith Museum of Fine Art, Auburn University. Copyright, Art © Estate of Yasuo Kuniyoshi/Licensed by VAGA, New York.

be dominant, but that does not mean that realism, forms of modernism, folk art, representational abstract art, or other styles are dead or were eliminated by non-representational abstraction. These traditions continued throughout the second half of the twentieth century and persist in the twenty-first. Visits

to a series of art galleries in major US cities or perusal of any recent catalogue of American art from Sotheby's or Christie's would support the notion that practically all previous styles still coexist in the work of American artists. Importantly, as we will see in coming chapters, however, the seismic shift in the direction of American art to abstraction and innovation altered the behavior of the art market.

Changes in the Markets for Contemporary American Art

Technical innovations have altered and are drastically altering the nature of the nexus between galleries, artists, and auction houses. Important caveats must attend any discussion that uses auction data as representative of the American art market. It must always be remembered that success is primarily defined by being included in *secondary art markets*—that is, *auction or resale markets*.[21] The dimensions of the American art market and the formal tests of some of the propositions regarding art and artists are framed by auction markets, a necessity since, as we pointed out in Chapter 1, data from gallery and other sales are generally not available and are even secretive in nature. But it must be admitted from the outset that there are hundreds of thousands of professional artists and that the attempt of any artist to gain success is attended by an extremely low probability.

The analysis of cultural anthropologist Stuart Plattner (1996) remains relevant in this regard. Plattner examines local art markets and describes the process of how artists pursue their profession, many of them attempting to make it to the higher levels of their profession—representation by recognized galleries and at auction in local markets and international markets, especially New York City. Of the some 200,000+ individuals who self-identify as painters as their profession, as noted in Chapter 1 of this book, fewer than 1 percent are represented by galleries all over the United States. The vast majority of even those who acquire gallery representation earn an income of $20,000–$30,000 a year. Even in the center of the marketplace for American Contemporary art, New York City, it has been calculated that only one artist in 111 will achieve "success defined as any sales in the auction (secondary) market (Singer 1988: 38–39, quoted in Plattner 1996: 85). And this statistic pertains even to *American artists who have exhibited in prestigious New York galleries.* Dealers thus have some non-trivial power to make or break artists, and getting gallery representation in either local or New York markets is often a matter of "knowing someone," luck, or being "found" by gallery owners in local exhibitions or at university art centers or art schools. Again, the probability of that kind of recognition is extremely low. But astute marketing and "hype" by

dealers and their influence on critics and collectors thus can make a clear and sometimes dramatic difference in the nature of contemporary art. As Plattner (1996: 198) put it, "the disarray of art theory [in contemporary art] thus leads to heightened risk in fine-art purchases, which has diminished the size of the market and created a situation where there are many more artists aspiring to avant-garde status than can be represented by dealers, which allows them to enforce exclusionary rules of representation."

This observation—that there is risk in buying contemporary art and that we have in effect left more traditional "schools" behind—is likely correct to an extent. Naturally, representational art flourishes, and there is risk in buying any art from any period due to unpredictable changes in tastes. However, a central point is fairly obvious—contrary to Plattner, there has been an incredible boom in contemporary art, and American artists have been major players in that boom. The source of that boom, the *value* as contrasted to the price of the art produced and the "staying power" of the art and artists, are much debated, and we remain agnostic on these issues.[22]

Dealers of contemporary art, especially those of the highest rank, have some control and are quite likely to *attempt* to manipulate art markets, influencing the kind and rate of innovation in that market. They are selling unique works by living artists at mid- or even early career whose value, in both money and artistic-value terms, is difficult to assess (see Chapter 7 on "bubbles" for a discussion of the possible value and direction of twenty-first-century art). The road to understanding issues in the marketplace for American art must always hold this caveat in mind, as will become obvious when dealing with empirical studies, such as we conduct in discussing the nature of the artists and the factors underlying the relation of age and creativity in Chapter 3 and art as investment in Chapter 5. But we must remember that the meme of the "starving artist" is not so far off the mark. We are analyzing "the ones who made it" in the formal and anecdotal discussions in this book.

American Artists Used in Formal Studies in This Book

Creating a formal study of, say, the return on investments in American art (see Chapter 5) or studying particular aspects of the market requires the collection of data. Thus, we assembled a new data set of auction observations between 1987 and 2013 (twenty-seven years) from askART.com, a site that only presents results on American art. The data set consists of paintings offered at auction by American artists born before 1900 (as early as 1826), culminating in data

on the "youngest" (though now deceased) artists in our group of eighty artists born before 1960 (Jean-Michel Basquiat, 1960–1988). Tables 2.1 and 2.2 designate the artists contained in our sample, along with their birth and death dates. We divide our sample of paintings into artists born before and after 1900 for good reason. In particular, those born after 1900 and who were painting mainly, though not necessarily, after 1950 are segmented because 1950 (see earlier discussion) appears to mark the beginning of the pronounced manipulation of demand for American paintings by (primarily New York) art galleries, collectors, and critics.

Table 2.1 contains thirty-three artists, although seven of them had fewer than thirty sales at auction during the twenty-five years of the sample.[23] For *some purposes* (see Chapter 3), we have eliminated artists with small numbers of observations.[24] The artists in Table 2.1 represent, and were partly chosen for, a wide variety of artistic styles (impressionist, realist, tonalist, luminist, ashcan, modernist, etc.).

Forty-eight American artists born after 1900 comprise our sample of Contemporary American artists, and our sample for auction observations on works by these artists is indeed twenty-seven years, 1987–2013. As might be

Table 2.1 Thirty-three American Artists Born in the Nineteenth Century

Artist	Life Span	Artist	Life Span
George Inness	1825–1894	John Marin	1870–1953
James McNeill Whistler	1834–1903	John Sloan	1871–1951
Winslow Homer	1836–1910	Ernest Lawson	1873–1939
Mary Cassatt	1844–1926	Everett Shinn	1876–1953
Thomas Eakins	1844–1916	Walt Kuhn	1877–1949
William Merritt Chase	1849–1916	Joseph Stella	1877–1946
Theodore Robinson	1852–1944	Marsden Hartley	1877–1943
John Henry Twachtman	1853–1902	Arthur Dove	1880–1946
John Singer Sargent	1856–1925	Max Weber	1881–1961
Maurice Prendergast	1858–1924	Charles Bellows	1882–1925
Childe Hassam	1859–1935	Edward Hopper	1882–1967
Frederic Remington	1861–1909	Charles Demuth	1883–1935
Arthur Davies	1863–1928	Milton Avery	1885–1965
Robert Henri	1865–1929	Georgia O'Keeffe	1887–1986
George Luks	1867–1933	Grant Wood	1891–1942
William Glackens	1870–1939	Stuart Davis	1892–1964
		Charles Burchfield	1893–1967

Table 2.2 **Forty-seven American Artists Born Post-1900**

Artist	Life Span	Artist	Life Span
Philip Evergood	1901–1973	Robert Rauschenberg	1925–2008
Mark Rothko	1903–1970	Wolf Kahn	1927–
Hans Burkhardt	1904–1994	Alex Katz	1927–
Fairfield Porter	1907–1975	Helen Frankenthaler	1928–2011
Millard Sheets	1907–1989	Robert Indiana	1928–
Norman Lewis	1909–1979	Nathan Oliveira	1928–2010
Franz Kline	1910–1962	Cy Twombly	1928–2011
Romare Bearden	1911–1988	Claes Oldenburg	1929–
William Baziotes	1912–1963	Jasper Johns	1930–
Ida Kohlmeyer	1912–1963	Sam Gilliam	1933–
Agnes Martin	1912–2004	James Rosenquist	1933–
Jackson Pollock	1912–1956	Jim Dine	1935–
Philip Guston	1913–1980	Frank Stella	1936–
Ad Reinhardt	1913–1967	Red Grooms	1937–
Robert Motherwell	1915–1991	Larry Poons	1937–
Milton Resnick	1917–2004	Brice Marden	1938–
Andrew Wyeth	1917–2009	Bruce Nauman	1941–
Wayne Thiebaud	1920–	Susan Rothenberg	1945–
Richard Diebenkorn	1922–1993	Eric Fischl	1948–
Ellsworth Kelly	1923–2015	Julian Schnabel	1951–
Roy Lichtenstein	1923–1997	David Salle	1952–
Larry Rivers	1923–2002	Kenny Scharf	1958–
Kenneth Noland	1924–2010	Jean-Michel Basquiat	1960–1988
Joan Mitchell	1925–1992		

expected, the productive periods of these artists did not begin until the 1920s. Table 2.2 provides the names and birth-death dates of forty-eight of the most prominent artists of the period. The list includes a sample of artists from various movements—abstract expressionism, pop art, op art, minimalism, color-field painting, and so on. These artists were selected for their variety of styles and because their auction records contained sufficient numbers of observations to conduct statistical tests and research. It is worth noting that seventeen of these artists were still living as of 2013; they form the basis for our analysis of the effect of an artist's death on the prices for his or her paintings in Chapter 7.

Our data set includes the title of the piece, date of auction, height and width of the piece, media (e.g., oil or watercolor), whether the piece was

signed by the artist, the age of the artist at creation, and the "premium price" (calculated in real terms—that is, accounting for price level changes—and in terms of "hammer price" plus the buyer's premium) of the piece at auction for the artists described in Tables 2.1 and 2.2.

Artistic Styles

The style or "school" of an artist is often of interest in research on American artists of all periods. There are numerous means of classifying artists, moreover. One might use "abstract" versus "figurative," landscape, figure, or still-life artist, or dozens of other classifications. Any classification can be challenged. Tables 2.3 and 2.4 provide one listing for the school most associated with a particular artist—not that such placement, even as represented in these tables, is uncontroversial. For example, the first artist listed in Table 2.2—George Inness—has been lumped with the American impressionists (see Table 2.3). Inness, however, during his lifetime resisted this characterization. He is, moreover, also included with another category of late nineteenth-century American artists—the tonalists. Homer and Eakins were "realists," but may be put in other categories. Other artists are far easier to classify, with, for example, Georgia O'Keeffe or Arthur Dove clearly representing those who have come to be known as "modernists."

Table 2.3 "School" Membership for Thirty-three Early American Artists

Impressionists	Modernists	American Scene
Inness	Kuhn	Eakins
Whistler	Weber	Remington
Homer	Avery	Bellows
Cassatt	O'Keeffe	Hopper
Chase	Davis	Wood
Robinson	Burchfield	Henri
Twachtman	Davies	Shinn
Sargent	Prendergast	Glackens
Hassam	Dove	Luks
Lawson	Hartley	Sloan
	Marin	
	Stella	
	Demuth	

Table 2.4 "Schools": Artists Born Post-1900

Abstract Expressionists	Contemporary (Including Op Art, Pop Art, Hard-edge, etc.)	Realism, Representative, Figurative, and Other
Mark Rothko	Alex Katz	Philip Evergood
Hans Burkhardt	Wayne Thiebaud	Fairfield Porter
Norman Lewis	Richard Diebenkorn	Millard Sheets
Franz Kline	Ellsworth Kelly	Romare Bearden
William Baziotes	Roy Lichtenstein	Ida Kohlmeyer
Agnes Martin	Robert Indiana	Andrew Wyeth
Jackson Pollock	Claes Oldenburg	Wolf Kahn
Philip Guston	Sam Gilliam	Nathan Oliveira
Ad Reinhardt	James Rosenquist	
Robert Motherwell	Jim Dine	
Milton Resnick	Frank Stella	
Larry Rivers	Red Grooms	
Kenneth Noland	Larry Poons	
Joan Mitchell	Brice Marden	
Robert Rauschenberg	Bruce Nauman	
Helen Frankenthaler	Susan Rothenberg	
Cy Twombly	Eric Fischl	
Jasper Johns	Julian Schnabel	
	David Salle	
	Kenny Scharf	
	Jean-Michel Basquiat	

The artistic "school" of an artist (i.e., the synergy that accrues to an artist from being a member of a group) could be a factor in several economic aspects of artistic creation. Often there is economic value in being a member of a school of artists—for example, the impressionists. Tastes change, often rapidly, in art demand. One way to view this effect is through the lens of microeconomics and the theory of the firm. Schools are not firms in the strict sense of the word, but they are close cousins. Artists will gravitate to other artists in a process that may involve sharing techniques, subjects, and styles. One of the premier American impressionists, Childe Hassam, not only later gravitated to artists of this style in the United States, he learned some of the looser styles of impressionism, particularly that of Renoir, during his second trip to Paris (1887–1889). (For an example, see his *Seine at Chatou*, painted in 1889, where his impressionist style was fully

FIGURE 2.6 Childe Hassam, American, 185–1935. *The Seine at Chatou*, 1879. Watercolor and gouache. Robert B. Ekelund, Jr. and Mark Thornton Collection, by permission. Copyright, public domain.

developed; Figure 2.6). This loose coalitional framework by artists such as Hassam is analogous to a voluntary coordination process in which producers exploit the economics of joint identification. Such is the economic motive of schools, whether in art, literature, economics, or elsewhere.

And these divisions may be further divided (Davies was actually a "symbolist" rather than a "modernist"). Clearly, the least cohesive group is the "American scene artists," which includes Eakins, a brilliant realist, Hopper, with a unique style, and a group of ashcan artists, all with great variability in approach, subject matter, and style. However, there is not much debate over the vast majority of artists in the three categories, except, of course, that categories may be refined or changed to fit other scenarios (landscape, figurative, still life).

Modern and Contemporary artists—those listed in the second column of Table 2.4—are more difficult to categorize vis-à-vis abstract expressionists, and their placement in a "school" is extremely controversial when precise movements are identified. Abstract expressionism, beginning in the 1940s, with Russian antecedents in the works of Wassily Kandinsky and others, emphasized, as the name suggests, the expression of emotional intensity in abstract, mainly non-figurative terms. The movement in the main dealt (and deals) with the primitive, the spiritual, and a Freudian style of subconsciousness or "inner life."

The forebears of the abstract expressionists constituted a glorious stew of influences. As we have noted, the move to abstract painting was at least partly spawned by politics—specifically the anti-communist witch hunts of the 1940s and early 1950s—but "abstraction" in art per se existed long before, even in American painting.[25] Artists of European movements—many post-impressionists, such as the inventors of cubism, Picasso and Braque, and the fauvist ("wild beast") painters, such as Matisse—were working abstractly early in the twentieth century. Rather, the abstract expressions of the 1940s, 1950s, and 1960s found their origins mainly in surrealism and other movements resting in "dreams," imagination, and existentialism. The ideas and styles of European post-impressionist painters, such as Picasso, Matisse, and Braque, migrated to the United States in their own works and in the work of Americans who studied abroad and adopted such styles in art and sculpture. Jackson Pollock, formerly a "social realist/ American-scene painter," was painting such abstract canvases in the 1940s. That does not mean that all abstract expressionists, such as those listed in Table 2.4, followed the same style. Willem de Kooning introduced abstracted figures into his painting; Jackson Pollock ("Jack the Dripper") created "drip paintings" with duco paints and spray guns, learned in part from the Mexican artist David Alfaro Siquieros; Mark Rothko went so far as to deny that his "color field" painting was abstraction at all. Other painters went to still different abstract styles, such that the list of abstract expressionists in Table 2.4 is extremely diverse and could be rearranged in many different ways.

While there might be argument as to how to "classify" American artists of the second half of the twentieth century, one thing is clear: Jackson Pollock and the abstract expressionists set the stage for virtually all Contemporary art that followed, giving rise to virtually all of the non-realist movements in Contemporary art from the 1970s to the present. Table 2.4 lists a sample of artists from these movements, which, for convenience, we designate as "Contemporary." Pop art, hard-edge painters, op art, post-minimalism, neo-expressionists, and geometric painters are all lumped together in this category. Their one commonality is that they are influenced by "innovations" begun by Pollock and the early abstract expressionists.

It is worth noting in the context of "schools" that figure painting has flourished and is flourishing in the contemporary world as well. Artists in the lineage of Homer, Chase, Whistler, and the classical portrait and landscape painters flourish still. Some important "realist" painters of figures, landscapes, and still lives are listed in column 3 of Table 2.4.

In sum, the categorization of painters into "types" or "schools" can be difficult and debatable. In the end, there are no "schools"—only individuals

with unique styles and approaches to Contemporary art. Clearly, however, Contemporary art is predominately "innovative" and the product of artistic developments in the 1940s and 1950s in the United States.

Buying and Selling American Art

Fundamentally, there are two methods of acquiring art—what may be termed primary sales and secondary sales. A primary sale would be from the artist or from a gallery that represents the artist—that is, an agent for the artist or the artist's family, should the artist be deceased. Here, the designation of "primary sale" becomes a bit tricky. If a gallery owner were to invest in art from a living or deceased artist, a sale from that gallery would be a secondary sale, even though the material may be offered to demanders for the first time. Galleries often bid to represent an artist's atelier (the remains of her work in the hands of her family or legatees) after the artist's death.

Private sellers and galleries in the United States and from around the world participate in hundreds of art fairs year round all over the United States and the world—more than two hundred of them. About one-third of gallery business is conducted at these fairs. These fairs, akin to antique, classic automobile or many other fairs, are institutions that bring buyers and sellers together. As with auction houses and galleries in situ, fairs are of varying qualities and specializations. Prestigious and lower-quality galleries are either invited or pay fees to be represented at fairs to display some of their wares. Sellers have the opportunity to meet buyers (and vice versa) and to acquire information that matches buyers and sellers. Sellers often bring particular artists represented by or candidates for representation by the gallery. There is some specialization with fairs (only contemporary art, for example), or participants may represent many areas of collecting. It is also a market where collectors may become acquainted with new and/or well-recognized artists. The art fairs at Miami, Basel, London, and New York (Frieze, for example), the Armory Show fair in New York, and more recently fairs in China, are only a few of hundreds of art fairs (with an ever-growing number in many parts of Asia). Often those fairs specializing in modern and contemporary art, and others as well, witness the exchange of many millions of dollars' worth of art, as well as the "birth" of new and desirable international artists (Kazakina 2015; Reyburn 2015).[26]

The opening section of this chapter discussed the means of selling American art in the nineteenth and early twentieth centuries. While "gallery sales" of American art had a slow start and sales were often made in shops dealing with other merchandise (frames and so on), the number of galleries

selling American art as at least part of their inventory of paintings and drawing grew as the nineteenth century progressed. American artists studied in European artistic capitals, to be sure, but their productivity and creativity was beginning to find itself through US sales and exhibition venues—both those that dealt exclusively with American art and those that combined American and other art (mainly European). The Alfred Stieglitz and Macbeth galleries were in the vanguard of this push for a "uniquely" American art, but there were literally hundreds of others.

We have calculated the following numbers of dealers and auctioneers from the period of 1913 (the date of the Armory Show) to 1940 using Hall's (2001: table 1.1) exhaustive research (see our Table 2.5). The results are quite surprising. The Armory Show introduced both the European and the American avant-garde to the American public. The reader might recall that the "standard narrative" of the development of art in the United States was that, though American art was purchased in the nineteenth and twentieth centuries up to the "revolution" of abstract expressionism in the 1940s and 1950s, American art was the "poor cousin" of the Europeans. According to this narrative, "good" American artists studied in Europe, and art by Europeans dominated the American scene. It has been assumed that owning contemporary European paintings—after the Armory Show certainly—was the measure of affluence and that this trend continued until American art "invented itself" after the abstract expressionists. Hall's analysis reveals that this view must be seriously modified. He notes that were that the case, one would expect to observe an explosion of New York galleries selling European modernists. However, while the number of art dealers was growing over the first part of the twentieth century, "the most striking find is that the largest single constituency, sixty-five in total, who were in existence for at least some part of the period, specialized in twentieth century American art" (Hall 2001: 47). Adding to the surprise, according to Hall, there were thirty-seven new entrants during the 1930s. And the growth continued.

Table 2.5 Specialities of New York Galleries 1913–1940

Selling Both 19th- and 20th-Century American Art	Selling Only 20th-Century American Art	Selling 19th- and/or 20th-Century European and American Art	Selling Old Masters
87	65	51, with only 16 selling 20th-century European art exclusively	5

Source: Hall (2001: table 1.2).

The growing reception of American art by collectors and museums over this period was astonishing. Although sales obviously followed the business cycle to a degree, falling in the 1930s (though the fall was mitigated by museum sales), these numbers show a growing acceptance of American art. Guilbaut (1985: 91) also reports a quickening of gallery growth (from 40 to about 150) after 1940, much of that perhaps related to pent-up demand generated by wartime economic activity. And today, members of the Art Dealers of America (http://www.artdealers.org/member-galleries) specializing in American art number more than forty member galleries, most of them in New York City.[27] Many more exist today in New York City, and when regional galleries are also considered, growth in the sale of American art is astonishing. When all dealers are considered, art galleries within the United States dealing primarily or exclusively in American art number in the hundreds.

Auction Sales of American Art

While there are approximately 250 auction houses in the United States that include American art as part of their sales, the nexus of the market is in the Northeast, particularly in New York City. The international character of the market is revealed by the fact that some 33 percent of global fine-art sales were made in China in 2011 (rising to about 50 percent in 2014),[28] although the prime market for fine art resides in New York City and London among a small number of houses. These market leaders include two major names, Sotheby's (founded in 1744) and Christie's (founded in 1766), followed by Phillips de Pury (1796), Bonhams (1793), Freeman's (1805), Swann's, Doyle's, Skinner's, and a number of others in New York City and regional markets. Many houses specialize in areas such as rare books, automobiles, coins, or photography, but the largest houses contain "departments" that deal in specializations, including American art. The "big four" are considered to be Christie's, Sotheby's, Bonhams, and Phillips, all maintaining an international presence in the auction markets. There are, of course, many other houses in the Northeast, and perhaps hundreds more across the country. There are auction facilities for every pocketbook and for every conceivable item or collectible. Importantly, both major and lower-tiered auction houses began specialized sales in American art (largely art produced before 1950) in the 1970s, separating them from "modern and contemporary" sales, which contain chiefly post-1950 American paintings. This is one reason that, for some investigations, we divide our sample between artists born before 1900 and painting before 1950 from those who painted in more contemporary styles.

The process of buying and selling at all these auction houses is essentially the same. The house follows an English auction, where price is bid to some maximum. When the bid reaches maximum, the auctioneer strikes the hammer—this is the *hammer price*. If the price does not meet the *reserve*—the minimum acceptable price set by the seller in conjunction with the auction-house "specialist"—the painting is *bought in*—that is, remains unsold. All items, however, are subject to both buyer's and seller's premiums. The seller of an item must agree with the auction house on a seller's premium—on items less than $100,000, typically 10 percent. That means that the seller must pay 10 percent of the hammer price to the auction house for the listing of his or her item.

The successful buyer also pays a buyer's premium on the item, and it is a percentage of the hammer price. Table 2.6 provides the buyers' premiums from 1975 through 2014 at the major houses. If, for example, a painting were estimated to achieve a projected hammer price between $10,000 and $20,000 and were to sell at the auction for a hammer price of $15,000, the buyer would currently pay $15,000 plus a buyer's premium of $3,750 (25 percent of the hammer price) for a total premium price (hammer plus buyer's premium) of $18,750. The seller would also typically pay the auction house a seller's premium on the hammer price of 5 to 10 percent, so that, if 10 percent as in the example, the seller's premium would be $1,500. The auction house, neglecting all other factors, would realize $5,250 from the sale of the painting. This simple example shows how auction houses create revenue and profits. Table 2.6 shows a general upward trend in buyers' premiums since 1992, regardless of the painting's hammer-price category. Buyers' premiums on less expensive paintings have risen from 10 percent to 25 percent; on medium hammer-price paintings, from 10 percent to 20 percent; and for the more expensive paintings, from 10 percent to 12 percent (the total premium paid by a buyer is cumulative, 25 percent on the first $100,000, and so on).

Naturally, "deals" are made for both buyers and sellers of elite merchandise. The fight for "good material" to sell at auction is on. All manner of devices are being used to attract sellers. Auction-house guarantees—a guaranteed price plus some of the overage, for example—is and has been a common tactic. The auction house may offer a consignor some "enhanced hammer," where a seller receives some split (say 4 to 7 percent) of the auction premium. For example, if a high-value item sells above $2 million, the consignor receives 4 to 7 percent of the 12+ percent the buyer paid in premium, thus reducing the auction house "take." Auction-house guarantees (third-party guarantees) may be financed by banks, collectors, hedge funds, or investment institutions specializing in art markets as well.[29] This is evidence of intense competition

Table 2.6 Buyers' Premiums at Sotheby's and Christie's, 1975–2014

1975–1992	1993–1999	2000–2003	2004	January 2005–September 2007	September 2007–June 1, 2008	June 1, 2008–2013	2014
10% all lots	15% up to $50,000	20% up to $10,000	20% up to $20,000	20% up to $200,000	25% up to $20,000	25% up to $50,000	25% up to $100,000
	10% above $50,000	15% between $10,000 and $100,000	15% over $20,000	12% above $200,000	20% between $20,000 and $500,000	20% between $50,000 and $1,000,000	20% between $100,000 and $2,000,000
		10% above $100,000			12% above $500,000	12% above $1,000,000	12% above $2,000,000

among the brokers to get sellers to put their property, hopefully of higher quality, up for auction. All auction houses are competing for material to sell. It is on this basis that profits are made.

The Credence Factor and the Auction Market

The mechanisms through which art is bought and sold, mainly in galleries or art fairs and at auction houses as described in the preceding, are rife with the credence problems briefly described in our opening chapter. That issue looms so large in art markets that the problems associated with markets in art, as described in the present chapter, are worth repeating. Consider the critical issue of credence in more detail.

Clearly we know more about some products or services than we know about others, with art in the latter category. First, economists distinguish between what have been called "search goods" and "experience goods" (Nelson 1970, 1974). We generally know the characteristics of a search good before we purchase it—a brand of toothpaste, a bag of chips, or the imprimatur of a national or other brand name. A sign advertising Kentucky Fried Chicken or Taco Bell tells us accurately what is being sold at the establishment and also indicates the nature and quality of the product to us. If we are frequent chicken buyers at KFC, the advertisement alone provides information on the anticipated quality of the chicken we purchase. If, however, we purchase a new Frigidaire refrigerator or a Honda automobile, the quality may only be imperfectly known to us. The nature and quality of these experience goods must be "experienced" after we have had time to use them.[30] Other things equal, the higher the value of a purchase relative to our income or wealth, the more we are willing to invest in information concerning the item or service—and in the time spent investigating.

There are, however, some goods and services whose qualities are not readily discernible either before or after purchase. We do not know the quality of psychiatric treatment or a heart bypass operation for what may be many years after the treatment or the operation. These goods are particularly vulnerable to fraudulent behavior and are generally called "credence goods" (first identified by Darby and Karni 1973). Ultimately, the quality of experience or credence goods or services becomes apparent, however, so that credence goods may be of varying types. For some of these goods, it is very costly to determine quality; with others, less so, and for some, it is practically impossible to determine quality.[31]

Naturally, market forces provide a multiplicity of solutions to these issues that are inherent to all trade. We have already mentioned some of them.

"Branding" in advertising, for example in the fast-food case, is one market approach to the problem, albeit not always a perfect one. Franchising and quality certification for restaurants and many other businesses—pest control, for example—provide consumers with assurances of quality and credence in products and services. Seller reputation and "buy-back" or warranty provisions also reduce information costs to buyers of used cars, refrigerators, and other "experience" goods.

How do market forces add credence to art trading? Clearly, for all traders, galleries, private sellers, and auction houses, reputation is important. Many galleries specialize in dealing with particular artists, living or dead. Verification is, in general and naturally, easier when the artist is living. Authentication for galleries dealing in a particular group of artists is often a matter of long-term experience with a particular artist's works. One can hardly represent an artist's output for decades without gaining expertise in the authenticity of his or her works. Established and reputable dealers or galleries provide credence for the works sold of particular artists, although that form of credence may facilitate fraud (see the details of the Knoedler case in Chapter 6). When a gallery represents the work of an artist or an atelier of a deceased artist, additionally, the provenance or history of a work is often known or recorded, giving credence to the sale of works. Moreover, there are implicit buy-back provisions if a buyer has purchased a fake from a reputable gallery. In extreme cases of individual sellers of little or no repute, the principle of caveat emptor applies, and although the laws of fraud apply, prosecution, if even possible, is costly and problematic.

Auction houses also deal with the "information problem" concerning works of art. The larger and more elite houses hire more knowledgeable "experts" in the various fields of art. These experts pass judgment on the authenticity of works that sellers wish to consign for auction. If accepted for auction at an agreed-upon "reserve," the price below which the seller/consignor will not sell, a photograph of the piece is placed in a catalogue for the auction. The auction house, at the advice of the experts, will gauge a painting to be fully authentic, "attributed" to the artist, or of the "school" of the artist. The highest level of certification is, of course, that it is represented as being by the hand of the artist. Other information will be published in the catalogue—the piece's dimensions, whether and where it is signed, the provenance or history of the ownership of the piece, and other pertinent information. (Other things equal, *the more prestigious the gallery or auction house, the greater the credence in authenticity among buyers.*) All of these factors lend credence to the piece of art, but they provide no guarantee. Experts can be and are sometimes fooled, and for some (perhaps even many) works, attribution is always "up in the air."

One former director of the Metropolitan Museum of Art in New York City (the late Thomas Hoving) once opined that as much as 30 to 40 percent of the art in museums was fake!

Why must caveat emptor be the watchword when purchasing most art? It is not only possible, but probable that some fakes or questionable works will get past this process of authentication by auction-house experts. This possibility is recognized by all reputable auction houses, and a "limited warranty" is issued in the auction catalogue. Consider the following such guarantee listed in Christie's American-art catalogue of May 16, 2012: "Subject to the terms and conditions of this paragraph, Christie's warrants for a period of five years from the date of the sale that any property . . . which is stated without qualification to be the work of a named author or authorship, is authentic and not a forgery" (Christie's 2012: 159). Naturally, this guarantee is subject to a number of stringent qualifications—it does not apply to works designated "attributed to the artist" or "of the school" of the artist, and so on. Furthermore, there are numerous other qualifications; to wit,

it does not apply where (a) the catalogue description or salesroom notice corresponded to the generally accepted opinion of scholars or experts at the date of sale or fairly indicated that there was a conflict of opinions; or (b) correct identification of a lot can be demonstrated only by means of either a scientific process not generally accepted for use until after publication of the catalogue or a process which at the date of publication of the catalogue was unreasonably expensive or impractical or likely to have caused damage to the property. . . . [Further, it] is Christie's general policy, and Christie's shall have the right, to require the buyer to obtain the written opinions of two recognized experts in the field, mutually acceptable to Christie's and the buyer, before Christie's decides whether or not to cancel the sale under the warranty. (2012: 159)

Such a warranty thus carries so many qualifications that relief from fraud is difficult and expensive.[32] The same goes for many "buy-back" agreements in sales between buyers or collectors and galleries and purveyors of art. As such, the *issue of credence is at the heart of our entire discussion of art*—from the ability of auction experts and gallery owners to determine "quality" and legitimacy, to the amount individuals will be willing to invest in art or art funds, to the assessment of artists by demanders at the death of the artist and many other issues. In short, credence is vital to all aspects that speak to the functioning and operation of art.

American Art and Institutional Change

The present chapter has served as a brief introduction to some fundamentals concerning the American art market and art markets in general. The vast and often-complex history of the development of American art cannot be told in any brief synopsis. It is not our intention to do that in this book. Rather, we are interested in the economic market for American art in a somewhat technical rather than an aesthetic sense—for example, is it a profitable source of investment income?—and in somewhat technical rather than aesthetic issues relating, for example, to how to identify a bubble in that market. We have considered only some of the fundamentals of the American art market in the present chapter, but many additional issues pertaining to that market are of interest.

Many believe that American art—art produced in North America—was and is "derivative"—that is, based on styles, genres, and associated nationalities of those who immigrated here or studied abroad from colonial days to the present. While there is always some truth to the fact that art (or literature or science) is not produced in a vacuum—with no relation to what has gone before—the criticism is, we believe, off the mark when it comes to the development of American art and the market for it.

Surely much contemporary art produced in the United States—including installation and performance art—is "innovative" to some great extent. But the artists of the Hudson River school (never an actual "school" but a conglomeration of artists interested in similar subjects, initially centered around the landscape of the Hudson River) were "original" in their own way. Landscape painting had a long tradition in England and on the Continent for hundreds of years before Thomas Cole and Asher B. Durand put brush to board or canvas in the 1800s. But their innovation and that of their followers was in the cast they put on the spectacular and unique scenery of the New World. The "newness" of America and its economic development, immigration, and population movements underscored and corresponded to the pursuits of its artists to a large extent. The landscape of North America was vastly different—paintings, at least in subject matter, had to be different. (This fact tempers any arguments that American art was wholly "derivative" of European influence.) Additionally, the art of Spanish and other colonialism, for example, could not have helped but influence the art of Western America. Styles of American art were thus a mixture of European influences and down-home artistic conceptions of individual artists in the early period. Subject matter was a different story. European development had being ongoing for several thousand years, whereas America was a new nation. The entire European Continent could

fit into several large U.S. states, moreover, so that transportation costs were relatively low. Americans of the East longed for a glimpse of the magnificent scenery of their great land, and artists were more than happy to respond, as we noted earlier in this chapter. Vistas of the West were so desired that they were objects Americans of the East would pay to see.

There were ever-growing and ever-changing relations with the art of Europe, particularly that of France and Austria and the German states. The post–Civil War era, in particular, created a two-way flow of American and European artists that lasted well into the twentieth century. Barbizon painters were especially important models for much of American landscape painting at the time. European wars and other dislocations brought artists and their styles to our shores as well. The ebb and flow of these influences produced an American art both somewhat imitative and somewhat original in the American marketplace. Artist-teacher Robert Henri and photographer Alfred Stieglitz capitalized on the idea of a "uniquely American art" (each in his own manner), although both, each again in a different confrontation, had had contact with avant-garde European movements. Their progeny, both some of the ashcan-school painters and Stieglitz's modernists (Hartley, O'Keeffe, Demuth, Marin), began to constitute a distinctly American tradition in art that continued through the twentieth century.

We also believe it interesting that world events have had such an enormous impact on the evolution of American art. Disruptions created by all European wars (and the American Civil War as well) had a sometimes profound impact on the movement of art and artists to American shores. World War I brought the era's avant-garde artists from Europe to live or sit out hostilities in the United States. World War II, with the win by the Allies, most especially created a vacuum in the locus of the center of the art world—Paris. The center of that world moved to New York and to new and innovative techniques: partly inspired by the kind of abstract art that had developed in America; partly though participation in foreign movements (e.g., Wassily Kandinsky and modern art); and partly out of the political necessity of disguising "socialist" art with forms of abstraction. After these developments came the multiplicity of schools and streams of American Contemporary art and the tentacular international development of "innovative art" around the world, not all of which will become "established as part of the pantheon" or stand the test of time.

Economically, we argue that *throughout* American history, not simply in the modern age, a distinctly American "brand" of art developed. At first, its uniqueness was driven by geographic and transportation cost considerations, as well as by the enormous talents of some early American artists. Economic development meant surging populations and a westward movement, along with

continuous interchange with the artists and artistic conceptions of Europe. These developments ultimately defined a "brand name" for American art. The restlessness of art and artists of the nineteenth century and the first half of the twentieth in American art is reflected in contemporary developments— developments that have produced a boom.

The decade-plus-long boom in contemporary art, especially in Contemporary American art, must be reckoned with. Just as art of all ages must be evaluated, Contemporary art must go through the merciless fires of time. We agree with Tyler Cowen that there are always and in all times cultural "pessimists" and cultural "optimists." The former "take a strongly negative view of modernity and of market exchange . . . [and] typically believe that the market economy corrupts culture" (1998: 9). Conversely, the cultural optimist "suggests that the arts tend to flourish in a modern liberal order" (1998: 13). The market process—whereby new and generally innovative artists "test the waters"—does not inhibit art, but rather is the modus operandi of the growth and change of art. It is inevitable that some will not like or demand forms of innovative Contemporary art (e.g., Christo's "land art" or Jeff Koons's giant in-flatable figures). Others will and most certainly do. Will the artists regarded as avant-garde today have lasting reputations (such as Rembrandt or Van Gogh, or even Americans Asher Durand or Thomas Cole)? Only the market pro-cess through time will make that determination. The huge advantage of free commerce and the market process is that it matches art suppliers with art demanders of Contemporary art and all kinds of art. Works from a long tra-dition of representative art (landscapes, figures, still life, and so on) continue to be bought and sold. As such, markets are a "matching" of artists' particular productions and demanders of those works. Importantly, that matching takes place within an evolving capitalist system and evolving marketing institu-tions. Reductions in information costs to buyers of art and access to buyers by sellers has made the market vastly more efficient. To discover a seller's wares, a buyer now only needs to pull up a website. Art fairs, the number of galleries, and the number and specialization of auction houses all have helped create a more efficient market for American art of all types.

Finally, it is worth noting that the origins of much Contemporary art may be said to be American, but an American art has always existed. American art and the marketplace of American art has been the handmaiden or associ-ated product of the evolution of the United States of America from colonial times to the present. Moreover, the fate of American art in the marketplace has been molded by the institutions, particularly the marketing institutions, of capitalism. As we noted in this chapter, early work was sold in general-merchandise stores, later in specialized establishments specializing in art,

then in specialized businesses in American art (particularly in the large Northeastern cities), and now on the Internet as well as in specialized galleries and auction houses. Naturally, further evolution may be expected, but much may be learned by analyzing past and contemporary artists and some of the institutions through which American art is sold. We begin with the nature of American artists.

Chapter 3

Mystery of the Artist's Nature

CREATIVITY, AGE, AND ECONOMICS

DEMOGRAPHY AND THE characteristics of artists and scientists have been of interest to statisticians for more than one hundred years going back to Quetelet (1835), who sought to explain the creative differences between French and English playwrights. Sir Francis Galton made important inquiries into the nature of "genius"—the famous nature-versus-nurture question—in 1869 (Stigler 1986). Modern writers have carried the search for links between creativity and factors affecting human inquiry much further into statistics and social science. For example, the relations between age and creativity have been of interest to psychologists and other scholars (Jones 2010) for a number of years. Allegations that, for example, physicists, mathematicians, and poets peak at early ages have become accepted lore for decades. Many of these memes have become objects of close study. The psychologist Dean Smith Simonton (2014) is by far the most respected and prolific developer of what is sometimes called "historiometry"—a statistical evaluation of psychometric data (often in retrospect) to explain creativity and career paths in many specialties on the basis of past behavior, experience, and genetics.

The calculation of the relative impact of genetic or environmental factors on the incidence of creativity is difficult since measurement is a central problem. Simonton (2014: 26) writes,

> However easy it is to compile such family pedigrees, their relevance to the nature/nurture issue is more ambiguous because parents provide not just genetic make-up for their offspring, but also environmental influences, including role models and mentors.... Interestingly, artistic geniuses hail from far more unstable, dysfunctional, unconventional, and even multicultural family backgrounds than do scientific geniuses.

These and many other factors will have an impact on creativity and productivity in many fields, and they will act differently on the areas of inquiry in question. Historiometrists, or those using numbers from historical or anecdotal data, may emphasize and have emphasized birth order, gender, cultural influences, and many other possible explanations, almost exclusively with anecdotal evidence and statistics.

Artists are no exception in investigating the mystery between creativity and age, but economists have come somewhat late to the game. Naturally, economists would, at least in part, always emphasize that monetary incentives are in play. High returns to the top-level achievers in certain fields—technology or art—will often stimulate study and attempts to master those areas so that *relative* returns may be important in explaining some productivity. Acting, music, writing, poetry, and art attract many, but the level of high rewards is often reached by only a small percentage of entrants. (There are likely two hundred thousand or more working artists in the United States alone today, for example, but few with high annual incomes.) Economists would also emphasize such factors as artistic education (human-capital acquisition) and associations with other artists, learning by doing (many great artists have been basically self-taught), and the economic environment in which the potential artist finds herself.

Unfortunately, many of the factors for which economics seems germane to understanding creativity are, like those studied by the psychologist or sociologist, difficult or impossible to quantify. A recent exception presents itself as contrary to this position, however. The economics of age, artistic creativity, and productivity has been the subject of interesting and excellent research by economist David Galenson. Galenson, using both statistical and anecdotal methods, divides artists into two types, innovative and experimental, to investigate *how type of creativity is related to age*. Galenson's extensive investigation deals primarily with *international* artists in his initial contributions (e.g., Galenson 2001) and is not specifically aimed at analyzing the age-productivity profiles of *American* artists, although some of the latter are included in his many discussions. We extend these and other methods to a new sample of eighty *American artists born prior to 1960* in this chapter (see Chapter 2 for lists of the artists we study). Since the market for American art was starkly energized in the post–World War II era when the center of the art world moved to the United States, specifically to New York City, from Europe (Guilbaut 1985, 1992), the major works of American artists have tended to become more innovative in character and produced at earlier and earlier ages. Thus, may artistic type be linked with the age at which major works are produced? Or, are there other important factors at work here, such as the *changing nature of*

capitalism and the role of the artist—changes in marketing methods employed by American artists and their representatives? It is also important to analyze the importance to artistic success of being associated with a "school" on the value of art. Here we also evaluate the use of *anecdotal evidence* in the age-creativity relationship of two major American artists (Georgia O'Keeffe and Jackson Pollock), as it poses a general problem with attempts to link artists to creativity and productivity. Network effects and "expert opinion," as a proxy for anecdotal evidence, are also examined for our sample of artists. Our results suggest that a number of factors must be used to link age to artistic creativity, although Galenson's valuable research is an excellent introduction into that relation. While Galenson's inferred link between the *type* of artist and peak productivity has been challenged, an investigation between age and productivity (generally) is independent of that relation. Thus the former cannot be, and is not, neglected here.

The Age-Creativity Relation and American Artists

Thus, possible sources of human creativity and the age at which it emerges is an eternal question mark for psychologists (Lehman 1953; Lehrer 2012; Simonton 2000), scientists (Jones 2010; Pringle 2013), and scholars in the social sciences, as discussed earlier. Such questions have been pondered for generations, and we confine our study to American painters, but there are deeper issues that must be mentioned briefly—namely, the role of the artist in society. Before proceeding, we should be clear that in what follows, we measure artistic creativity, or productivity, by the value (price) of the artist's painting arising from a market transaction involving the painting. While some might argue that this is a poor measure of the artist's contribution to society and its culture, it is certain that the value of a painting is an objective measure of at least one aspect of artistic productivity. Furthermore, economists would argue that the value of a painting also embodies agreement, at least between buyer and seller, on the worth of the aesthetic aspects of the painting that the artist produced. In taking this approach, we follow virtually every past study that has empirically analyzed the determinants of artistic creativity or productivity.

The Artist and Societal Structures

The artist has had a role in society for, perhaps, five millennia. The artist has been viewed as a creator-craftsman for hundreds of years. The Renaissance

certainly propelled that idea, with students (Da Vinci and Michelangelo) apprenticed to a "master" artist in a class where collaboration was extolled. The artist was considered a "craftsman" who put in his or her time to achieve a high level of excellence. This is reminiscent of the so-called ten-thousand-hour rule (Gladwell 2008) on how to achieve world-class prominence in some fields, an idea that might partially apply to never-changing rules of play (games, classical music) but not to less-structured pursuits. The artist, at least in the craftsman conception, adhered to *tradition*, as opposed to innovation.

Deresiewicz, in an important essay (2015), speaks of a phase wherein the artist was regarded as a "genius," often a "solitary genius," after which yet another stage was reached—the "professional" artist. In this stage "you didn't burst from obscurity to celebrity with a single astonishing work. You slowly climbed the ranks. You accumulated credentials. You amassed a resume. You sat on the boards and committees, collected your prizes and fellowships" (Deresiewicz 2015). You were a professional, and that is a concept (along with earlier notions) that survives today. But underlying all of these conceptions of the artist was "the market"—how artists got or get paid and whether the artist's spiritual mission could, would, or should be monetized. Thus, we wish to emphasize that forms of capitalism, viewed as the "market," underlie or at least partially underlie the conception of the market. And capitalism, viewed as the *form* of market transactions, has further changed the status and role of the artist today. Marketing in its many forms, at least according to some, has changed the status of artistic endeavor. Artists typically have websites on the Internet, for example. Contemporary artists are represented by galleries across the nation, but most of the "hot" artists are represented by galleries in New York City. William Deresiewicz (2015: http://www.theatlantic.com/magazine/archive/2015/01/the-death-of-the-artist-and-the-birth-of-the-creative-entrepreneur/383497/) describes this change succinctly: "The professional model remains the predominant one. But we have entered, unmistakably, a new transition, and it is marked by the final triumph of the market and its values, the removal of the last vestiges of protection and mediation. In the arts, as throughout the middle class, the professional is giving way to the entrepreneur, or, more precisely, the "entrepreneur": the self-employed . . . the "entrepreneurial self." We agree fully with this assessment and would go further to argue, as we will in the present chapter, that entrepreneurial-marketing forms of capitalism have much to do with the genre of art being produced, as well as artistic creativity and productivity by Americans. Our thesis, then, is that technology and the evolution of market forces explain the value/age profiles of many major American artists.

The Economist Speaks

Most studies by social scientists of the key relationships between age, art genres, and artistic creativity and productivity have been hampered by a lack of hard data on cause and effect. But there is one important exception. As noted in the introduction to this chapter, studies of *artistic* creativity and age must confront the work of David W. Galenson. Over the past decade and a half (2001, 2006a, 2006b, 2009, and in many articles in the popular press and NBER studies), he has attempted to classify artistic creativity by considering peak age of productivity, using both statistical and anecdotal evidence (each of them legitimate methods of economic inquiry). His central task has been to link age with artistic creativity; the fundamental theoretical argument, however, involves type of artist as well. In Galenson's conception, artists may be divided into two camps: experimental artists—empirical artists, or experimenters, *for whom no work is finished*; and innovative or conceptual artists, who produce works that "embody innovations derived by deductions from general principles" (2001: 51), a position he has held throughout multiple investigations into artistic creativity (2006a: 55; 2009: 13–15). Working method (planning, executing, and finishing) helps determine the *type* of artist. Much preparatory work—such as preliminary sketches—is made by the conceptual artist, who communicates emotions and ideas and whose goals are frequently stated in advance. So much planning may take place that the art is in effect finished before it is begun (think Andy Warhol). Specific procedures are followed by artists of this type, and innovations appear suddenly. For experimental artists, a lifetime of work is produced, aimed at "getting it better." Paintings are "never finished" and innovations appear in a large oeuvre or body of work (think Whistler, according to Galenson). There is much trial and error. Experimenters reach peak value at later (over forty generally) ages, whereas conceptual types peak at younger ages.[1] While much of Galenson's work has been directed to a coterie of international artists, he has directed some of his analysis exclusively to American art and artists (2002).

Galenson's hypothesis regarding age and creativity has met criticism on several fronts. Two, for example, relate respectively to artistic working methods, age, and the *type* of artist. Ginsburgh and Weyers (2006) examine the working methods of Old Masters (drawing vs. the use of color) and show, convincingly, that a distinction between innovative (conceptual) and experimental artists is unconvincing. More recently, Hellmanzik (2009) has used statistical methods on a sample of 214 prominent American and European artists born between 1850 and 1945 to analyze how birth-year cohort, on the one hand, and artistic style, on the other, have an impact on the age at which peak

performance is achieved. Her investigation shows that innovative technology applied to art, rather than some simple bifurcation of creativity type, explains success in the art world (also see Galbraith and Hodgson 2014).

This chapter uses Galenson's *methods*, both formally empirical and anecdotal, to study possible relations between artistic creativity and age for two different cohorts of American artists. First, we employ a unique data set of auction values for a cohort of thirty-three important American artists between 1987 and 2011, with all artists considered *born prior* to 1900 (most of whom worked in the first half of the twentieth century). Next we consider forty-seven artists born after 1900 and investigate their age-productivity relation. Those born after 1900 include a large number of what would now be called "modern" or "contemporary" artists, including the abstract expressionists—for example, Jackson Pollock—as well as many schools of contemporary artists [some who were alive as of 2013] such as Warhol, Frankenthaler, and Olivera. Our technique replicates that used by Galenson (2001) and Galenson and Weinberg (2000) to study age and creativity type, but it employs a new sample of the most important American artists born up to 1960 and does not neglect those artists for whom the relation between age and peak value is insignificant.[2] We additionally consider time and artists in a fixed-effects framework to link age and creativity, measured by age at peak value, using our entire sample. Within this framework, we also study the impact of "schools" on return to artists in the cohort in the full recognition that "school designation" is an extremely variable and tricky business. The question of artistic peak, as viewed by experts, versus market peak, is analyzed, after which we assess the quality of anecdotal evidence that may be used to uncover the relation between age and artistic creativity—using American modernist artist Georgia O'Keeffe and abstract expressionist Jackson Pollock as examples. Finally, we summarize the implications of our results and suggest that artistic creativity may contain dimensions either unknown or completely divorced from the age of artists, and we statistically analyze some of those possible determinants. Our extension concludes that artistic creativity is probably determined by many factors (age possibly being one of them) and that a more complex analysis—one underlining some of the ever-changing institutions of markets and capitalism—must be used to help explain creativity using the artists and sample employed.

Artists Born Prior to 1900 and the Age-Productivity Hypothesis

Suggested principles linking age to artistic and other kinds of creativity in a number of disciplines are numerous (Abra 1989; Freundlich and Shively 2006),

as we suggested earlier in the introduction to the chapter.[3] Areas of peak age are, in this literature, assigned to poets, philosophers, scientists, mathematicians, and others. Received argument (Lehman 1953) is that productivity, in general, declines with age, but contemporary psychological and economic literature presents strong challenges to that presumption (Jones 2010; Lindauer 2003). Galenson also implicitly challenges that presumption and employs quantitative and anecdotal approaches to bifurcate creativity to link it to the age at which artists reach creative heights. His quantitative and formal approach is based on auction data and a qualitative (anecdotal) approach relying heavily on quotations from artists and art historians, textbook illustrations, museum collections, and retrospective exhibitions. This anecdotal approach comprises the mass of Galenson's evidence and consists of voluminous quotations from the artists themselves. For statistical analysis, Galenson relies on auction statistics (from *Le Guide Mayer*, now *artvalue.com*) between 1970 and 1997 to establish peak value and relates it to artists' ages when that value is reached at auction. Using a multiple-regression technique, he argues that variation in auction prices is a function of the artist's age when each painting was created, the medium (paper or canvas), the size of the work, and the date of its sale at auction (2001: 13). These results have been consistently cited in his work. Galenson examined seventy-five American artists painting in the twentieth century and found that, for fifty-seven of the seventy-five Americans, age had a statistically significant impact on the value of an artist's work. In a table (2001: 17, table 2.2), Galenson ranks American artists by birth age, purportedly showing that "if we divide the American artists into those born through 1920 and those born thereafter, the median age at peak creative value falls from forty-four years for the thirty-one artists in the earlier group to thirty-four years for the twenty-six artists in the later one (2001: 14, 18). Here Galenson is suggesting that those born before 1920 are "experimental" artists and that those after tend to be conceptual artists, although Galenson does not apply that judgment to all of them. Elsewhere Galenson (2005b, 2006a) and Galenson and Weinberg (2000) studied twentieth-century American artists (again born between 1900 and 1920 and between 1920 and 1940) and found that artists born in similar time periods exhibited the same creativity characteristics.[4] In short, experimental artists generally reach their peak creativity at older ages in the 1900–1920 cohort than conceptual artists born afterward, mainly those born after 1920. This is the centerpiece of Galenson's argument regarding artistic creativity. American artists from all periods are characterized by Galenson in the same manner as all artists. They fall into either the experimental or the conceptual camp. But Galenson goes further. In spite of earlier American painters' visits to France—where many were

introduced to the conceptual art of the emerging French approaches (impressionism, fauvism, cubism, symbolism, neo-impressionism, the Barbizon school of painters)—their initial academic training in the United States trumped these influences. Said Galenson (2001: 114), "In most cases their conception of art had therefore been formed prior to their exposure to the latest European developments, and American artists born before 1900 almost all shared a very traditional conception of painting. In view of this, it is not surprising that most expressed attitudes toward their craft that clearly identify their approach as experimental."[5]

This view is applied to the American modernist John Marin (1870–1953), a protégé of the great photographer and promoter of modernism Alfred Stieglitz (Messinger 2011), who is quoted as finding as he painted "things cropping up I never intentionally intended." American "modernism"—a descriptive term usually meaning a reaction to academic realism and including abstraction, as well as an abstract but representational or modified realism—is therefore not associated directly with conceptual art by Galenson. He therefore believed the vast majority of the painters born prior to 1900 (or even 1920) tended to be experimentalists—painting without exacting plans for the final products and influenced by received academic styles.[6]

Throughout a range of contributions, Galenson has studied a number of American artists. In a National Bureau study (2005b) of late nineteenth-century artists, Galenson employs his bibliographic evidence to show that of six great artists of the period, only two (Thomas Eakins and John Singer Sargent) could be identified as "innovators," while four others (Mary Cassatt, Winslow Homer, Albert Pinkham Ryder, and James McNeill Whistler) developed "slowly" into experimentalists. The selection of these particular artists was made because their works were reproduced in five out of six art-history textbooks.

Artists Born between 1900 and 1960 and the Age-Productivity Hypothesis

Galenson's 2002 paper and later his book (2006a) dealt with peak ages for American painters of the second half of the twentieth century. In his book, however, using similar methods as in earlier work (2001) to obtain bibliographic evidence (textbook illustrations and peak age in works in retrospective exhibits), Galenson returned (2006a: 36, table 2.5) to the statistical auction data of 2001 (table 2.2). He concluded that, given the comparability of age in both bibliographic and formal regression data, five of the artists were experimental (Mark Rothko, Arshile Gorky, Willem de Kooning, Barnett Newman,

and Jackson Pollock) and five were "conceptual" (Roy Lichtenstein, Robert Rauschenberg, Andy Warhol, Jasper Johns, and Frank Stella).

A far more in-depth analysis of the post-1900-born artistic scene (most painting after 1945 or 1950) is provided in Galenson's paper of 2002. While the paper does purport to show that Jackson Pollock was the "greatest modern painter," it provides clear statements concerning the transition of modern art (in the form of abstract expressionism) to contemporary "innovative art." Or, as Galenson put the matter, "In 1955, few in the art world could have predicted how quickly and how thoroughly abstract expressionism would be eclipsed by new styles devised by younger artists" (2002: 117). Considering a sample of thirty-five painters born after 1900, Galenson looked at fifty-six books on art history; the illustrations contained in these books; and the single paintings most reproduced by each of these artists and the *age* at which the artists executed these particular paintings. Galenson (2002: 117) concludes that there is

> a striking difference by generation in the artists' ages. The median age at which the Abstract Expressionists executed their 9 entries . . . compared with a median age of just 31 for the 12 entries of the next generation. None of the 9 paintings by the first generation was done by an artist under the age of 38, but 10 of the 12 works by the second generation was done by artists younger than that, and fully half were made by artists aged 30 or younger.

As evidence for this purported "phenomenon," Galenson again appeals to the anecdotal evidence that the abstract expressionists were "experimenters" without a precise conception of the final product, whereas those who came after were "innovators":

> Unlike the Abstract Expressionists, the leading painters of the next generation did not belong to any single group or movement. Yet they did share a common concern with replacing the complexity of Abstract Expressionist gestures and symbols with simpler images and ideas, and in pursuing this goal they succeeded in replacing their predecessors' experimental method with a conceptual approach.

One must observe, as Galenson does, that the "new" post-abstract expressionists were and are extremely diverse in execution, spanning pop art, California figurative painting, and myriad other styles. But, all considered and with the use of ten artists (*out of the thirty-five artists whose illustrations he calculated*)

who hold the record number of illustrations, Galenson offers "method of execution" as the rationale for concluding that five of these ten artists are "experimentalists" and five are innovators. As noted earlier, the experimentalists are Gorky, de Kooning, Newman, Pollock, and Rothko; the innovators are Johns, Lichtenstein, Rauschenberg, Stella, and Warhol. We comment at some length on this approach later in this chapter.

Measurement and Model Specification

We employ two birth cohorts to study the hypotheses advanced by Galenson regarding age and creativity: (a) those American artists born prior to 1900 (see Table 2.1 for a list of those artists); and (b) those born post-1900 but before 1960 (see Table 2.2). Using these data, we seek to provide a direct empirical test of the proposition that age at peak value has a direct effect on whether (and which) artists may be classified as either experimental or conceptual. More generally, we study the factors that produce artistic creativity over the life cycle.

Artists Born before 1900

A primary objective of this chapter is to replicate Galenson's empirical procedure using a new data set, with an eye toward evaluating the robustness of his inferences regarding the nature of the age-creativity relationship for American artists born in the nineteenth century. We begin by summarizing Galenson's empirical methodology and then introduce our new sample of nineteenth-century American artists who worked before 1950.

In examining the age-creativity relationship, Galenson (2001) challenged the presumption that creativity declined with age (see, e.g., Lehman 1953) and employed a quantitative approach to bifurcate creativity to link it to age at which artists reach creative heights. In both his early and later works, he augments his statistical evidence with considerable anecdotal evidence. As noted earlier, for statistical analysis Galenson relies on auction data (from *Le Guide Mayer*, now *artvalue.com*) between 1970 and 1997 to establish peak value and relates it to artists' ages when that value is reached at auction. He argues that variation in auction price is a function of the artist's age when each painting was created, the support (paper or canvas), the size of the work, and the date of its sale at auction (2001: 13). Specifically, he estimated the five following models for each artist by least-squares regression and selected as best the one with the highest adjusted R^2 (see Appendix 3.1 for a definition).

$$\ln(\text{realprice}) = \alpha_t + \beta_1(\text{AGE}) + \gamma_1\left[\ln(\text{SIZE})\right] + \gamma_2(\text{SUPPORT}) + \sum_{j=3}^{6}\gamma_j\text{DY}_{j-4} + \varepsilon$$

$$\ln(\text{realprice}) = \alpha_t + \beta_1(\text{AGE}) + \beta_2(\text{AGE})^2 + \gamma_1\left[\ln(\text{SIZE})\right]$$
$$+ \gamma_2(\text{SUPPORT}) + \sum_{j=3}^{6}\gamma_j\text{DY}_{j-4} + \varepsilon$$

$$\ln(\text{realprice}) = \alpha_t + \beta_1(\text{AGE}) + \beta_2(\text{AGE})^2 + \beta_3(\text{AGE})^3$$
$$+ \gamma_1\left[\ln(\text{SIZE})\right] + \gamma_2(\text{SUPPORT}) + \sum_{j=3}^{6}\gamma_j\text{DY}_{j-4} + \varepsilon \qquad (3.1)$$

$$\ln(\text{realprice}) = \alpha_t + \beta_1(\text{AGE}) + \beta_2(\text{AGE})^2 + \beta_3(\text{AGE})^3 + \beta_4(\text{AGE})^4$$
$$+ \gamma_1\left[\ln(\text{SIZE})\right] + \gamma_2(\text{SUPPORT}) + \sum_{j=3}^{6}\gamma_j\text{DY}_{j-4} + \varepsilon$$

$$\ln(\text{realprice}) = \alpha_t + \beta_1(\text{AGE}) + \beta_2(\text{AGE})^2 + \beta_3(\text{AGE})^3 + \beta_4(\text{AGE})^4$$
$$+ \beta_5(\text{AGE})^5 + \gamma_1\left[\ln(\text{SIZE})\right] + \gamma_2(\text{SUPPORT}) + \sum_{j=3}^{6}\gamma_j\text{DY}_{j-4} + \varepsilon$$

where [ln(realprice)] is the logarithm of the hammer price of the painting deflated by the consumer price index (CPI); AGE is the age of the artist at the time of the painting's creation; ln(SIZE) is the logarithm of the surface area of the painting; SUPPORT is a dummy variable, where SUPPORT = 1 if the painting is on canvas and 0, otherwise. DY_i is a set of five-year-interval time period dummies (1990–1994 was the base period), and ε is a stochastic disturbance term. If the AGE terms are jointly significant (at the $\alpha = 0.10$ level), a graphical value/age profile of the artist was created.[7] In all his subsequent work involving statistical modeling of individual artists, Galenson consistently refers to this statistical analysis in his 2001 book. It is thus fair to say that this procedure forms the formal basis for all of his statistical inferences regarding creativity.

Galenson examined seventy-five American artists painting in the twentieth century and found that, for fifty-seven of the seventy-five Americans, age had a statistically significant impact on the value of an artist's work. As noted earlier, Galenson splits his sample at 1920 and found that the (thirty-one) artists born prior to 1920 had an average age at peak creativity of forty-four years while those (twenty-six) artists born after reach peak creativity at an average of thirty-four years. He takes this to imply that most, if not all of those artists born before 1920 were experimentalists while those born after were mostly conceptual artists.[8] He is even clearer, also as noted earlier, concerning the age, productivity and experimental character of American artists born before 1900.

In the remainder of this chapter and throughout much of the remainder of this book, we estimate and interpret many empirical models of various aspects of the American art market. While those familiar with the empirical techniques may well find our applications overly simplistic, others, not technically oriented, may find our statistical analysis impenetrable and hence ignore it. This would be unfortunate because we feel that much of what we must say that is new and worthwhile arises from the quantitative and qualitative behavioral implications of these statistical results. Consequently, we offer an Appendix 3.1 (see Appendices) to help the non-technically oriented reader understand where our behavioral inferences are coming from and to follow our empirical analysis. It is written to provide the reader with an intuitive interpretation of only the most important aspects of our statistical results. We encourage the non-technically oriented reader to give it a look.

To determine whether Galenson's inferences can be supported with an alternative set of data, we assembled a new data set of auction observations from 1987 through 2011 (twenty-five years) from askART.com, a site that only presents results on American art.[9] The data set consists of paintings offered at auction by American artists born in the latter half of the nineteenth century and painting before 1950. We are interested in artists born prior to 1900 to test Galenson's contention that these artists are predominantly experimentalists. We truncate our sample of paintings at 1950 because that seems to mark the beginning of the pronounced manipulation of demand for American paintings by (primarily New York) art galleries, collectors, and critics. Thirty-three artists met these criteria; however, seven of them had fewer than thirty sales at auction during the twenty-five years of the sample. These seven include Arthur Davies and Ernest Lawson (twenty-five sales each), Grant Wood (twenty-four sales), Mary Cassatt (twenty-three sales), John Henry Twachtman (eighteen sales), Thomas Eakins (seventeen sales), and James McNeill Whistler (twelve sales). Data on these artists are included in our pooled (fixed-effects) analysis since there is no reason not to do so, but we did not include them in our individual-artists analysis because making inferences on their individual value/age profiles based on such limited data would be too risky. Thus our individual-artists analysis is based upon twenty-six artists whose records at auction over the 1987–2011 period contain more than thirty observations. Even so, these twenty-six represent and were partly chosen for their wide variety of artistic styles (impressionist, realist, tonalist, luminist, ashcan, modernist, etc.). These artists, their life spans, and the number of sales during the sample period are listed in the first three columns of Table 3.1.[10]

Our data set includes the title of the piece, date of auction, height and width of the piece, media (for example, oil, watercolor, and so on), whether

Table 3.1 Summary of Results and Implications of Galenson's Procedure Applied to a Sample of Twenty-six Well-Known American Artists Born Prior to 1900

Artist	Life Span	Number of Observations	Specific Value/Age Profile: Order of Best-Fitting Age Polynomial	Age Terms Jointly Sig ($\alpha = 0.10$)	General Trend in Value/Age Profile: Effect of Age on Value over Career	Statistically Significant ($\alpha = 0.10$)	Implications for Galenson's Creativity Dichotomy
George Inness	1825–1894	110	Fourth ($R^2 = 0.40$)	No	Negative ($R^2 = 0.36$)	No	Uncertain
Winslow Homer	1836–1910	104	Fourth ($R^2 = 0.39$)	Yes	Positive ($R^2 = 0.31$)	No	Uncertain
William Merritt Chase	1849–1916	43	Fifth ($R^2 = 0.36$)	No	Positive ($R^2 = 0.23$)	No	Uncertain
Theodore Robinson	1852–1896	43	Third ($R^2 = 0.80$)	Yes	Positive ($R^2 = 0.77$)	Yes	Experimental
John Singer Sargent	1856–1925	77	Fifth ($R^2 = 0.55$)	Yes	Negative ($R^2 = 0.47$)	Yes	Conceptual
Childe Hassam	1859–1935	278	Fifth ($R^2 = 0.53$)	Yes	Positive ($R^2 = 0.45$)	Yes	Experimental
Frederic Remington	1861–1909	75	Fourth ($R^2 = 0.73$)	Yes	Positive ($R^2 = 0.65$)	Yes	Experimental
Walt Kuhn	1877–1949	121	First ($R^2 = 0.61$)	No	Positive ($R^2 = 0.61$)	No	Uncertain
Max Weber	1881–1961	86	Fourth ($R^2 = 0.59$)	Yes	Negative ($R^2 = 0.55$)	Yes	Conceptual
George Bellows	1882–1925	50	First ($R^2 = 0.64$)	Yes	Negative ($R^2 = 0.64$)	Yes	Conceptual
Edward Hopper	1882–1967	42	Fifth ($R^2 = 0.82$)	Yes	Positive ($R^2 = 0.70$)	Yes	Experimental
Milton Avery	1885–1965	400	Fifth ($R^2 = 0.80$)	Yes	Negative ($R^2 = 0.74$)	Yes	Conceptual
Georgia O'Keeffe	1887–1986	64	Second ($R^2 = 0.69$)	Yes	Negative ($R^2 = 0.67$)	Yes	Conceptual
Stuart Davis	1892–1964	65	Fifth ($R^2 = 0.75$)	Yes	Positive ($R^2 = 0.55$)	Yes	Experimental
Charles Burchfield	1893–1967	208	Fifth ($R^2 = 0.68$)	Yes	Positive ($R^2 = 0.64$)	No	Uncertain
Robert Henri	1865–1929	85	Fifth ($R^2 = 0.62$)	Yes	Positive ($R^2 = 0.52$)	Yes	Experimental

Everett Shinn	1876–1953	184	Fifth (R^2 = 0.26)	Yes	Negative (R^2 = 0.24)	Yes	Conceptual
William Glackens	1870–1939	32	First (R^2 = 0.78)	No	Positive (R^2 = 0.77)	No	Uncertain
George Luks	1867–1933	42	Fifth (R^2 = 0.69)	No	Negative (R^2 = 0.60)	No	Uncertain
John French Sloan	1871–1951	97	Third (R^2 = 0.68)	Yes	Negative (R^2 = 0.65)	Yes	Conceptual
Maurice Prendergast	1858–1924	41	First (R^2 = 0.47)	Yes	Negative (R^2 = 0.47)	Yes	Conceptual
Arthur Dove	1880–1946	52	Fifth (R^2 = 0.81)	Yes	Positive (R^2 = 0.78)	Yes	Experimental
Marsden Hartley	1877–1943	74	Fourth (R^2 = 0.85)	Yes	Negative (R^2 = 0.80)	Yes	Conceptual
John Marin	1870–1953	228	Fifth (R^2 = 0.69)	Yes	Negative (R^2 = 0.64)	No	Uncertain
Joseph Stella	1877–1946	64	Fifth (R^2 = 0.56)	Yes	Negative (R^2 = 0.39)	No	Uncertain
Charles Demuth	1883–1935	61	Fourth (R^2 = 0.49)	No	Positive (R^2 = 0.43)	Yes	Experimental

the piece was signed by the artist, the age of the artist at creation, and the "premium price" (calculated in real terms and in terms of "hammer price" plus the buyer's premium) of the piece at auction for the artists described in Table 2.1 in Chapter 2. These data, with hammer price deflated by the consumer price index (CPI) (1982–1984 = 100), were used to estimate the models specified in equation set (3.1), à la Galenson. We attempt to replicate Galenson's procedure as closely as possible.[11] This means, for example, that we use "hammer price" as our price variable, as did Galenson and Weinberg (2000: 769n1), even though we believe "premium price" (hammer price plus the buyer's premium) to be a more appropriate measure.[12] However, we are unable to precisely replicate Galenson's variables in two cases. First, Galenson had data on the paper-canvas dichotomy to determine his SUPPORT measure (support is the material that the painting is executed on); we have data on the medium used (oil vs. other), which closely parallels a paper-canvas dichotomy. Second, the time dummies DY_j are dichotomous variables, the jth dummy taking on a value of one if the painting was sold at some point during the ith five-year interval. For our sample, DY_1 takes a value of one if the painting was sold during the 1987–1991 period, DY_2 takes a value of one if the painting was sold during the 1992–1996 period, DY_3 takes a value of one if the painting was sold during the 1997–2001 period, and DY_5 takes a value of one if the painting was sold during the 2007–2011 period. We use the 2002–2006 time period as our base period primarily because no recessions occurred during that period; Galenson used slightly different five-year intervals, since his data covered a different time span.

There may be concern with these estimates for individual artists regarding fragile parameter estimates attendant to small sample sizes for some of the artists in both the current sample of early American artists and our sample of Contemporary American artists to be treated later. However, we are reasonably confident in the overall robustness of our individual artists' analysis for the following reasons: There is a time honored (ad hoc) "rule of five" for ordinary least squares parameter estimation; it suggests that one should have at least five observations per parameter to be estimated. The five model specifications to be estimated for our individual artist's analysis are listed in equation set (3.1). There the largest model to be estimated involves eleven parameters (a constant, a fifth-order polynomial in age, size, medium, and three time dummies), indicating a required sample size of at least fifty-five observations. Of the seventy-two artists (seven had already been eliminated from the early American sample due to sample sizes less than thirty) involved in both of the early and contemporary individual artist's analysis, only seven have fewer than fifty-five observations. Thus the "best" model estimated for sixty-five of

our seventy-two individual artists have no robustness issues. Even for the seven questionable models (six of which were in the early American sample), five still satisfy the rule of five—in these cases, the "best model" was less than a fifth-order polynomial, reducing the sample size requirement. For these reasons, we think our meta-analysis of the individual artists is valid.[13] The results found for the "best" estimate (as judged by adjusted R^2) of the models of equation set (3.1) for each artist in the sample can be found in Appendix Table 3A.1; those results are summarized in columns 4 and 5 of Table 3.1.[14] Column 4 gives the specific model in equation set (3.1) that turned out to be best for that artist and the associated adjusted R^2; column 5 gives the results of an F test of the joint significance of the age terms in the best specification. First, observe that the F statistics in column 5 are statistically insignificant for six of our twenty-six artists. This result suggests that Galenson's taxonomy is not a good description of reality since there is no statistical evidence that they peak either early or late in their careers. Of the "best" specifications, five are single peaked; four are linear and one is quadratic. Age was insignificant in the linear specifications for two artists, Kuhn and Glackens; for them, the current auction prices of their work show no statistically discernible pattern over their working life. The two other linear specifications indicate that prices peaked at the beginning of their careers (Bellows and Prendergast). According to the experimental-innovator taxonomy based on their age/value profiles, these two artists would be classified as innovators. Georgia O'Keeffe is the artist whose "best" specification is quadratic. Peak value for her value/age profile occurs at an intermediate point in her career: at about age thirty-one. Using Galenson's age forty as a benchmark divider between experimental and innovative artists, O'Keeffe would be classified as an innovator, whereas Galenson goes to great lengths to identify her as an experimentalist.

The remaining twenty-one artists have a potentially multipeaked value/age profile. This result is problematic for a creativity taxonomy because there is no way to understand a priori—that is, without plotting the profile (or solving polynomial equations for critical points)—whether the trend in the value/age profile over the artist's productive lifetime is positive or negative. Alternatively, for these twenty-six artists, the effect of age on the market value of their work can be viewed as cyclical, typically involving *multiple* cycles. This means that over a cycle an artist may be identified as experimental, and then innovative, or conversely, depending on the shape of the cycle. If we are to categorize the type of creativity exhibited by these artists, we must know the manner in which these cycles trend over the artists' work life. If the general trend across the cycles is upward over time, we can think of them as experimental (since higher prices would tend to be garnered later in their careers); if the trend in

the cycles is generally downward, they can be thought of as innovators (since higher prices would tend to be garnered earlier in their careers). The question of how to classify the artist whose cycles do not trend over time is problematic to the Galenson taxonomy.

One way to obtain a general indication of which way the creativity cycles trend over an artist's working life is to look at a linear estimate of the value/age profile.[15] Appendix Table 3A.2 presents such linear estimates, and the results are summarized in the last three columns of Table 3.1. Column 6 indicates whether the coefficient on the age term is positive or negative and gives the adjusted R^2 value associated with the model; column 7 indicates whether the AGE coefficient is statistically significant; and column 8 presents the implications of the results regarding Galenson's creativity taxonomy. Perusal of the table indicates that there are eight artists whose value/age profiles show a positive trend over their work life; nine artists who show a negative trend; and nine artists who show no statistically discernible trend. Consider first those artists exhibiting a positive and statistically significant trend. Column 4 of Table 3.1 shows that for most of these artists, age affects the value of their work in a cyclical manner; column 6 shows that these cycles trend upward over time. This is the type of value/age profile that Galenson would say identifies artists whose creativity is experimental. Modernist Arthur Dove's value/age profile, shown in Figure 3.1, is an example of this group (see Figure

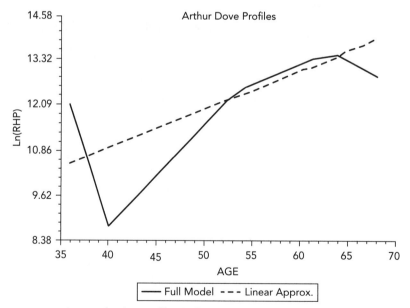

FIGURE 3.1 Age–real-price profile: Arthur Dove.

FIGURE 3.2 Arthur Dove, American, 1880–1946, *Woodpile*, 1938. Ink and watercolor on paper. Robert B. Ekelund, Jr. and Mark Thornton Collection, by permission. Copyright, public domain.

3.2, *Woodpile* [1938], by Dove, who is often cited as the first artist to produce a wholly abstract painting in the United States). The curvilinear function in Figure 3.1 is a figure depicting the estimated relationship for Dove shown in Table 3A.1, computed for a 24" x 24" oil painting sold in the 2002–2006 period; the straight line is similarly derived from Dove's linear estimate in Table 3A.2.

Next consider those artists exhibiting a negative and statistically significant trend. Column 4 of Table 3.1 shows that for most of these artists, age affects the value of their work in a cyclical manner; column 6 shows that these cycles trend downward over time—a value/age profile that Galenson would say exemplifies artists whose creativity is innovative. American-scene/ashcan painter John French Sloan's value/age profile, shown in Figure 3.3, is an example of this group.

Finally, consider those artists who have a statistically insignificant trend in their value/age profiles. Some artists in this group illustrate a logical inconsistency in the experimental-innovative taxonomy. For three of these artists (Homer, Hartley, and Burchfield), age was found to be a statistically significant determinant of value based on the *F*-tests of column 5 of Table 3.1. Galenson

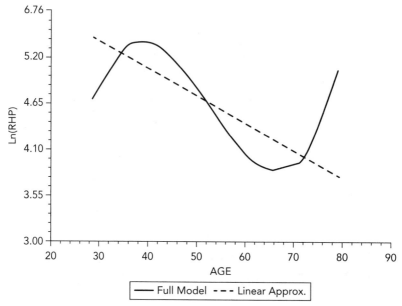

FIGURE 3.3 Age–real-price profile: John Sloan.

would then locate a maximum of the estimated function and conclude that the artist was an experimentalist or an innovator, depending on that location. However, any such conclusion is, in fact, unjustified for this group of artists. All the statistical results of Appendix Table 3A.1 indicate is that age affects value in a cyclical manner; they reveal nothing directly about whether these cycles trend upward or downward over time. That information is given in columns 6 and 7 of Table 3.1, and for these three artists there is no statistically discernible trend, either upward or downward. So although age is statistically significant in column 5, these artists cannot be legitimately classified as either experimental or innovative.

Winslow Homer, whose value/age profile is shown in Figure 3.4, illustrates this point. His AGE coefficients in Appendix Table 3A.1 and in column 5 of Table 3.1 are statistically significant, both individually and jointly, but his AGE coefficient in Table 3A.2 and columns 6 and 7 of Table 3.1 is statistically insignificant. Even though the trend line shown in Figure 3.4 slopes slightly downward, it could as easily be a flat line through the point of mean age and mean value (log real price). Homer's auction prices fluctuate about a particular (typically, high) price throughout the preponderance of his work life. Hence Homer cannot be classified as either an experimentalist or an innovator based on the statistical evidence. (One of his great works, *Eight Bells* of 1886, is shown in Figure 3.5).

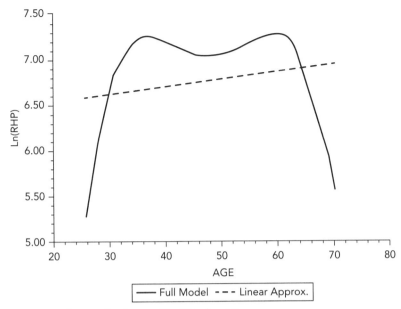

FIGURE 3.4 Age–real-price profile: Winslow Homer.

FIGURE 3.5 Winslow Homer, American, 1836–1910, *Eight Bells*, 1886. Oil on Canvas. Addison Gallery of American Art, Phillips Academy, Andover, MA/Art Resource, New York. Copyright, public domain.

Further, the age–peak-value profiles we obtain are exactly the opposite results from those of Galenson on Dove and Sloan. According to Galenson (2001: table 2-2), Dove would appear as an innovator with peak value at age thirty-six, and Sloan as an experimentalist at age forty-eight. While some of our results coincide with those obtained by Galenson (where the same artists appear in both samples), most do not. In short, his results cannot be replicated formally with an alternative data source. Nine artists overlap in our full statistical sample with Galenson's (2001).[16]

About the only conclusion that can be drawn from these individual artist results is that any claim that nineteenth-century American artists were all, or overwhelmingly—with notable exceptions—experimentalists is simply not justified. Our sample had as many (actually, one more) innovators as experimentalists, and about one-third did not fit into his creativity taxonomy at all. If Galenson's contribution is a *theory* concerning artistic productivity, it must explain artists from both early (for example, born pre-1900) and late (born after 1900, 1920, or 1940) periods. Importantly, the 1920 and 1940 cutoffs are not merely "proxies" in Galenson's analysis. His quest to link peak value, age, and type of artistic productivity applies to each individual artist in order to provide information on an age-productivity analysis for *individuals*. It apparently does not do so with our cohort of early American artists.

A Fixed-Effects Model

Although these results clearly indicate that the "one size fits all" assumption regarding individual artists is not justified, Galenson (with Weinberg [2000] and in other work) implicitly makes just that assumption. In Galenson and Weinberg's (2000) paper, data are pooled on *all* artists in their sample, and they estimate a specification of the two-way fixed-effects model that allows for differential age responses for artists born before and artists born after 1920.[17] The crux of their conclusions, both statistically and anecdotally, is that artists born before 1920 did their best work later in life (around age forty-five on average), while those born after 1920 did their best work in their early careers (around age thirty-five on average). We now investigate an important primitive to their general conclusion—namely, that all artists born before 1920 are experimentalists (i.e., do their best work later in their careers). Many of the artists born before 1920 in their sample are also in our sample; so our individual-artist results cast some doubt on the legitimacy of this conclusion.

But we can directly test this hypothesis by using our sample to estimate a two-way fixed-effects model. Equation (3.2) shows the "best" estimate, equation (3.3) shows the linear estimate, and Figure 3.6 shows the implied value/age profile.

$$\ln(\text{realprice}) = -20.2570 + 1.8764\,\text{AGE} - 0.0734\,\text{AGE}^2 + 0.0014\,\text{AGE}^3 - (0.13)10^{-4}\,\text{AGE}^4$$
$$[3.73]\qquad[4.31]\qquad\quad[-3.79]\qquad\quad[3.37]\qquad\qquad[3.04]$$
$$+\left[(0.4589)10^{-7}\right]\text{AGE}^5 + 0.8610\,\text{LNSIZE} + 1.0604\,\text{SUPPORT}$$
$$[2.75]\qquad\qquad\qquad\quad[33.58]\qquad\qquad[19.10]$$
$$+\,32\text{ artist dummies} + 24\text{ time-period dummies}\qquad\qquad(3.2)$$
$$R^2 = 0.6181\quad F = 73.77\quad N = 2,889$$

$$\ln(\text{realprice}) = -1.7988 - 0.0076\,\text{AGE} + 0.8872\,\text{LNSIZE} + 1.0387\,\text{SUPPORT}$$
$$[11.45]\quad[4.11]\qquad\qquad[34.55]\qquad\qquad[18.59]$$
$$+\,32\text{ artist dummies} + 24\text{ time-period dummies}\qquad\qquad(3.3)$$
$$R^2 = 0.6055\quad F = 74.90\quad N = 2,889$$

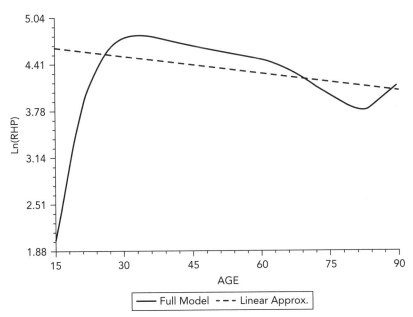

FIGURE 3.6 Value/age profile: thirty-three early American artists.

Note first, that in equation (3.2), all of the AGE coefficients are individually and jointly significant and that the model exhibits the familiar cyclical value/age pattern. Interestingly, equations (3.2) and (3.3) indicate that the cycles trend downward over time. This result is confirmed in Figure 3.6 of the value/age profile, which also indicates that value peaks at about age thirty-three—very much like the *post-1920* results in Galenson and Weinberg (2000). Thus, our statistical evidence suggests that if we treat all of the nineteenth-century artists in our sample as one "representative" artist (exhibiting the coefficient estimates shown in equation [3.2]), that artist would be viewed as an innovator in the Galenson taxonomy, not an experimentalist, as Galenson and Weinberg (2000) suggest.

Data on Cohort of Artists Born between 1900 and 1960

As we have seen, Galenson's contention that American artists born prior to 1900 are basically experimentalists finds no support in our data set, but that is only half of his story. What can be said of the creativity characteristics of artists born after 1900? Table 2.2 of Chapter 2 reports the names and life spans of the artists in our sample born after 1900 and painting post-1950. This list, of course, includes many of the abstract expressionists and Contemporary artists, as well as those artists who represent Contemporary figurative art. Indeed, in 2012 a number of these artists were still alive and working. As in our analysis of those artists born before 1900, we replicate Galenson's statistical estimation strategy and summarize those results in Table 3.2. The actual estimates of the "best fitting" polynomial model and its linear version for each artist can be found in Appendix Tables 3A.3 and 3A.4, respectively.

We now turn to an examination of the value-and-age relationship for our sample of American artists born post-1900. These forty-seven artists map fairly well onto the thirty-five reported in Galenson's historiographic study of American artists (see 2002: 199, table 2). Clearly, taken as a group and using sample auction data, these artists born post-1900 are innovators in both linear and non-linear fashions. There are, however, some clear differences between our more direct statistical tests and those "count" data used by Galenson. But Table 3.2 clearly indicates that, taken as a group, the post-1900-born American artists were "innovators."

The status of individual artists must be considered, however. As with Table 3.1, columns 4 and 5 of Table 3.2 summarize the results of the best-fitting polynomials shown in detail in Appendix Table 3A.3, and columns 5–7 summarize the overall trends shown in detail in Table 3A.4. Half (twenty-three) of

Table 3.2 Summary of Results and Implications of Galenson's Procedure Applied to a Sample of Forty-six Well-Known American Artists Born after 1900

Artist	Life Span	Number of Observations	Specific Value/Age Profile		General Trend in Value/Age Profile		Implications for Galenson's Creativity Dichotomy
			Order of Best-Fitting Age Polynomial	Age Terms Jointly Significant ($\alpha = 0.05$)	Effect of Age on Value over Career	Statistically Significant ($\alpha = 0.05$)	
Phillip Evergood	1901–1973	73	Fourth ($R^2 = 0.70$)	Yes	Negative ($R^2 = 0.66$)	Yes	Conceptual
Fairfield Porter	1907–1975	85	First ($R^2 = 0.71$)	Yes	Positive ($R^2 = 0.71$)	Yes	Experimental
Millard Sheets	1907–1989	113	Second ($R^2 = 0.49$)	Yes	Negative ($R^2 = 0.45$)	No	Uncertain
Hans Burkhardt	1904–1994	69	Second ($R^2 = 0.80$)	Yes	Negative ($R^2 = 0.49$)	Yes	Conceptual
Mark Rothko	1903–1970	121	Fourth ($R^2 = 0.89$)	Yes	Positive ($R^2 = 0.78$)	Yes	Experimental
Ad Reinhardt	1913–1967	76	Fourth ($R^2 = 0.44$)	Yes	Positive ($R^2 = 0.42$)	Yes	Experimental
Agnes Martin	1012–2004	138	Fourth ($R^2 = 0.77$)	Yes	Positive ($R^2 = 0.60$)	No	Uncertain
Alex Katz	1927–	278	Fifth ($R^2 = 0.77$)	Yes	Negative ($R^2 = 0.76$)	Yes	Conceptual
Andrew Wyeth	1917–2009	193	Second ($R^2 = 0.49$)	Yes	Positive ($R^2 = 0.47$)	Yes	Experimental
Brice Marden	1936–	96	Third ($R^2 = 0.75$)	Yes	Positive ($R^2 = 0.66$)	Yes	Experimental
Claes Oldenburg	1929–	203	Fifth ($R^2 = 0.50$)	Yes	Negative ($R^2 = 0.45$)	Yes	Conceptual
Cy Twombly	1928–2011	219	Fourth ($R^2 = 0.53$)	Yes	Negative ($R^2 = 0.48$)	No	Uncertain
David Salle	1952–	191	Fifth ($R^2 = 0.78$)	Yes	Positive ($R^2 = 0.48$)	Yes	Experimental
Ellsworth Kelly	1923–2015	112	Second ($R^2 = 0.69$)	Yes	Negative ($R^2 = 0.66$)	Yes	Conceptual
Eric Fischl	1948–	170	Fourth ($R^2 = 0.77$)	No	Positive ($R^2 = 0.77$)	Yes	Experimental

(Continued)

Table 3.2 Continued

Artist	Life Span	Number of Observations	Specific Value/Age Profile		General Trend in Value/Age Profile		Implications for Galenson's Creativity Dichotomy
			Order of Best-Fitting Age Polynomial	Age Terms Jointly Significant ($\alpha = 0.05$)	Effect of Age on Value over Career	Statistically Significant ($\alpha = 0.05$)	
Franz Kline	1910–1962	180	Fifth ($R^2 = 0.79$)	Yes	Positive ($R^2 = 0.74$)	Yes	Experimental
Helen Frankenthaler	1928–2011	192	Fifth ($R^2 = 0.70$)	Yes	Negative ($R^2 = 0.69$)	Yes	Conceptual
Ida Kohlmeyer	1912–1963	74	Fourth ($R^2 = 0.66$)	Yes	Positive ($R^2 = 0.62$)	No	Uncertain
Jackson Pollock	1912–1956	53	Fourth ($R^2 = 0.83$)	Yes	Positive ($R^2 = 0.75$)	Yes	Experimental
James Rosenquist	1933 –	148	Second ($R^2 = 0.69$)	Yes	Negative ($R^2 = 0.68$)	Yes	Conceptual
Jasper Johns	1930 –	83	Fourth ($R^2 = 0.35$)	Yes	Negative ($R^2 = 0.22$)	Yes	Conceptual
Jim Dine	1935 –	210	Fifth ($R^2 = 0.44$)	Yes	Positive ($R^2 = 0.42$)	Yes	Experimental
Jean–Michel Basquiat	1960–1988	597	Fifth ($R^2 = 0.78$)	Yes	Negative ($R^2 = 0.77$)	Yes	Conceptual
Joan Mitchell	1925–1992	210	Fourth ($R^2 = 0.85$)	Yes	Negative ($R^2 = 0.85$)	Yes	Conceptual
Julian Schnabel	1951–	189	Fifth ($R^2 = 0.58$)	No	Positive ($R^2 = 0.58$)	No	Uncertain
Kenneth Noland	1924–2010	235	Fifth ($R^2 = 0.63$)	Yes	Negative ($R^2 = 0.40$)	Yes	Conceptual
Kenny Scharf	1958–	170	Third ($R^2 = 0.50$)	Yes	Negative ($R^2 = 0.47$)	No	Uncertain
Larry Poons	1937–	73	Fifth ($R^2 = 0.48$)	Yes	Negative ($R^2 = 0.37$)	Yes	Conceptual
Larry Rivers	1923–2002	187	Fourth ($R^2 = 0.62$)	Yes	Negative ($R^2 = 0.56$)	Yes	Conceptual
Milton Resnick	1917–2004	88	First ($R^2 = 0.72$)	Yes	Negative ($R^2 = 0.72$)	Yes	Conceptual
Nathan Oliviera	1928–2010	98	Third ($R^2 = 0.64$)	Yes	Negative ($R^2 = 0.60$)	Yes	Conceptual
Norman Lewis	1909–1979	62	Fifth ($R^2 = 0.71$)	Yes	Negativ ($R^2 = 0.66$)	Yes	Conceptual

Name	Dates	N	Peak decade (R²)		Trend (R²)		Type
Philip Guston	1913–1980	157	Fourth ($R^2 = 0.71$)	Yes	Positive ($R^2 = 0.67$)	Yes	Experimental
Red Grooms	1937–	83	Second ($R^2 = .51$)	Yes	Positive ($R^2 = 0.46$)	Yes	Experimental
Richard Diebenkorn	1922–1993	156	Fourth ($R^2 = 075$)	Yes	Positive ($R^2 = 0.75$)	Yes	Experimental
Robert Indiana	1928–	170	Fourth ($R^2 = 0.58$)	Yes	Negative ($R^2 = 0.56$)	Yes	Conceptual
Robert Motherwell	1915–91	286	Fourth ($R^2 = 0.54$)	Yes	Negative ($R^2 = 0.51$)	Yes	Conceptual
Robert Rauschenberg	1925–2008	225	Fifth ($R^2 = 0.67$)	Yes	Negative ($R^2 = 0.42$)	Yes	Conceptual
Romare Bearden	1911–88	72	Fourth ($R^2 = 0.48$)	Yes	Positive ($R^2 = 0.38$)	Yes	Experimental
Roy Lichtenstein	1923–97	394	Fifth ($R^2 = 0.52$)	Yes	Negative ($R^2 = 0.45$)	Yes	Conceptual
Sam Gilliam	1933–	65	Fifth ($R^2 = 0.43$)	No	Negative ($R^2 = 0.52$)	No	Uncertain
Susan Rothenberg	1945–	82	Third ($R^2 = 0.80$)	Yes	Negative ($R^2 = 0.68$)	Yes	Conceptual
Wayne Thiebaud	1920–	199	Fifth ($R^2 = 0.44$)	Yes	Negative ($R^2 = 0.38$)	Yes	Conceptual
William Baziotes	1912–63	62	First ($R^2 = 0.78$)	Yes	Positive ($R^2 = 0.78$)	Yes	Experimental
Wolf Kahn	1927–	159	First ($R^2 = 0.80$)	Yes	Positive ($R^2 = 0.80$)	Yes	Experimental

the artists have a significant negative trend in their value/age profile (making them innovators); 35 percent (sixteen artists) have a significant positive trend in their value/age profile (making them experimental); and 15 percent (seven artists) have no significant trend in their value/age profile (however, for only two of these artists are the age terms jointly insignificant in Table 3.2; so for the other five, age matters, there is just no significant trend in the effect of age on value). As shown in the following, these results are confirmed by the pooled-model results.

Galenson's tactic is to give a ranking of the artists by the number of illustrations of particular paintings in fifty-six books on art history, giving him five "experimentalists" (Gorky, de Kooning, Newman, Pollock, and Rothko) and five "innovators" (Johns, Lichtenstein, Rauschenberg, Stella, and Warhol). To the extent that Galenson's list of ten artists and ours correspond for the ten artists he analyzes (out of the thirty-five he uses to make the "count"), there is no conflict between his historiography and our formal statistical designations (see Appendix Tables 3A.3 and 3A.4). However, we include Norman Lewis and Agnes Martin, the former who was clearly an abstract expressionist and the latter who considered herself of this movement. Both, from our statistical analysis, do not appear as experimentalists, but neither are analyzed by Galenson.

Galenson's and our large contingent of "innovators" (some of them still living) contain a "mixed bag" of artists of diverse styles. The five identified by Galenson do in fact show up as "innovators" in our formal statistical analysis. However, our sample results (which are not necessarily those chosen for "count data" by Galenson) would identify a number of so-called innovators as experimentalists. Specifically, these include Ad Reinhardt, Philip Guston, Richard Diebenkorn, Jim Dine, Red Grooms, Brice Marden, Eric Fischl, and David Salle as experimentalists. The point, even with a confusion as to who is and who cannot be labeled an "abstract expressionist," is threefold: (1) not all abstract expressionists were "experimenters"; (2) not all of the mélange of artists who followed in the late 1950s through the present in an innovative vein were "innovators" in the sense defined by Galenson—much planning, works finished before they are begun, and so on; and (3) "working methods" may not be the key to understanding the peak value of an artist. Thus the link of experimenters and innovators to age, the latter being older and the former younger when their most reproduced work is found in art books, can only be maintained with the particular count data Galenson uses to rank *ten* artists! Once more, it may be the case that artists are becoming more "innovative" (achieving peak values at younger and younger ages) through time, but that

may not be due to simple factors linking age with "working methods" but to many other factors, some of them fundamental to the art markets.

A Fixed-Effects Model of Artists Born Post-1900

As we did earlier for artists born prior to 1900, we now estimate a two-way fixed-effects model for our pooled sample of artists born after 1900. Our purpose is primarily to check on Galenson and Weinberg's conclusion that artists born later in our sample are more likely to be innovators than those born earlier. Equation (3.4) shows the "best" estimate, equation (3.5) shows the linear estimate, and Figure 3.7 shows the implied value/age profile.

$$\ln(\text{realprice}) = 1.69441632 + 0.09844909\,\text{AGE} - 0.00233170\,\text{AGE}^2$$
$$\qquad\qquad [3.70] \qquad\quad [3.86] \qquad\qquad\quad [-4.51]$$
$$\qquad + \left[(0.158932)10^{-4}\right]\text{AGE}^3 + 0.6950636\,\text{LNSIZE}$$
$$\qquad\qquad [3.37] \qquad\qquad\qquad\qquad [63.29]$$
$$\qquad + 0.6889894\,\text{SUPPORT} + 45\text{ artist dummies}$$
$$\qquad\qquad [19.72]$$
$$\qquad + 26\text{ time-period dummies} \qquad\qquad\qquad\qquad (3.4)$$
$$\qquad\quad R^2 = 0.6876 \quad F = 215.29 \quad N = 7,413$$

$$\ln(\text{realprice}) = 3.15739848 - 0.00841911\,\text{AGE} + 0.69661352\,\text{LNSIZE}$$
$$\qquad\qquad [13.15] \qquad\quad [-6.12] \qquad\qquad [34.55]$$
$$\qquad + 0.68691017\,\text{SUPPORT} + 45\text{ artist dummies}$$
$$\qquad\qquad [19.62]$$
$$\qquad + 26\text{ time-period dummies} \qquad\qquad\qquad\qquad (3.5)$$
$$\qquad\quad R^2 = 0.6867 \quad F = 220.40 \quad N = 7,413$$

In comparison to our pre-1900 results, the best-fitting polynomial was cubic for the post-1900 artists. But the overall trend in the value/age profile, as shown in the linear specification, is quite similar (in both direction and magnitude) to that found for our sample of artists born before 1900. Therefore, based on our sample, there appears to be no convincing evidence to suggest that younger artists are more innovative than older ones. This inference, since it is counter to that of Galenson and Weinberg, begs a deeper inquiry into the question.

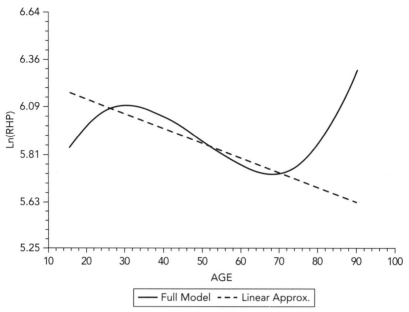

FIGURE 3.7 Value/age profile: forty-seven artists born after 1900.

Is the Growth of "Innovation" Positive through Time?

Early evidence on this question was first presented by Galenson and Weinberg (2000). Using a sample of 4,395 paintings by American artists born between 1900 and 1940, they found that younger artists tend to reach their peak prices at an earlier age (i.e., are more likely to be innovators) than older artists, suggesting that as we move through any sample of American artists, those artists born later in the sample would be more likely to be innovators. Specifically, Galenson and Weinberg split their sample into paintings by artists born 1900–1920 and those by artists born 1920–1940, and they estimated value/age profiles for each sub-sample. Based on these profiles, they found that artists in the earlier cohort tended to attain peak prices at around age fifty, while those in the later cohort attained peak prices at around age twenty-nine. They conclude, "As the experimental methods of abstract expressionists were replaced by a variety of conceptual approaches, . . . the value of experience to painters declined sharply, and the age at which successful artists produced their best work declined precipitously" (Galenson and Weinberg 2000: 775). Thus Galenson and Weinberg's answer to the preceding question would seem to be yes: as we move through time, the artists in the latter part of the sample are younger relative to those in the earlier part of the sample and hence more innovative.

However, our prior fixed-effects analyses can shed some light on the generality of that inference. Our early American sample consisted of artists born

prior to 1900, and our contemporary American sample consisted of artists born after 1900. We have estimated value/age profiles for both cohorts, and the "best fitting" results for each have been presented and discussed earlier; those results are summarized by the graphical profiles displayed in Figures 3.6 and 3.7. While the null hypothesis that the coefficients on the AGE variables are the same across the "best" specification of both cohorts produces an F statistic in excess of 12, indicating rejection at any reasonable level, the representative artist from each cohort is found to be an innovator. Both profiles indicate that peak prices are attained at ages in the early thirties (lower than the age-forty dividing line proposed by Galenson and Weinberg), and the overall trend (linear results) in each profile is negative and statistically significant. Furthermore, the AGE coefficients in the linear models for each cohort do not differ significantly from each other at conventional levels ($t = 0.925$). Thus the preponderance of evidence from our statistical analysis so far suggests that innovation does not grow over time; early American artists were innovators, and contemporary American artists were also innovators.[18]

But our results, as with Galenson and Weinberg's, are based on a statistical snapshot rather than a motion picture. That is, we both (arbitrarily) split our samples—they at 1920, and we at 1900—and draw contradictory conclusions regarding the changes in the creative characteristics of the artists in the sub-samples. If we really want to know if artistic creativity is becoming more innovative over time, we must sequentially increment the earlier sub-sample while correspondingly decrementing the latter and observe the creativity implications as artists in the latter sub-sample become younger and younger. In the following, we present the results of such an analysis.

Our sample, which pools the data on both early and contemporary American artists, born between 1825 and 1960, consists of data on 9,100 paintings sold at auction between 1987 and 2011.[19] We use these data to estimate fixed-effects models of the linear version of the value/age profile, à la equations (3.3) and (3.5), under various assumptions regarding the sub-sample divisions based on birth dates of the artists involved. We confine our attention to the value/age profile that is linear in age for simplicity; we have noted earlier that, while the AGE coefficient in this model is a biased estimate of the AGE coefficient in the true value/age profile polynomial, it is an unbiased estimate of the overall effect of age on value—which is what we are after. Equations (3.3) and (a version of) (3.5) provide a starting point for our analysis by dividing the sample into two sub-samples—those artists born before 1900 (the "pre" sample) and those born after 1900 (the "post" sample).[20] Table 3.3 presents the relevant results for the value/age relationship

under alternative assumptions regarding where to split the pre and post sub-samples. Column 1 gives the decade used to partition into pre and post sub-samples. Column 2 presents the estimated coefficient on the AGE variable in the pre sub-sample model. Column 3 presents the percentage of the total sample in the pre sub-sample. Column 4 presents the estimated coefficient on the AGE variable in the post sub-sample model. Column 5 presents the difference in the pre and post coefficient estimates, and column 6 presents the results of a *t* test on whether the difference is statistically significant at the $\alpha = 0.05$ level.

Several interesting inferences are available from Table 3.3. First, note the results when the sample is split at 1920. The post sample, by definition composed of younger artists, has a markedly steeper slope to the value/age profile than the pre sample. This sample division produces the largest and most statistically significant coefficient difference of all the sample divisions we considered. This steeper slope indicates a more innovative set of artists, and since this post-1920 group is also younger, this result dovetails with that found by Galenson and Weinberg (2000), who also split their sample at 1920: younger artists are more innovative.[21] But the remainder of Table 3.3 suggests that this result may not generalize. With the exception of the 1910 sample split, no other sample division indicates a statistically significant difference between the pre and post sample value/age profile. Thus replicating Galenson and Weinberg's analysis with our data, and splitting the sample at any decade other than 1910 or 1920, would lead to the conclusion that there is no significant difference in the creative characteristics of American artists according to

Table 3.3 Does Innovation Grow Over Time? A Decade-by-Decade Analysis

Sample Break	Value/Age Coefficient for Artists Born Prior to the Sample Break	Percentage of Total Sample in the Pre-Break Sub-sample	Value/Age Coefficient for Artists Born Prior to the Sample Break	Coefficient Difference $(\beta_{pre} - \beta_{post})$	Difference Statistically Significant at the $\alpha = 0.05$ Level (t stat, $H_0: \beta_{pre} = \beta_{post}$)
1900	−0.0075	32%	−0.0095	0.0020	No ($t = 0.925$)
1910	−0.0047	38%	−0.0124	0.0077	Yes ($t = 3.146$)
1920	−0.0014	49%	−0.0188	0.0174	Yes ($t = 7.728$)
1930	−0.0069	75%	−0.0121	0.0052	No ($t = 1.636$)
1940	−0.0072	85%	−0.0024	−0.0049	No ($t = 1.036$)
1950	−0.0076	89%	0.0067	−0.0133	No ($t = 1.641$)

age. Finally, note that when we split the sample at decades following 1920, the AGE coefficient for the post sample group gets smaller in absolute value and eventually becomes positive. As these sample splits correspond to artists in the post sample getting younger and younger, it seems that over time, innovation is decreasing, not increasing, as might be inferred from Galenson and Weinberg. Of course, some of these coefficient estimates are not statistically significant, and the 1940 and 1950 splits result in small post sub-samples. But Table 3.3 does make it clear that there is no general evidence that artists are becoming more and more innovative with the passage of time.

Our conclusion is worth restating. While our fixed effects analysis finds that the value-age profile for artists born before 1900 are qualitatively quite similar to that for artists born after 1900, further analysis shows that if we split the sample at those born before or after 1920, as Galenson and Weinberg did, we find a significant difference between the value-age profiles, with the younger group being more innovative à la Galenson and Weinberg. On the other hand, if we split the sample at any decade other than 1910 or 1920, we find no statistical evidence of differing value-age profiles for younger versus older artists. This result casts some doubt on the generality of the Galenson-Weinberg findings.

The Use of Anecdotal or "Bibliometric" Evidence

That a theory linking age to *type* of artistic creativity *may* be correct is certainly plausible, but *measurement* to support the thesis is critical to that conclusion. Anecdotal evidence often supports (or does not support) more formal types of evidence, so that in virtually all of his major contributions (2006a, 2009) Galenson assembles data from books, critics, art historians, and artists themselves to contrast with the direct statistical evidence in his initial contribution. These data are set beside the regression evidence from Galenson (2001) with only a small addition of statistical data. This forms the whole of Galenson's evidence after 2006. While information acquired and assembled from books, critics, and artists is often excellent illustrative material and certainly a valid method of *suggesting* conclusions, serious issues arise when using it as proof of a theory. First, there may be selection bias in the choice of artists to study—using only those artists with significant age–peak-value correlates in 2001 (Table 2.2), a potential bias that carries over to anecdotal studies. This sort of bias is at least a possibility. But more critically, the use of anecdotes from text illustration, gallery shows, museum holdings, and so on is subject to a serious problem. Galenson finds a surprising (non-formal) correlation between one-person shows, illustrations in art books and textbooks,

and museum retrospectives for *some* artists.[22] These are offered in support of his never-changing thesis regarding age-creativity profiles. Galenson notes regarding his bibliographic text count that "these reproductions are chosen to illustrate each artist's most important contribution or contributions. No single book can be considered definitive, because no single scholar's judgments can be assumed to be superior to those of his peers, but pooling the evidence of many available books can effectively provide a survey of art scholars' opinions on what constitutes a given artist's best period" (2006a: 25). However interesting the anecdotal evidence, Galenson completely neglects the most serious possible lacuna in this kind of evidence—the so-called superstar effect—noted by a critic of his most recent book (Hutter 2010: 157).[23] The "judgments" of scholars, contemporaneously or historically, cannot be assumed to be independent. Furthermore, artists' illustrations are costly, which may impact the identity and quantity of artists included in a book.[24]

The essence of Galenson's problem is the following. Standard utility theory as applied in economics supports the idea that choices are made individually. But, undeniably as noted by Thorstein Veblen (1934 [1899]), Robert Frank (1985), and most forcefully Sherwin Rosen (1981), plus a host of psychologists (Frey 2008a; Kahneman 2011), any individual's utility from getting on the bandwagon for a given artist or painting is conditioned by his or her environment, by the stock of human capital in art history, and, perhaps most important, by the opinion of one's peers. Network and "superstar" effects, noted by Hutter (2010), where there is a joint interest due to additional individuals to communicate and work with, also play a critical role in forming any individual's utility function. This is particularly true in a small-group situation where (for example) religious or cult beliefs are at issue. It is also likely the case among a relatively small group of "opinion makers" such as art critics, art historians, art-textbook writers, and museum curators. (Smaller numbers mean lower costs of communications between art historians, critics, museum professionals, and so on.) Bandwagon effects are common in art markets and have been so for longer than the most recent period in American art, exemplified by artists that Galenson labels "innovators." The "discovery" of a Damian Hurst, or an Edward Hopper for that matter, is the occasion for the interdependent utility function to be activated among critics, gallery owners, museum curators, and textbook writers.[25]

Anecdotal Analysis of Georgia O'Keeffe

Consider, for example, the modernist artist Georgia O'Keeffe, where our formal statistics (see Tables 3.2 and 3.3) present evidence opposite to Galenson's

argument (based on anecdotal evidence) that she was an "experimental" artist (2009: 96). Our data show that higher-valued work occurred at auction at *earlier* ages. These were her skyscraper pictures of New York City, substantially complete in 1926, and, *per Galenson*, the flower pictures begun in 1924, subsequently dropped, and returned to later in life (2009: 98).[26] This would seem to support an argument that O'Keeffe was an innovator, but Galenson (2009) identifies O'Keeffe as an experimental painter—one whose work should have peaked at an older age. His statistics (2001: table 2.2) show her peak age at forty-eight, but in 1926 O'Keeffe was thirty-nine. Actually, O'Keeffe's flower pictures were begun long before 1924 (Lynes 1999, Vol. I, plates 286–306) and her preparatory *drawings* of New York skyscrapers were begun at latest by 1925 (Lynes, Vol. I, plates 514–521). We do not show that she reached value peak at an older age so that statistically our data support Galenson's anecdotal identification of paintings at peak value at a younger age—yet he labeled her an experimentalist. Galenson's anecdotal evidence that O'Keeffe was an experimentalist, however, rests on the following (2009: 96–97):

1. Color is central to her work.
2. Appearances, not the mind, are vehicles for truth as she sees it.
3. O'Keeffe "painted to capture the beauty and color she saw around her" (2009: 96).
4. Paintings did not express emotion.
5. She did not plan paintings—"rarely even blocks out her design in advance" (2009: 97).
6. O'Keeffe painted in series (like Monet)—multiple variations on a theme (for example, her "door" paintings).
7. She believed that artists had to develop slowly—therefore no abrupt shifts in style.

Galenson uses secondary sources and quotations from O'Keeffe herself to try to make these points that would establish her as an "experimentalist." Most of the New York skyscraper paintings and the flower pictures were fashioned when O'Keeffe was in her thirties (see Figure 3.9). This comports with *our* statistics, but where does this leave his theory linking artistic type of creativity to age? And we could anecdotally construct a different narrative about O'Keeffe as to kind of artist.

Color is certainly a part of O'Keeffe's achievement, but it is subsidiary to her central aim, which was the use of *Japonisme* (planerism) to get to *inner* abstract interpretations of external natural forms.[27] The insinuation that "the mind" was not a vehicle for "truth" in art for O'Keeffe is also wide of the mark.

FIGURE 3.8 Georgia O'Keeffe, American, 1887–1986, *Black Mesa Landscape,* 1930. Oil on canvas mounted to board. Georgia O'Keeffe Museum, Santa Fe/©Art Resource, New York; © ARS.

Her goal was the modernist credo of interior emotional interpretation, which could be exceedingly abstract, of what was "seen." She agreed with Kandinsky that "art could be as abstract as music and that the *inner* sensation or emotion counted for more than the outer object or image" (Rose 1997: 99, our empha-sis). She was not painting "what she saw" but her inner voice and emotions relating to "what she saw." Furthermore, all artists "plan" paintings, either on paper, in preparatory oil sketches, drawing or sketching on the canvas or support or in their heads. O'Keeffe was, from the beginning, not an exception.

Examples drawn from O'Keeffe's *catalogue raisoneé* are legion and drawn from her entire career.[28] Further, multitudes of artists, both earlier and contem-porary, paint in "series"—that is, with similar *subject matter or variations on subject matter.*[29] An examination of O'Keeffe's doors, *Ranchos Church*, skulls, and so on are in fact shifts in style *as* shifts in subject matter. (One of those styles involved the landscapes she painted after a permanent move to New Mexico, *Black Mesa Landscape, New Mexico / Out Back of Marie's II* (1930), shown in Figure 3.8.)

Anecdote and Jackson Pollock

One of *the* most important abstract expressionists and possibly the most influ-ential painter of the later twentieth century, as Galenson (2002) affirms in

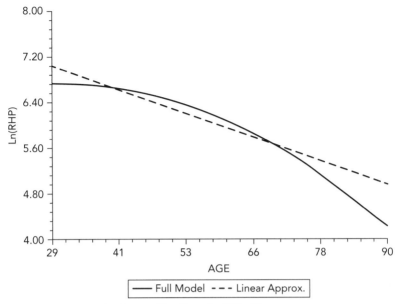

FIGURE 3.9 Age–real-price profile: Georgia O'Keeffe.

answer to the title of his paper, was Jackson Pollock. Galenson's insistence that Pollock was an experimentalist does comport with our linear profile from auction data shown in Figure 3.10. It appears that Pollock did experimental work throughout most of his early career, at least up to the age of thirty-one (when he created his first major show for Peggy Guggenheim in 1943). That early output, moreover, "overwhelms" his lifetime output in quantity for, as Galenson clearly shows, his great innovations occurred between 1947 and 1953 (between the age of thirty-five and forty-one). But we do not believe that this linear profile captures the nature of Pollock's type of creativity as an artist. One may tell a very different narrative to arrive at an understanding of the nature of Jackson Pollock. We argue that Pollock's profile does not suggest that he is an experimentalist.

Pollock (1912–1956) was one of five sons. His young life was one of disruption, confusion, and chronic alcoholism, a lifelong problem that often brought him for extended stays in addiction hospitals and mental institutions and to Freudian and Jungian psychoanalysis. (Alcohol eventually killed Pollock when he died in an auto accident, hitting a tree on August 11, 1956.) Pollock's early training in New York City was at the Art Students League, studying with the very conservative regionalist painter Thomas Hart Benton in the early 1930s. Benton was employed, as were virtually all of the leading lights of abstract expressionism, by the Works Progress Administration's Federal Art Project.

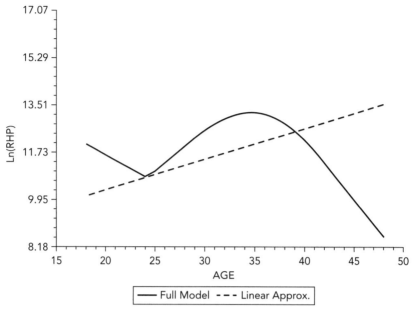

FIGURE 3.10 Profile of auction results for Jackson Pollock.

While Benton, a teacher at the Art Students League, became a close friend and painting partner of Pollock's, he was a vocal enemy of the kind of modernism Pollock later exemplified. Pollock was associated with the WPA/FAP throughout the 1930s. The chief work of this project was the depiction of social realism—evolving in part from the ashcan movement earlier in the century. Both the ashcan and social realism schools attempted to depict life as it really was at the time—poverty-stricken masses, starving children, and disgusting capitalists/bureaucrats passing out scraps to the poor.

Several of his brothers were formally associated with the Communist Party and, throughout the 1930s, Pollock was associated with communists and artists who were members of the party. In particular, Pollock was influenced by two of the leading Mexican artists of the day—José Clement Orozco and David Alfaro Siqueiros, who in the mid-1930s conducted a workshop on innovative techniques and painting processes. Pollock learned much from both of these artists—both avowed communists—especially from Siqueiros, who introduced him, in 1936 at age twenty-four, to duco (synthetic resins), spray paint, paint gun techniques, and acrylic paint as medium. Despite continued bouts with alcohol, Pollock painted a number of works that reflect both Benton's and, especially, Mexican influences. He was also, at this time, a great friend and helper to Siqueiros on communist projects, including communist

propaganda and materials for May Day parades. Although there is little evidence that Pollock was ever an avowed communist, it is Siqueiros's working methods that establish him as something of an innovator, rather than an experimentalist. While there is no evidence that Pollock experimented with drip paintings at this time, his observation of Siqueiros had a profound influence on the young artist. According to Naifeh and Smith (1989: 288), Pollock's leading biographers,

> where Benton wrought murals and easel paintings and sketches just as Michelangelo or Tintoretto had done centuries before, Siqueiros painted floats as well as well as mural, banners, placard, and rally decorations. After having observed Benton through the long weeks of preparation on the New School murals—assembling the sketches, gessoing the panels, mixing the tempera, lighting the plasticine model, transferring the cartoons—Jack must have felt liberated as he watched the spry, wiry Siqueiros standing over a twenty-five-foot-square painting laid out on the floor in front of him, spray gun in hand, shooting a jet of Duco at an image the size of a boulder.... [and further, quoting Axel Horn] "the possibility inherent in the experimentation at the Siqueiros workshop offered [Jackson] a way out of his lack of technical facility."

Between the experiences with Siqueiros and his first "drip painting" in 1947 (which began to revolutionize Western art), Pollock lived through multiple influences, including his "discovery" by art dealer-collector Peggy

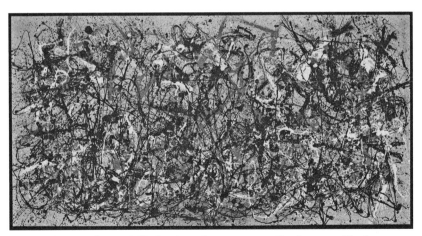

FIGURE 3.11 Jackson Pollock, American, 1912–1956, *Autumn Rhythm*, 1950. Enamel on Canvas. The Metropolitan Museum of Art/Art Resource, New York; © ARS, New York.

Guggenheim and art critic and avowed socialist Clement Greenberg. Regular exhibitions by Guggenheim and later with the Betty Parsons Gallery between 1943 and 1947 saw Pollock's turn to abstraction, similar to that of surrealists and other abstract painters. His personal influences perhaps contributed to Pollock's mindset, including incarcerations for addiction, bipolar disorders, exposure to Picasso's primitive subconscious images, manifestations of the unconscious (Freudian-Jungian) brought on perhaps by alcohol, abandonment or coverup of imagery (or poor traditional imagery as a painter), and psycho-sexual problems. There were many other supposed explanations. He, as well as many other artists, had "dripped" and poured before. But, whatever the foundation, Pollock, with the help of later representatives such as Betty Parsons and Sidney Janis, as well as critics such as Clement Greenberg, became the focal point of American art in the post–World War II period.

By 1947, when he produced his first drip paintings, Pollock was most certainly an innovator. He did not "plan" his works, as made clear in the preceding quotation by Naifeh and Smith (1989: 288). And that feature of the "experimenter," according to Galenson, is the distinguishing mark that divides artists who went before abstract expressionists and those who came after. Consider Galenson's analysis of Andy Warhol, the apotheosis of innovators in the second half of the twentieth century. The use of actual mechanical techniques and the use of serial forms are noted as foundations of Warhol's work (both of which had been used before), and Galenson writes that "both of Warhol's innovations consisted of new conceptions: because the ideas constituted the innovations, they could be introduced immediately, *without the need for experimentation*. Furthermore, because it was the ideas that mattered, the quality of the craftsmanship with which they were implemented was not significant" (Galenson 2002: 123, italics ours). Warhol was most certainly not the first artist to use silkscreen processes—their use in Asian countries goes back a thousand years, and they were used by artists in the United States in the 1930s—and mechanical techniques such as lithography were in existence in America for more than a hundred years. In short, if experimentation is the real standard of differentiation between the abstract expressionist and those innovators who came later, Pollock was an innovator.

But there is perhaps another reason for the startling innovations that Pollock introduced into American art when he was still a relatively young man. Few have emphasized the political influences and environment that affect the demand for and supply of Pollock's work (and other abstract expressionists as well). Between 1938 and 1942, Pollock and most of the other abstract expressionists worked for the WPA artists' project, but by 1938 suspicion, first of

Marxist and later of communist, infiltration of this group (plus many others) had captured governmental attention. Moving from an anti-Marxist to an anti-communist stance, Martin Dies's Committee to Investigate Un-American Activities began an American-style pogrom against a number of perceived anti-US groups. Throughout the post-1938 era, Pollock worried that his association with the WPA "social realists" and their Mexican counterparts could bring on harassment and even prosecution. The harassment, unrelated in 1938 to McCarthy's later witch hunt of the 1940s (Harper 2012), continued until the end of the WPA subsidies and into the 1940s. As Naifeh and Smith report (1989: 321–322), in 1938 "the summer hearings of Texas Congressman Martin Dies's Committee to Investigate Un-American Activities had struck a moral blow at Federal One, successfully branding it a 'hotbed for Communists' and 'one more link in the vast and unparalleled New Deal propaganda machine.'" Pollock's return to abstraction and surrealism could have been a predictable and natural response to this change in demand and a reaction to institutional forces surrounding artists in general, and Pollock in particular (for an example of Pollock's abstract expressionism, see Figure 3.11, *Autumn Rhythm (Number 30)* [1950]). Indeed, one report (http://www.jackson-pollock.org/convergence.jsp) (says the following concerning Pollock's seminal painting *Convergence* of 1952: "At the time of the painting the United States took very seriously the threat of Communism. . . . Convergence was the embodiment of free speech and freedom of expression . . . some of Pollock's works were even sponsored by the Congress for Cultural Freedom (an anti-communist advocacy group founded in 1950), which was backed by the Central Intelligence Agency (CIA)." Social realism was "out" because it depicted "the worst" of America, whereas one could read hope into abstraction.[30]

As to the principal argument given by Galenson for Pollock's and other's "experimentalist character"—much preparation, cartoons of what is to be painted, studies, and so on—Naifeh and Smith's (1989: 539) comments on Pollock's methods appear to be quite the opposite. They note that

> Jackson had finally found what was, for him, the perfect image: an image that freed him from the lifelong consternation of pencil and paper, brush and canvas, chisel and stone, all the tools that had proved too slow, too fixed, and too explicit; an image that allowed him to attenuate the heavy, obscurantist energy of the brush into the lyrical, long-winded energy of the line, an image that could capture every spin, every transformation in his imagination's eye, no matter how fleeting.

These are not the methods of an experimental painter—they are the methods of Pollock and the innovators that followed him.

We do not argue that either of these narratives concerning O'Keeffe or Pollock are "correct"—only that, using anecdotal evidence, a *number of narratives* could be told about age and creativity with respect to O'Keeffe, Pollock, or any artist that contradicts Galenson's results. While some anecdotal evidence is certainly not without value, the confusion from both statistical and anecdotal evidence throws extreme doubt on Galenson's theory of age and creativity type.[31] Both anecdotal and statistical data are necessarily flawed.[32] That is true for Galenson's entire research project, as it is for our own. We believe, however, that, to gain confidence in a theory about artists' ages and creativity type, statistical evidence adds credence to the vagaries of bibliographic investigation. But both formal and anecdotal evidence cannot verify Galenson's theory of age and artistic creativity. Artists who are "insignificant" in the data must be explained. We conclude that there must be other important and critical factors explaining artistic creativity.

Schools and Creativity

Age at peak value (at auction) may be related to the style or school with which an artist is associated. For example, Hellmanzik (2009) has shown clearly that artistic style is related to age at peak value in her study of 214 European and American artists using a sample of auction results. She shows that the artists comprising the Fauves, the Nabis (or Pont Avon school), and the post-impressionists peak at an earlier age than those associated with impressionism, surrealism, abstract expressionism, pop art, and other styles. Artists themselves are subject to network effects. In an interesting and important paper, Fabien Accominotti (2009) uses Galenson's bibliographic evidence to show that a typology of creativity must differentiate between creativity taking place *within* artistic movements and other types. He argues that there may be an age movement (lower ages) related to artistic work, but that it is driven by "the evolution of movement-related creativity alone." This means that artistic creativity (and the age-creativity question) is supported by more than the individual artist alone. Artists owe their peak creativity to involvement in specific artistic movements. (Accominotti's statistical analysis and conclusions are based on Galenson's biographic data.) This analysis, however, is strongly suggestive of a networking *among* artists in creating and signaling their creativity, and we believe that this argument has merit.

Our results and other research, including that of Hellmanzik and Accominotti, suggest that factors other than a dichotomy between innovators and experimenters might explain the link between age and artistic creativity. Along with Hellmanzik, we suggest, using a different sample of artists, that the artistic "school" of an artist (i.e., the synergy that accrues to an artist from

being a member of a group) could be a factor. In fact, there is economic value in being a member of a school of artists. One way to view this effect is through the lens of microeconomics and the theory of the firm. Schools are not firms in the strict sense of the word, but in a Coasian framework they are close cousins. Artists will gravitate to other artists in a process that may involve sharing techniques, subjects, and styles. This loose coalitional framework is analogous to a voluntary coordination process in which Coasian producers exploit the economics of joint identification. Such is the economic motive of schools, whether in art, literature, economics, or elsewhere. Our results in the following show that the return from activities can be non-trivial.

We investigate this question empirically by dividing the artists in our sample into three schools: American impressionists (ten), modernists (thirteen), and American-scene painters (ten), as in Table 3.4. Naturally there may be dispute concerning where a particular artist is placed; Inness vehemently denied he was an impressionist, but most historians think of him that way; Homer and Eakins were "realists" but may be put in other categories. And these divisions may be further divided (Davies was actually a "symbolist" rather than a "modernist"), but this does not really influence our proposed test. Clearly the least cohesive group below are the "American-scene artists," which include Eakins, a brilliant realist, Hopper with a unique style, and a group of ashcan artists, all with great variability in approach, subject matter, and style. However, there is not much debate over the vast majority of artists in the three categories.

Table 3.4 "School" Membership for Thirty-three
Early American Artists

Impressionists	Modernists	American Scene
Inness	Kuhn	Eakins
Whistler	Weber	Remington
Homer	Avery	Bellows
Cassatt	O'Keeffe	Hopper
Chase	Davis	Wood
Robinson	Burchfield	Henri
Twachtman	Davies	Shinn
Sargent	Prendergast	Glackens
Hassam	Dove	Luks
Lawson	Hartley	Sloan
	Marin	
	Stella	
	Demuth	

To estimate the value of belonging to a particular American school, we created two dummy variables: IMPSCH = 1 if the artist belongs to the impressionist school, = 0 otherwise; and MODSCH = 1 if the artist belongs to the modernist school, = 0 otherwise. This makes the base group the American-scene artists, and they are so loose-knit that perhaps a "no group" designation would be equally appropriate. We next estimated five models with polynomials in AGE ranging from one to five; each also included size, support, an inverse Mills ratio (IMR) to correct for excluding no-sales, the two school dummies, and the four five-year period indicators. The results for the "best" specification are presented in equation (3.6). As can be seen, AGE has its familiar cyclical pattern, and a linear specification (not shown) indicated that the cycle trends downward over time.

$$\ln(\text{realprice}) = -10.628 + 0.3517\,\text{AGE} - 0.0068\,\text{AGE}^2 + 0.00004\,\text{AGE}^3$$
$$[-10.58]\ [7.21]\qquad\quad [-6.58]\qquad\quad [5.66]$$
$$+0.77\,\text{LNSIZE} + 0.781\,\text{SUPPORT} + 1.165\,\text{IMPSCH}$$
$$[29.03]\qquad\quad [12.89]\qquad\qquad [14.63]$$
$$+0.480\,\text{MODSCH} + 0.63\,\text{DY1} - 1.087\,\text{DY2} + 0.1669\,\text{DY3}$$
$$[6.92]\qquad\qquad [-3.99]\quad [-6.95]\qquad [1.84]$$
$$-1.497\,\text{DY5}\tag{3.6}$$
$$[-6.23]$$
$$R^2 = 0.3975\quad F = 158.12\quad N = 2{,}889$$

The important result here is the magnitude and statistical significance of the artistic-school dummies. It can be shown for log-linear models such as this that the percentage difference in the real auction price caused by being in the group indicated by the dummy is $100 \times (e^{\beta} - 1)$, where β is the estimated coefficient on the dummy. Thus being in the impressionist school pays the average artist a premium of $\{100 \times [\exp(1.165) - 1]\} = 220.6$ percent over the average American-scene school artist. For a member of the modernist school, the premium is smaller but still substantial: $\{100 \times [\exp(0.4795) - 1]\} = 61.5$ percent. Both are statistically significant at traditional levels.

In short, value added is part of a painting group or style. This is yet another determinant of artistic creativity that adds additional credence to the statistical results suggested by Hellmanzik (2009) and the anecdotal data (used by Galenson) in Accominotti (2009). Artists work "together" in the sense that their own work is based on observed styles, especially if they are remunerative.[33]

We can apply this same analysis to our sample of artists born after 1900. However, unlike the early American sub-sample, the placement of modern and contemporary artists into schools is fraught with difficulties. The abstract expressionists are often lumped as artists distinct from "contemporary" artists, such as the pop artists, the post-expressionists, and the many other variants that followed. Strictly speaking, all of the post-abstract expressionists owe a great deal to the smaller coteries of painters who developed in the late 1940s and early 1950s. Many of them paint "abstractly" and could therefore be included as abstract expressionists. But for the sake of "school identification" we offer the delineation in Table 3.5, with the huge caveat noted earlier in mind. These school divisions can be incorporated into a specification analogous to equation (3.6). Here, AE = 1 if the artist is a member of the abstract-expressionist school, = 0, otherwise; CONTEM = 1 if the artist is a member of the Contemporary school, = 0, otherwise; and the base group is the catch-all category "realism, representative, figurative and other." Estimating that model for this post-1900 sample yields the following results (equation 3.7).

$$\ln(\text{realprice}) = 13.728 - 0.6738 \, \text{AGE} + 0.0193 \, \text{AGE}^3 - 0.00002 \, \text{AGE}^3$$
$$[11.67] \quad [-6.15] \qquad [5.32] \qquad\qquad [-4.73]$$
$$+\left[(0.107)10^5\right] \text{AGE}^4 + 0.593 \, \text{LNSIZE} + 0.539 \, \text{SUPPORT}$$
$$[4.30] \qquad\qquad [45.02] \qquad\qquad [13.02]$$
$$+1.950 \, \text{AE} + 1.147 \, \text{CONTEM} - 0.85 \, \text{DY1} - 0.411 \, \text{DY2}$$
$$[20.57] \qquad [18.14] \qquad\qquad \left[-7.06\right] \quad [-3.35]$$
$$-0.063 \text{DY3} - 0.143 \, \text{DY4} - 0.191 \text{DY5} \qquad\qquad\qquad (3.7)$$
$$[0.52] \qquad\quad [-1.18] \qquad [1.49]$$
$$R^2 = 0.3036 \quad F = 248.33 \quad N = 7,413$$

Again, the important results are the magnitude and statistical significance of the artistic-school dummies. In particular, being in the abstract-expressionist school pays the average artist a premium of {100 × [exp (1.95) − 1]} = 603 percent over the average artist in the catch-all category. For a member of the Contemporary school, the premium is smaller but still substantial: {100 × [exp(1.147) − 1]} = 215 percent. Both of these are statistically significant at traditional levels. Thus it appears that productivity (at least, as measured by auction-sales prices) gains from being identified with even a nebulously defined school are substantial.

Table 3.5 "Schools" of Artists in Sample Born after 1900

Abstract Expressionists	Contemporary (Including Op Art, Pop Art, Hard-edge, etc.) (1)	Contemporary (Including Op Art, Pop Art, Hard-edge, etc.) (2)	Realism, Representative, Figurative, and Other
Mark Rothko	Robert Motherwell	Robert Indiana	Philip Evergood
Hans Burkhardt	Milton Resnick	Claes Oldenburg	Fairfield Porter
Norman Lewis	Larry Rivers	Sam Gilliam	Millard Sheets
Franz Kline	Kenneth Noland	James Rosenquist	Romare Bearden
William Baziotes	Joan Mitchell	Jim Dine	Ida Kohlmeyer
Agnes Martin	Robert Rauschenberg	Frank Stella	Andrew Wyeth
Jackson Pollock	Helen Frankenthaler	Red Grooms	Wolf Kahn
Philip Guston	Cy Twombly	Larry Poons	Nathan Oliveira
Ad Reinhardt	Jasper Johns	Brice Marden	
	Alex Katz	Bruce Nauman	
	Wayne Thiebaud	Susan Rothenberg	
	Richard Diebenkorn	Eric Fischl	
	Ellsworth Kelly	Julian Schnabel	
	Roy Lichtenstein	David Salle	
		Kenny Scharf	
		Jean-Michel Basquiat	
		Andy Warhol	

Factors Affecting Creativity

This chapter, using a sample of eighty important American artists born before and after 1900, studies the empirical relations between two characterizations of artists and age at peak creativity. Age may well be a factor in creativity, but it is only one of many probable factors. The issue of interdependent utility functions and bandwagon effects is actually critical to the arguments relating age to creativity. It is hardly a secret that the bandwagon effect became of vital importance in the United States after World War II (Guilbaut 1985, 1992; Wood et al. 1993). The rise of the hyped New York gallery system, along with important art critics, promoted particular artists and stimulated demand for innovators—as they do to this day. Modern electronic communications and art fairs around the world spur such activity, especially with respect to contemporary art. Innovation and innovative technologies (as described by Hellmanzik 2009), along with a shifting taste parameter, determine an artist's career. New elements of marketing, including the use of digital technology (including

social media and Web marketing) are major keys to success (Moureau and Sagot-Duvauroux 2012) for many artists. That was also the case in the first half of the twentieth century as collectors and museums acquired American art.[34] However, given the conditions of sale—a far more limited number of galleries—and communications over this period, the bandwagon effect was likely not as strong. This means that sales by the cohort of artists we have selected for study represent more of a "supply-side effect" (or a more purely "artistic effect") than those painting *after* mid-twentieth century. Buyers were concentrated in New York City, with museums dispersed throughout the country and few specializing in American art. To be sure, there was artistic activity in the Midwest and Southwest United States (the Taos school, for example), but the level of market activity in American art was far more limited in the first half of the century than after the abstract-expressionist movement and the innovators of the second half. Our pre-1950 sample of painted works is thus more "homogeneous" regarding a bandwagon effect for this reason.

Galenson has found an age differential between those artists born before 1920–1940 and those after (Galenson 2005b), and he offers this as proof that this differential identifies experimental versus innovative artists and a link between age and productivity.[35] But this neglects the nature of modern market institutions and their functioning. He and Weinberg (2000) attribute this result, in the main, to the demand differences that appeared in the second half of the twentieth century, but they fail to recognize the centrality of demand, *marketing*, and technological changes in supporting or determining their distinction relating age to creativity/productivity.[36] The sheer number of galleries and artistic venues, the growth of artistic criticism, and much lowered information costs all play a role in this phenomenon. Contemporary art is regularly hyped by New York galleries and at art fairs across the United States and internationally. No sooner than one artist reaches peak value in gallery or auction sales, another is found with "newer" ideas to take her place. This endless cycle of boom and bust, largely created by high-end dealers, has created an artistic "tulip mania" for contemporary art. Contemporary art dealers make visits to university and other art schools to discover the latest "tulip." New artists are discovered almost daily. As one writer put it (Crow 2013: C20), "the ring of a faraway phone is heard in an East Village apartment—and a style is born." The pull of novelty is often determined by price, where "focus" (that is, painting in the same style over long periods of time) is rarer. These aspects of the market point to the problems associated with Galenson's attempt to link age with types of creativity. Demand and price clearly drive the innovation in contemporary art (which is sometimes both "con" and "temporary"). But this phenomenon, as Galenson admits, is principally realized in the twentieth

century.[37] It is not surprising that Galenson's most robust results are from a comparison of artists born pre- and post-1920, but a testable theory linking age and artistic creativity must cover *all* artists. We have shown statistically that it does not cover a large cohort of American artists born in the nineteenth or twentieth centuries. More than a third of a sample of thirty-three early American artists produces insignificant results relating age to "peak value," and our results contradict those found by Galenson in a number of cases.[38] That is also true of artists considered who were born in the twentieth century.

Interesting literature in psychology and other disciplines offers paths to creativity that could be helpful in identifying the link between artist's creativity and age. Specific-human-capital accumulation in a style and then a defense of that capital may account for being wedded to a style, but that is far less common in contemporary art (Crow 2013). Sadly, there is always a drop-off of work at the end of life—an artist may become too sick to work.[39] Indeed, one may believe that serious illness (one that permits recovery) would diminish artistic creativity, for example. Psychologist Tobi Zausner (1998) provides a test that models a period of illness as creative chaos and shows that artistic creativity resulting in a "new stage of life" was enhanced in many cases. Interestingly, he cites Charles Demuth's floral imagery (as observed by Demuth's friend, poet William Carlos Williams) as having emerged from contact with his mother's garden at an early age during convalescence after he was hospitalized for diabetes. It may well be that his peak creativity was not based on age, but rather on an early bout with serious diabetes (which later caused his death). Other factors are central to artistic creativity as well. The net accumulation of human capital is a critical factor in many fields (Jones 2010).[40]

Artistic creativity is complex—age may well be a factor, but induction as employed by Galenson is a poor tool to uncover a relationship between kinds of artists and age.[41] A statistical result in search of an explanation will not do. A theory must be refutable in some fashion, and insignificance cannot simply be eliminated. If age and type of creativity are to be studied and explained, ad hoc rationales for "exceptions" cannot be as widespread as we have found with American artists.[42] Age may well be a factor, but realized prices are affected by styles and style changes as well.[43] Demand, at all times, is an impetus to creativity and to type of creativity. More important perhaps, there are network effects between artists themselves. As Accominotti (2009) has argued with anecdotal evidence, as Hellmanzik (2009) has shown statistically with respect to artistic styles, and as we have shown in a preliminary statistical test, there are likely benefits to interaction within "schools." The marginal value attached to artistic interaction may be a significant determinant of creativity. Human capital (its ascendance and decline) may also offer valuable information for

artistic creativity and psychological studies of creativity. The sources and dating of artistic creativity are not to be found in the simple distinctions offered by Galenson. Our statistical studies of the age-creativity relation among a cohort of important American artists born before and after 1900 appear to add credence to a more complex explanation. A solid explanation of artistic creativity is in part a black box, but the changing nature of the artist from lonely genius to "professional" and finally to entrepreneur most certainly impinges on the age-creativity link in artistic production. Clearly, as a number of writers have shown, and as we have partly argued in this chapter, such creativity is related to peers (probably as school associated), market conditions, human capital, marketing, and expert opinion. Nevertheless, it is worth remembering that the creative process in all areas is basically mysterious and that artistic success is elusive (Plattner 1996). As one writer (Lehrer 2012: 253) expounds, "Every creative story is different. And every creative story is the same. There was nothing. Now there is something. It's almost like magic."

Chapter 4

American Art, "Experts," and Auction Institutions

ART CARRIES NUMEROUS "credence" qualities. If a genuine piece of art is not examined physically, the representation of a third party either at an auction house, at a gallery, or elsewhere serves to provide some level of credence to buyers, as does the work's provenance (the chain of possession from artist to the present). Naturally, there are credence issues when a piece of art may not be "right"—art-market parlance for being genuine and not a fake.[1] These critical issues have created a market for "experts" on particular artists or genres of American art in general. Major and minor auction houses hire in-house or outside experts in all major collectibles (stamps, coins, antique automobiles, and so on) and in virtually all categories of art—impressionist, Contemporary, American, Mexican, Latin American, African, or Asian art. Auction-house evaluators also routinely consult known "experts" on an artist or style for their opinion on the authenticity of works of art. The provenance, exhibition, and ownership records and condition all go into the expert's evaluation of what the art might bring at auction. The auction as an institution is one of the central points of intersection between the artist or the artist's reputation and the economic market for art.

In addition to credence developed through expertise, economists are interested in other questions that relate to credence to buyers and the supply of and demand for art. Are the estimates provided by auction houses "efficient" or "unbiased"? For example, if a piece of art by a particular American artist is given a catalog estimate that the hammer price will fall between $10,000 and $20,000, is that expectation realized at the mean or, *on average*, $15,000 over time? If this average or mean hammer price is realized over many estimates of similar work by a particular artist, economists would call the estimates "efficient in an economic sense," or "unbiased" in a statistical sense.

Is the auction house, in other words, an honest broker? Is it "truthful" in its a priori or presale estimates published in catalogs or the Internet? Is it "fair" to art demanders and consignors in providing accurate information? Does the house consistently over- or underestimate prices, in strategic fashion in its own interest, or are the experts incapable of providing unbiased estimates, intentionally or otherwise?

A second and related question of interest to economists concerns the relationship between the estimates provided by auction houses and the occurrence of "no-sales" (called "bought-ins") since revenues are reduced to both auction houses and sellers when an item does not sell. Naturally, predicting sales is also predicting the elements in no-sales. Here we consider eighty American artists at auction between 1987 and 2013 with more than 14,000 observations for paintings (for the full list of artists, see Chapter 2) and provide statistical tests as to whether the estimates given by auction experts, at least for our sample, are unbiased and whether they can predict price, sales, and, of course, no-sales. We focus in this matter on no-sales and on some of the reasons why the status of "no-sale" or "bought-in" might be generated. No-sales are naturally of interest to buyers and sellers of art as well as to the auction house, for it is on sales that auctions make a profit.

Sellers of art, collectors, and auction houses run into other problems as well. Suppose, for example, that a painting fails to sell at auction when put up at some point in time. If the seller places her property at auction (at the same or another auction house), is the painting "burned" by having failed to sell the first (or second) time? Lower estimates and prices of these artworks are expected, especially when the second or third sale follows close behind the no-sale. The issue has been considered before (Ashenfelter and Graddy 2003: 773–774; 2011) in other contexts and with other samples (and results). In this chapter, we consider pairs of American art sales (including initial no-sale items) that came up for our eighty artists between 1987 and 2013 and did not sell to determine whether the item is "burned," receiving a lower price in subsequent sales. In addition, we analyze the potential role of the ever-increasing "buyer's premium" in contributing to the burning process.

In a related vein, it is no secret that auction houses have steadily raised the premium price on buyers of art and other collectibles. This rise has, allegedly, been accompanied by a general lowering of the seller's premium charged to the consignors of art, but the seller's premium is kept *secret* (negotiated with the auction house). Clearly the price *paid* by a buyer is the hammer price plus the premium charged to the buyer. If that premium is, say, 25 percent and a painting or other object achieves a hammer price of $10,000, the effective price to the buyer is $12,500. Do changes in this "total" price affect art prices,

hammer prices, auction-house revenues, and other interesting magnitudes? This chapter studies these and the aforementioned questions to discover possible answers regarding American art.

Experts, Credence, and the Auction Process

Given the proliferation of "fakes" in the market, a demand for experts to provide some credence to art has grown. A live artist may be consulted, of course, as to whether a work is by her hand or not, thereby giving solid evidence and full credence that a work is "right" and that the buyer may have full confidence in the authenticity of the product. For deceased artists, other systems of credence provision must be employed. A market for expertise develops wherein individuals become experts on the work of individual artists or periods or types of art. The following is only a partial list of credence-providing methods:

- Private expertise develops among individuals or groups who deal with particular artists. There are, for example, committees that deal with the work of Andy Warhol, Georgia O'Keeffe, or Robert Rauschenberg. These committees may administer the estates of particular artists (see next point) and until recently, when legal challenges to decisions of the committees or individuals are being raised, could be paid to assess the authenticity of paintings.[2]
- A subset of the preceding may represent artists' estates for the benefit of legatees of the artist; these experts may be paid by and/or often contain family members of the artist.
- Dealers or groups of experts may assemble *catalogues raisonnés* on artists, which list and illustrate all known works up to a date in time (addenda are often issued as additional works come to light). Naturally, inclusion in a *catalogue raisonné* enhances credibility in the authenticity of a painting.[3]

Auction Houses and Credence

Auction houses hire groups of experts to work "in-house" to investigate the authenticity of works and their condition to provide presale estimates. Such estimates are generally given in an auction catalog that is distributed to (likely) customers or sold to potential buyers, appearing online as well. These estimates contain low and high values within which the auction house believes that the hammer price will fall. The estimated range *includes* the experts'

assessed value of the pieces, which account for the work's *provenance*, its *exhibition history*, and its *appearance in books* related to the artist. Condition of the work is also critical to the estimate, but the low estimate is a function of the *secret reserve* established by the seller, below which the painting will not be sold. This reserve is negotiated by the auction experts and the seller, but in no case can it be higher than the published low estimate (that is a law in New York). Importantly, the expertise of the first-level auction houses— Christie's and Sotheby's (and others such as Philips de Pury and Bonhams in particular areas), who deal in upper-end material—may be assumed to be of a higher level and quality than that of second-tier, third-tier, and lower-level auction houses.[4] It is in the interest of all auction houses to encourage sellers to set the *lowest* reserve possible to raise the probability that the item will be sold. Other things being equal, (1) the stronger the seller's reserve, the higher the low estimate will be, given the willingness of the auction house to take the piece at the seller's reserve; (2) auction-house estimates that encompass as much prospective-value information as possible about the picture should be unbiased predictors of ultimate real prices of the art sold, especially over time;[5] and (3) the closer the high and low estimates, *ceteris paribus*, the lower the probability of sale (the higher the probability of "no-sale").

Thus, two overriding questions exist with respect to art and other auctions: (1) Do auction experts correctly (on average) predict art prices in efficient fashion? (2) Do auction experts who set auction estimates predict the volume of sales or no-sales (for which sellers and the auction house receive nothing) with respect to final results? Further, do presale estimates determine whether an item will sell or not? (These are testable propositions, and a number of writers have examined them.)

Estimating Auction Bias

Ordinarily we would expect presale estimates of art to be efficient, offering the prospective buyer an honest valuation of a painting—certainly over a longer time period. It is in the interest of all market participants—buyers and sellers—to receive unbiased "best" information in all markets, including art. Here we use a newly constructed sample of over 14,000 works by eighty nineteenth- and twentieth-century American artists born before 1960 to consider estimated bias and the determinants of no-sales in American art auctions. Milgrom and Weber (1982), Ashenfelter (1989), and Louargand and McDaniel (1991), for example, with respect to bias, argued that presale auction estimates are unbiased in predicting price in art and other markets.

In efficient and competitive auction markets, we would expect these results.[6] Some empirical studies, but certainly not all, support this theoretical result. Many empirical studies find consistent biases in presale auction-house estimates as predictors of art prices (see Table 4.1). That is, the preauction estimates either systematically overestimate or systematically underestimate efficient (mean) prices. While some of these studies contain problems (to be addressed shortly), it is worthwhile considering the issue of bias in some detail. "Bias" may be the result of the consistent failure of experts to correctly gauge the price of art. Expert estimates are generally made on the physical characteristic of the work (size, medium, etc.), on past sales and trends of similar examples of the artist's work, on provenance of the piece, on inclusion in exhibitions (past and present), on renown of the owner and, last but not least, on condition of the work.[7]

Why would an auction house underestimate a work or give a piece a larger window in estimates? There are a number of possible reasons. A purposeful underestimate may lead sellers of artwork to alter downward the perceived value of the property. The seller would then settle for a lower reserve price, increasing the probability that the item will sell (making the seller *and* the auction house happy). The seller may also experience a pleasant surprise when the work sells over the estimate, making her eager to use the house again. Under- (or over-) valuation may actually be a matter of strategy on the part of the auction house—for example, to get sellers to accept lower reserves, to increase sales rates, giving the auction house a veneer of authority, or to create sales records that may be touted in advertising. Not least, low estimates are thought to generate excitement among demanders.

As noted in Table 4.1, underestimation is present in about half of the studies relating auction-house presale estimates and resulting prices. Beggs and Graddy (1997) find the possibility of underestimation in impressionist paintings using 14,000 observations between 1980 and 1990 with a decline in values as auctions progress. D'Souza and Prentice (2002) find that the auctioneer of 159 sold Australian paintings "systematically provided downwards-biased estimates" of prices. Ekelund, Jackson, and Tollison (2013), using 2,500 observations of eight early American artists including no-sales ("the Eight") between 1987 and 2008 find consistent underestimates of price by auction houses. As they point out, there are demand as well as supply motives of auction houses to underestimate the value of art: "*Ceteris paribus*, more buyers will bid on lower-price paintings than higher-priced ones. Thus, by understating the value of the painting, the auction houses draw more bidders into the auction" (2013: 351).[8]

Table 4.1. Bias Estimates by Auction Houses

Research	Sample and Details	Results/Implications
Milgrom and Weber (1982)		No bias
Ashenfelter (1989)	Impressionists	No bias; estimates truthful
Louargand and McDaniel (1991)	Various auctioned items (1989–1990)	Efficient estimates on average
Beggs and Graddy (1997)	Impressionist (1980–1990) Contemporary (1980–1994)	No systematic bias, but presale estimates decline with order in an auction; overestimate Contemporary and underestimate impressionist
Ekelund, Ressler and Watson (1998)	Mexican art (1977–1996)	Overestimate
D'Souza and Prentice (2002)	Australian art	Underestimate
Mei and Moses (2005)	American; nineteenth-century; Old Masters; impressionists (1950–2002)	Bias (overestimate) for "masterpieces" (high-priced art) and overestimate for Old Masters
Valsan and Sproule (2008)	Abstract painters (European)	Overestimate
Beggs and Graddy (2009)	Impressionist (1980–1990) Contemporary (1980–1994)	No bias in an estimated "anchoring" model
McAndrew, Smith, and Thompson (2012)	Impressionists	Possibly no bias (include no-sales)
Ekelund, Jackson, and Tollison (2013)	Early twentieth-century American art ("the Eight") (1987–2012)	Underestimate
Farrell and Fry (2013)	Australian art	No bias
Fedderke and Li (2014)	South African art (2009–2013)	Duopoly in market causes "follower" to overestimate spread in order to attract auction works
Von Zuydtwyck (2014)	German paintings (online auctions, 2012–2013)	Overestimate
Teti, Sacco, and Galli (2014)	Italian futurist paintings	Underestimate

Likewise, there may be incentives to overestimate the value of art. While there may also be reasons to undervalue lower-priced (say less than $100,000) art, there are good reasons to overestimate the value of high-priced art.[9] The latter may be a competitive device to encourage consignors to place art with an auction house. And, naturally, since the "take" of the auction house depends on the hammer plus premium paid by buyers as well as sellers, auction-house profits are enhanced when high prices are realized through overestimation. Mei and Moses (2005) recognized a so-called masterpiece effect for high-price paintings[10] (see Table 4.1), as did Valsan and Sproule (2008) with general over-estimates calculated by Von Zuydtwyck (2014). Earlier Ekelund, Ressler, and Watson (1998) in a small sample of Mexican and Latin American art taken between 1977 and 1996 found an upward bias of 2.7 percent.

"Truth-telling" with experts at auction houses, however, has certain merits. If the auction house is an "independent" mediator between buyers and sellers, unbiased information reduces information asymmetries so commonly found in art markets. This would conceivably add confidence in the results obtained by buyers and sellers. If total accuracy—given the history of the artist, provenance, and exhibition history of the painting and condition of the work—is presented, accuracy of estimate may not materialize for every sale, but expertise could develop over time, producing unbiased estimates.[11] Certainly the empirical literature provides some evidence that accurate estimates are to be expected with samples of work. Ashenfelter (1989) finds this result with respect to impressionist pictures, as do McAndrew, Thompson, and Smith (2012).

Clearly there is a gap in studies that do not consider the impact of no-sales on the estimation of bias.[12] An important step (and the only exception, to the best of our knowledge) in estimating bias by inclusion of "no-sales" has been made by McAndrew, Smith, and Thompson (2012). (The study also includes no-sales, as discussed later in this chapter.[13]) This chapter employs a more standard approach by using an inverse Mills ratio arising from a sample-selection probit estimate, as suggested by Heckman (1979), to correct for sample-selection bias.[14] We find that, even after controlling for selection bias, presale auction estimates appear to be biased downward.

In addition, we address this question with a unique sample of data. While the literature has seen some focus on American art, especially in the realm of investment return (Agnello 2002; Agnello and Pierce 1996), all of it has been either related to a massive coterie of international artists that includes American artists assigned to genres (Renneboog and Spaenjers 2012) or to paired sets of observations in order to determine art-investment outcomes (Agnello and Pierce 1996; Mei and Moses 2002, 2005). No study has

segmented a defined group of representative American artists for study in that regard.

Buyers' and Sellers' Premiums

One important issue must be addressed before turning to our statistical analysis, and that is how we measure the "price" of the painting. Each painting sold at auction actually has three prices: the price received by the seller, the price at which the auctioneer "hammers down" the sale (hammer price, HP), and the price paid by the buyer (premium price, PP). While there is typically a commission paid by the seller to the auction house, its magnitude is usually subject to bargaining between the participants, so it is not public information. Thus, we have no information on the price received by the seller. Regarding the other two prices, it is important to distinguish hammer price from what we term "premium price." The premium price (PP) is the hammer price (HP) plus a percentage of the hammer price paid by the buyer (BPP). When our data source (askART.com) reports "price," it is most often reported as "premium price." Thus there is a need to adjust our data for the buyer's premium in order to obtain the hammer price. While there are several hundred auction houses in the United States, the two largest are Christie's and Sotheby's. At these houses, premiums are virtually identical (see Table 4.2, which replicates Table 2.6 from Chapter 2). Other auction houses have followed these premiums over time, but, in general, charge somewhat lower premiums for art sales. Sotheby's and Christie's sell in national and international markets, while others typically sell in regional markets or, if internationally, in particular areas of products.[15] Since (at least, early) American paintings would generally be expected to appeal primarily to a national market—to US buyers, with the exception of some postwar American Contemporary paintings—we feel comfortable in using the auction-house commission schedule shown in Table 4.2 to reconcile hammer prices and premium prices for our data set. Since, as Table 4.2 reveals, buyers' premiums have evolved in a complicated manner, the two prices (hammer and premium) must be reconciled. (The method of doing so is not trivial, and we provide our resolution in Appendix 4.1.)

It is of more than passing interest that the buyers' premiums at the two auction houses closely follow one another. Such behavior was, in fact, the subject of successful antitrust action in the United States (Ashenfelter and Graddy 2005), but that is not at issue here.[16] At issue is that the data has been adjusted so as to represent two prices—the hammer price and the premium price by the means described in Appendix 4.1. Again our primary focus addresses the popular question of whether there is systematic bias in

Table 4.2 Buyers' Premiums at Sotheby's and Christie's, 1975–2014

1975–1992	1993–1999	2000–2003	2004	January 2005–September 2007	September 2007–June 1, 2008	June 1, 2008–2013	2014
10% all lots	15% up to $50,000	20% up to $10,000	20% up to $20,000	20% up to $200,000	25% up to $20,000	25% up to $50,000	25% up to $100,000
	10% above $50,000	15% between $10,000 and $100,000	15% over $20,000	12% above $200,000	20% between $20,000 and $500,000	20% between $50,000 and $1,000,000	20% between $100,000 and $2,000,000
		10% above $100,000			12% above $500,000	12% above $1,000,000	12% above $2,000,000

auction-house estimates of hammer prices for art—using tests that account for "no-sales" where artworks do not meet the sellers' reserve and are "bought-in." While others (see Table 4.1) have addressed this question with alternative data sets, the impact of "no-sales," where artworks are bought-in because they do not meet the seller's reserve, generally has not been considered.

Estimation Procedure

Important pieces of information available to potential buyers prior to a typical art auction are the low- and high-price estimates that the auction house places on the value of each painting. The low estimate (L) is related to—and, some say, is determined by—the seller's reservation price; certainly, the seller's reservation price cannot exceed the auction house's low estimate. It is commonly believed that the typical reservation price is set at 70–75 percent of the low estimate, but that price may go as high as 80 percent or right up to the low estimate.[17] The upper estimate (U) can be viewed as the price that the painting could reasonably be expected to fetch in a lively auction. Note that L is not a floor price (a seller may set her reservation price on a particular painting at zero), nor is U a ceiling price (a vigorous, highly contested auction of a popular piece would be expected to fetch prices in excess of U); they simply establish the bounds of an expected price as determined by an art expert at the auction house, in consultation with the seller.[18] Thus if one wants a single measure of the auction house's assessment (AV) of the price at which a painting will sell, the natural measure is the arithmetic mean of L and U—that is,

$$AV = \frac{L+U}{2} \tag{4.1}$$

It follows that the requirement for the auction house's assessment to be an unbiased estimate of the hammer price (HP) of a painting is that the expected value of the hammer price equal the value assessed by the auction house.

$$E[P] = AV = \frac{L+U}{2} \tag{4.2}$$

As noted in Table 4.1, a number of investigators have addressed the question of whether the auction house's assessment is an unbiased estimator of hammer price from both theoretical and empirical perspectives. Unfortunately, the empirical analysis of the question has produced mixed

results. The empirical techniques employed range from simple analysis of descriptive statistics, to correlation analysis, to regression and probit analysis. But these empirical studies have a common statistical flaw: they ignore no-sales. No-sales typically make up 25–33 percent of the samples employed in many of the preceding studies.[19] The problem with excluding these paintings from the sample and dealing only with ones that were actually purchased is that the excluded works may not be a random draw from the population of paintings; hence the remaining paintings cannot be viewed as arising from a random sample and this therefore can lead to misleading inferences.

A study by McAndrew, Smith, and Thompson (2012), as indicated earlier, provides some evidence that the bias findings of the preceding studies could well be attributable to sample-selection bias. They use an inventive procedure to impute prices for no-sales, analyze the full sample of prices (market prices plus imputed prices for no-sales), and find no presale bias in auction-house estimates. They also replicated previous work that ignored no-sales and found a systematic understatement of hammer prices by auction-house estimates. Thus it is entirely possible that prior findings of bias were statistical artifacts attributable to the failure to take no-sales into account.

The problem of left-censoring of a sample of art auction prices due to no-sales must be addressed for any statistical analysis of such prices to be believable. While McAndrew, Smith, and Thompson developed a novel approach for dealing with the problem of "no-sales," we utilize an alternative, well-known, and well-accepted procedure available for dealing with this type of sample-selection problem in regression analysis. Heckman (1979) showed that bias in least-squares estimates due to sample selection could be eliminated by adding an inverse Mills ratio (based on the probability of each respective observation being included in the sample) to the model as an additional explanatory variable. This procedure is the one that we will use to analyze the question of whether auction-house estimates are unbiased predictors of actual hammer prices for more than 14,000 paintings of eighty American artists sampled between 1987 and 2013.

A Model for Investigating Bias in Presale Auction Estimates

The model we employ to empirically investigate the possibility of this type of assessment bias is in sympathy with, but a bit more general than, those employed in prior studies. We begin by assuming that we can summarize the relationship between the transaction prices of, say, n paintings sold at auction

$(P_i, i = 1, \ldots, n)$ and the auction house's estimate of the sales price $(AV_i, i = 1, \ldots, n)$ of those paintings by the following general relationship:

$$P_i = \theta(AV_i)^\lambda \bullet \exp(\varepsilon_i),_{\ i=1,\ldots,n,} \tag{4.3}$$

where θ and λ are unknown parameters and ε is a stochastic disturbance term. This formulation allows us to test for two types of potential bias: what we call multiplicative bias, measured by θ, and what we call proportional bias, measured by λ. These interpretations require some explanation.

First note that if $\theta = \lambda = 1$ and $E[\varepsilon] = 0$, then AV would be an unbiased estimator for P—that is,

$$E[P_i] = AV_i, \ i = 1, \ldots, n, \tag{4.4}$$

as noted previously. Thus a test of the joint null hypothesis $\theta = \lambda = 1$ is a test of whether AV is an unbiased estimate of P. Now assume for a moment that $\lambda = 1$ but $\theta \neq 1$, so that

$$E[P_i] = \theta AV_i. \tag{4.5}$$

Thus if $\theta > 1$ $(\theta < 1)$, AV understates (overstates) P on average by a factor of $|\theta - 1|$ percent. Note that this percentage does not change with the level of AV.[20] Since θ is a multiplicative factor in our model, we call this type of over- or understatement "multiplicative bias." This type of bias (or an additive bias, which can always be transformed to an "on average" multiplicative bias) is the one typically considered in prior studies.

Alternatively, assume $\theta = 1$ and $\lambda \neq 1$, so that

$$E[P_i] = (AV_i)^\lambda \tag{4.6}$$

In this case, P will increase more than proportionately, proportionately, or less than proportionately to AV as $\lambda > = < 1$. Unlike multiplicative bias, this type of bias changes as a percentage of the auction-house estimates. In particular, if $\lambda > 1$, auction houses then understate the value of "better" (that is, higher value) paintings by more in percentage terms than they do "lesser" (that is, lower value) paintings. Since λ measures the percentage change in P attributable to a given percentage change in AV, we call this type of bias "proportional bias." Note the substantial and increasing bias when the traditional

view would have concluded no bias since $\theta = 1$. Finally note that if $\theta > 1$ and $\lambda > 1$, there is a consistent understatement of hammer prices by the auction house, and that understatement increases more than proportionately to increases in the estimated values of the paintings.

Consider estimation of the magnitude of any extant biases in the auction houses' assessments of paintings of eighty American artists sold at auction during the period 1987–2013. We begin with the complete data sample of 14,052 paintings discussed earlier, 3,649 of which were no-sales. However, one of our artists, Bruce Nauman, sold no oil paintings at auction during our sample period. Since medium plays a major role in many of the empirical models to be estimated later, we deleted his 131 paintings from the sample, leaving a sample of 13,921 paintings, 3,615 of which were no-sales. In either case, no-sales comprised 25.97 percent of the sample. Since our analysis of bias will employ only data on those paintings that sold ($n = 10,306$), we employ Heckman's sample-selection correction to avoid biases due to non-random exclusion of the 3,615 no-sales. We further note that all dollar-denominated variables that we analyze in the following (prices, assessed values, limits, and so on) are expressed in real—that is, price-deflated—terms (CPI, 1982–1984 = 100).

Correcting for sample-selection bias arising from excluding no-sales requires an inverse Mills ratio, which can be derived from a probit model estimating the probability of each of the 13,921 paintings being sold. The dependent variable in the model was SOLD, whether the painting sold at auction (SOLD = 1) or was a no-sale (SOLD = 0). The specific probit model used to estimate the inverse Mills ratio is discussed in detail in the next section. Suffice it to say here that the model included explanatory variables measuring characteristics of the painting and artist, conditions of sale, and general economic conditions. The Chi-square statistic measuring the fit of the estimated model ($\chi^{2*} = 212.19$) was statistically significant at well beyond the $a = 0.01$ level, and the equation correctly predicted over 98 percent of the paintings that sold. If the predicted value for the ith painting from the probit equation is z_i, then the inverse Mills ratio (IMR) corresponding to that painting is

$$\text{IMR}_i = \frac{f(z_i)}{1 - F(z_i)}, \tag{4.7}$$

where $f(\cdot)$ is the density and $F(\cdot)$ is the distribution function of the standard normal distribution is evaluated at (\cdot). We create this measure for all 13,921 observations and employ it (for the 10,306 sold paintings) as an explanatory variable in the regression analysis to follow.

The model we posited earlier, rewritten to include the IMR, is

$$P_i = \theta(AV_i)^{\lambda} \bullet \exp(\gamma IMR + \varepsilon_i).$$ (4.8)

Taking logarithms of both sides, we find

$$\ln(P) = \beta_1 + \beta_2 \ln(AV) + \beta_3 IMR + \varepsilon.$$ (4.9)

Observe that $\beta_1 = \ln(\theta)$, $\beta_2 = \lambda$, and $\beta_3 = \gamma$, so that the joint test for unbiasedness, H_0: $\theta = \lambda = 1$, translates to the joint test H_0: $\beta_1 = 0$ and H_0: $\beta_2 = 1$. We estimate equation (4.9) by ordinary least squares (OLS) to test for whether the price estimate implied by the auction-house bounds is an unbiased estimate of the actual price paid for the painting.

Now assume that the transaction price (P) is the hammer price (HP) and that the auction-house estimate (AV) is given by the arithmetic mean of their upper- and lower-price estimates, as in equation (4.2). Using as a sample the 10,306 paintings of American artists in the sample sold at auction in the period 1987–2013, we find

$$\ln(HP_i) = 0.2668 + 1.014 \ln(AV_i) - 0.8811(IMR_i) + e_i.$$
$$(6.89) \quad (376.15) \qquad\quad (-15.00) \qquad\qquad (4.10)$$
$$R^2 = 0.942 \quad F^* = 83,635$$

(The numbers in parentheses are t-statistics based on White's heteroscedasticity-consistent standard errors.[21])

The results indicate that the individual null hypothesis $\beta_1 = 0$ can be rejected at the $\alpha = 0.01$ level and the individual null hypothesis $\beta_2 = 1$ can be rejected at the $\alpha = 0.01$ level [$t = (1.014 - 1)/0.0027 = 5.18$]. The F reported in the preceding refers to a test of the joint significance of the regression's slope coefficients (i.e., H_0: $\beta_2 = \beta_3 = 0$); the relevant test for an unbiased estimate of the value of a painting refers to the joint test H_0: $\beta_1 = 0$ and H_0: $\beta_2 = 1$. The calculated F value for this test is 129.04, indicating that unbiasedness in the auction-house estimates can be rejected at the $\alpha = 0.01$ level [$F_c^{0.01}(2,10304) = 9.21$]. Not only do we have strong evidence of bias, but our results allow us to dissect the bias into its various sources. Since the constant term is statistically greater than zero, θ must be greater than unity. Indeed, $(\hat{\theta} = \text{antilog}(0.2668) = 1.306)$ so that we estimate a significant multiplicative bias in the amount of 31 percent (i.e., $\hat{\theta} - 1$). Thus the auction-house estimates tend to understate the hammer

price of paintings sold at auction by about 30 percent, and that magnitude is consistent throughout the range of assessed values.

Similarly, since $\lambda(=\beta_2)$ is statistically greater than unity, there is also a proportional understatement in the auction-house estimates. Specifically, our results indicate that a 10 percent increase in the auction house's estimate will result in a 1.4 percent increase in hammer price. This magnitude at first seems quite small, but its effect can accumulate rather quickly, especially for expensive paintings. For example, a picture that the auction house assesses at $50,000 should have a hammer price of about $58,178, other things being equal, roughly a 16.4 percent understatement by the auction house. But a painting assessed at $500,000 should have a hammer price of about $600,835, roughly a 20.2 percent understatement. Taken together, these results suggest that auction houses consistently underestimate hammer prices, and that understatement increases with their assessed value of the painting.[22]

As a final consideration, we turn to the stochastic properties of our model. While we have assumed that the disturbance term of our model is normally distributed, equations (4.4) and (4.9) make it clear that it is in fact log-normally distributed (that is, normally distributed in its logarithms). It follows that price and AV should also be considered to be log-normally distributed. McAndrew, Smith, and Thompson argue that in this case, the appropriate estimator for the auction house's assessed value is the geometric mean of assessed-value limits, not the arithmetic mean; that is,

$$\ln(AV_1) = \frac{\ln U + \ln L}{2} \neq \ln\left[\frac{U+L}{2}\right] \tag{4.11}$$

We used the arithmetic mean for AV in the prior analysis; if we substitute the geometric mean of the limit values for AV1 into the model explaining hammer prices, we find

$$\ln(HP_i) = 0.2963 + 1.013 \ln(AV1_i) - 0.8895(IMR_i) + e_i$$
$$\quad (7.67) \quad (376.7) \quad\quad (-15.15) \tag{4.12}$$
$$R^2 = 0.943 \quad F^* = 84,488$$

(The numbers in parentheses are t-statistics based on White's heteroscedasticity-consistent standard errors.[23]) These results are almost exactly those found for hammer prices when we proxied AV1 with the arithmetic mean of the limits. The constant term is statistically significant at the 0.01 level and implies a $\hat{\theta}$ value of

1.345, so that there is a 34.5 percent multiplicative understatement of hammer price by the auction houses' value estimates. $\hat{\lambda}$ is also statistically greater than unity ($t = 4.81$), implying a 1.3 percent proportional bias downward. The joint test also rejects the null of unbiasedness at the $\alpha = 0.01$ level [$F^*(2,10304) = 140.05$]. It appears that the only gain to employing the geometric mean of the limits in lieu of the (log of the) arithmetic mean is that the statistical results are marginally stronger.

These results taken together clearly indicate that auction houses' assessed values of paintings systematically understate the prices of paintings sold at auction, from both a multiplicative and proportional perspective. What incentive do auction houses have to follow this policy of consistent understatement when economic theory suggests that, in general, they have no incentive to do so? One explanation might lie in conservative forecasting. All economists are aware of the advantages of conservative forecasting: If a "low" forecast proves accurate, the obvious response is "I told you things would not go well." But if things turn out better than forecast, all are pleased. This is the rationale proposed in many prior studies: if an owner receives a price for his work more than the amount he expected based on the auction house's estimate, he will be pleased and perhaps offer future paintings to the house for auction, as mentioned earlier in this chapter. Moreover, if prices are underestimated, then reserve price, usually a percentage of the low estimate, will be lowered, thus increasing the likelihood of a sale.

There is, however, a demand-side explanation as well. Auction houses are in business to sell paintings to collect both seller's and buyer's premiums. The probability of selling any given painting increases with the number of bidders. More buyers will bid on lower-priced paintings than higher-priced ones. Thus, by understating the value of the painting, the auction houses draw more bidders into the auction. From then on, auction dynamics may yield a higher selling price than would have resulted from fewer bidders. These two conjectures may help explain the theoretical anomaly that we observe in terms of auction-house estimates. And, of course, the auction house may act strategically to balance underestimation for lower-priced pieces with overestimates for high-priced art or other merchandise for reasons enumerated earlier in the present chapter.

The recent and dramatic uptick in the art auction markets, especially for impressionist, modern, and contemporary art at the highest levels, brought forth commentary from important observers that seems to support the above assessment. Fall (2015) sales at Sotheby's, Christie's, and Phillips in these categories alone were expected to be in the area of $3 billion; pre-auction

assessments outlined the drama and "theatrical tactics" that encourage buyers to bid and sellers to part with cherished pieces (Dobrzynski 2015). The auctioneer's dream, according to Dobrzynski, is to underestimate the first item in an auction so low that the realized hammer price triples the low estimate. Furthermore, general underestimation keeps buyers in the market and keeps them from leaving the salesroom at mid-auction. The drama and auction-house activities are choreographed twice a year for the big spring and fall sales, but it is a constant quest to discover the specific tastes of buyers and the willingness of sellers to part with great or good material that will please buyers. Thus, enter the third-party guarantors. These may be collectors, dealers, banks, hedge funds, or others willing to put up money for sellers to be attracted to auction their works. It is also a method for the auction houses to lay off risk, but at a cost. The complicated contracting with third-party guarantors takes on many forms. The auction house may pay a lump sum for the guarantee or a percentage of the hammer price and/or a share of the buyer's premium that might happen to exceed the estimate. To complicate matters even further, the guarantors may themselves bid on the items they've guaranteed—with each auction house individually contracting (with each item and guarantor) for the method of payments. The market is clearly opaque, clearly suggesting that auction houses, especially with the highest-valued art, use careful strategy in setting estimates.

This last observation suggests a potential reconciliation of the diverse bias findings in Table 4.1. If a sample is dominated by lower-valued paintings, as ours is, one might expect to find one result—say, that assessed value understates price—while a sample dominated by higher-value paintings could yield the opposite conclusions. There is some evidence that auction-house experts do strategically assess paintings according to their expected values. For example, some art experts familiar with auction-house estimating practices have privately suggested that auction-house experts pay much closer attention to the factors affecting the assessment (provenance, condition of the work, etc.) for paintings whose anticipated value exceeds $100,000 than they do for paintings whose anticipated value is less than $100,000.

To test this notion, we added a dummy variable (= 1 for paintings whose nominal sales price exceeded $100,000; = 0, otherwise) and an interaction term (the product of the dummy variable and the mean assessed-value measure) to the model specified in equation (4.12). The results indicated that the constant term was significantly larger and the lnGMAV coefficient significantly smaller for the higher-valued paintings than for the lower-valued ones.[24] Thus we have two distinct models for evaluating presale bias, one relevant for paintings valued at less than $100,000 and another for paintings valued above

$100,000. Both models have multiplicative factors that indicate that assessed value understates price—*ceteris paribus*, the understatement being markedly greater in the higher-valued case. Unlike our previous results, however, the proportionality-bias results indicate that, ceteris paribus, assessed value overstates price (since both estimates of the exponent of AV are significantly less than one) in both models. Since the multiplicative- and proportionality-bias factors work in opposite directions, both factors must be taken into account when evaluating their net effect on bias. It turns out that for paintings under $100,000, assessed value understates price, but the extent of the understatement, in percentage terms, falls as assessed value rises.[25] The same can be said of the high-value model estimates.[26] However in this case, the fact that the extent of the underassessment falls as assessed value rises leads to an interesting result. At an assessed value of around $11,000,000, the degree of underassessment due to the multiplicative effect is basically offset by the degree of overassessment due to the proportionality effect, so that the assessed value and expected price are roughly the same. Furthermore, as assessed value rises past $11,000,000, assessed value overstates market price, leading to a "masterpiece effect" à la Mei and Moses. To illustrate, an assessed value of $55,000,000 leads to an expected price of slightly over $43,000,000. In any event, since very few of the paintings in our sample have hammer prices in excess of $11,000,000, we are confident in our original conclusion that presale assessed values understate actual hammer prices for our sample of eighty well-known American artists.

Predicting No-Sales

The relatively large percentage of no-sales, sometimes as large as 30 or 40 percent, in many auctions has to be explained. Some have suggested that the size of the window indicates risk avoidance on the part of the auction house, produced by a lack of certainty about the market value of the piece. Larger windows between the low and high estimate thus would signal more uncertainty. Hodges (2012: 1) analogizes the art auction market to the financial market and concludes that the former mimes the latter and that "the relative magnitude of the estimate range signals to buyers the experts' confidence in a work's value. A smaller relative magnitude signals higher expert confidence in its value and its liquidity (its ability to be resold). A larger relative magnitude signals an illiquid work, one whose final sale price is depressed by an illiquidity discount." Hodges argues thus that the larger the spread of the estimate, the higher the probability of a no-sale (due to illiquidity) and vice versa for a smaller estimate spread. Hodges finds some evidence of this proposition. More than a decade

earlier, however, Ekelund, Ressler, and Watson (1998: 39) argued the follow-
ing that posits a result opposite to Hodges:

> Since the low estimate, in part, may be determined by the seller's
> reserve price and the high estimate is determined exclusively by the
> auction house evaluator, the size of the window can be an indication or
> signal of the level of reserve price relative to the auctioneer's guess. In
> particular, a small window indicates that a relatively high reserve price
> has pushed the low estimate upward toward the auction houses high-
> est estimate. Alternatively, a large window indicates a relatively low
> reserve price and the low estimate will be well below the high estimate.
> From this conjecture, we predict that pieces with small windows may
> have an artificially elevated low estimate (and thus reserve price) and
> therefore will be associated with more "no sales."

A test on Latin American art sales between 1977 and 1996 supports this prop-
osition. Ashenfelter and Graddy (2003: 779) reiterate this possibility—that
the no-sale rate due to uncertainty on the part of the "experts" may be aug-
mented or simply explained by the ability of sellers to negotiate higher reserve
prices. These writers cite evidence "that this may be occurring." In their data
sets of contemporary art and impressionist and modern art, a smaller spread
between the high estimate and the low estimate is positively correlated with
an item being bought in (i.e., the reserve price not being met) (Ashenfelter
and Graddy 2003: 779).

Is this result obtained in our study of American art? We restate the prop-
osition in simple form: Each auction transaction is given an estimated range
over which "experts" have predicted the price will fall. The estimates that are
published in an auction catalog (and online) before the auction reflect the
negotiations between the auction-house specialist and the seller. Auctioneers
have an interest in getting material—especially, good material—and to set a
secret reserve (never published) below which an item will not sell. It is in the
auction house's interest that the item sells since that is the only way the house
creates revenues. There is a seller's premium (percentage of the hammer) and
a buyer's premium (percentage of hammer price), but a sale has to transpire
for the house to collect.

Thus it is in the interest of the auction house that the seller agrees to
set the reserve as low as possible. The secret reserve is thought to be 70 to
75 percent (on average) of the low estimate. Strong sellers want the reserve to
be close to, or possibly equal to, the low estimate. This negotiation does not
alter the "experts'" view of the estimated high hammer price that the piece

might bring. Thus, when estimates are narrower in terms of range ($50,000–$60,000, rather than $40,000–$60,000), it may be a signal that the secret reserve is high, perhaps even higher than the auction house would like. If the seller's bargaining power is strong or the auction house is weak (possibly because it is in the lower-tier category), the house may be forced or negotiated, sometimes by hard bargaining, into setting a higher low estimate. The narrowed estimate thus increases the probability that the piece will not sell.[27] Thus the probability that the piece will be "bought-in" is higher.

These two views form a set of mutually exclusive and exhaustive hypotheses that can be tested within the context of an appropriately specified model estimating the probability of a painting selling at auction. According to the "financial view," a wider high–low estimate range indicates a riskier investment and therefore should reduce the probability that the painting will be purchased. According to the "institutional view" (i.e., the view that takes into account the institutional arrangements of the art auction market), a narrower high–low estimate range may result from upward pressure on the low estimate due to bargaining between the auction house and the seller and hence militate against sale of the painting. Rephrasing, this view suggests that a wider range of estimates should increase the probability of a painting selling. Thus, if we include a variable measuring the range of the high–low estimates in a probit model estimating the probability of sale, along with other variables measuring characteristics of the painting, artist, and conditions of sale, a negative and significant coefficient on the range variable would support the financial view, while a positive and significant coefficient would support the institutional view. Table 4.3 presents the results of estimating such a model using our sample of 13,921 paintings defined earlier in the chapter.[28]

The key variable in the model is RANGE1, which is defined as the difference between the real values of the high and low presale estimates. Additional variables include the logarithm of the real value of the low estimate (LLEST1), the age of the artist at the time of the painting and its square (AGE and AGE^2, respectively), the logarithm of the size of the painting in square inches (LNSIZE), dummy variables for medium (DMED = 1 for oil, = 0 otherwise) and for whether the painting was signed by the artist (SIGNED = 1 if signed, = 0 if unsigned), a set of five-year time-period dummies defined in Chapter 3 (DY8791 is the base five-year period) to provide some measure of changing overall economic conditions over the sample period, a dummy variable indicating the Great Recession (GR = 1 if year of auction was 2008 or 2009), and a dummy variable indicating whether the painting was painted before or after 1950 (PRE1950 = 1 if painted before 1950), since we argued in

Table 4.3 Probit Model Estimating the Probability of a Painting Selling

Variable	Coefficient Estimate	t-Ratio
CONSTANT	0.803997	5.72531
RANGE1	2.41082e-007	3.69612
LLEST1	−0.0180699	−2.20004
AGE	−0.0103233	−2.17745
AGE2	0.000106451	2.16145
LNSIZE	−0.0215306	−2.2184
DMED	0.100953	4.0136
SIGNED	0.0880443	2.30082
DY9296	0.00171374	0.02385
DY9701	0.291323	3.99348
DY0206	0.345829	4.80994
DY0711	0.0914472	1.28872
DY1213	0.103009	1.36327
GR	−0.221422	−4.3631
PRE1950	−0.0264741	−0.88943

Dependent Variable is Sold: Sold = 1 if painting sold; = 0 if no sale.

Chapter 3 that there was a fundamental change in the American art market around 1950.

LLEST1 was included to provide for an independent effect of the low estimate. Regardless of its effect on range, the higher the low estimate, the more expensive the painting, and hence the less likely its sale according to the law of demand; this relationship is supported by our results. We find LLEST1 to be negative and significant at the 0.05 level. AGE and AGE2 are both statistically significant at the 0.05 level, and their magnitudes and sign pattern suggest that the probability of sale is minimized at an artist age of around fifty-one years. This is in concert with our Chapter 3 results that a painting's value is maximized at about that artist's age, and in view of the law of demand, the more expensive the painting, the less likely it is to sell. The coefficients on DMED and SIGNED are both positive and statistically significant at the 0.05 level; oils and signed paintings are more likely to sell. All the five-year time-period dummies except DY9296 are statistically significant at, at least, the 0.10 level (two-tailed test) and positively signed. Apparently, the art market (in terms of sales) was relatively static in the 1987–1996 decade, grew significantly in the 1997–2006 decade, and grew at a slower, less pronounced rate in subsequent years. The GR dummy is negative and statistically significant at

the 0.01 level; the Great Recession hurt art sales. The PRE1950 dummy is statistically insignificant; apparently, whatever effects the institutional changes occurring in the 1950s had on the art market did not translate into effects on the probability of a painting selling.

All of the preceding results make theoretical and intuitive sense. It follows that if there are any important variables that have been inadvertently omitted from the model, their absence has not biased the estimates of the included variables to a degree sufficient to make those estimates unbelievable. It therefore seems reasonable to suggest that the model shown in Table 4.3 is an appropriately specified model. Consequently, we may conduct a legitimate test of the financial versus institutional views of the effect of the high–low estimate range on the probability of a painting selling in an auction market based on the results in Table 4.3. Those results provide clear and convincing support for the institutional view; the coefficient on RANGE1 is positive and statistically significant at the 0.01 level. Increases in range increase the probability of a painting selling, or alternatively, decreases in range increase the probability of a no-sale.[29] These results are consistent with the notion that a narrow range may be due to a low estimate that is "too high" due to seller/auction-house bargaining; they are quite inconsistent with the view of the high–low estimate range as a view of risk. Finally, it is important to note that the results of Table 4.3 were used to generate the IMR variable used in our earlier bias analysis.

Are American Paintings That Do Not Sell "Burned"?

Is a painting's future diminished because it is unsold the first time it comes to auction? Many collectors and gallerists believe that an unsold piece is "damaged goods" or "not fresh to the market." Will it receive a lower return on a second or third selling attempt? Using repeat-sales data on impressionist art, Ashenfelter and Graddy (2003: 773–774) found that it did.

Ashenfelter and Graddy described their "test": "We have looked at whether there appear to be any differences in prices and estimates for paintings that came to auction and did not sell during their first appearance at auction, but sold during their second appearance at auction (unsold-sold sample), vs. those that sold both times (sold-sold sample)." They add, "The ratios we look at are the estimate during a painting's second appearance at auction over the estimate of the same painting during its first appearance at auction (estimate 2/estimate 1) and the sale price during the painting's second appearance at auction over the estimate of the same painting during its first appearance at auction (sale price2/estimate1). We average these over the unsold-sold sample

and the sold-sold sample." They found that "the sale price in the second sale is on average 1.75 the estimate in the first sale, and the sale price in the second sale is on average 3.77 the estimate in the first sale IF the painting was sold in the first sale" (2003: 774).

Beggs and Graddy (2008: 301) further investigate this phenomenon and find that lower returns occur when an unsold painting comes up a second time. They conclude that "these lower returns may occur because of common value effects, idiosyncratic downward trends in tastes, or changes in the seller's reserve price." Their method is to compare sale-sale with no-sale–sale works, much as Ashenfelter and Graddy did in the preceding discussion. In this paper, however, Beggs and Graddy partition their sample into two groups: a group of paintings that came to auction three times and sold the first time, did not sell the second, and sold the third, versus a group that came to auction twice and sold both times. They find a sizable discount on the first group as compared to the second *unless* the piece goes to a different auction house than where it failed.

A painting whose sale suffers adverse consequences due to a failure to sell at a prior auction is often said to be "burned." While Ashenfelter and Graddy and Beggs and Graddy address this potential effect as we outlined earlier, our sample allows us to take a different tack: We consider paintings that appear twice in our auction data on American artists; there are 1,820 such paired offers in our data set. We use these data to empirically analyze the following question: If a work did not sell in its first appearance at auction, was the probability of its sale or its price affected when the painting was put up for sale the second time?

We begin by addressing the question of the extent to which the fact that a painting did not sell in its first offering at auction affects the probability that it will sell in its second offering at auction. The model we propose is basically the one we posited in the previous section to explain the probability of a painting selling for the full sample, with a couple of differences. We do not include a SIGNED dummy since virtually all paintings in this sample were signed, and we do not include a PRE1950 dummy since it was found insignificant in the prior model. We do, however, add a variable not included in the previous model, and it is crucial to the question at hand. That variable is UNSOLD1, a dummy variable indicating whether the painting sold in the first auction (UNSOLD1 = 1 if the painting did not sell in the first auction; = 0 if it did sell). All other explanatory variables are as defined for the model in the previous section (see Table 4.3). The dependent variable is SOLD2, a dummy indicating whether the painting sold at the second auction; the model is estimated using probit analysis on our sample of 1,820 paired offerings. The results are

presented in Table 4.4. RANGE2 and LLEST2 refer to the high/low expert-estimate range and the log of the low estimate, respectively, for the second offering at auction. They have the correct signs, but they are statistically insignificant. Upon reflection, this result may not be too surprising. If the fact that paintings went unsold in the first auction affects the range of expert estimates and the expert's low estimate in the second auction, then the UNSOLD1 variable would be expected to "steal" significance from the range and low-estimate variables. The age variables and DMED perform as expected. LSIZE is (unexpectedly) positive but statistically insignificant. All of the time dummies are negative, which may be due to the idiosyncratic nature of the sample (i.e., in the full sample about 9,600 paintings did not have the possibility of being burned; these 3,640 do have that possibility), but all of them are statistically insignificant at the 0.05 level. Finally, note that the Great Recession variable (GR) is negative and significant, as expected.

The result that is key to our current question is the relationship between whether the painting sold at the first auction and the probability that it will sell at the second auction. The coefficient on UNSOLD1 is negative and significant at the 0.01 level. This means that if the painting did not sell at the first

Table 4.4 How Does "Burning" Affect the Probability of the Sale of a Painting? Probit Estimates

Variable	Coefficient Estimate	*t*-Ratio
CONSTANT	2.58508	3.69188
RANGE2	1.78e-007	0.993179
LLEST2	−0.0278135	−1.17697
AGE	−0.044339	−3.15034
AGE2	0.00045	3.00771
DMED	0.11693	1.6837
LSIZE	0.017759	0.715761
DY9296	−0.827314	−1.4108
DY9701	−0.501873	−0.85683
DY0206	−0.537903	−0.922153
DY0711	−0.814873	−1.39992
DY1213	−0.809606	−1.38598
GR	−0.390159	−2.92456
UNSOLD1	−0.322324	−4.78252

Dependent Variable is SOLD2: SOLD2 = 1 if painting sold at the second auction; = 0 if no sale.

auction, the probability that it will sell at the second is statistically significantly reduced. Specifically, the probability that the representative painting in our paired sample will sell at the second auction is about 73 percent—if the painting sold at the first auction. That probability goes down to about 60 percent if the painting did not sell at the first auction.[30] Thus, at least according to one definition, burning can account for about a 13 percent reduction in the probability of subsequent sale.

However, the probability of sale is not fundamental to the question of burning; what happens to the *price* of a painting is fundamental. To investigate this question, we estimate a regression model in which (the logarithm of) real hammer prices of paintings sold in the second auction are a function of, among other things, whether the painting sold in the first auction (UNSOLD1). Since we examine real hammer prices, we must rule out paintings that did not sell at the second auction, which reduces our paired-offers sample from the 1,820 paired offers that we used in the preceding probit analysis to 1,322 paired offers in which the painting sold at the second auction (and may, or may not, have sold at the first). Specifically, the basic model we estimate parallels those of Galenson, as reported in Chapter 3, in which (the logarithm of) real hammer prices are a function of a polynomial in AGE (we use a quadratic in the following), medium, size, and a set of five-year time dummies. To this basic model, we add three variables measuring conditions of sale—GR, UNSOLD1, and PCTPREM2—and a variable correcting for our censoring no-sales at the second auction from the sample (IMR4). The basic variables are as defined earlier, as are GR and UNSOLD1; PCTPREM2 is the total premium paid by the buyer expressed as a percentage of hammer price (where both premium and price refer to the second auction). While the relationship between buyers' premiums and hammer prices is considered in more detail in the subsequent section, suffice it to note here that the buyer must pay the premium price (hammer price plus buyer's premium) to purchase a painting at auction. Thus any change in buyers' premiums will affect a buyer's willingness to buy a given painting and hence the hammer price he is willing to pay for it. PCTPREM is therefore an appropriate part of any model purporting to explain hammer prices. Finally, note that IMR4 is the inverse Mills ratio obtained from the probit model in Table 4.4 as applied to the paintings that sold at the second auction. That is, it corrects for deleting the 498 no-sales at the second auction from our paired-offer sample; it does not correct for deleting all of the single offers from our full sample.[31]

The results of our least-squares regression analysis of this model are presented in Table 4.5. The coefficients on AGE and AGE2 are both significant at

the 0.05 level, but their sign pattern indicates that value minimizes at around age fifty-eight, not maximizes at around age forty to fifty as Galenson suggests. If this result is viewed as anomalous, it may be due to the idiosyncratic nature of the sample, as noted earlier. However, it may also signal the potential frailty of Galenson's procedure when additional variables are added to the model. The size and medium variables behave as expected. An oil painting fetches a 74 percent [= exp(0.554) − 1] premium over non-oil paintings, and a 10 percent increase in size (square inches) yields about a 4.7 percent increase in real hammer price. The time-dummy results suggest that for the first fifteen years of the sample, real hammer prices remained relatively stable, but in the latter part of the sample they statistically significantly increase at progressively higher rates. The Great Recession dummy is negative and significant: if the second auction took place in the Great Recession (2008–2009), hammer prices were about 38 percent [= exp(−0.475) − 1] lower. The PCTPREM results are negative and statistically significant at the 0.01 level: a 1 percent increase in the average buyer's premium decreases real hammer prices by about 17 percent, *ceteris paribus*. Finally, and most important, note that the UNSOLD1 coefficient is negative and statistically significant at the 0.01 level. If the painting did not sell at the first auction, its hammer price will be about 60 percent [=

Table 4.5 How Does "Burning" Affect the Value of a Painting? Regression Estimates

Variable	Coefficient Estimate	t-Ratio
CONSTANT	9.28495	14.1951
AGE	−0.0462901	−2.47166
AGE2	0.0004059	2.06097
DMED	0.554296	6.68685
LSIZE	0.468002	17.3129
DY9296	0.0173342	0.0322499
DY9701	0.174932	0.328568
DY0206	1.40501	2.64227
DY0711	2.16092	4.03544
DY1213	2.29815	4.26579
GR	−0.475109	−2.10581
UNSOLD1	−0.917363	−9.14345
PCTPREM2	−17.2086	−23.4681
IMR4	1.89635	4.11057

Dependent Variable = log(real hammer price).

exp(−0.92) − 1] lower than if it had sold. This is convincing evidence that the burned effect has sizable negative effect on second-auction pieces. In conclusion, note that IMR4 is positive and statistically significant at the 0.01 level; it was necessary to explicitly correct for the omission of no-sales at the second auction from the sample.

Both the probit and regression results generally conform to expectations. Most variables behave as expected, but some variables may be viewed as exhibiting anomalous results. These anomalies may well be due to the necessity of using a paired-offer sample, rather than the full sample, to address the "burned" question. But with respect to the question of burning, the probit and the regression results are clear: if a painting goes unsold at the first auction, the probability that it will sell and, given that it does sell, the hammer price at which it sells at the second auction are both significantly reduced. "Burning" is a real phenomenon that can have pronounced effects on the value of a painting.

Premium Manipulations and Auction-House Profits

The auction institutions through which American and all other art is sold are profit-maximizing conduits where *both* buyers and sellers pay to market paintings. An obvious question to be raised, given a glance at Table 4.2, is whether the continuous increases in premium price have had effects on auction-house profits. Since the laws of demand and supply apply to American art and all art at auction houses, an important question arises: What is the *net* effect on revenues and profits when the effective price of a painting or artwork is *raised* by increasing buyers' premiums, all in the context of auction policy on both sides of the market? Clearly, the effect of changes in buyer's premium on auction-house revenues is determined by their effect on hammer prices. Thus an important first question to address in determining their effect on profits is the painting-specific issue of how changes in buyers' premiums affect hammer prices. To investigate this question, we pare our sample of 13,921 paintings by eighty artists down to only those paintings that were sold at auction at least twice during the period 1987–2013. This reduces the initial sample to 827 pairs of sales of paintings by seventy-one American artists. We limit the sample in this way for two important reasons: (1) it allows us to employ a price-difference approach to modeling hammer prices; and (2) paintings sold at least twice are, by definition, the most marketable of all of the paintings on which auction data

are available. As such, their sale should be less affected by changes in buyers' premiums than other paintings, so that their use provides a strong test of hypotheses regarding the effect of changing buyers' premiums on hammer prices.

A typical approach to modeling hammer prices is to express them as a function primarily of painting and artist characteristics and of conditions of sale. Issues arise in determining what painting and artist characteristics to include in the model. But when we model the difference in hammer prices (i.e., the price at which the painting was sold minus the price at which it was bought), all of these painting and artist characteristics "drop out" of the model since they do not change over the period of time that the painting was held. The only intertemporal factors affecting the change in hammer prices are changes in the conditions of sale, which we measure with two variables: the holding period and the change in the buyer's premium.[32] This allows us to estimate a relatively simple model of the difference in real hammer prices:

$$\Delta \ln\left(\text{RealHammerPrice}_i\right) = \alpha + \delta_1 \Delta\left(\text{Trend}_i\right)$$
$$+ \delta_2 \Delta\left(\text{AverageBuyersPremium}_i\right) + \varepsilon_i, \quad (4.13)$$

where the dependent variable is (the logarithm of) the real price the buyer paid for the ith painting subtracted from (the logarithm of) the real price that buyer received when she sold it; Trend is a daily time trend (beginning with January 1, 1987, and ending with December 31, 2013), so Δ(Trend) is just the period in which the buyer bought the ith painting subtracted from the period in which she sold it (i.e., the period for which she held the painting); and Δ[AverageBuyersPremium (ABP)] is the average buyer's premium (i.e., the total buyer's premium expressed as a percentage of hammer price) paid when the painting was purchased subtracted from that paid by the new buyer when it was sold.

Estimating this model using the data on the 827 paired sales of American art sold at auction during the 1987–2013 period yields the following results:[33]

$$\Delta \ln\left(\text{realHP}\right) = -0.0705 + 0.00035 \, \Delta\text{Trend} - 11.3806 \, \Delta\text{ABP}$$
$$(-2.15) \quad (18.66) \qquad\qquad (-14.25) \qquad\qquad (4.14)$$
$$R^2 = 0.379 \quad F^*(2,824) = 251.6$$

The model explains about 38 percent of the difference in the (log of) real hammer prices and is a statistically significant improvement over the sample mean in explaining those differences at any reasonable level of significance. The holding-period coefficient is positive and statistically significant at the 0.01 level, indicating that real prices grew at a rate of about 0.00035 percent per day on average over the holding period, which translates to about 13.6 percent per year. Of more immediate concern, however, is the negative and highly significant coefficient on the average buyer's premium. Apparently, a 1 percent increase in the average buyer's premium will result in about an 11.4 percent decrease in real hammer prices. This result suggests that raising buyer's premiums, which auction houses have done routinely since 1993, has an important, and perhaps dramatic, negative effect on auction-house revenues, not to mention returns to the seller.

To get a feel for the magnitude of this loss, consider the following example. Suppose a painting sold in 2014 for a hammer price of $250,000. According to Table 4.2, the buyer's premium on that painting would be $25,000 on the first $100,000 and $30,000 on the next $150,000 for a total buyer's commission of $55,000 and an average buyer's premium of ($55,000/$250,000 =) 22 percent. This $55,000 is income to the auction house; revenue to the seller is (some portion of) $250,000. Now suppose we raise the average buyer's premium by one percentage point to 23 percent. In the absence of any price response to this change, the auction house would expect to receive a commission now of $57,500, with the seller still receiving (some portion of) $250,000 in revenue. However, the preceding results suggest that this "no price response" assumption is erroneous. A 1 percent increase in the average buyer's premium can be expected to reduce hammer prices by about 11.4 percent on average. Thus, raising the average buyer's premium from 22 percent to 23 percent should result in the new hammer price being 88.6 percent of what it was previously. That is, we could expect the hammer price on the painting to fall from $250,000 to $221,500, *ceteris paribus*. This, in turn, would cause the auction-house receipts in the form of buyers' premium to fall from $55,000 to $50,945 (= 0.23 × $221,500). Thus the auction house receives $4,055 less than it would have before the rate hike, and $6,555 less than it thought it was going to. Furthermore, the seller receives (some portion of) $28,500 less than he would have before the rate hike.

Based on these results, it seems clear that raising the average buyer's premium could have potentially devastating revenue effects for both the auction house and the seller. Presumably, auction houses are aware of this effect. Why, then, would they continue to raise buyers' premiums? We suspect that the

answer lies in the fact that the preceding analysis considers only the demand side of the market. Increases in buyers' premium could also result in revenue-enhancing supply-side effects, so that the net effect on auction-house revenue and income is positive. We now turn to a consideration of these potential supply-side influences.

The fight for "good material," including early American art and, especially, first-rate Contemporary art, to sell at auction is on. All manner of devices are being used to attract sellers of high-quality paintings, including those of Americans Edward Hopper, Georgia O'Keeffe, Jasper Johns, and Mark Rothko. The use of auction-house guarantees—a guaranteed price plus some of the overage, for example—is and has been a common tactic. The auction house may offer a consignor some "enhanced hammer," where a seller receives some split (say four to seven percentage points) of the auction premium. For example, if a high-value item that sells for above $2 million, the consignor would receive 4–7 percent of the 12+ percent the buyer paid in premium, thus reducing the auction-house "take." Auction-house guarantees (third-party guarantees) may be financed by banks, collectors, hedge funds, or investment institutions specializing in art markets as well.[34] This is evidence of intense competition of the brokers to get sellers to put their property and hopefully higher-quality items up for auction. Thus any reduction in quantity demanded of art could be offset by an increase in both the quantity and quality of art that the two major auction houses attract, signifying a shift to the right of a hypothetical supply curve, as well as a shift rightward in a *quality-adjusted* demand curve.

For more than a decade, Christie's and Sotheby's have focused on shifting their revenue streams from sellers to buyers (see Table 4.2). They have, in effect, attempted to increase both the quality and quantity of art for sale at auction. Typically the seller would pay 10 percent on an item selling for under $100,000 hammer (higher for low-valued items), but lower rates on higher-priced items and nothing on items selling for $1 million and above. These rates are negotiated by the auction house and seller and may range from 0 to 10 percent or more, depending on the assessed value at sale to the auction house of pieces of art. All kinds of incentives are given to sellers. Auction-house or third-party guarantees, waiving or lowering the seller's commission, a split with sellers of the buyer's premium obtained on a sale, or other means may be used to pry paintings from collections and (sometimes) museums. Keen competition on the consignment side of the market occurs to obtain more and better material. This policy would shift the supply curve for American (or other) art rightward, and the corresponding increase in art

quality would shift the "constant quality" demand curve rightward as well. Whether or not this policy has, over time, been profit maximizing is an open question.[35]

The issue, therefore, is whether Sotheby's policies regarding both buyers' and sellers' premiums have increased or decreased profits over time. There are problems in answering this critical question. Since the negotiations with sellers over premium and other arrangements are strictly kept secret, all that is known is the changes in the buyer's premium and the published financial records of Sotheby's (since it is a public company). It is also worth noting that while the auction house's take from sales may be declining in percentage terms, the quantity and quality of works sold may be such as to make the business profitable. High and well-published prices for particular artworks have been achieved. It may be, moreover, that the elasticity for very high-priced work is low so that any losses at the lower end are more than made up by increases in high-priced goods. Factually, Sotheby's has been a profitable business. The question then becomes whether, in the aggregate, increases in the buyer's premium along with concomitant alterations in bargaining with consignors increases or decreases profits over what they *would have been* in the absence of the raises in buyers' premiums. We believe that an empirical study relating buyer's premium to profits provides insight into this critical question.

The question of the impact of buyer's premium on total hammer sales and/or profits is a company-specific, as opposed to a painting-specific, question. The data we employ to address this question—total revenue from commissions (from buyers and sellers) and total hammer sales—come from yearly Securities and Exchange Commission reports filed by Sotheby's over the period 1989–2014 (relating to data from 1988–2013). To these variables, we add yearly data on the Consumer Price Index (CPI) and a yearly time trend. In the analysis to follow, we view these commissions as profits to the auction house. This seems reasonable since they are clearly revenue to the auction house in excess of the amount that it must pay to the seller (hammer sales), and most other variable costs (shipping, insurance, and so on) are passed on to the buyer. Also, we compute the premium paid to the auction house as a percentage of hammer sales (PCTPREM) by taking the ratio of commissions to hammer sales. This measure is not strictly equivalent to an aggregate version of the average buyer's premium measure used in our previous analysis because it also includes sellers' premiums. However, the measures are very similar in both interpretation and magnitude.[36]

We have made the assertion that Sotheby's profits have risen over time. This may be true in a nominal sense. But a more appropriate measure

of long-run performance is whether real (price-deflated) profits have risen over time, and if so, by how much. We address this question by estimating a simple exponential trend for real profits. That is, we regress the logarithm of real profits (commissions deflated by the CPI) on a yearly time trend and find

$$\text{LREALPI} = 5.1044 + 0.0248 \text{ TIME} \qquad (4.15)$$
$$(31.29) \quad (2.577)$$
$$R^2 = 0.34 \quad F = 11.74$$

This result indicates that real profits grew at about 2.5 percent per year over the past twenty-five years. Also, since the CPI grew at a rate of about 2.5 percent per year over that same period, nominal profits grew at around 5 percent per year.

Apparently Sotheby's profits have been growing in both nominal and real terms over the past twenty-five years. It is not possible to assess the relative quality of this performance since we have no data on other auction houses for comparison. However, relative performance vis-à-vis other auction houses is not the central question. We are primarily interested in the question of whether rising premiums have caused profits to grow faster or slower than they otherwise would have. To address this question, we estimate a model in which the logarithm of real profits (LREALPI) is determined by premium expressed as a percentage of hammer sales (PCTPREM), a yearly time trend (TIME), and a dummy variable for the Great Recession (GR = 1 if year is 2008 or 2009, = 0 otherwise). We find (with t ratios in parentheses)[37]

$$\text{LREALPI} = 6.667 - 0.0755 \text{ PCTPREM} + 0.0229 \text{ TIME} - 0.194 \text{ GR} \qquad (4.16)$$
$$(13.09) \quad (-3.21) \qquad\qquad (3.79) \qquad\qquad (-2.08)$$
$$R^2 = 0.63 \quad F = 12.05$$

The growth rate in profits seems to be about the same as the long-term trend estimated earlier (2.3 percent vs. 2.5 percent), and the Great Recession had the expected negative effect—both results being statistically significant at the 0.05 level. The interesting result relates to the effect of PCTPREM on LREALPI; it is negative, statistically significant, and large: a 1 percent increase in PCTPREM results in about a 7.5 percent decrease in real profits.

What do these results imply about the success of Sotheby's policy of combining supply-side competition with increases in buyer's premium? Sotheby's itself predicted that its 2014 premium-structure change will result in buyers paying about 2 percent more on average than before the buyer's premium increase. Under the assumption of a constant premium structure, we can use equation (4.16) to estimate 2014 real profits, and we find them to be estimated as $315.58 million (1984 dollars). We compare this to a forecast based on equation (4.16), which allows us to take the premium increase into account. The average premium for the twenty-five-year sample is 20.15 percent. If we increase this to 22.15 percent and substitute this figure and 26 for TIME into equation (4.16), we find a forecast of real profit for 2014 of $267.76 million (1984 dollars). It appears that Sotheby's can expect about a $48 million decrease in real profits below what they would have expected had they not increased buyers' premiums. This comes to 15 percent real-profit reduction, almost exactly what the coefficient on PCTPREM would predict for a 2 percent increase in premiums. It would therefore appear that the increase in buyers' premiums may promote an end that is no part of Sotheby's intention: rather than providing more revenue to finance their competition to secure more and better paintings from sellers and thereby increase profits, they are likely to see a 15 percent drop in profits from what they would have been without the premium increase. Assuming no further premium increases and with a natural growth rate in real profit of 2.3 percent per year, it will be after 2020 before real profit reaches the point that it would have been in 2014 had there been no increase in buyers' premiums.

Of course, these are only crude estimates, and other events could occur to mitigate these predictions. For example, competition on the supply side to secure more and higher-quality paintings by offering sellers various incentives may indeed increase profits. If that is the case, a reduction in sellers' premiums could partially offset the negative effects on real profits of the increase in buyers' premiums. However, with an average seller's premium of less than 5.7 percent, there is not a lot of wiggle room there. In any event, even if the sizes of our estimates are excessive, they remain statistically significant and in a direction that should give Sotheby's (and Christie's and other auction houses) pause when it comes to raising buyers' premiums.

Artists and Auction Markets

Artists and markets have always been entwined, no matter the status of the artist as "isolated genius" or spiritual conduit or professional or entrepreneur. Perhaps she is all of these things. But while art is clearly an aesthetic

or spiritual experience, and the nature of the artist may be fashioned by the kind of art she engages in and many other factors (see Chapter 3), there is a necessity to exist for the artist—that necessity involves some kind commerce. That is the case for all artists at all times. That issue was no less important for American artists as they lived and evolved through the nineteenth, twentieth, and twenty-first centuries. As noted in Chapter 2, the art market is facilitated by a number of institutions. In terms of sales, art, including American art, travels through two major institutions: private sales (through galleries, artists themselves, the Internet, etc.) and public auction sales. In the present chapter we have presented some insights through the window of auction processes to characterize one of the two major institutions through which American art (and all other forms of art) is sold.

The whole auction-house issue relates to the matter of credence in buying and selling art. The auction house—fully half of all art sales in the United States—in dealing with American art must develop estimates of a range of prices over which that art (or any art or item sold) will fall in the auction. The expert, in this process, considers the past and probable future values of similar works by the artist, the picture's provenance/ownership, appearance in books including *catalogue raisoneé* (if one exists for the artist), exhibition history, and the condition of the work. That estimate and the fact that the auction house has *accepted* the work for sale adds credence to the potential buyer. One might reasonably expect that the higher the level of prestige of the auction house, the more credence is provided since these houses are generally in a position to pay more for "experts."

This process is of interest to the economist who wants to assess the quality of the estimates and the credence they provide to buyers. Various studies and possibilities exist. While a few studies have found that auction-house estimates are unbiased, many more find either underestimates or overestimates given that a mean or average value should be estimated over time. We find, for our sample of eighty American artists, that values over our sample period are underestimated. We provide plausible reasons for underestimation. But this fact is revealed in a particular sample taken at a particular time. (Other samples of other types of art reveal different results—see Table 4.1.) One particularly interesting prospect, one we have some evidence for, is that lower-price art is underestimated, while higher-priced art is overestimated *in the interests of the profit- or revenue-maximizing auction house*. This means that buyers should beware auction-house estimates if they anticipate unbiased accuracy and credence in the value of that on which they bid. According to Dobrzynski (2015), "even experienced collectors have trouble discerning what's actually happening at an auction—and not just because of the prearranged minimum-price

guarantees. At the auction, guarantors may well be bidding on the very works they've already underwritten, sending the price higher than the prearranged floor. And dealers—usually sight unseen, on the phone—may be bidding on works by artists they represent to protect their prices." Caveat emptor is the watchword.

Art-auction institutions and a fundamental understanding of them provides many other insights into market functioning. We have argued, with evidence from American art, that both sales and no-sales are predicted by the estimate range established and published by auction houses. Specifically, we have argued that the tighter the range, the greater the number of no-sales or items "bought in" by the auction house. The essential reason: "strong" sellers will demand higher reserve prices. With an unchanged high estimate, the probability that an item will sell is lower.

Likewise, examination of the auction process with respect to American art reveals some interesting questions. The issue of whether pieces of American art are "burned" when they fail the first time at auction was investigated using our data. We found that burning is an actual phenomenon for our sample of American art. If a painting does not sell on first offer, its hammer price will be approximately 60 percent lower if it sells on the next offering. Any unsold painting has real consequences for its price when there is an attempt to sell at a subsequent auction (over our auction-data period).

Boom times, tempered perhaps by bubble market behavior (see Chapter 7) in the art market, are spilling over into American art generally and to Contemporary American art specifically. A general competitiveness between auction houses for material and enticing sellers with lower or negotiated sellers' premiums have been accompanied by rising buyers' premiums (see Table 4.2). Using our sample of American artists, we estimate that the rapid rise in buyers' premiums (which raises the price to the buyer) has, as predicted by the law of demand, reduced the revenues of one publicly held house (Sotheby's) below what they would have been in the absence of such price increases.

The marketplace for American art, particularly high-level art, has been located at a number of private galleries (mainly in New York City) and at auctions, almost exclusively in the United States, particularly in New York City. The present chapter has investigated how eighty American artists have fared within this process. The use of auction data naturally has both advantages and limitations. One advantage is the ability to uncover how well American artists have performed in terms of investment. And American art, particularly Contemporary American art, has become for many, as precious metals and commodities are for some, an object for investment speculation, which is the subject of Chapter 5.

Chapter 5

Early and Contemporary American Art as Investment Vehicles

THERE ARE CLEAR signals that fine art, like precious metals, gems, and other so-called treasure assets, are becoming the object of investment, especially in the portfolios of the mega-wealthy. Prestigious investment companies, such as Morgan Stanley, are offering advisors and analysis of the market. Fine art and other collectibles and valuable items such as gold, stamps, and coins have often become investment repositories, especially during periods of economic turmoil and expected inflation. Fine art is now at or near the top of the list. The press tracks the course of these so-called passion investments. The *Financial Times*, the *New York Times*, Bloomberg, dozens of other news services, and numerous art-related publications issue regular evaluations of the art market written by specialists in particular areas. Art galleries have made use of data compiled by economists in advertising and sales.[1] The Fine Art Fund, a private-equity firm in London, advises investors in the global art market, and several other organizations have arisen for that purpose and for other "treasure" assets. Investors are advised of the vagaries and capriciousness of the art market as a monetary investment.

Academics and professionals interested in these matters have grown in number as well.[2] Basically two methods have been used to calculate investment returns for art: hedonic regressions and repeat-sale regressions (RSR), both with data gathered from art auctions. These methods have been used for myriad data sources and genres of art. This chapter is centered on American art as a monetary investment using a new sample of eighty artists born in the nineteenth and twentieth centuries whose paintings were sold at auction between 1987 and 2013. Our analysis employs both the hedonic and repeat-sales

approaches. Most important, our analysis differs from existing estimates in two important respects: (1) by including all transactions costs of trade at auction: specifically, we include adjustments for buyers' and sellers' premiums on hammer price in the analysis of investor return, as well as for art that does not sell ("no-sales")—that which is "bought-in"—that is, pieces that did not meet sellers' reserve prices; and (2) by clearly bifurcating the sample of American artists painting before 1950 and those painting afterward (which includes "modern and contemporary" artists as a separate category).[3] Our results suggest that the investment return on all American art is even lower than commonly estimated, especially pre-1950 art, meaning that the "consumption component" of art purchase is likely higher than previously calculated. We proceed by briefly discussing the importance of studying early American art as a separate category from Contemporary American art; the literature on investment in this and other areas; methodologies and results obtained; and a review of our method and data. We then present the results of our empirical analysis and discuss the comparative returns to American art as an investment for both "early American artists," or those born before 1900, and "contemporary American artists" (those born after 1900 but before 1960). We argue that, statistically, these two categories of American art clearly constitute different markets, and we analyze each cohort of artists separately.

American Art as an Investment Vehicle

An obvious question is whether and why American art created by artists born prior to 1900 and painted before 1950 should be singled out as an object of investment return. Different classes of art (French impressionism, Asian art, German expressionism, and so on) will yield alternative returns, and, clearly, Americans have purchased the art of many countries worldwide, sometimes as investment assets. But much of this art is the subject of worldwide purchase, especially in London, Paris and, more recently, Asian markets. Americans' stylistic dominance of the art world did not begin until the advent of abstract expressionism, a period that also heralded the advent of demand manipulation by critics, galleries, and auction houses, continuing to the present day. American creativity, spurring the explosion of the Contemporary art market, has been a vital force in the world markets since the innovative developments of the 1950s onward, differentiating that period from what went before. American art produced prior to 1950 constitutes, currently and historically, a more contained geographic and economic market.[4] Americans have been the primary purchasers of pre-1950 American art from specialized dealers and auction houses in America over the last two centuries.[5] The world has had

time to assess the ultimate place of older living and dead artists in the pan-theon of painters of a style or genre. An active market developed in American art that has grown to this day, spreading from the center in New York City throughout the nation. The number of galleries dealing in early American art (prior to 1950) and the number of auction houses selling it grew steadily, with an estimated two hundred galleries selling American art between 1913 and 1940 (Hall 2001), with hundreds more to follow.[6] Our initial focus in this chapter is on this group of artists.[7]

The selection of the period of artists born before 1900 and painting up to 1950, separating it from Contemporary American art, is thus deliberate. There are, of course, many investment opportunities in art produced by Americans *after* 1950, and "Contemporary art" is considered to be a "hot area" for some collectors and investors, as we will see later in this chapter and again in Chapter 7 on "bubbles." Traditionally, however, the market for American art has found a line of demarcation at about 1950 with market analysts, deal-ers, collectors, and auction houses. At that point, the market for American art was bifurcated due to the (principal) type of art produced.[8] The origins of abstract expressionism, already underway during World War II (Jackson Pollock's famous *Mural* was painted in 1943) and through the 1940s, sparked an earthquake in the *type* of art produced. Innovation became the order of the day as Galenson and Weinberg (2000) suggested. Henceforth "pre-1950s" American art became a bifurcated category, and it remains so. The major and many less prestigious auction houses separate sales of American art from "Contemporary art" in their annual auctions and have done so for decades. Such artists, in contrast to many contemporary innovators, have undergone the test of time in the appraisals of collectors and museums, creating some stability in the category. Economic studies testing investment returns have also focused on this period as a separate investing category (see Questroyal 2013: 15, citing Mei and Moses, ArtasanAsset.com).[9] Adding to the volatility of post-1950 American art is also, as Galenson suggested, its increasingly innovative character, whereby artistic reputations are made at younger and younger ages and where auction houses sell work by artists in early or mid-career. Demand for Contemporary art is often the subject of "attempted man-agement" (Thompson 2008: 189–199) by critics, museum curators, galleries, and artists themselves.[10] No sooner than one artist reaches her peak, others are recruited by dealers, often from university and other art schools, to take their place. One observer (Crow 2013: C20) put the matter succinctly: "The ring of a faraway phone is heard in an East Village apartment—and a style is born." This is not to say that contemporary art markets are characterized by great instability or lack of investment opportunities or that the attempt

to manage Contemporary-art demand is not a profit-maximizing response to innovation—only that the pre-1950 market is different and more "settled" and is recognized by sellers as such. Consequently, our study of investment returns may produce lower-return estimates than a post-1950 sample of artists, as discussed later in this chapter. As such, our results are preliminary, and other samples using other periods and/or other artists may produce alternative results. Before turning to our two sets of results, consider again the issue of art as an investment.

Art as an Investment: Conventional Wisdom

Art is sold in primary markets by artists themselves and in markets such as galleries, which may represent a set of artists or may purchase works from artists or collectors for sale. An important secondary market exists in the form of auction houses, most importantly represented by Sotheby's and Christie's in world capitals. A growing number of regional auction houses also sell American art, enhancing the "liquidity" of holding art, as has the number of galleries dealing in art from all over the world.

Purchasing art as an investment, especially as a short-term investment, is quite risky for a number of reasons. Unless one reduces information cost by purchasing professional advice, a high degree of connoisseurship is clearly required. Transaction costs are the major reason for the risk in purchasing fine art as an investment. If, for example, one purchases a painting for a total price of $100,000 (a medium-priced work by today's market standards) in 2013 and sold it for $125,000 in 2014, that 25 percent increase may appear to be a substantial return. However, if resold through a gallery in 2014, fees for the consignment could range from 20 to 40 percent, making the total investment returns far less attractive. Attempts to "flip" art through auction houses are likewise fraught with transactions costs. Selling costs, including the charge of a percentage of the hammer price, shipping, and photography for catalogs, mean that 10 to 15 percent or more of the $125,000 must be spent by a person flipping art for a monetary return. When such costs are considered, buying art as an investment becomes problematic in contrast to traditional assets—less so if transactions costs are spread out over a longer term. But that has not deterred investors from such activities.

Several scholars have reported on investment returns to art with contrasting results (Ashenfelter and Graddy 2003: 769, table 1 summarizes many of these studies). Most estimates of real return are relatively low, with some exceptions. Goetzmann (1993), using the Reitlinger (1961) and other (Mayer)

data, finds an overall real annual mean return of 17.5 percent for *all paint-ings* over a large swath of the twentieth century (1900–1986)—higher but far more volatile than bond and London stock returns (Goetzmann 1993: table 2), with highest returns in the post-1950 decades. (Other periods bring returns down to levels below or comparable with bond returns.) Further, he finds rel-atively high standard deviations for art investment, concluding that "there is little evidence that art is an attractive investment for a risk-averse investor" (1993: 1375).[11] Naturally some artists fare far better than others.[12] Returns, both nominal and real, vary within the many studies, but generally they are below 4 percent for art investments over many periods and samples.

Exceptions to the relatively low returns for "all art" may be found in specific genres or types of art, including American art. Mei and Moses (2002), using the RSR method, find considerably higher nominal and real returns over the period 1900–1986 for all art (American, impressionist, and Old Masters), with relatively lower standard deviation. Their study was assembled from catalogs for "American, nineteenth-century and Old Master, and Impressionist and Modern paintings sold at the main sales rooms of Sotheby's and Christie's (and their predecessor firms) from 1950 to 2000" (2002: 1657). If a catalog entry noted a prior sale, the earlier sale price was recorded. However, the Mei and Moses data (from *Hislop's*, various years) do not include no-sales or bought-ins—those paintings that did not reach the reserve price set by the seller—and do not account for transactions costs on the part of the buyer or seller.[13] Real returns are calculated for the three genres in totality and for the subcategories for various time intervals. They conclude that "art had a real annual compounded return of 8.2 percent comparable to that of stocks dur-ing the 1950–1999 period" (Mei and Moses 2002: 1661), outperforming both bonds and Treasury bills. The authors also noted that volatility over the period was comparable to two stock indices (S&P 500 and the Dow).[14]

A more recent hedonic study has found, with a large sample of more than 1.1 million observations of auction sales between 1957 and 2007 for 10,442 art-ists, that constant-quality art prices increased "by a moderate 3.97 percent in real USD terms on a yearly basis" (Renneboog and Spaenjers 2013). Further, these authors found that "for the second half of the twentieth century … estimates are substantially below those reported by Goetzmann (1993) and Mei and Moses (2002)." Renneboog and Spaenjers's study is remarkable for its comprehensive inclusion of global artists and for its attempt to seg-ment about half of the artists considered into fourteen art movements. Their conclusion: art investments perform similarly to corporate bonds but with greater risk.

Returns to American Art Investment

American artists are included in many of the studies of "all art" in order to determine investment risk and return, but few have focused exclusively on American art and artists. Two exceptions are papers by Agnello and Pierce (1996) and Agnello (2002). Agnello and Pierce, using hedonic regression on American artists born prior to World War II whose works sold well at auction with high auction volume between 1971 and 1992, calculated a nominal 9 percent increase over the period with a 3 percent rise in real prices. They also calculated returns for each of the individual sixty-six artists in the sample (1996: 370–371, table II).[15] These investigators conclude that the sample paintings yield a nominal return of 9.3 percent, which, when added to the agio of a consumption return (they use Stein's utility return [1977]), produces an investment return competitive with long-term government bonds and T-bills over the period (but not stock returns). The authors also studied genre effects (eight of them) and found that "high priced avant-garde, still life, or figure paintings" can achieve higher nominal returns than 9.3 percent.[16]

Agnello (2002) extended his study of the American market using a hedonic model of ninety-one American artists born before World War II whose works were traded in high volume between 1971 and 1996. Agnello excludes no-sales and includes genre effects (Currier 1991) but includes a risk variable. He concludes that the *nominal* return is only 4.2 percent with the enlarged sample, which is lower than the returns to stocks, short- and long-term government bonds, and inflation over the period. However, Agnello notes that "if the purchaser is knowledgeable, lucky, and can afford to buy the best quality (high-end works), painting values can do much better than merely holding their real value. Paintings at the very high end of the price spectrum yield a nominal return of 9.9 percent per year which exceeds all the benchmarks except the S&P 500" (2002: 460).[17]

Our study divides American artists by birth cohort, as noted earlier. Using our sample from askART.com, thirty-three well-known American artists, listed in Table 5.1, meet these criteria. Since we are interested in both hedonic-return estimates and repeat-sales return estimates, we further limit the sample to those artists who had individual paintings offered for sale at auction multiple times during the period 1987 through 2013. This truncation reduced the number of artists included in the sample to thirty-one (Whistler had no multiple offers, and Eakins had four offers but no sales during the sample period). Paintings by these artists offered for sale multiple times during the sample period constitute the sample used in our hedonic analysis. Analyzing returns for repeat sales requires that we further restrict our attention to only

Table 5.1 Thirty-three American Artists Born in the Nineteenth Century

Artist	Birth/Death	Artist	Birth/Death	Artist	Birth/Death
Inness*	1825–1894	Remington*	1861–1909	Hartley	1877–1943
Whistler	1834–1903	Davies*	1863–1928	Dove	1880–1946
Homer*	1836–1910	Henri*	1865–1929	Weber*	1881–1961
Cassatt*	1844–1926	Luks	1867–1933	Bellows*	1882–1925
Eakins	1844–1916	Glackens*	1870–1939	Hopper*	1882–1967
Chase*	1849–1916	Marin	1870–1953	Demuth	1883–1935
Robinson*	1852–1944	Sloan	1871–1951	Avery*	1885–1965
Twachtman*	1853–1902	Lawson*	1873–1939	O'Keeffe*	1887–1986
Sargent*	1856–1925	Shinn*	1876–1953	Wood*	1891–1942
Prendergast	1858–1924	Kuhn*	1877–1949	Davis*	1892–1964
Hassam*	1859–1935	J. Stella	1877–1946	Burchfield*	1893–1967

Note: * denotes that paintings of that artist enter the multiple-sale sample.

those paintings that actually sold multiple times. This truncation reduced our repeat-sales sample to paintings by twenty-three of the artists whose works sold multiple times during the sample period. The artists whose paintings are in our repeat-sales sample are marked with an asterisk in Table 5.1. We will specifically define these samples in the discussion of our empirical analysis that follows.

Methodological Considerations

There are several methodological issues relating to the empirical analysis of art as an investment that warrant discussion. Among these is the use of auction data, the exclusion of "bought-ins," the empirical method to be employed, and the data employed in the empirical analyses. There is inherent selection bias in the use of auction data, a problem that has been recognized by virtually all researchers. We, as have all others, selected artists who have a "record" in the auction market, a small percentage of all artists. If an artist appears early in the sample period but does not appear in sufficient numbers later, she is not counted. Auction houses themselves discriminate in the artists they select to sell. They are in business to earn income and do not accept artists that do not sell (or do not sell at a high enough price) to include as auction material. This means that there is a clear and persistent upward bias in artists selected. The "also-rans" are not represented, nor are those "overspecialized" in style, appealing only to a small segment of the buying market. Such works are often

sold through private dealers.[18] Auction data also may introduce selection bias on the upper end of art prices. "Masterpieces" may also leave the sample so that resale is impossible. Many of the highest-priced paintings are destined for museum collections. This is especially so over a longer time.

As noted earlier, paintings may also be "bought-in" by their inability to meet reserve prices. A painting must sell at auction to have an observed price. If the painting does not sell, this fact does not imply that its price is zero—simply that its price is less than the reservation price of the seller. Although we can only guess at what the market price of a bought-in painting might be, it is clear that by not including it in the sample, an upward bias would result. Should a buyer in the sample be a real art investor and decide to sell, again within the sample period, when art prices are rising and the value of the painting is likely to have increased, an upward bias in the sample would also occur. These and other problems related to the use of auction data have been noted by many researchers in the area (e.g., Goetzmann 1993: 1371; Ashenfelter and Graddy 2003; Beggs and Graddy 2008), but there are other aspects to investigating art as an investment vehicle—importantly, the methods of statistical testing used.

Repeat-Sales versus Hedonic Approaches: Pros and Cons

Since art is an infrequently traded asset, much like real estate, it should not be surprising that methods found useful in valuing real estate have also been applied to estimating returns to art. Two such methods are hedonic price functions and repeat-sales analysis, and they have found considerable application in the study of art as an investment. Each approach has its advantages and disadvantages.

The hedonic approach assumes that the value of a painting is a function of the characteristics of the painting (size, media, etc.), characteristics of the artist (age, etc.), and the conditions of sale (season of sale, etc.). If we could estimate the implicit prices attached to these characteristics, the product of these implicit prices and their corresponding characteristic values should, perhaps after some transformation, sum to the value of the painting. Additionally, since we are interested in estimating the returns to art as an asset, we must add a measure indicating the timing of the purchase (so that the change in value over time may be estimated). This leads to the following hedonic price function (see Agnello 2002: 451):

$$\ln\left(P_{it}\right) = \beta_{0} + \sum_{j=1}^{k} \beta_{j} X_{ji} + C\left(t\right) + \mu_{t}, \tag{5.1}$$

where $\ln(P_{it})$ is the natural logarithm of the price of the *i*th painting sold in time period *t*, the X_{ji} are the characteristics (noted earlier) of the *i*th painting, the β_j ($j = 1, \ldots, k$) are the unknown coefficients of the *j* characteristics (typically estimated by least-squares regression), $C(t)$ is a time-varying market-wide effect that can be specified according to the purposes of the model, and ε_t is a stochastic term. The semilog specification is typical of hedonic models and is employed based on the assumption the hedonic price of the *j*th characteristic should be a function of the value of the painting $\left(\dfrac{\partial P_{it}}{\partial X_j} = \beta_j P_{it} \right)$.

Specification of $C(t)$ is key to measuring the return on art and is conditioned by the way we wish to address that question. For example, if we wish to create a yearly return index from which we could (among other things) compute a mean return for art, we could specify a set of yearly dummies ($D_{it} = 1$ if painting *i* was purchased in year *t*, = 0, otherwise) so that

$$C(t) = \sum_{t=1}^{T} \alpha_t D_{it}, \qquad (5.2)$$

where α_t are also estimated by least squares. In this case, the omitted time dummy defines the base year of the return index, and the return-index value in year *t* is given by $\exp(\alpha_t)$. The resultant return index can then be used to compute a global rate of return on art. However, as Agnello (2002) points out, if we are only interested in an overall estimate of the rate of return on art as an asset, then creating the return index is an unnecessary intermediate step. We can specify

$$C(t) = \alpha_t \text{ TIME}, \qquad (5.3)$$

where TIME is a traditionally defined time-trend variable, so that α_t (or more appropriately $[\exp(\alpha_t) - 1]$) can be interpreted as an estimate of the implicit global rate of return on art (Agnello 2002: 451).

A major advantage of the hedonic approach is that it wastes no data; if the painting was sold during the sample period, it is an appropriate element of the sample. The method has a sound theoretical foundation in Lancasterian demand theory in that the value of an asset is based on the value of its characteristics and their implicit prices. The procedure is straightforward, but it is not without its disadvantages, some severe. Since bought-in paintings are, by definition, not sold, they cannot be included in the sample, and thus the sample is not random on that account; there is a potential for sample-selection

bias and, as a consequence, the art rate-of-return estimates are likely to be biased upward. The procedure excludes the consideration of both buyers' and sellers' premiums paid to auction houses, which are substantial in the case of art, and ignoring them will also result in overstatement of the rate of return.[19] Equation (5.3) defines the global rate of return on art as an instantaneous rate of return. Since art is typically held for long periods, an instantaneous rate of return may be misleading. The characteristics included in the hedonic model are often determined by data availability rather than theory, so that specification error is always a possibility. We conclude that the hedonic approach has some intriguing advantages, but that it has enough potential drawbacks that it would be wise to buttress inferences based on it with evidence from other approaches.

An alternative to estimating returns to art based on a hedonic price function is the repeat-sales approach. This approach requires that a given painting be sold at least twice during the sample period to be included in the sample; hence the name. Specifically, if painting i was purchased in time period t for P_{it} dollars, held k periods and sold in period $(t + k)$ for $P_{i,t+k}$ dollars, the holding-period return $(r_{H,i})$ is defined to be

$$r_{H,i} = \frac{P_{i,t+k} - P_{i,t}}{P_{i,t}},$$

(5.4)

and the average return per period $(r_{PP,i})$ is

$$r_{PP,i} = \left(\frac{P_{i,t+k} - P_{i,t}}{P_{i,t}} \right) / k.$$

(5.5)

It is worth noting, from equation (5.4), that $(1 + r_{H,i}) = \left(\frac{P_{i,t+k}}{P_{i,t}} \right)$. It can also be shown that $\ln(1 + r_{H,i}) \cong r_{H,i}$, so that $\ln \left(\frac{P_{i,t+k}}{P_{i,t}} \right) = \ln(P_{i,t+k}) - \ln(P_{i,t}) \cong r_{H,i}$. The relevance of these observations will become clear in what follows.

The technique for analyzing repeat-sales data is called, aptly enough, repeat-sales regression (RSR). It relies on the same analytical foundation as the hedonic model, but it explicitly includes returns, so its specification is considerably more abbreviated and its estimation more complex than its hedonic counterpart. To see this, substitute the expression for $C(t)$ in equation (5.2) into equation (5.1), rewrite it for period $t+k$, and subtract equation

(5.1) from the result. If the market's evaluation of the value of the various characteristics of the paintings (β_j's) remains stable over time, the subtraction results in the cancellation of the values of the paintings' characteristics, so, for the ith painting, all that remains on the right are two dummies (for periods $t + k$ and t), their corresponding coefficients, and a stochastic disturbance term—that is,

$$\ln(P_{i,t+k}) - \ln(P_{i,t}) = \alpha_{t+k}D_{t+k} - a_t D_t + \varepsilon_t. \tag{5.6}$$

Pesando (1993) has estimated this version of the RSR model. However, Goetzmann (1993) showed that it is more efficient to specify a full array of dummies and to define them such that $D_{it} = 1$ if the ith painting is held in the tth period; $D_{it} = 0$, otherwise. So the basic RSR model becomes

$$\ln(P_{i,t+k}) - \ln(P_{i,t}) = \sum_{t=1}^{T} \alpha_t D_{it} + \varepsilon_i. \tag{5.7}$$

Specified in this manner, α_t, the coefficient estimate for D_t, (or more precisely $\exp(\alpha_t) - 1$) is the average of the returns on all paintings held in period t. These can be used to create an index of art returns over time, which, in turn, can be used to estimate an overall (or global) return on art. While returns calculated in this manner are unbiased estimates, they are not efficient (in the sense of minimum variance). Since the return on a given piece of art is determined by adding per-period returns over the holding period, the error variances of the return estimates vary with the length of the holding period, and since the length of the holding period varies across paintings, the model's disturbances are heteroscedastic. Case and Shiller (1987) suggest dealing with this problem first by regressing the squared residuals from a least-squares estimate of equation (5.7) on holding period and a constant, and then using the predicted values from that regression as weights in a generalized least-squares (re-)estimate of equation (5.7). This is the RSR procedure used by Goetzmann (1993) and Mei and Moses (2002, 2005).

However, as with the hedonic procedure, if all we wish from our repeat-sales analysis is an estimate of the global return on art, obtaining unbiased and efficient estimates of a yearly return index is an unnecessary intermediate step. All that is needed is to calculate per-period return, as in equation (5.3), for each painting, average those returns across paintings, and then compound

those estimates up to some meaningful figure—say, yearly returns—which can be compared across asset classes.

The repeat-sales approach also has advantages and disadvantages. First, among the advantages, it relies on the same theoretical foundation as the hedonic approach. Second, as long as the buying public's valuation of the painting's characteristics (i.e., the hedonic prices) does not change over time, the only data required on a given piece are purchase price, sales price, and holding period. The procedure can thus be viewed as building "constant quality" into the return estimate, and thereby avoiding many of the model-specification issues inherent in the hedonic approach. But the procedure also has several disadvantages. The requirement of multiple sales necessarily reduces the sample of paintings available to analyze, often markedly so. If the hedonic prices do change over time, which is more likely the longer the holding period, then constant quality is no longer ensured, and the return estimates will be biased. Of all the paintings available for sale, only the most marketable are resold, leading to an upward bias in return estimates. Although it is conceptually possible to, at least in part, incorporate buyers' and sellers' commissions paid to auction houses, applications make no attempt to do so, which results in an upward bias in return estimates. Thus it is not inappropriate to buttress repeat-sales return estimates with estimates from alternate (hedonic) procedures, as well.

Data Considerations in Our Analysis of Early American Art

Earlier in this chapter ("Art as an Investment: Conventional Wisdom"), we noted that askART.com had data on thirty-three well-known American artists born before 1900 and painting before 1950 whose paintings were offered at auction between 1987 and 2011. Of these artists, thirty-one had paintings offered multiple times during this period, and twenty-three of these had paintings that actually sold multiple times. The data thus contained 290 paintings offered at auction multiple times, 101 of which actually sold multiple times. However, the unit of observation in our hedonic analyses is neither artist nor painting; rather, it is an offer at auction. The 290 paintings were offered at auction 605 times during the sample period. Most of the paintings were offered for sale only twice (269 paintings; 538 offerings), but seventeen paintings were offered three times (51 offerings), and four paintings were offered four times (16 offerings),

This entire set of 605 offerings formed the basis of our hedonic sample. Our basic data set included the title of the piece, date of auction, height and width of the piece, media (oil, watercolor, and so on), the high and low auction-house estimates of the value of the painting, whether the piece was signed by the artist, the age of the artist at creation, and the "premium price" ("hammer price" plus the buyer's premium) of the piece at auction. To these data we added information on the value of the Consumer Price Index (CPI) for the month that the auction took place, a daily time trend (beginning with January 1, 1987, and ending with December 31, 2011), the buyer's premium as a percentage of hammer price, and the value of the Standard & Poor's stock-price index on the date of the painting's sale. However, hedonic estimation requires that a painting have a price associated with it, which in turn requires that it be sold. Of the 605 offers for sale during this period, 365 resulted in sales. These 365 sales constituted our hedonic sample.[20] However, to analyze the effect of no-sales, we require an estimate of the probability of each observation being included in the sample. We obtain this estimate from a probit analysis based on the entire set of 605 observations, even though we employ those results only in the 365 sample of sales.

The unit of observation in our repeat-sales analysis of art returns is a paired set of exchanges of a painting: the first exchange being viewed as the purchase, and the second, the sale of the given painting. As noted earlier, 101 paintings were sold multiple times during the sample period. Of these, ninety-seven were sold twice and four were sold three times (eight resales).[21] This set of 105 resales constitutes our repeat-sales sample. We now turn to our empirical analysis of investment return on early American art.

Repeat-Sales Investment Estimates: Early Period

Our repeat-sales sample consists of 105 paintings of twenty-three artists that were sold at auction at least twice during the period 1987–2011. In principle, the only information we need on these paintings to compute a global return on early American art for that period is a purchase price, a sales price, and the holding period. Since our holding-period data are calculated in days, we can use equation (5.5) to compute average daily return on each painting over the holding period, average that across paintings to get a global daily return, (r_D) and then compound r_D according to the formula

$$r_G = \left[(1 + r_D)^{365} - 1 \right]$$ (5.8)

to obtain a yearly global-return estimate (r_G), which can be meaningfully compared across asset classes.

In computing the return on a painting, it is important to be precise regarding what prices are to be used. This precision, in turn, requires knowledge of the workings of the art auction market. Two prices relate to the sale of a painting at auction: the hammer price (HP), the bid price at which the sale is hammered down; and the premium price (PP), the hammer price plus a commission (expressed as a percentage of the hammer price) that the buyer must pay to the auction house in order to secure the painting. This buyer's premium is often substantial, currently ranging between 12 percent and 25 percent of hammer prices at Sotheby's and Christie's, and it is difficult to imagine the buyer not taking it into account when making her bid. However, the buyer's premium is not the only complication entering the computation of return. The seller must also pay the auction house a commission for selling a painting. Unlike the buyer's premium, the seller's premium is negotiated between the buyer and the seller and is not public information. Most discussions of the seller's premium refer to it as a percentage of hammer price; seldom is it suggested that the premium is as high as 20 percent. Thus 5 percent of the hammer price could be a conservative estimate of the seller's cost (seller's premium plus other fixed costs) of selling a painting. It is also worth noting that in rare cases of very high-quality art, the bargaining between seller and auction house can result in the seller not only not being charged a premium, but also in the seller receiving part or all of the buyer's premium (Bowley 2014).[22] These observations suggest that when a person buys a painting, she pays the premium price (PP), and after holding it for k periods, she sells it and receives some portion (m) of the hammer price (HP), so that holding-period return for the ith painting should be computed as

$$\left(m * \mathrm{HP}_{i,t+k} - \mathrm{PP}_{i,t} \right) / \mathrm{PP}_{i,t}, \tag{5.9}$$

where m would equal, say, 0.95 in the case of a 5 percent seller's premium.

It is very important to take explicit account of the buyer's and seller's premiums when computing return, as the following example illustrates. In a recent report on investment returns to early American paintings (Questroyal 2013), the following calculation is made: A painting by Maurice Prendergast, *The Paris Omnibus*, sold for \$168,000 in 2005 and for \$362,000 in 2011, yielding a compound annual return of 14 percent. It was also noted that both prices include

the buyer's premium. Presumably they arrived at the 14 percent return figure as follows: holding-period return is $r_H = (362{,}000 - 168{,}000)/168{,}000 = 1.155$, so that, for a holding period of six years, annual return $r_A = (1 + r_H)^{1/6} - 1 = 0.1365$ or approximately 14 percent. As noted earlier, using premium price for the amount paid by the buyer is correct, but using premium price for the amount received when sold is a dramatic overstatement; at most, the seller of this painting would receive its hammer price. A premium price of \$362,000 paid in 2011 corresponds to a hammer price of \$299,583.[23] This leads to an adjusted holding-period return of $r_H' = (299{,}583 - 168{,}000)/168{,}000 = 0.783$, so that adjusted annual return is $r_A' = (1 + r_H')^{1/6} - 1 = 0.1012$ or 10.12 percent, a drop of about 27.8 percent from the return estimate based on premium prices alone. However, this is still likely an overstatement of seller's return, since the seller would almost certainly have to pay a seller's premium of at least 5 percent. In this case, he would receive only $0.95(299{,}583) = \$284{,}604$ for the sale of his painting, so that his holding period return $r_H'' = (284{,}604 - 168{,}000)/168{,}000 = 0.694$, and the annual return would be $r_A'' = (1 + r_H'')^{1/6} - 1 = 0.0918$ or 9.18 percent. Hence computing return based on premium prices alone results in a 34.4 percent overstatement of the likely annual return on the painting. Caveat emptor; ignoring buyer's and seller's premiums can lead to very misleading results in computing art returns.

We used equation (5.9) and an appropriately modified version of equation (5.5) to compute annual returns on art under various assumptions regarding the magnitude of the seller's premium. The results are presented in Table 5.2. The first row displays the computations of (both arithmetic and geometric) mean daily and annual returns under the assumption of a 20 percent seller's premium. Likewise, the second and third rows display analogous computations under the assumption of 10 percent and 5 percent seller's premium, respectively. Row 4 assumes that no seller's premium is paid. Rows 5 and 6 assume that the seller can bargain the auction house out of part of the *buyer's premium* equal to 5 percent and 10 percent, respectively. Row 7 assumes that the seller can bargain the auction house out of the full buyer's premium, so that he receives the full premium price for the painting. While this scenario is conceptually possible in the case of some very valuable (\$50+ million) paintings, it is not remotely likely for the paintings in our sample. However, it serves as an extreme case, and it is apparently the assumption under which Mei and Moses compute their returns.

In surveying the results, observe that the arithmetic- and geometric-mean daily returns, and hence their annualized counterparts, are almost identical.[24] This similarity may be due to the notion that compounding daily in the arithmetic case is essentially equivalent to continuous compounding in the geometric case. It is also clear that (buyer's and) seller's premiums cut significantly into art return. If sellers pay an unlikely 20 percent seller's premium, or even a more likely 10 percent seller's premium, for the paintings in our sample, their average returns will be negative. Small, or no, seller's premium payment results in a small, but positive nominal return. Alternatively, if sellers receive the premium price for their paintings, as Mei and Moses assume, they outperform the market.

All of this begs the question of the comparative profitability of art as opposed to the market portfolio of financial assets. Finance theory suggests that over the long run one is unlikely to find an asset, or set of assets, that will outperform the market portfolio of financial assets. Thus one way to address the desirability of art as an investment is to compare the return on art to the return on the market portfolio. This question is addressed in the last row of Table 5.2. There the (arithmetic and geometric) daily and annual average return on the S&P 500 is computed under the assumption that, for each painting, the market portfolio was bought (instead of the painting) the same day as the painting, held for the same period as the painting, and sold on the same day the painting sold. Under these assumptions, the average yearly return on the S&P 500 is 8.76 percent, which exceeds the return estimates in all but one of the scenarios and more than doubles any of the reasonably likely scenarios. In line with much of the previous research on the question, one must conclude that art is not a good investment in comparison to purchasing the market portfolio of financial assets.

The preceding results do reinforce one long-held adage regarding the purchase of art: "Buy as high-quality a piece (spend as much) as you can afford." This reinforcement comes from comparing the returns under the premium-price scenario with the S&P 500 returns; as already noted, the premium-price scenario outperforms the market portfolio by about 1.76 percent per year. Recall that the premium-price case assumes that the auction house wants to sell the painting so badly that it is willing to give away the full buyer's premium in order to auction it off. This situation would only be feasible for very high-priced paintings (perhaps to enhance the reputation of the auction house to attract other high-priced work). Thus, if one buys a very high-priced painting, one can expect a return in excess of the market, not necessarily from increases in the intrinsic value of the painting, but rather from avoiding

Table 5.2 Average Return on American Art Sold at Auction 1987–2011: Paired Sales

Price Received by Seller	Arithmetic Mean			Geometric Mean			
	Mean Daily Return	Standard Deviation	Annualized Rate of Return	Mean Daily $\Sigma\ln(1+r_i)/n$	Standard Deviation	Mean Daily Return	Annualized Rate of Return
0.8HP	-0.0001	0.00064	-3.9%/yr	-0.0001	0.000063	-0.0001	-3.9%/yr
0.9HP	-0.000013	0.00062	-0.47%/yr	-0.000013	0.00062	-0.000013	-0.47%/yr
0.95HP	0.000035	0.00062	1.29%/yr	0.000035	0.00062	0.000035	1.29%/yr
HP	0.000084	0.00063	3.11%/yr	0.000083	0.00063	0.000083	3.11%/yr
1.05HP	0.000132	0.00064	4.94%/yr	0.000132	0.00064	0.000132	4.94%/yr
1.1HP	0.000181	0.00066	6.83%/yr	0.000181	0.00066	0.000181	6.83%/yr
PP	0.000274	0.00069	10.52%/yr	0.000274	0.00069	0.000274	10.52%/yr
S&P 500	0.00023	0.00034	8.76%/yr	0.00023	0.00034	0.00023	8.76%/yr

the seller's premium and by extracting rents from the auction house in the amount of the buyer's premium.

Hedonic Investment-Return Estimates: Early Sample

To arrive at our hedonic returns estimate, we employ the data set of 365 sales of paintings offered multiple times at auction between 1987 and 2011, discussed earlier, to estimate a version of equation (5.1). The specific version we specify uses the natural logarithm of premium price as the dependent variable and includes as painting characteristics the size of the painting in square inches (SIZE) and its square (SIZE2) and a dummy variable for medium (DMED = 1 if oil; = 0, otherwise); as artist characteristics, we include the age of the artist at the painting's creation (AGE) and its square (AGE2) and a set of eighteen artist dummy variables;[25] as conditions of sale, we include three seasonal dummy variables (summer is the excluded season); and to measure the time component (TREND), we include a daily time trend (January 1, 1987 = 1; December 31, 2011 = 9,131). The hedonic coefficients and the growth rate are estimated by least-squares regression (OLS). The estimates of the full hedonic model of early American artists for both premium and hammer prices, with and without sample selection correction, can be found in the appendix to this chapter (Table 5A.1). The results and implications of these estimates are discussed in the following.

These results suggest several interesting implications regarding American art painted before 1950. Note that SIZE, SIZE2, AGE, and AGE2 are all statistically significant at the 0.01 level, and each set has a sign pattern that suggests a maximum. According to our estimates, a 3,810-square-inch painting maximizes value, and the average artist sees the value of his work maximized at slightly over age forty-one. The coefficient on the dummy for medium is also statistically significant at the 0.01 level and suggests about a 70 percent premium, *ceteris paribus*, for a work in oil.[26] Thirteen of the artist dummies are positive, ten of which are statistically significant at the 0.05 level, and five are negative, two of which are statistically significant at the 0.05 level. All seasonal dummies are statistically significant, with the premium for spring sales being the greatest.

The coefficient of most interest, however, is the estimated growth rate, given by the coefficient on the trend variable. The daily growth rate in the value of art, statistically significant at the 0.05 level, in our sample is 0.0000617, which annualizes to $[(1.0000617)^{365} - 1] = 0.0228$, or about 2.3 percent per year

in nominal terms. While seemingly a bit low, this estimate is in fact quite reasonable when compared to other American art-return estimates.

Using a different sample of American artists, born before World War II and covering a different time period (1971–1996), Agnello (2002: 460) estimates a nominal return on American art of 4.2 percent per year. However, a portion of Agnello's sample involves art painted after 1950.

As we noted earlier (and the reason we restricted our sample to pre-1950 paintings), the post-1950 era is characterized by alternative innovative styles and by high (and highly volatile) prices, perhaps due to demand manipulation by art galleries, collectors, and critics. It is thus reasonable to expect higher prices and returns to prevail during this period. If one attributes a moderate amount of the return difference to post-1950 demand manipulation, say 30–40 percent, then the return estimates would be quite close.

Since we are interested in the characteristics of art as an investment, a reasonable question is "What is the opportunity cost of buying and holding art?" If, as many finance experts suggest, we use the return on the Standard & Poor's stock-price index as a measure of return on the market portfolio, we find that the average yearly return over the 1987–2011 period is 9.1 percent per year. Comparing this return to our estimate of return on early American art, we see that an investor could roughly quadruple his money by putting it into the market portfolio rather than into the "average" painting in our sample.

The result that art is a poor financial investment is neither new nor surprising. People buy art for many reasons; its investment aspects are likely low in the hierarchy of these reasons. However, the investment performance of art may be worse than our hedonic estimates lead us to believe. The reason is that our hedonic model ignores "bought-ins," paintings that are offered for sale but do not meet the seller's reservation price and hence go unsold. To our knowledge, "bought-ins" are simply ignored in studies of art returns, hedonic or otherwise. This is unfortunate, since their exclusion results in sample-selection bias. Heckman (1979) describes a method of dealing with that problem: one estimates a probit model explaining whether a painting is included in the sample—sold, in this case—as a function of some known characteristics of the painting. One then uses the result to create an inverse Mills ratio (IMR). Including the IMR in the original regression as an additional explanatory variable corrects for sample-selection bias and provides consistent coefficient estimates.

Our sample includes all paintings by the selected artists offered for sale multiple times in the period 1987–2011, both those that sold and those that did not, for a total of 605 auction offerings. We used these data to estimate the probability of the painting being sold (i.e., included in the sample) as a

function of the auction house experts' high and low estimates of value of the painting, the artist dummies, the season dummies, and the trend variable. The core of correcting for sample-selection bias lies in correctly predicting which observations will be included in the sample—that is, which paintings sold in this case. Our probit model correctly predicted over 91 percent of the sales, indicating that it was reasonably reliable for the purpose at hand. We then used the predicted Z values from this probit to create an IMR and included it in the original model (365 observations). The results are presented in column 3 of Appendix Table 5A.1, labeled model II.

The magnitude and significance of the characteristics (SIZE, $SIZE^2$, AGE, AGE^2, and DMED) coefficient estimates remain substantially unaltered. As for the artist dummies, some that were insignificant became significant (e.g., Shinn, Weber, and Stella) and conversely (e.g., O'Keeffe); one switched signs but remained insignificant (Robinson). It is fair to say that up to this point, the results have not been substantively affected by the sample-selection correction; however, the remaining results, all dealing with some element of time, are definitely affected. The seasonal dummies become negative, two are insignificant, and one is marginally significant at the 0.05 level. *Most important, the trend variable becomes negative and significant; its coefficient estimate is −0.0000744, which translates to **a yearly growth rate of −2.7 percent**.* (Note that this is a conservative estimate of the potential loss.) We noted the intuitive result that ignoring no-sales should result in an overstatement of the return growth rate. In this case, it apparently resulted in a roughly 5 percent overstatement, turning the growth rate from positive to negative. At the minimum, this result suggests that hedonic return estimates that ignore no-sales should be viewed with extreme caution.

Finally, note that the IMR is positive and statistically significant at any reasonable level, so increases in the IMR increase painting prices. While not immediately obvious, a little reflection provides a sound intuitive rationale for this finding. Increases in the Z values predicted from the probit model imply increases in the probability of the auction offer being included in the sample—that is, increases in the probability of a painting being sold. However, increases in the Z values also imply increases in the IMR, so that increases in the probability of a painting selling are associated with increases in the IMR. If increases in the probability of a painting selling are taken to mean increases in the painting's marketability, then the IMR result simply means that the more marketable paintings receive higher prices—a finding that is very appealing to common sense.

The results found so far refer to return as measured in the rate of growth in the premium price of art. This is certainly a legitimate approach, and one

that is used in several previous studies of art returns—for example, Mei and Moses (2002, 2005). However, it results in an overstatement of return because it ignores the deleterious effects on return of not receiving the buyer's premium and having to pay a seller's premium when the asset (painting) is sold. An alternative, and equally legitimate, means of measuring return is to consider the rate of growth in the hammer price of art. This approach also has shortcomings as a measure of return growth, perhaps more so than using premium prices, because it produces errors on both ends of the investment-return calculation; that is, it ignores having to pay a buyer's premium when the painting is purchased (which affects both the numerator and denominator of the return calculation) and also having to pay a seller's premium when the painting is sold. Nevertheless, this approach has been used by Agnello (2002) and Agnello and Pierce (1996).[27] Thus an obvious question arises as to the robustness of our estimates with respect to the specification of the "price" of a painting—premium versus hammer.

Consequently, we re-estimated models I and II of Appendix Table 5A.1 using the (natural) logarithm of hammer price as the dependent variable in lieu of the (natural) logarithm of premium price. The results, without and with the sample-selection correction, are presented in columns 4 (model III) and 5 (model IV), respectively. Comparing the corresponding results of model I with model III and model II with model IV shows a remarkable similarity in the coefficient estimates and their statistical significance. That is, the coefficients and *t*-statistics on the painting and artist characteristics and on the seasonal dummies are nearly identical in models I and III and in models II and IV. Indeed, the only coefficients showing a marked difference between the corresponding models are the growth-rate estimates. Without correcting for sample-selection bias, the daily growth rate falls by about a third, from 0.0000617 in the premium-price case to 0.0000475 in the hammer-price case. More meaningfully, hammer prices increased at a 1.75 percent annual rate compared to the previously noted 2.3 percent increase for premium prices. We note two points regarding this difference. First, the smaller growth rate in hammer prices should be expected. The difference between premium and hammer prices is the buyer's premium, and the buyer's premium, expressed as a percentage of hammer price, increased by about eight percentage points, which amounts to an 80 percent increase, over the sample entire period.[28] Thus, a bit less than one-third (about 31 percent) of the increases in premium prices can be attributed to increases in buyer's premium. Second, given the prices paid for the paintings in our sample, there is literally no chance that the seller could receive any portion of the buyer's premium as an inducement to sell. Thus it is reasonable to conclude that our premium-price results

overstate nominal returns on the art in our sample by about one-third, and that factor is conservative.

Finally, note that the hammer-price estimates, when corrected for excluding no-sales, estimate an even greater negative nominal return than did the premium-price estimates. In this case, the estimated daily growth rate was a statistically significant (at the 0.05 level) value of −0.0000908, which translates to about −3.26 percent per year. Thus it seems clear that ignoring no-sales accounts for the positive return on art, at least in our sample. Interestingly, however, correcting for no-sales has almost exactly the same effect on estimated return, regardless of whether we use premium or hammer prices. In both cases, returns drop by about 0.00014 percent per day, or slightly over 5 percent per year. To make matters worse, recall that these results refer to nominal returns. If we factor in a 2.7 percent average inflation rate over the period, the holder of the average painting in our sample could expect, at best, to break even and more likely would lose about 6 percent in real terms.

Although the hedonic models considered so far fail to address the appropriate price variable, the results presented in Appendix Table 5A.1 are still interesting and important because they permit direct comparison with previous research on art investment returns. We firmly believe that any model concerned with the demand for art ought to employ premium price as the appropriate price measure because that is what the buyer pays to purchase the painting; additionally, Mei and Moses apparently use premium prices to compute investment return on art. Similarly hedonic models of hammer prices allow an "apples to apples" comparison with the investment-return estimates of Agnello (2002) and Agnello and Pierce (1996). More important, these comparisons allow us to get some feel for the potential impact of ignoring no-sales. However, our discussion of the incorporation of transactions costs into return estimates in the previous section suggests a (set of) price measure(s) that may be more appropriate for potentially accurately assessing investment returns to art. We can include the buyer's premium in our price measure by valuing the price of the painting the first time it is sold in our sample at the premium price and by valuing it for each subsequent sale at the hammer price. Call this price measure RP. Moreover, we can incorporate seller's premiums by measuring price as some percentage (say, m) of hammer price after the first sale. Appendix Table 5A.2 presents estimates of the same hedonic specifications as in Table 5A.1, except that for models V and VI, price is defined to include a buyer's premium for the first time the painting appears in the sample, but no seller's premium, so that subsequent appearances of the painting are valued at the hammer price; and for models VII and VIII, price is defined to include a buyer's premium for the first time the painting appears in the sample, and a

seller's premium of 10 percent, so that after the first appearance of the painting in the sample, it is valued at 90 percent of the hammer price. The estimates of the full hedonic model of early American artists for both premium and hammer prices, with and without sample selection correction, which also account for transaction costs (buyer's and seller's premiums) can be found in Table 5A.2 in the Appendices. The results and implications of these estimates are discussed in the following.

Comparing the coefficient estimates in Tables 5A.1 and 5A.2 reveals a surprising robustness of the hedonic price estimates on the painting characteristics, artist dummies, and seasonal variables. If there is a general statistical comparison between the two tables worth noting, it is that, except for a few artist dummies, the *t*-statistics in Table 5A.2 are smaller than their corresponding values in Table 5A.1. Even so, generally speaking, the coefficients that were statistically significant in Table 5A.1 are also statistically significant in Table 5A.2; likewise, those that were insignificant in Table 5A.1 are also insignificant in Table 5A.2. Since the behavioral implications of these results have been previously examined, we will eschew further treatment here.

The key results for comparison between the two tables relate to the investment-return estimates. In Table 5A.2 we find that daily return, ignoring seller's premium, is 0.000049, and incorporating a 10 percent seller's premium is 0.000043.[29] These estimates translate into yearly returns of 1.8 percent and 1.57 percent, respectively. The yearly return estimate for model V (1.8 percent) is a bit below that of model I (2.3 percent) but quite close to that of model III (1.75 percent), indicating that incorporating buyer's premiums may yield a lower return estimate than that based on premium prices alone, but that using hammer prices alone may potentially understate return, *ceteris paribus*. However, if we also allow for a seller's premium of 10 percent of the hammer price, return falls to 1.57 percent, markedly smaller than any of the uncorrected estimates. Correcting for sample-selection bias appears to drop the daily trend coefficients in both models by about 0.000135. In fact, the daily trend coefficients in models VI and VIII translate to yearly growth rates of −3.11 and −3.29, respectively. Based on these results, our previous conclusions of a small nominal 2 percent return on art purchases as a maximum and a potential 3.3 percent decline in return on art purchases after correcting for no-sales seems justified, although both magnitude and direction require further investigation with different data and other models before acceptance of these conjectures is warranted.

Investment-Return Estimates for Contemporary Art

Conventional wisdom and recent record price experiences would seem to suggest that returns on American-based Contemporary art would be much higher than those for American art produced earlier than 1950. After all, as noted in Chapter 1 of this book, America has apparently "stolen" the art market from Europe in the postwar period with an exponential flow of "innovations," springing somewhat from the abstract-expressionist movement of the 1940s and 1950s producing higher returns. Here we examine the artists of Table 5.3 to attempt to understand if this is the case.

While increased artistic innovation is a sound cultural reason to analyze Contemporary American art separately from early American art, there are

Table 5.3 Forty-seven American Artists Born Post-1900

Artist	Life Span	Artist	Life Span
Philip Evergood	1901–1973	Robert Rauschenberg	1925–2008
Mark Rothko	1903–1970	Wolf Kahn	1927–
Hans Burkhardt	1904–1994	Alex Katz	1927–
Fairfield Porter	1907–1975	Helen Frankenthaler	1928–2011
Millard Sheets	1907–1989	Robert Indiana	1928–
Norman Lewis	1909–1979	Nathan Oliveira	1928–2010
Franz Kline	1910–1962	Cy Twombly	1928–2011
Romare Bearden	1911–1988	Claes Oldenburg	1929–
William Baziotes	1912–1963	Jasper Johns	1930–
Ida Kohlmeyer	1912–1963	Sam Gilliam	1933–
Agnes Martin	1912–2004	James Rosenquist	1933–
Jackson Pollock	1912–1956	Jim Dine	1935–
Philip Guston	1913–1980	Frank Stella	1936–
Ad Reinhardt	1913–1967	Red Grooms	1937–
Robert Motherwell	1915–1991	Larry Poons	1937–
Milton Resnick	1917–2004	Brice Marden	1938–
Andrew Wyeth	1917–2009	Bruce Nauman	1941–
Wayne Thiebaud	1920–	Susan Rothenberg	1945–
Richard Diebenkorn	1922–1993	Eric Fischl	1948–
Ellsworth Kelly	1923–2015	Julian Schnabel	1951–
Roy Lichtenstein	1923–1997	David Salle	1952–
Larry Rivers	1923–2002	Kenny Scharf	1958–
Kenneth Noland	1924–2010	Jean-Michel Basquiat	1960–1988
Joan Mitchell	1925–1992		

Note: This table was current as of 2013.

economic reasons to do so as well. We have noted earlier that 1950 marked the onset of pronounced demand manipulation by art dealers and so on. But from an investment perspective, an even more important reason to look at the two markets separately is the difference in the amount of trading. We will discuss our paired-offer sample of Contemporary art in detail momentarily, but for now note that while our Contemporary sample contains only 50 percent more artists, it contains data on five times as many paintings, two-and-a-half times as many offers, three times as many sales on second offers (used as the hedonic sample), and six times as many repeat sales as our early American sample. Since this increased trading activity can, by itself, lead to considerably different investment returns, we would be remiss if we pooled the samples.

Data Considerations in Our Analysis of Contemporary American Art

The data set on askART.com had data on the forty-seven well-known American artists listed in Table 5.3, who were born after 1900, who painted primarily after 1950, and whose paintings were offered at auction between 1987 and 2013. Of these artists, forty-six had paintings that were offered and/or sold multiple times during that period. The sample thus contained data on 1,381 paintings, 687 of which actually sold multiple times. As before, however, our unit of observation is neither painting nor artist; it is an offer at auction. The 1,381 paintings were offered at auction 3,010 times—1,505 paired offerings—during the sample period. Most of the paintings were offered for sale only twice (1,208 paintings, 2,416 offerings), but 130 were offered three times (390 offerings), 29 were offered four times (116 offerings), and 17 were offered more than four times (88 offerings).

The entire set of 1,505 paired offerings formed the basis of our hedonic sample. We collected data on the same variables as we employed in our prior early American analysis.[30] As also noted there, of the 1,505 paired sales, 1,084 resulted in second-offer sales. These 1,084 sales constituted the sample used to estimate our hedonic model. However, we employ the full 1,505 sample to estimate the probit model from which we compute the IMR to analyze the effect of no-sales. Only 1,084 of those ratios were employed to estimate our hedonic model.

The unit of observation in our repeat-sales analysis is a paired set of exchanges on a painting. After deleting no-sales in both the first and second offerings, we arrived at a set of 687 paintings that were sold multiple times during the sample period. We then deleted all paired sales having a holding period less than thirty days to arrive at our sample of 641 repeat sales. We

make this final deletion for two reasons: First, it eliminates return aberrations resulting from speculators attempting to "flip" a painting. It also makes sense to eliminate the holding period of the first thirty days since, while buyers make an immediate commitment, they are also given the usual "grace period" of thirty days by the auction house to pay for their purchases.

Hedonic Results for Contemporary Artists

The estimates of the full hedonic model of Contemporary American artists for both premium and hammer prices, with and without sample selection correction, can be found in Appendix Table 5A.3. The results and implications of these estimates are discussed in the following. As can be seen, the models' specifications are basically the same, except for the number of artist dummies, as that employed in Table 5A.1. A perusal of Table 5A.3 indicates that, as in Table 5A.1, the estimated coefficients and their statistical significance are remarkably similar across corresponding specifications. Also, as with the early American art hedonic, the SIZE and SIZE2 coefficients are highly statistically significant and have a sign pattern indicating a value-maximizing size. In this case, that size is about 12,500 square inches, over ten times the sample mean. As in the early American art case, we conclude that the typical contemporary painting's value tends to increase at a decreasing rate with increased size. But here the similarity with our early American results ends. The AGE and AGE2 coefficients are both statistically significant but exhibit a sign pattern implying a *value-minimizing age*. Depending on the model specification, art value tends to reach a minimum for contemporary artists between ages fifty-five and sixty. We saw similar results for contemporary artists in our hedonics in Chapter 4. Perhaps, in Galenson's parlance, contemporary artists begin as innovators and switch to experimentalists later in their career. Alternatively, since the minimum comes at such a late age, it may be that the later rise in price is in anticipation of the artist's imminent retirement or death. More will be said on this possibility in Chapter 7. In any event, this age effect appears to be real, not anomalous, for the contemporary artists in our paired-offer sample. There is a premium for contemporary oil paintings, but it is only a little over half the size found in the early American case—56–60 percent as compared to 90–100 percent. As we did with the early American artists, we conducted a prefatory analysis of average prices among artists. Apparently the artists in our contemporary sample are considerably more homogeneous than our early American artists. In the early American case, the average prices of eighteen artists differed significantly from the base artist (Inness); in the contemporary case, only four artists had average prices that differed significantly

from the base artist (in this case, Basquiat was arbitrarily chosen as the base artist). As can be seen from Table 5.5, Rothko, Pollock, and Johns had average (log) prices significantly higher than Basquiat's, and only Schnabel had significantly lower average prices, at least based on our paired-offer sample. Regarding the auctions' seasonal effects, average prices received at auction do not differ significantly between winter and summer, the base season. Spring auctions garner higher prices than summer, at the 5 percent level, and fall auctions receive higher prices at the 10 percent level. These seasonal and artist inferences hold regardless of specification.

From an investment perspective, the key hedonic results arise from the estimated rates of return, read from the trend coefficients. These daily returns can be converted to yearly returns by taking one plus the trend coefficient to the 365th power and subtracting one from the result. Doing this yields roughly a 9.8 percent annual return based on premium price and a 9.3 percent return based on hammer price.[31] None of these rates is negative, and all are considerably higher than their early American counterparts. Finally, note that the IMR correction for no-sales is negative and statistically significant for both the premium- and hammer-price models.[32] Because it is negative, rather than positive as was the case for the early American results, it tends to slightly increase the estimated rates of return in the corresponding models. It is certainly not the case that including the IMR results in negative returns for contemporary art, at least in our paired-offer sample.

The implications of contemporary American art as an investment are quite different from those of the early American counterpart. As we found earlier, the Standard & Poor's 500 stock market index exhibited about a 9 percent per-year return over the sample period. Based on the 9.3–9.8 percent average yearly returns estimated earlier for contemporary American art, that genre appears to markedly outperform its early American counterpart as an investment vehicle. Indeed, it may slightly outperform the market. Thus, although it is riskier (has a higher variance) than the market portfolio (S&P 500), it may still be an attractive investment vehicle, at least from an average-return perspective. It goes without saying that this inference runs counter to much of the conventional wisdom regarding art as an investment.

Repeat-Sales Results

The rates of return computed from our hedonic estimates are instantaneous rates (i.e., computed as $[(\partial P/P)/\partial t]$) and may be misleading for longer holding periods. Furthermore, the hedonic return estimates either ignore buyer's and seller's premiums (the premium-price case) or treat buyer's premium as a

cost on both ends of the transaction, buying and selling the painting, which is technically incorrect. Thus, to inquire further into the properties of contemporary American art as an investment, we employ our sample of 641 paired sales, to compute discrete rates of return, considering the appropriate buyer's premium, positing alternative sellers' premiums, and employing the actual holding period for each paired sale. The results of this analysis are presented in Table 5.4. The computations are based on equation (5.9) and an appropriately modified version of equation (5.5) and assume that the buyer pays the premium price when he purchases the painting (first sale) and receives some portion of the hammer price (due to paying the seller's premium) when he sells the painting (second sale). As with our corresponding early American analysis, the first row of the table assumes a seller's premium of 20 percent of the hammer price; the second row, 10 percent; the third row, 5 percent; the fourth row, no seller's premium; the fifth and sixth rows assume a rebate of 5 percent and 10 percent, respectively, of hammer price to the seller at the second sale; the seventh row assumes no buyer's or seller's premium is paid at either end of the paired sale; and the eighth row computes the return on the S&P 500, assuming the market portfolio was bought for the same amount and at the same time as the painting and was sold at the same time the painting sold (that is, it is the opportunity cost of buying the painting).

The first impression one gets from perusal of Table 5.4 is that these estimated rates of return are huge. Even assuming an unlikely event of paying a 20 percent seller's premium, the implied yearly rate of return is about 20 percent higher than those estimated for contemporary American art in our hedonic analysis and truly dwarfs our corresponding early American art estimates of Table 5.2. As we will argue in the following, however, these are likely reliable return estimates and are certainly not out of line with the findings of others regarding returns on modern and contemporary art.

Table 5.4 suggests the following inferences:

1. The difference between yearly return estimates from assuming an appropriate buyer's premium and a 20 percent seller's premium and alternatively assuming that neither a buyer's premium nor a seller's premium is paid, à la Mei and Moses, is about fourfold (11.6 percent to 44.4 percent, respectively). Thus our earlier inferences regarding the hazards of ignoring buyer's and/or seller's premium when computing returns are still relevant, even in the Contemporary art case.
2. The yearly return on the S&P 500 index is 8.6 percent, very close to the 8.76 percent found in the early American case, even though the holding period and the years covered by the samples differ. Thus, every one of

Table 5.4 Returns Computed from Repeat Sales: Contemporary American Art

Price Received by Seller	Arithmetic Mean		
	Mean Daily Return	Standard Deviation	Annualized Rate of Return
0.80HP	0.000301	0.0021	11.6%
0.90HP	0.000489	0.0023	19.5%
0.95HP	0.000583	0.0024	23.7%
HP	0.000677	0.0026	28%
1.05HP	0.000772	0.0027	32.5%
1.1HP	0.000960	0.00296	41.9%
PP	0.001007	0.0030	44.4%
S&P 500	0.000227	0.00034	8.6%

the art-market scenarios in the table is consistent with an above-market-portfolio rate of return on art as investment.

3. As noted earlier, the most likely scenario is that the seller pays a premium of 5–10 percent of the hammer price when she sells. Thus, in this typical case, one could expect a yearly investment return on contemporary American art of about two to three times that of the market portfolio.

4. The yearly return assuming no seller's premium is paid is 28 percent, and assuming that neither buyer's nor seller's premium is paid is 44 percent. Since painting prices are considerably higher in our Contemporary art sample, these scenarios may well be more relevant than they were in the early American art case.

These inferences, as well as our hedonic results, suggest that contemporary American art is a profitable and attractive financial investment, aside from any utility gains from possessing a magnificent piece of art. A caveat is in order, however. Table 5.4 also indicates that the risk (as measured by the standard deviation/variance of return) of holding American art is about seven to ten times as great as that acquired in holding the market portfolio. Since none of the estimated art returns in Table 5.4 is seven to ten times as great as the return on the market portfolio, contemporary American art may not be such an attractive investment on a risk-adjusted basis. Nevertheless, the result that it is an attractive investment based on average yearly return contravenes much of the conventional wisdom regarding art as an investment.

Early American versus Contemporary American Art: Two Distinct Markets

The results from both our hedonic and resale approaches are revealing from a number of important perspectives. First, it is quite clear, as we have hypothesized in part from the evolution of art marketing, early American art (pre-1950 or so) and Contemporary American art (post-1950) are two distinct markets. The returns we have calculated, with due caveats for the artists selected and the period studied, are dramatically different. As noted earlier, the calculated returns between these two cohorts is approximately 12 percent in the hedonic results. This result by itself indicates that early and Contemporary art are *different* markets. This result is strongly buttressed by the RSR results. If we use hammer price, the difference in return between early and Contemporary American art using resale data is *triple* for Contemporary art. Paired-sales results are not an anomaly. For example, using the latter calculation, that difference is 15 percent versus 44 percent. If the buyer's premium is added, the difference is 3 percent return for early American art versus 28 percent for Contemporary art. These huge differences most certainly do not violate common sense, as the world has watched soaring sales of Contemporary art for the last two-plus decades.

Data as well as conventional wisdom validate the differences we found with our sample. James Tarmy, writing for *Bloomberg News* (2014) calculated the (total) auction sales of the top ten living artists in 1993 and 2003, following their sales through 2013 (and of course the recession of 2008). Tarmy expected to find booms and busts, but he did not. Of the top ten living artists in 2003 (six of whom were American), here is what he found: "Total sales for every one of these artists grew. For eight out of 10, the increase was more than 200 percent in a decade" (Tarmy 2014). As further evidence, Tarmy went back to 1993 to find the top ten earners that year (five of whom were American) and looked at their returns in the 1993–2013 period. Sales went up for four of the ten by more than 2,700 percent. While this is a "broad stroke" calculation (total sales, not median price), it suggests that, at least for those in the highest echelon of art in the Contemporary period, Contemporary art at the highest levels is a spectacular investment, at least in the short run. These results and our own also suggest that multimillionaire and billionaire collectors are driving that market. What is it to one of these individuals if the S&P 500 or GDP falls? Whether these prices are sustainable (or will grow) over the very long run is naturally an open question, and taste change has created dramatic cycles before. For the present, anecdotal and statistical evidence such as that presented in this chapter reveals a clear dominance for modern and Contemporary American art.

Investment in American Art

This chapter, employing a new and specific sample of American artists, investigated investment returns using both hedonic and resale estimation techniques for both early and Contemporary American art. One lacuna in other studies is that they do not take no-sales (or "bought-ins") into account when assessing returns. We find that the exclusion of paintings that do not sell creates sample-selection bias that can inflate investment-return rates. Our hedonic results suggest that early American art might engender a small positive nominal return if we ignore no-sales, but that return falls to –3.3 percent when we attempt to account for the inherent sample-selection bias in ignoring no-sales. Hedonic returns for Contemporary American art tell a very different story. Returns of 9 to 10 percent apply to art produced after 1950, supporting the perceived boom in Contemporary art with about a 12 percent difference in return when buyers' premiums are factored into that percentage. (It is always important to remember that these estimates—which might seem a bit high—are taken from a specific sample and over a specific time period. Others samples and time periods might yield different results).[33]

Most important, unlike other studies, we analyzed the impact of transactions costs—buyer's and seller's premiums—on art-investment returns in a sample of artists over a specific sample period. The impacts of those costs are assessed under different assumptions regarding the amount of the effective seller's premiums as a percentage of hammer price. We find that if sellers pay a 5 percent premium at auction, their returns are slightly lower those found in our hedonic study. Under other scenarios, with higher sellers' premiums, returns would be negative for early American art. Both hedonic and repeat-sale approaches agree: the impact of including buyer's and seller's premiums in art investments is to lower returns, possibly making them negative in the case of pre-1950 American art and of a lower percentage with Contemporary (post-1950) art.

The fact that inclusion of transactions cost to buyers and sellers of art reduces return in some genres and over some periods return may not be terribly surprising, although it clearly alters returns in a non-trivial manner that has not been recognized.[34] Importantly, other costs *and benefits* alter return. Holding art is costly in a number of dimensions. Art must be insured against theft and fire. Deterioration is inevitable, especially for works on paper. Restoration can be expensive. Most important, on the benefits side, art yields consumption utility or "psychic income." Our results, using the most plausible assumptions, demonstrate that when transactions costs and other factors are included, the consumption return must be higher than previously thought

for the artworks in our sample. Investment returns equilibrate in competitive markets, meaning that with lower (or possibly negative) investment returns, the utility produced by pre-1950 American paintings and Contemporary art must be higher. Mandel (2009) captures psychic returns, which he links to Veblen's "conspicuous consumption," by succinctly reconciling the explosive art market with the low rates of return found in many studies, including our own. He notes (2009: 1662), "Financial returns are low since they tell only part of the story: the price of art reflects not only the desire to smooth consumption over time as for any investment vehicle, but also the utility derived from its conspicuous consumption. The utility dividend in turn endogenously moderates the level of art returns. While the cyclicality and variance of artwork returns are similar to those of equity—they are both driven by the stochastic endowment process—art investors need to be compensated by less in financial terms for the risks they are incurring." These psychic returns must be higher when transactions costs are included.[35]

Important caveats concerning our results are in order. We must emphasize that our findings pertain only to our sample of American artists over our sample period, although there is plentiful anecdotal and statistical evidence from our investigation that early and Contemporary art are distinct markets. Results may change significantly for tests using other painters over this and other time periods. Moreover, the comparison of transactions costs in all investments must be made when assessing the returns to holding art. *All* assets carry transactions costs wherein brokers and auction houses skim off potential returns, lowering the possibility of "flipping" assets unless assets are held over a long period.[36] But our findings show that, for our sample period and for the artists sampled, previous calculations of art investment returns have been biased upward by the exclusion of no-sales and by the exclusion of transaction costs to buyers and sellers.

Chapter 6

American Art and Illegal Activity

AN ECONOMIC PERSPECTIVE

ART THEFT AND the faking of a piece of art differ in numerous respects. Faking art that has already been produced (a replication fake) and producing a work that might be in a style by the artist (a forgery, sometimes called a pastiche) are also different. Exchange is "forced" in the case of theft, for one thing, and it is "voluntary" in the case of fakes. But there are commonalities as well. If art did not carry a private value—a desire to possess art that exceeds its supply—neither theft nor fakes nor forgeries would materialize. Both theft and forgery, or illegal reproduction, are the source of real resource expenditures or dissipations. Artists are affected. Museums, galleries, and collectors are affected. Art consumers are affected. Art thieves and fakers must invest real resources to carry out nefarious activities. And art crime grows, according to most estimates, by 10 percent in value terms a year. Art theft alone is, by most estimates, regarded as the third-largest criminal enterprise in the world. It is also highly successful, with estimates that only 5–10 percent of the 50,000–100,000 works stolen each year are recovered. More alarming, perhaps, in the midst of astonishing increases in the price of art, we hear that art (legally or illegally obtained) is "money" in the drug and other nefarious trades that use it as "collateral" in criminal activity.

This chapter presents an economic characterization of theft and fakery in the art world generally and with respect to American art specifically.[1] We consider a common thread in these two activities, concepts we have met before in this book—credence and information costs. An evaluation of an economic theory of theft as applied to art and the potential costs and benefits to thieves and to those who could be victims of art theft is conducted with evaluation of the status of the illegal market today. Next, the issue of fakery and forms of fakery take center stage, and art fraud is analyzed as an economic issue. An

elaboration of and characterization of the economic and legal consequences of theft and fakery in the contemporary illegal art market conclude the chapter. We also emphasize the role of stolen and faked art in many kinds of criminal activity, including money laundering.

Credence and Information Costs

A museum trip brings much to the viewer. Art, at its best, has the power to change lives. It may be art of many different varieties that we are attracted to. We may find inspiration, invention, ideas, or simply beauty in looking at paintings, sculpture, and other media. The art may be medieval, impressionist, modern, very contemporary, folk, and any of dozens of other genres. We may pause and ponder long before a Gauguin oil of the Breton countryside or before a color-field painting by Mark Rothko. We may be prostrate at the beauty of a Rembrandt portrait or a medieval Madonna. But, although shocking, no less an authority than a former director of the Metropolitan Museum of Art, the late Thomas Hoving, as we have noted elsewhere in this book, has estimated that as many as 30 to 40 percent of paintings in American *museums* are fakes!

There is no easy way to determine whether Hoving's statement is correct or not, but it is a fact that art (as all products) requires an element of credence that the painting is a work by the nominal signer and that it is "genuine" in every respect. The art market is filled with credence and information issues: credence in the seller; credence in the "expert"; credence in the authenticity of the object sold. There is also credence that artists themselves will not produce paintings identical to those they have already sold, although that has been a practice in the past.[2] Where multiples such as prints or woodcuts are concerned, a "limited-edition print" usually means that the plate, woodblock, linoleum cut, and so on, will be destroyed or rendered unusable after the advertised number of images has been produced.[3]

When attending a museum or attending an exhibit, we in effect put credence that the item represented is genuine, that it is what the museum label or curator says that it is. When buying a painting, unless we are unscrupulous or crooked, we not only want some indication of authenticity, we also want to know whether the item is stolen and whether we are being duped into purchasing a work that does not carry a clear title. And clear title depends on the legal rules in particular locales. Generally, in Anglo-Saxon law, as in the United States and England, purchase of a stolen work, whether the purchaser knows it is stolen or not, leaves the purchaser liable for the object's return. In Latin, the maxim *Nemo dat quod non habet* (no one is able to give what they do

not have) applies. In countries that practice civil law, however, the purchaser under such circumstances has a greater claim than the original owner. That includes a number of European countries and Japan, for example. Statutes of limitations on prosecution in various jurisdictions also vary, putting more uncertainty into the mix.

These issues underline the importance of information cost on the part of museums, collectors, and all transactors. The provenance—or the history of the chain of ownership from artist to the current owner-seller (as we have noted before)—helps provide credence to a buyer. As we discussed in Chapter 2, auction-house experts and other sellers are charged with determining the authenticity of a work (often through its provenance) to some extent. This determination, be it by auction house prior to sale or by the buyer-collector, carries costs—information costs concerning the artistic item. Provenance to works can be faked (Hoving 1996; Salisbury and Sujo 2009), however. Paintings can be faked or forged, either to represent an existing painting or a "new" painting by an artist, preferably by a dead artist to help avoid detection. Thus enters an information cost to all buyers of art and sellers of art seeking to *establish credence*. The emergence of experts and other means relating to particular kinds of art, to particular pieces of art, or to particular artists has long accompanied trade in art. Appeal to such experts or other forms of authentication on the part of buyers seeking information, however, is costly. Institutions and services of all kinds have emerged to provide information on these credence goods. The issues of credence and information cost thus riddle the market for all art, including American art. To better understand how these economic ideas inform the art market, we consider admittedly unsavory aspects of the market—theft, fakes, and forgery.

Art Theft

Art theft is estimated, at a minimum, to constitute $6–10 billion of black market transactions per year, an astonishing amount when one considers the value of all theft.[4] The greatest art theft in history—now amounting to perhaps $0.5–$1 billion or more in paintings—took place in the United States.[5] On the evening of St. Patrick's Day on March 18, 1990, thieves disguised as police gained admittance to the Isabella Stewart Gardner Museum in Boston, stealing thirteen pieces of art, including a Vermeer, two Rembrandts, a Manet, and drawings by Degas, plus other works. The works, despite a continuing $5 million reward, remain missing.[6] While there has been a massive effort to recover these works, art theft (generally constituted of paintings worth $10,000 or less) is not at all surprising when one considers that the

probability of being caught as an art thief is extremely low (some estimates put it at 10 percent or less), and, in general, punishments for such crimes have been low historically. Credence, information cost, and economics are at the base of this phenomenon that makes art theft one of the most popular illegal activities in the world.

Two aspects of this phenomenon must be considered in analyzing art theft in the United States and elsewhere: (1) art theft is usually an economic calculation; (2) art theft requires explicit or implicit cooperation between illegal and legal markets. First consider the pure economics of art theft. Economists argue that, whether we consciously realize it or not, our activities or actions are guided by calculations of cost and benefit. An afternoon golf game might seem appealing. It would, on the one hand, bring us pleasure, utility or "benefits," but it would cost us time off from work or forgoing some other activity. We must give up the real resources that could be produced in the afternoon doing whatever has the most monetary or real benefits to us. There is an opportunity cost to the time given up—it may be woodworking, napping, practicing the piano, or working at our job, whatever is highest value. We will, in economic jargon, take afternoons off to play golf until the additional or marginal value of one more afternoon off just equals the additional or marginal cost in terms or money or psychic value (utility) of what we give up. The same basic calculation takes place in all cases, including theft and fakery of art or anything else.

Economists began to apply a "marginal calculation," such as described in the preceding, to illegal activities in the 1970s (Becker 1968; Becker and Stigler 1974; Ehrlich 1973), although such calculations had been suggested early in the nineteenth century by social reformer Edwin Chadwick (Ekelund and Price 2012; Hèbert 1977). The essence of the idea is simple. A thief will act rationally, just as our golf enthusiast. He or she will maximize the value of criminal activity by continuing to commit these acts until the marginal cost of the criminal act equals the marginal benefits of the act. Specifically,[7]

$$\text{Marginal Benefit}_{\text{Criminal Act}} = \text{MarginalCost}_{\text{Criminal Act}}$$
or (6.1)
$$
\begin{aligned}
\text{Marginal Benefit}_{\text{Property Crime}} = \ & \text{Probability (Apprehension)} \\
& \times \text{(Cost of Apprehension)} \\
& + \text{Probability (Conviction | Apprehension)} \\
& \times \text{(Cost of Conviction)} \\
& + \text{Probability (Punishment [including severity]} \\
& \quad | \text{ Conviction)} \times \text{(Cost of Punishment)}
\end{aligned}
$$

In plainer words, theft takes place up to the point where the additional cost of the next caper is equal to the additional benefit to the thief. Note that when the *marginal or additional* benefits of theft exceed the *marginal or additional* cost, criminal activity will continue, and when the marginal cost exceeds the marginal benefits, criminal acts will be reduced. This is not an either/or proposition. The rational thief will equalize these values in order to maximize his or her benefits. The key for *public policy* is to identify and analyze the institutional changes that would alter marginal incentives of perpetrators (thieves). The *marginal costs* to a thief of a contemplated robbery are summarized in the preceding equality, where the additional costs of an art theft would be equal to the sum of the probabilities of being apprehended and convicted—and the anticipated severity of the punishment for the crime. Note that for a thief, costs and benefits are "prospective" before the act. The thief will calculate the known or probable monetary rewards from an art theft or any theft (marginal benefit of the theft) and set them against the probable (marginal) costs of the theft. Equation (6.1) reveals, completely apart from the moral issues, that the cost of the theft will be product of the probabilities of apprehension (getting caught) and being tried and convicted of the crime and the punishment for the crime, including how severe the punishment might be.

Art Theft: General Considerations

Consider some general aspects of theft, specifically art theft, before an elaboration on the benefits and cost to art thieves. Note that special provisions, such as an elimination of a statute of limitations, do not apply to the repatriation of art looted by the Nazis during World War II and to objects deemed part of national heritage. We here analyze "ordinary" art theft from personal collections, museums, and galleries.

Art theft can take place under alternative circumstances ranging from an opportunistic event to organized channels—gangs of art thieves and international syndicates that launder money for illegal activities such as drug or arms trading. Generally, and as noted earlier, it is believed that the return to the average garden-variety art thief is only 10 percent or less of the value of work stolen. Kempton Mooney (2002: 22) describes the thief in the following manner:

> Whether the artwork is stolen to collect a reward, to be ransomed, to be sold through a network of dealers, or to be kept as a personal possession, all those who are involved in art theft can be divided into two categories. They either seek to obtain and keep a work of art to possess

or to capitalize on a work by holding it for a short time before sending it elsewhere.

We will see in our discussion that there are many nuances to Mooney's description, but a number of widespread misconceptions must be dispensed with first.

Myth and fact mixed with fiction have built up around art theft (and forgery). Motion pictures, television, and mystery novels find art crime attractive grist for plots. Motion pictures such as *Gambit* (1966 and the remake in 2012) and *The Thomas Crown Affair* (1968 and the remake in 1999) portray art theft and forgery as a game involving forgery, amusement, insurance fraud, and myriad other plot developments.[8] Some mystery novels or movies (*Dr. No*) portray an eccentric wealthy person who establishes for himself or herself a magnificent personal museum of great art—all stolen. But in the case of high-value art, these plot lines are fundamentally fiction.[9] It is not impossible, of course, for drug dealers and others either to use art not so much to assemble a collection as to use as collateral for deals or to launder money by buying art in legitimate or illegitimate fashion (which is thought to be practiced in countries such as China to avoid currency restrictions). In the latter case, one might use an individual or a network of individuals to purchase art legitimately from auction houses or galleries with drug money—cash converted into a bank deposit. The legitimately purchased art—possibly with clear title from auction house or gallery—may then be sold, and the proceeds are the laundered legitimate money. (We discuss this intriguing possibility later in this chapter.) But much of the ballyhoo surrounding the "glamour" of art theft is farfetched. The vision of a wealthy art collector surrounded by a personal museum of stolen masterpieces is most unlikely, though not unheard of—much of the utility from possessing art is displaying it for others, and that increases the probability of discovery. Likewise, stolen high-value and well-known art is difficult to sell without discovery. Contemporary stolen-art databases make at least some auction sales exceedingly difficult, and, unless received by purchasers who know the art is stolen or by someone who does not do "due diligence," sale is practically impossible. But within these parameters, approximately $6–$10 billion in art is stolen every year, bested only by drug deals and illicit arms trading.

Marginal Benefits of Art Theft

The marginal benefits from stealing art are prospective in many cases—cases of opportunistic, unplanned ("grab and run"), or poorly planned behavior.

Other cases involve serpentine rings of art thieves with destination or disposition of the stolen property in mind. Generally speaking, the return on the former type of theft is quite low—only 10 or 15 percent, or even much less, of the fair market value of the work. There is, of course, a high transactions cost of finding someone who will pay for the art (not recognizing it as stolen) unless the thief is in some kind of "association" or network of thieves. (Stolen art is in general difficult to fence!) If the work is well known or the robbery well publicized, it is generally not possible to dispose of the work in the aftermath of the robbery. A generation or more must lapse before the work *may* be passable. But it may be becoming somewhat less likely in the case of *well-known, higher-valued* art due to Internet data banks (see discussion later in this chapter) that include historical information. Economists would therefore predict that lesser-known artists and second- and third-rate pieces (or "undiscovered" preparatory drawings for better-known works) would be the object of theft. That is what journalist Joshua Knelman found in his excursion into the world of art theft (2011). In interviews with a well-known art thief (named "Paul"), Knelman (2011: 56–57) found that

> it was easy to make a living from stealing art, according to Paul, if a thief made intelligent choices, if he stayed below a certain value mark—about $100,000. Less was better. Don't steal a van Gogh. To someone who knew how to work the system, the legitimate business of fine art became a giant laundry machine for stolen art. You could steal a piece and sell it back into the system without anyone being the wiser. . . . "It's called 'pass the hot potato,'" Paul told me. "A dealer sells it on to the next dealer, and the next, until nobody knows where it came from. . . . And it is the same wherever you are. . . . Art is something you have to think about as a commodity that goes round in circles. The only time it appears in the open is when someone tries to filter it into the legitimate art market—auctions, art fairs, gallery sales, dealers. Otherwise it's hidden away inside someone's home."

Marginal Costs of Art Theft: Apprehension, Conviction, Severity

Equation (6.1), relating theft to its costs and benefits, it must be noted, refers chiefly to a means for reducing crime from an "equilibrium situation." The system is in equilibrium when, with public enforcement, the marginal costs to property crime are equal to marginal benefits. If some exogenous factor affects either benefits or cost, the rational criminal will engage in more or less

of a particular crime. With respect to art, a mechanism that might increase apprehension or getting caught—new sensor technology that allows the tracking of stolen paintings or new and higher investments in art-theft prevention technology—will increase the probability of apprehension and tend to reduce art theft. Traditionally, however, apprehension has been difficult, especially in the longer run. Many art thefts have been made with (possible) payoffs a generation later, especially for high-valued works.

Examples involving American art are plentiful and instructive. Alfred Stieglitz's gallery in New York City was robbed of three Georgia O'Keeffe paintings in 1946. The paintings, which likely circulated in the black market for years, turned up three decades later as purchases of Princeton University's art gallery. O'Keeffe sued for their return, and, while the statute of limitations had run out on the property, she was successful in their return in a 1979 court case. Most likely the stolen art changed hands a number of times between the theft and its discovery, underlining the serpentine and difficult nature of much art theft. A more recent case involved Alexander Acevedo of the Alexander Gallery in New York City, who believed that he had acquired a portrait by the early nineteenth-century painter John Singleton Copley at a good price at auction ($85,000). But his honesty and due diligence revealed that the painting had been stolen from Harvard University's storage in 1971, and he reported the picture to the FBI. The painting, worth possibly over a million dollars, was returned to the auction house and thence to Harvard University (Wallack 2013). The Copley was purchased in 2006 among items from the Stair Galleries' auction in upstate New York of an estate of one Melvyn Kohn, alias the late William M. V. Kingsland. More than one hundred stolen works included in that estate were brought to light by this purchase, and ownership of the art is still a mystery (Konigsberg 2008).

Conviction and punishment have been difficult because apprehension has been at such a low rate. Art theft is of low priority to law enforcement at all levels. Art theft tends to be romanticized in Hollywood fashion. While not a victimless crime, art theft cannot compete with the violent activity in civilized societies, including the drug wars, the "war on terror," or rape and murder. Moreover, the victims are often seen as from the wealthier classes of society or as covered by insurance companies, themselves often viewed unsympathetically. According to the *Art Newspaper* of England, "the rate of recovery and successful prosecution in cases of art theft is startlingly low, with one expert putting it at only 1.5 percent globally" (Gerlis and Pes 2013). Recovery is higher in Italy, with a Carabinieri force of 350 agents (recovery is 30 percent), but, in the United States, there are only fourteen FBI agents, in England three agents of the Metropolitan Police, and in Canada a single agent to track down

art thieves.[10] Generally, however, the public system of enforcement of art theft has been distinctly lackluster and virtually ineffective. Incentives of museums and individual collectors have also contributed to the popularity of art theft. Museums are reluctant to report art theft since it may reveal lapses in their security systems and may discourage lenders or increase the cost of borrowing collections from other art venues. Private collectors may not want to call attention to lax security or possible tax consequences in this very opaque market. (Many private collectors remain uninsured for this reason.) The evolution of self-enforcement at the market level has shown promise, however, for those art thefts that are reported.

Evolution of the Market for Art-Theft Enforcement: An Economic Analysis

Markets tend to evolve in a manner that produces economic efficiency, providing protection from fraud perpetrated on buyers and sellers. The point of view expressed by the equation of marginal benefits and marginal costs reveals the manner in which art theft might increase or be reduced. An increase in cost—by increasing apprehension, conviction, or punishment—or a decrease in benefits by a reduction in value or by making art more difficult to steal would, other things being equal, reduce theft. Reliance on public-sector enforcement well into the twenty-first century has failed to stem art theft. Lackluster enforcement, coupled with the rising value of art in the United States and abroad, has brought art theft to the third-leading crime behind drug-arms crime and money laundering. (Art theft, as mentioned earlier, may be linked to both of these criminal activities.)

But markets evolve, seldom achieving but generally moving in the direction of economic efficiency. The art market began to gather steam in the postwar era in the United States with the advent of abstract expressionism and new forms of art. The number of galleries increased, as did the number of auction houses. Collectors multiplied and are multiplying at high rates as incomes of the top-tiered individuals rise. Interest in art surged in the 1980s and continues to soar in impressionist and American art and in modern, "Contemporary" and pre-1950 art, as well. This intensification created a growing number of "specialist" auctions—Christie's and Sotheby's began offering separate American-art auctions in the late 1970s, as have a number of auction houses up to the present (see Chapter 2). Market values in real terms have increased exponentially, as has art theft. Museum thefts, according to one estimate, averaged about thirty-five per year between 1995

and 2010, with the (total) number of known artworks missing as of 2012 at more than 350,000, worth billions of dollars.[11] With the general inflation of values, the market has evolved, but since it is somewhat lower-valued work that is the prime target of thieves, a great deal of American art is particularly vulnerable.

The give and take between theft and theft prevention have reached new technological heights. Museum security now uses all kinds of technological devices to discover art theft. Patrons may be tracked through ultrasound as they visit a museum. Sensitive and sophisticated camera systems may be installed (along with guards). Sensors to aid tracking may be attached to paintings. But art theft, both high-value, well-known pieces and the vast majority of works coming from private collections (especially in the United States), small museums, and churches (in European countries), has continued unabated. Organized American and international crime has perpetrated many of the high-visibility thefts, but lower-level, more opportunistic thefts are rising dramatically as the price of art, privately and at auction, rises to levels never seen before. Art has become the object of investor cartels, hedge funds, and stock market–style conglomerates. The value of art traded (from around the world) reached approximately $64 billion in 2015 (https://news.artnet.com/market/tefaf-2016-art-market-report-443615).

Contemporary American art has begun to share in, if not to lead, this inflation. Of sixteen of the *highest-priced* artworks ever sold at auction in real terms (as of November 2013), four were by Americans (one by Andy Warhol and three by Mark Rothko), all purchased in 2012 and 2013.[12] The highest price, in *real terms*, ever paid at auction was $151.4 million in 2014 for Van Gogh's portrait of Dr. Gachet, followed by Francis Bacon's *Three Studies of Lucien Freud* at $144.5 million.[13] The names creating the highest values (and the fuel of the art market) are familiar combinations of modern and Contemporary artists: Edvard Munch, Jasper Johns, Pablo Picasso, Gustav Klimt, Willem de Kooning, Jackson Pollock, Paul Cézanne, Barnett Newman, Andy Warhol, Mark Rothko, Claude Monet, Amadeo Modigliani and Thomas Eakins, with a spattering of Old Masters such as Titian, Da Vinci, and Pontormo. The general uptick in great art offered at auctions and private sales (gallery and other) means that some art of lesser quality on the walls of museums and in private collections is rising in value as well. American artists have begun to share in the largesse, certainly in art by *Contemporary* American masters but also by those American artists born in the pre-1900 era. In 2014 a painting by American modernist Georgia O'Keeffe sold for $44.4 million at auction in New York. (Private sales of American paintings have exceeded that amount.) A rising tide does tend to lift all boats in the world of art, making art theft,

along with drugs and weapons, a leading black market item. One suspects that the lesser-quality art of well-known artists and the work of lesser-known artists are the central objects of rational thieves. Names such as Picasso, Dalí, Miró, Chagall, Warhol, Rembrandt, and Renoir top lists of most-registered stolen art (Coombes 2013: 76), but these works do not include, in all likelihood, the most famous and recognizable works of such artists.

What has been the public response? A multitude of countries have gotten into the game of pursuing art thieves, but virtually none of them, except possibly Italy, has devoted great resources to the effort. We have already mentioned the paltry number of investigators assigned to art theft by the FBI, Interpol, an international police force, and the Metropolitan Police in England. But individual nations, especially Italy and France, have also sponsored publicly funded investigators (Italy being the most vigorous prosecutor). There are, importantly, other methods of tracking stolen art, and, again, many individual countries and consortiums have established "stolen art registries." Estimates vary depending on the year of accounting, but as of 2013, the following numbers of missing items existed in the following three databases, a miniscule portion of all stolen art: Interpol 40,000; FBI Art Register 7,500; and Scotland Yard 57,500.

Importantly, many countries sponsor their own art-loss registries as well. Italy's may contain more than 300,000 missing items, and similar registries (with much lower numbers) exist around the globe. At least twenty-six countries around the world have government-sponsored stolen-art databases (including the United States and United Kingdom); local and state police listings are numerous, and private and civic websites also exist globally (http://www.saztv.com). But, again with the possible exception of Italy, recovery rates are only around 10 percent per annum. A recent report (Wallack 2013) notes that between 1979 and 2013 the FBI recovered only 7 percent of those on its loss register.[14] A number of problems exist with the public system. A usable register must contain as many stolen artworks as possible, but rules and regulations make registration difficult for many sites. Items for registration at most public compilations require detailed information such as local police reports, descriptions, photographs, and provenance. Moreover, both public and private registries require that an item be above a certain value ($2,000, $5,000, or $100,000, for example) and charge a fee for registration. Naturally, for high-value art, this is a small portion of the value of artwork. But for lower-level thefts, it is an encumbrance to the recovery of property. The FBI itself notes that among art thieves there is an in-depth knowledge of the market. More important, on a domestic and a global level, there is a distinct lack of cooperation among law-enforcement agencies and a clear dearth of art experts

and art-theft experts on squads that do exist. The difficulty of registry is one factor, but, perhaps more important, it may also be the case that national agencies (e.g., the FBI or the Italian art-recovery apparatus) do not want to relinquish power and jobs by surrendering accounting and enforcement to more centralized agencies. For all these and other reasons, reportage, at least public reportage, is opaque, and it is little wonder that a comprehensive online database cannot be assembled to provide an acceptable "due-diligence" standard for transactors in art (McFarland-Taylor 1998).

The Market Responds

We have argued that high values of art at auction have brought theft from museums, collectors, and dealers to new heights. There is evidence that major art theft is on the rise. Since 2000 there have been seventeen *major* museum thefts compared with only five over the 1990s. It may well be that black markets in drugs and weapons have fueled this surge, not as "Dr. No"-style collectors, but in the use of art to launder money, provide collateral for drug transactions, barter for other goods and services on the black market, and provide "diversified assets" for criminals. Once more, even if the black market return on a picture is as much as 10 percent of an item's value, theft of a $50 million painting will yield $5 million in value to be laundered or otherwise used in a black market. Markets, however imperfectly, have responded in a manner similar to other product thefts and fakery. Illustrative are the following developments:

- Successful theft requires credence (or illegality) on the part of art purchasers. The initiating thief generally gets a fixed fee (a small percentage of value), but the price rises as the work moves through a long chain of purchasers. Provenance is often manufactured and obscured with an intentionally convoluted and ill-defined paper trail presented to a buyer or potential buyer. That requires due diligence on the part of an honest purchaser. Enter the Art Loss Register (ALR) of London, founded by Christopher Marinello but now run by Julian Ratcliffe. This register contains 360,000 items, the largest database of international stolen, missing, or illegally obtained "cultural" art. Six countries as of 2008—the United Kingdom, the United States, Germany, France, Italy, and Switzerland—lead in the number of registered thefts (Straus 2009: 100). The ALR is not only a registry; it also engages in physical *recovery* of stolen art. Between 1991 and 2013, ALR had recovered over £160 million worth of stolen items (Preston 2013). Often

recovery takes decades or even generations, but the ALR contains historical information on stolen art, which aids in recovery. Importantly, ALR is a for-profit company, charging museums, collectors, and other information banks to list items on its registry. Further, it has paid informants in the past but has shied away from actually paying ransom to recover stolen goods, which, of course, might encourage theft. However, once recovered, the ALR may charge a significant fee (20 to 30 percent) for return of stolen property. In response to some of ALR's practices, Christopher Marinello left the firm and has founded his own competing private loss register (Duray 2013) titled Art Recovery International.

- The development of IFAR—the International Foundation for Art Research—in the United States in 1969 is dedicated to discovery concerning authenticity, ownership, theft, and other artistic, legal, scholarly, and commercial art concerns.[15] IFAR was organized as and remains a nonprofit itself, but in 1991 it spawned the Art Loss Register, described in the preceding, which is a *for-profit* company. IFAR helped create ALR to expand and market the database (which IFAR owns). IFAR is based in New York and will aid in the authentication of art; it does so by enlisting experts around the world, charging an initial fee of $400 for artworks it agrees to authenticate. If the work passes an initial screening, an additional $3,000 can be charged with all liability carried by the individual or museum that wishes to purchase authentication. IFAR sponsors stolen-art alerts and publishes a quarterly journal.

- *Catalogues raisonnés*—volumes on specific artists containing all known works of the artist *up to the date of publication*—also are aids to discovering whether a painting is authentic, as we have noted before in this book. They also can help owners, potential purchasers, and museums in doing due diligence on whether an item is stolen because many such catalogs list the known provenance of each piece, often including the owner at the time of publication. One excellent (charge-free) aspect of IFAR is that it provides a list in-progress or completed *catalogues raisonnés* or other significant works on particular artists. The works themselves are referenced in IFAR's accounting. The list of American artists (hundreds as of 2015) is long; many references are not in *catalogues raisonnés* per se but reference works or biographies on particular artists.

- The rise of the "expert" has accompanied new technological procedures concerning stolen art (see later discussion with regard to "forgery" also). New security methods are available to museums and to private art collectors in addition to standard security technology. New technology permits fully

dedicated security systems to prevent art theft. Motion-sensor technology has expanded the reach of alarm systems, and, for highly valuable art, satellite tracking systems are being developed.

Clearly, market means to reduce and uncover art theft are moving ahead of the dramatic uptick in major and other art thefts due to rising prices. (Art markets move in cycles, just as do housing markets, but the "best of the best" will always find willing buyers and sellers.) While there is little one can do in the case of armed theft, the new technology discussed in the preceding offers some promise in preventing theft, particularly where major artwork is concerned.

The Economics: Demand, Supply, and Information

Unfortunately, the contemporary world of large-scale crime and problems relating to information cost does not bode well for the prevention, detection, and recovery of stolen art or for the rise in the latter. Art crime is now becoming an international problem relating to money laundering in the drug and arms trade. According to one expert (Charney 2009: xviii), forgers and small-time crime groups have been pushed aside, with organized crime being responsible for "the smuggling, the transport, the design of the crime, the sale of the stolen goods, or the theft itself" of high-value art. Furthermore, international syndicates have "brought to art crime the methods they use for their other activities, namely the threat of violence." Since the early 1960s, art and other valuable objects have been used as collateral or barter on an international black market. While low-level thefts remain the province of "ordinary" thieves and are not insignificant, there is clear evidence that art theft and distribution are becoming the province of international crime syndicates (Tijhuis 2009: 44). There are at least three likely reasons for this phenomenon: (1) the indisputable fact of massive inflation in the values of art of all kinds, including and perhaps especially American Contemporary art; (2) the rigid clampdown on currency controls in the developed world to stem drug, arms, and other illicit smuggling; and (3) the lackluster enforcement of crime in what is generally considered a secretive and opaque market.

Art has *become* money. With currency-transfer crackdowns, those in illegal trade have elevated art and other objects to the status of money, although money may still pass within tax-free nations of the world (Dobovšek 2009: 67), such as in the Arab states, Luxembourg, the Cayman Islands, and others. How might barter function for artwork? First, art is relatively portable and takes its own value in black market trades—stolen art is worth about a

range of 7 to 10 percent of auction value among thieves. Consider a hypothetical example of two syndicates, A and B, both with agents in Utrecht and Albania. Syndicate A is the seller of drugs at the value of $1 million and B is the buyer. The drugs are transferred in Utrecht, and in Albania the agent of syndicate B turns over a stolen painting worth $1 million in black market terms ($10 million in auction-house terms). The transaction is in barter, rather than risky monetary, terms. Of course there is risk in smuggling the painting out of Albania, but it may be far less than transferring cash or a deposit through the banking system. The painting may be then sold legitimately elsewhere in the world or kept as "treasure" or collateral for future use. According to Dobovšek (2009: 67), "money is often used to corrupt politicians now, while trade involves money less often and rather relies on the harder-to-track barter system. . . . So organized crime had to come up with new ways to hide money. Art crime is one of those ways. . . . Buying art legitimately, too, is a way that criminals can launder money in a legitimate investment that will retain its value over time." Such exchange is still costly (and risky), but it remains profitable. The object is to achieve legitimate possession of valuable assets.

While the use of art, stolen or otherwise, may be a new tool for money laundering, it is worth noting that these practices are in part the unintended consequences of currency regulations to control illicit goods. If there is a gross increase in the use of art as barter in illicit international transactions, and certainly anecdotal evidence suggests that this is the case,[16] incentives to use art are certainly increasing as the art market and the price of paintings reach new heights annually. Further, as currency controls are tightened in the United States, Europe, and elsewhere, the risk-adjusted cost of using barter will fall and the opportunity cost of using banking systems to launder money will rise. This does not mean that parts of the banking system, auction houses, and dealers are less often completely or partially opaque when it comes to regulations pertaining to currency transfers. As Nelson (2009: 200) points out, "whether overt or subconscious, the tendency is to favor business and to not look too closely at potentially questionable deals. One can always claim ignorance if a dealer or financial institution is found to have been passively complicit in a money-laundering transaction." In sum, the demand for art theft would appear to be expanding for many reasons, not least as a tool in money laundering.

The uncomfortable facts remain at present: art theft amounts to $6–$10 billion a year; recovery is at best 3–10 percent; the probability of being caught, despite new technology, is low, with "grab and run" the most common type of theft; and public law-enforcement agencies devote precious few resources to art recovery. Economic analysis has clear observations on art theft with

these characteristics. Public enforcement, even with substantial resources used, is difficult and clearly lackluster. Big-time theft is an *international* activity, whereas most nations sponsor *national* enforcement. Interpol does collect international data on theft, but it has not achieved much cooperation in the submission of entries to its database. (The submission process is said to be tedious and difficult, and property must cross international borders to be eligible.) National art-theft enforcement agents present difficult subjects for coordination, moreover, many believing that their influences and flow of rents will be diminished by an international and centralized source.[17] The same goes for lower-level enforcement activities within countries. It is not surprising that in the face of the new and increased prevalence of art theft, profit-maximizing (and other private) institutions have arisen. The Art Loss Register (ALS; and its precursor institution, IFAR) and, in the future, Art Recovery International appear to be the most centralized means of recovering stolen art. The ALS not only keeps the largest extant register on stolen paintings, past and present; it aids in the recovery with investigatory techniques. But it is costly as well. Fees to insurance companies, museums, and individuals for recovered art can be substantial, running to 20 or 30 percent of the value of the art recovered.[18]

The high cost of registration and recovery has implications for the economics of art theft. High-value art is pursued by economic agents—owners, insurers, police, and private recovery businesses. The average rational thief, given his or her knowledge concerning art, will focus on lower-valued pieces by lesser-known artists and secondary, tertiary, or minor pieces by better-known artists. Economics would predict that the vast majority of art stolen would be of lower value. This fact is underlined by Wallack (2013), who states that "while museum heists garner the most headlines, most of the art works listed in the Art Loss Register was taken from private homes and collections and are worth less than $10,000 each." Until the recent price inflations, in both pre-1950 and Contemporary art, that would apply clearly to art produced in America. Since it is not uncommon for stolen art to materialize after decades or generations, often as an inheritance, the cost of retrieval is high—an art database covering long periods of time is vital to recovery, as legitimate dealers or museums practice due diligence by consulting the Art Loss Register and other registries.[19] Given existing current public and private agents and agencies engaged in stolen-art recovery and their costs and incentives, an economist might even think of the system *as it exists* as "optimal." The marginal cost of recovering art to individuals or museums, in the state of low recovery rates by public means (police, FBI, Interpol, national police specialists), must equal the marginal benefits of recovery. When art is insured, the marginal cost *may* be smaller to those robbed, forcing costs on insurers. The recovery rate

will rise as the data banks improve with Internet exposure and are more frequently consulted by art purchasers. Unsurprisingly, one might expect entry into the art-loss market as the value of stolen paintings rises as well. New Internet technology—for example, posting losses in the "cloud"—may have promise, but art theft is a rising phenomenon. The fact remains that, given the current economic state of enforcement, incentives, information costs, and regulations, art theft will continue its upward trajectory.

Fakes and Forgeries

While art theft is growing in intensity as the art market prospers beyond belief, the market in art fakes and forgeries is ascending even faster in a world where *some* art will never be judged "genuine" and where legal judges, rather than experts, have determined the "authenticity" of works of art. Recall that a fake is an attempted copy of an artist's work (with or without signature), and a forgery is a work in the style of the artist but which is attributed, most often by signature, to be of the hand of the artist. They must be sold as such since copied works *including signature*—presented as such—may be and are sold legitimately. How prevalent are fakes and forgeries? As we have noted previously, the late director of the Metropolitan Museum of Art, who called himself a "fakebuster," provided insight as of 1996:

> The fact that there are so many phonies and doctored pieces around these days that at times, I almost believe that there are as many bogus works as genuine ones. In the decade and a half that I was with the Metropolitan Museum of Art I must have examined fifty thousand works in all fields. Fully 40 percent were either phonies or so hypocritically restored or so misattributed that they were just the same as forgeries. Since then I'm sure that that percentage has risen. What few art professionals seem to want to admit is that the art world we are living in today is a new, highly active, unprincipled one of art fakery. (Hoving 1996: 17)

Hoving's prediction has been borne out over the past two decades. A decade after Hoving wrote, a cascade of forgeries began to hit the American art market. A report in the *New York Sun* interviewed American art dealers. Stuart Feld, president of the Hirschl & Adler Gallery, specializing in American art, claimed that "we have hardly a week that goes by that we don't get two or three such submissions" and Alexander Acevedo of the Alexander Gallery claimed that

he was "bombarded with fakes. . . . It goes on every single day. It's like a mine-field. Wherever you turn that's a fake out there" (Hope 2006).

The fake/forgery situation remains a minefield. One of the most noto-rious episodes of forgery in recent times related to one Gladfira Rosales, who, with a co-conspirator, between 1994 and 2009 sold forged American art to two New York galleries—one of them, the Knoedler Gallery, the oldest and one of the most respected galleries in the city. The other was the Julian Weissman Gallery. Founded in 1846, Knoedler was forced to close in 2011 due to the scandal, one that has tentacles reaching to auction houses, collec-tors, and other dealers, galleries, and museums (e.g., the Kemper Museum of Contemporary Art in Kansas City, Missouri, which, ironically, was a victim in a Georgia O'Keeffe episode; see later discussion). Rosales and a co-conspirator boyfriend hired an artist in Queens, Pei-Shen Qian, who had been a street painter but was professionally trained to produce works by American abstract artists Jackson Pollock, Mark Rothko, Robert Motherwell, and others. Rosales then, according to a US attorney's press release (Duray and Russeth 2013), sold the paintings to Knoedler and one other gallery for about $32.2 million. The galleries then sold the pictures to victims for more than $80 million. Rosales made up false provenance for the pictures, claiming that she repre-sented a "Swiss client" and a Spanish collector who wanted to deaccession some of the works. In reality, the Swiss client never existed and the Spanish collector never owned any of the works. Rosales received the proceeds from the sales in a foreign bank account, hidden illegally from the Internal Revenue Service. In 2013 Rosales pled guilty to nine counts, among them wire fraud, conspiracy to commit money laundering, and filing false federal income-tax returns, all of which could get her ninety-nine years in prison and cost her restitution of $81 million. The Knoedler Gallery closed in 2011 amid multiple lawsuits from high-profile clients—suing for repatriation of money paid for forgeries.[20] The forger apparently left the United States for an Asian country. The much-respected president of Knoedler Gallery, Ms. Ann Freedman, and Julian Weissman (who was Motherwell's dealer when Motherwell was alive) continued to assert that they believed that the works were authentic (Cohen 2011). (Remember that to be convicted of fraud, one must represent the work as by the hand of the artist.)

A gnawing and relevant point remains. Despite some attempts to shore up the authenticity of the works by Knoedler, mainly by a few so-called experts on particular artists, the official Robert Motherwell and Barnett Newman Foundations—those directly responsible for legitimizing works by these artists—as well as others *privately* expressed doubts concerning the authen-ticity of the works Knoedler was selling. Even earlier, in 2005, a leading expert

on the work of Jackson Pollock had expressed doubts about two of the Pollocks that Rosales was selling through Knoedler. The real question is *credence*, of course. Why did not these foundations come forward? These and other foundations had stopped giving opinions as to authenticity due to the possibility of lawsuits (see later discussion). Museums have likewise stopped giving opinions on works to avoid legal action. Secrecy and silence rule the game. The "original owner" was kept a secret from buyers by Knoedler (who claimed to know who it was), and the provenance provided was simple "private collection," shored up by some "experts." With prices in the millions, one would think that more credence would be demanded, but that is not the practice.[21] According to *New York Times* writer Patricia Cohen (2014),

> these problems have permeated the industry for decades, said Stephen Urice, a professor at the University of Miami School of Law. He pointed to a 1978 court ruling: "In the fantasy land of marketing in the fine arts," prestigious names are "dropped freely as rain," and large sums quickly change hands. Judge J. Shorter of New York State Supreme Court wrote: "In an industry whose transactions cry out for verification of both title to and authenticity of subject matter, it is deemed poor practice to probe into either."

The opaque and secret nature of the art market—together with the threat of lawsuits for "expert verification" (those put in writing)—make fakery much easier. "Experts" will often not provide an opinion unless requested in writing and indemnified against lawsuits and damages—most have stopped "authenticating" altogether. It is not unheard of, moreover, for compilers of *catalogues raisonnés* to be so threatened as well. Credence is difficult to establish in such a world, although a decision by the New York courts provided some protection from some frivolous lawsuits regarding authenticity. Some, however, believe that the ruling may introduce further incentives for experts to avoid authentication.[22]

The Knoedler case was, at least in part, settled in February 2016. Buyers at Knoedler & Company naturally sued the gallery and its director, Ann Freedman, under the RICO statute (Racketeer Influenced and Corrupt Organizations Act) as having known that the works were fakes. But the case, as far as Ms. Freedman is concerned at least, came to an end with a whimper, not a bang. Collector Domenico De Sole sued Ms. Freedman for having sold him a fake Mark Rothko. De Sole claimed that the painting was given credence by showing him a list of known Rothko experts who had "viewed" the painting. However, given the prestige of the seller, De Sole did not check with these

"experts." The potentially disturbing and unsavory details of the case, and of trades in the art markets generally, were avoided when Freedman settled out of court with the collector. This famous (and ongoing—Knoedler is still liable to other buyers of the fake goods) case reveals, if nothing else, the highly opaque nature of the art market. And an underlying economic principle is set in bold: those with the best reputations—in this case, the Knoedler gallery and its managers—are in the best position to commit fraud when the "economics" are right. That is, when the benefits of fraud are at a high level and exceed the prospective costs (getting caught), more fraud may be expected. High levels of credence in certain galleries and dealers, coupled with the secrecies and virtually unregulated nature of the art market, guarantee that more cases such as Knoedler's will be forthcoming.

Print Forgery

If fakes and frauds are common in high-value "original" art, they run rampant in print sales. While the returns are not as great, forging prints is lower cost. Many artists include prints in their output. Prints are created by a wide variety of techniques, including etchings, woodblock prints, linoleum cuts, monotypes, lithographs, serigraphs, and many other forms of reproduction. These art forms bend the concept of "original." Unlike an oil painting, a watercolor, or a drawing, multiple print "originals" are produced. Ordinarily there is a defined print "run" in some predetermined number—ten, five hundred, or a thousand—that are signed and numbered by the artists as, for example, 2/10 or 436/500, meaning the second print in a run of ten or the 436th print in a run of 500. After the run is completed or supervised by the artist, the lithographic stone (on which the art is drawn), etching plate, piece of wood, or other medium that created the print is destroyed or defaced or preserved in a museum. This is done in order to prevent additional copies being supplied to the market. Sometimes preservation or destruction of the plates does not take place and "unauthorized" editions are printed. Artists' trust in the printer (or molders in the case of sculpture) is sometimes misplaced, producing fraudulent copies.[23] Prints produced under other conditions are, under strict market interpretation, considered fakes or frauds.[24]

Many important artists from around the world, including Picasso, Dalí, Miró, Diego Rivera, Hopper, Homer, and Warhol, created art through the medium of prints. Some artists have made a career almost exclusively in printmaking (e.g., Americans Gustave Baumann, Martin Lewis), but most artists include forms of printmaking in their artistic output. This fact has given forgers special opportunities to create fraudulent prints: rather than having to

reproduce or closely mime an oil painting or a watercolor "original," where only one or a few exist, the forger can create and sell in a medium where many prints are created as "originals." And the ability to fake prints opens a wide spectrum of methods. Unscrupulous printers and others steal or do not destroy the original stone or plate used for lithographs or etchings, producing multitudes of fakes. Technology is advancing these practices. New techniques in digital photography make it possible to produce "prints" to which forged names and numbering are attached.[25] Laser-transfer technology is readily available to forgers. Digital techniques can, using watercolor and fine papers, reproduce prints that are virtually indistinguishable from original watercolors. Major artists, including Miró, Dalí, Picasso, and Chagall, are routinely faked in this manner, as are American artists such as Robert Rauschenberg. The examples of fake-print sales through galleries or other institutions are legion. Many sources chronicle such fraud (see Conklin 1994: 82–83, for example). New methods of reproduction (such as giclée, a technique that produces especially accurate copies of an original on paper or canvas, and the increasing sophistication of 3D printing in the case of non-paper media such as oil and acrylic), together with a willingness to forge signatures, have become a major source of fraud. Amore (2015: 183–184) recounts a case involving "mail fraud" (under which it is illegal to use the US Postal Service to defraud the public) in which a family of forgers were selling and fraudulently "documenting" prints attributed as "originals" by Miró, Chagall, Dalí, and Picasso. "In all," according to Amore (2015: 184), "federal agents found and confiscated 50,000 prints supposedly by Dali; 20,000 Miros; 2,200 Picassos; and 650 Chagalls. They also took print reproduction equipment and seized over $1.3 million in cash, $1.5 million in properties, and three cars."

Print sales on eBay are likely more (perhaps much more) than 50 percent fakes, and there are even "fake tutorials" (not intended to encourage law breaking) published on the Internet, such as "How Art Forgers Sell Fake Art on eBay and Make Big Money," with subheads titled "Find Some Art," "Choose Your Artist," "Fake the Signature," "Write Your Descriptions" and "Skirting Fraud Laws" (see http://www.artbusiness.com/faketutorial.html). Descriptions may be couched in terms that disguise the inauthenticity of the print. Given the difficulty and costliness of authentication—and the gullibility of many buyers—fakes can easily be produced and sold on the Internet. But it is worth noting that most prints may be purchased in the $100 (or less) to $2,000 range. Only some prints have reached high enough values to encourage elaborate and expensive copies or reproductions. Some of Picasso's and Munch's prints have reached prices from $100,000 to well over $1 million at auction, for example, as have American prints by such artists as Edward

Hopper. Again, the central issue for buyers is credence in the seller, which is very often difficult to establish with eBay sales.[26] Prices adjust to the confidence one has in the seller so that a buyer might think she is getting a large "signed" Picasso color linocut for $1,200 at a good deal. An individual or expert with knowledge of the market would immediately know that this is far too good a deal and would identify the transaction as fraudulent or as the sale of stolen property. Fakes so crude as to be laughable to one only moderately acquainted with the artist's output may appear quite genuine to others.[27] Buyers who have little information and do not choose to engage in the cost of gathering information are prime pickings for fakers and forgers. Again, the level of credence is key and that will differ between individuals.

The Benefits and Costs of Fakes and Forgeries

Some believe that fakes and forgeries may actually carry *net benefits*.[28] Fakes and forgeries mean that an artist's work is in demand. According to Bruno Frey (1999: 7), there is a "propagation effect" wherein the artist benefits even if fakes are created without her consent since the artist's name is propagated, allowing sale of future works at higher prices (but see further discussion later in the chapter). Reproduction of an artwork provides a wider distribution to consumers, who experience utility increases revealed by their willingness to pay for fakes. Frey (1999: 8) also believes that fakes and reproduction of art raise "artistic capital" of the fakers, who might go on to "become masters later in their lives." Yet another advantage, according to Frey, is that fakes support creativity, giving present and future artists greater scope for creativity. While it is certainly true that most creative individuals rely in part on past achievements and that, in a Renaissance setting, copying was a teaching method, it is far from the case that the denial of all property rights to artists (and other creative persons) has positive net benefits.

Consider the costs to buyers, dealers, and artists themselves. Fakes and forgeries destroy the use of art as investment vehicles, as well as the trust built up in the marketplace between buyers and sellers. It is often said that a "near-perfect" copy of an artwork—achievable now by a range of technological developments—is "the same" as the original. It is not. Revelation of a fake always reduces the value of or "discounts" the faked picture. Individuals place utility and demand on the creative originality. Originality produces utility that a copy does not. Art historians place value on the context of an artistic production or discovery—how, for example, a particular piece fits within the entire oeuvre of the artist. That is lost, as is aesthetic context, when forgeries abound. But more than any other, the artist is the net loser from unrestrained

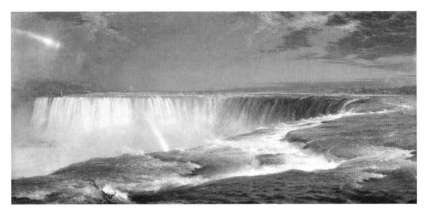

FIGURE 2.1 Frederic Church, "Niagara"

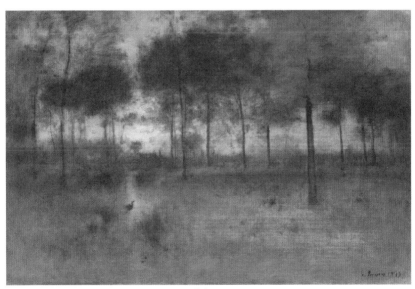

FIGURE 2.2 George Inness, Home of the Heron

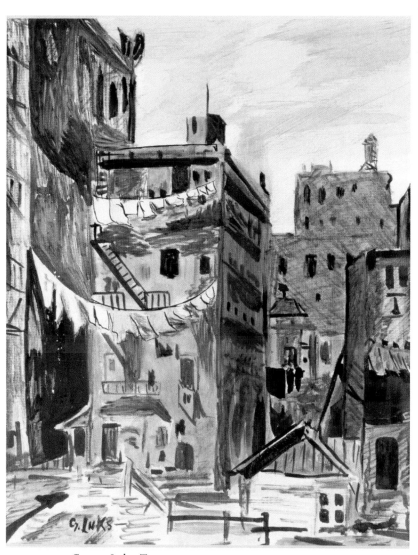

FIGURE 2.3 George Luks, Tenements

FIGURE 2.4 Max Weber, Seated Nude (1910–1912)

FIGURE 2.5 Yasao Kunioshi, "Circus Girl Resting"

FIGURE 2.6 Childe Hassam, The Seine at Chatou

FIGURE 3.2 Arthur Dove, "Woodpile"

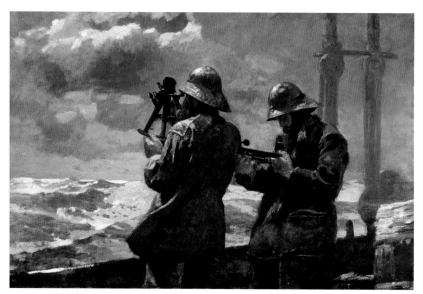

FIGURE 3.5 Winslow Homer, "Eight Bells

FIGURE 3.8 Georgia O'Keeffe, "Black Mesa Landscape"

FIGURE 3.11 Jackson Pollock, "Autumn Rhythm, 1950"

FIGURE 6.2 Arthur Wesley Dow, "Frost Flowers, Ipswich, Massachusetts," 1889

FIGURE 7.4 Mark Rothko Painting No. 5/No. 22, 1950

FIGURE 7.5 Agnes Martin Painting, The Tree

and unregulated faking and copying of his or her works. Frey (1999: 7) notes, correctly, that an artist may receive royalties from legal copying, but when illegal fakes or copying are produced, "the creator's name is propagated, thus allowing him or her to sell future (original) works at higher prices." We do not believe that, *on net*, this is so. While fakes may have "advertising" value, it is by no means clear that their existence will not make the sale of future original works by an artist of *lower* value.[29] If a buyer cannot be guaranteed that she is purchasing an original and if that doubt is buttressed by the knowledge that the producing artist is known to elicit legal fakes, the value of her art must be discounted. In extreme cases, value falls to the competitive cost of paint and canvas.[30]

The impact of fakes on an artist may be shown by recourse to an example from economic theory. Nobel Prize winner Ronald Coase (who won in 1991) developed a concept (in "The Durable Goods Monopolist") that has direct and important relevance to the art market. Coase asked a simple question: Are monopolies always successful, and if not, why not? Consider two diverse groups—real estate developers and artists of any kind. Assume that real estate developers own exclusive monopoly control over portions of land that are particularly desirable for housing development. To make the matter even simpler, we will assume that some individual (or collection of individuals) is in possession of monopoly control of all the land in the United States and that the monopolist can sell land at rates identified by the demand curve in Figure 6.1. If we assume that the total amount of land available is Q_c, the

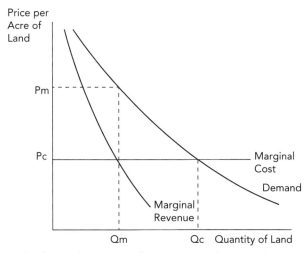

FIGURE 6.1 The demand structure of a durable good monopolist.

monopolist would want to sell Q_m land and charge the monopoly price P_m for it. Would anyone pay P_m for a plot of land? A moment's reflection reveals that a "durable-goods monopolist" would not be able to charge more than the competitive price for land (P_c). Clearly the monopolist must devise some means of guaranteeing buyers that $Q_m Q_c$ of land will not be sold so as to protect the value of their investment. Coase notes a number of ways that this might be accomplished. Guaranteed "buy-backs," leasing arrangements, and giving away $Q_m Q_c$ for non-market purposes (public parks, for example) might permit the monopolist to be able to charge monopoly price P_m. The set-aside land would not be offered for sale. Otherwise, the durable-goods monopolist *cannot behave as a monopolist at all*—he or she must charge the *competitive* price.

Additional reflection tells us why this principle applies to artists as well. Most artists find themselves in the position of the durable-goods monopolist who can only imperfectly make contractual arrangements with demanders of their art. While some living artists (Janet Fish, Chuck Close, for example) make huge income from their work, the sad fact is that *average* artists make only between $20,000 and $30,000 per year from their talent. A part of the reason is that they are, in effect, durable-goods monopolists—with at least some degree of monopoly over style. Some contractual arrangements to guarantee that they will not "overproduce" their art—driving down the price—*are* possible. As noted earlier, artists who work in "duplicative" media (woodcuts, lithographs, linocuts, prints, and so on) typically limit the edition of particular works, destroying plates at the end of a run as a guarantee to consumers of the value of their purchase. Artists may also change their "styles" so that production of a particular type ends. (Picasso went through numerous styles such as a Blue Period, a Rose Period, cubist, and neoclassical.) Additionally, some artists "advertise" that a portion of their output will not enter traditional markets (through their dealers).[31]

This economic principle has intuitive content as well. One of the reasons for maintenance of an artist's prices is the fact that unauthorized fakes will destroy the market for originals. This is secured by the enforcement of property rights. It is legally punishable to fake or copy an artist's work and to sell it as a work of the artist. Without this provision, artist's incomes would plummet and the market would not function to encourage innovation.

Fakes or forgeries may be and are regulated legally, but in general no enforceable and durable arrangements can be made between artist and demanders during the artist's lifetime to the effect that the artist will not "spoil the market" themselves by some "overproduction" of works. The prospect of this devaluation will, *ceteris paribus*, keep prices and returns at competitive levels. This is, perhaps, one reason for the general poverty of many artists—that is,

the "starving artists" syndrome. In other words, some would-be monopolists, who have exclusive control over resources, cannot always be successful at capturing the consumer surplus that monopoly pricing permits. This does not mean that other factors do not enter the art market that would have the contrary effects described earlier. "Hot" artists with aggressive dealers and advertising can stimulate demand while artists are alive—a common feature of the New York art market, for example. But prices are determined by *both* supply and demand, and the supply effect—created by "fakes" production and overproduction by artists themselves—is always in play in this market. According to one authority (Conklin 1994: 80),

> today, there are so many counterfeit prints by those artists in circulation [for example, Dalí, Chagall, Picasso, Miró] that auction houses refuse to sell prints said to have been done in recent years; for instance, Christie's will not sell any Dali prints published after 1949, because there is no catalogue raisonné for the artist's prints after that date. An artist's reputation often suffers when many forged prints overexposes the public to the artist's style, makes it seem that any skilled artist can create works like the originals, and makes the public suspicious of all the artist's prints.

It would appear, in short, that fakes create distortions in the art market, as predicted by Coase's durable-goods monopoly example.

Credence and Examples of Forgery and Art Crime

Some have likened the art market to a "Wild West" in that fakes and forgeries abound. That is not far from the truth in some cases, but better fakes bring enhanced fake detection. Other factors also enter the equation, such as legal liability in fake detection. Here we consider these and other important matters.[32]

Fakes and forgeries have riddled American art from the beginning.[33] Recall from Chapter 2 that the ardor of early American collectors in the postcolonial period for Renaissance paintings led them to buy fakes of Rembrandts and Rapheals created in Europe. Michelangelo himself is said to have borrowed other artists' drawings, copied them, and returned the fakes to the lender. (Picasso is said to have opined that good artists borrow, great artists steal.) As excellent American painters began to populate the nineteenth century, many turned to collecting their work, and many of those artists are the subject of forgery today. An American art forger, Ken Perenyi, began creating fakes of

these artists several decades ago. His book (2012) chronicles his involvement in faking a number of important nineteenth-century American artists. His technique followed that of classic methods of creating fakes. Rather than present crude facsimiles, Perenyi created works that were enough like the artist's productions to fool experts. This included a major study of the artist's works, a study of the materials used by the artist, the artist's working methods (e.g., brushstrokes), and the use of genuine supports (the materials artists paint on) used at the time. For example, some early artists used wood as the base to create pictures. The type of wood used may be determined by examining a known actual creation. Similar wood may be obtained, for example, by purchasing furniture—chests of drawers—and using the bottom of a drawer for backing. If a painter used canvas, old and worthless paintings created in the period may be bought and scraped to obtain an appropriate canvas. The paints used by an artist must be carefully studied, moreover, because use of a paint with ingredients (e.g., lead or a type of lead) that had not been invented or in use during the artist's lifetime can be a dead giveaway to a fakebuster. Perenyi used these and many other techniques to produce brilliant forgeries, not necessarily selling them as by the artist but entering them into the trade (food chain) nonetheless. Basically a self-taught artist, Perenyi was able to forge works by the maritime artist James E. Buttersworth, the brilliant bird and flower painter Martin Johnson Heade, the great *trompe d'oeil* painter of still life John F. Peto, the painter of Native American portraits Charles Bird King, and the popular painter of African-American subjects William A. Walker, among others.[34]

As we have seen, most fake prints are reproductions of existing work, although a high enough price will encourage the attempted faking of exact replicas. That is not the case with the lucrative practice of producing *new art* by a given artist. The technique of forging art—creating new art purportedly by the artist—is remarkably similar through the ages. Perenyi used it, as do all forgers. It is the use of pastiche by, as Hoving called them (1996: 106), *pasticheurs*. All artists use similar imagery from painting to painting—they (as do writers and musicians) "recycle" images of the ocean, flowers, leaves, backgrounds, and so on. A pastiche of a painter's work brings separate but familiar aspects of an artist's work together in order to create a "new" image that could have been painted by an artist. It must be stated that more than 90 or 95 percent of faked art is crude and immediately recognizable. But great forgers are, in addition to being talented, great students of the artists they forge. They gather as many available books, *catalogues raisonnés*, and biographies of an artist to produce convincing forgeries. Art restorers may evolve into forgers due to their intimate knowledge of the real work of artists. They

are sometimes able to produce "early, unknown" paintings by famous artists or, often, "preparatory drawings" of known works by an artist.

A famous recent case of possible American forgery dealt with "early, unknown" paintings purported to be by artist Georgia O'Keeffe and the provenance that supports them (Tully 2000). It is unclear whether this was an "immense hoax," misidentified genuine paintings of O'Keeffe, or the intentional introduction of fakes into the legitimate art market. The longer story is a confusing one that begins when O'Keeffe taught at West Texas State Normal College (now West Texas A&M) in Canyon, Texas, between 1916 and 1918. Over this period O'Keeffe created some beautiful "interpretive" watercolors in and around the canyon (Lynes 1999) and met and had an intimate relationship with a student, Ted Reid. Although the relationship was broken off (by the student, Reid), they maintained a lifelong friendship. Reid gave a package to one Emilio Caballero in 1975, who stored it in a garage; Caballero, the chair of the art department and a painter, then gave them to his daughter-in-law Terry Caballero (who was also the granddaughter of Reid). Terry Caballero contacted Gerald Peters, a well-known art dealer in Santa Fe and New York and Dallas who had been O'Keeffe's dealer for some years before she died in 1986, at the age of ninety-eight. Eventually Peters was contacted, who then brought the twenty-nine (later twenty-eight) watercolors (called the *Canyon Suite*) to Juan Hamilton, O'Keeffe's companion in her later years and the "go-to" person to authenticate her work. Hamilton, according to Peters, signed off on the authenticity of the pictures. The "newly discovered" O'Keeffes also traveled to the National Gallery of Art, where experts—one of them later a member of the group that put together the *catalogue raisonné* (Lynes 1999)—treated the works as genuine, according to Peters. No one, however, was willing to put the assessment in writing.

Hamilton's alleged opinion was the basis for other positive but mostly unwritten opinions on the watercolors, including that of Charles C. Eldredge, an expert on the artist, who wrote an essay on the paintings, placing them in O'Keeffe's oeuvre. (The essay was later reprinted in Peters and Eldredge 1994.) Moreover, the works were appraised by Eugene V. Thaw, an important dealer and collector, who evaluated the collection to be worth $5 to $7 million. Peters, on the basis of Hamilton's, Eldredge's, and Thaw's alleged evaluations, sold the twenty-eight watercolors to Crosby Kemper, a wealthy financier establishing a museum (Kemper Museum of Art and Design) in Kansas City, Kansas. The price was $5 million. Meanwhile, plans were firmed up for the National Gallery and the Georgia O'Keeffe Foundation to publish a *catalogue raisonné* of her works, and they hired Barbara Buhler Lynes in 1992 to spearhead the project. After seven years of intensive investigation, the committee

decided that the watercolors were not "right" and informed Kemper that they would not be included in the *catalogue raisonné*. Some of the paper used was not manufactured until 1930 or even 1960, and could not have been used by O'Keeffe in 1916–1918, although since O'Keeffe and Reid stayed in contact until his death (three years before O'Keeffe's), the watercolors could have been from a later period.

Kemper of course demanded his money back, and Peters complied. (Reputation and credence are everything in the art market.) The "experts" who had (at least) verbally acknowledged authenticity of the watercolors, including those associated with the Georgia O'Keeffe Foundation and the National Gallery, ran for the hills, denying or downplaying their attributions. Peters has not revealed his negotiations with the sellers of the paintings, but the sellers alleged that they never said definitively that O'Keeffe had given the watercolors to Reid. They did not know, and this fact points out the perils of authentication and provenance. Provenance, the history of the painting or art-work from the artist through the current owner, may be vague, convoluted, or "manufactured" to support a fake or forgery. Provenance may be forged, just as prints and paintings—traditionally, galleries and auction houses put stickers on the backing of paintings, helping to establish provenance, but these documents and rubber stamps may be and are forged to provide credence for stolen and forged art. The lack of a provenance, however, may not mean that the work is not genuine and of the hand of the artist. (The absence of evidence is not necessarily the evidence of absence.) So it may well be that some or all of the *Canyon Suite* watercolors are by O'Keeffe. (One expert has ventured the opinion that the "suite" was a gathering of students and O'Keeffe's work from a classroom.) Verification at this date, however, is impossible, making the watercolors "meta-credence" goods—verification may not ever be possible unless additional evidence is uncovered.

Some examples of forgery also involve theft. One case demonstrates the existence of an "art ring," as well as how a very legitimate dealer, experienced in American art, can be duped into buying stolen art. A piece by Arthur Wesley Dow, an American modernist, was stolen by an employee (who had two unwitting associates, one of whom was a painter) of UCLA. The painting, entitled *Frost Flowers, Ipswich* (1889; Figure 6.2), was forged by the painter as-sociate and replaced by the thief. Through other transactions, the associates found agents who then contacted a prestigious gallery in New York City. The painting was purchased by the gallery for $200,000, restored and sold for $317,000 (Mooney 2002: 25–26). The thief ultimately ran out of money and stole additional works, having her associate fake them. When the inadvertent faker asked some questions of one of the artists being faked (a hazard when

FIGURE 6.2 Arthur Wesley Dow, American, 1857–1922, *Frost Flowers, Ipswich, Massachusetts,* 1889. The Athenaeum. Image and copyright, public domain.

an artist is living), the plan began to unravel. Ultimately, one of the thief's associates turned "state's evidence" and a conviction for art theft was obtained. Despite some resistance by the gallery owner to police investigation, the matter was ultimately settled and the Dow was returned to UCLA.[35]

There are important lessons to be gleaned from this case. First, there is the issue of provenance. Dow's work is generally not well known. The thief represented the Dow painting to her associates, one of them an unwitting forger, as having belonged to her father. Arthur Wesley Dow had actually given the painting to UCLA in 1928. Perhaps that investigation (by the forging associate) would have been too costly, and most would probably not go further. Without a hitch, the Dow painting went up the "food chain" and ended up being offered to a well-known and reputable gallery. Did the gallery perform due diligence when probably given a circuitous story of provenance? In fairness, UCLA had not discovered the forgery/theft for some time, so art registers and the FBI were not notified. The point is that an economic cost/ benefit calculation must be made in terms of due diligence and investigations into provenance. The Los Angeles police report on this matter (http:// www.lapdonline.org/newsroom/content_basic_view/27408) makes clear the difficulties of establishing ultimate provenance and the gallery owner recalcitrance about giving up the painting: "A diligent search of UCLA archives located proof that the Dow family had donated the painting to the university in 1928. After a stiff court battle, [the gallery owner] was finally compelled to

produce the painting and relevant documentation through federal grand jury subpoenas." If a "diligent search" was required to establish initial ownership by the university, how expensive would that have been for the gallery, which did not know that the painting was stolen (let alone by whom or from where)? Anyone, including the great auction houses, can be deceived and many are. Sotheby's and Christie's have had to remove a number of works from their sales catalog through the years. What is clear is that the gallery was satisfied enough with what was told them to pay $200,000 for the piece.[36] Clearly, if the painting had been valued in the $5–10 million range, greater assurances *might* have been required.[37] Creation of fake art, especially of high value art, is ongoing, and it is a worldwide phenomenon with enormous implications for credence in the art market.[38]

Fake Detection: Provenance and Science

Provenance is one means of discovering fakes and providing credence in the originality of art. But provenance, like the art itself, can be and is often faked when fraud is perpetrated. That was done in most of the cases discussed in the preceding. Provenance was either supplied by a faker or, later, by one who would sell a piece as a genuine work by an artist. Recall that fakes may be made of any painting with signatures *so long as the fake is not sold as by the hand of the artist*—that is, it is sold as a fake. But in order to make the fake as pastiche of an artist's work plausible, supporting documentation is necessary. In addition to rings of art forgers, there is a cottage industry in provenance. A case where *actual provenance* is used to support the sale of a fake is revealed in an interesting tale concerning an American forger, whose deceptions came to light in May 2000 when Sotheby's and Christie's, the two premier auction houses in the world, offered the *same painting* by Paul Gauguin (Keats 2013: 25–27) for sale. The painting was a minor one called *Vase de Fleurs* and was once owned by Sir Laurence Olivier. Each house believed that theirs was authentic and submitted them to the Wildenstein Institute, which declared the one from Christie's to be a fake, although it carried a genuine certificate of authenticity—that is, appropriate provenance. The paintings were withdrawn from the auction, but the one at Sotheby's, consigned by Manhattan dealer Ely Sakhai, sold later for $310,000. Christie's Gauguin was returned to the Muse Gallery in Tokyo. The FBI later discovered that Sakhai was a clever forger who had been purchasing dozens of second- and third-rate works by well-known masters such as Monet and Renoir, forging them, and selling them abroad in Asia, along with the actual provenance. He would then sell the genuine paintings in the United States or in Europe, where they were purchased on their

own merits without provenance. It seemed clear that the auction houses knew of the pattern years before the Gauguin fiasco (Keats 2013: 26).[39]

The extent to which an art criminal might go to establish provenance is sometimes astonishing. An example from England is remarkable. One brilliant mastermind named John Drewe faked many things about himself. After finding a brilliant but impoverished painter named John Myatt, he cultivated officials, especially the director of archives, at the Tate Gallery. Most individuals support museums in an obtrusive way by donating art, but Drewe promised and made gifts to the archives section of the museum. By doing so, Drewe had unprecedented access to the archives and was treated grandly by the museum. After much research, Drewe discovered which artists did not keep good records of their output (Picasso did, for example); Drewe created a *pasticheur* out of Myatt and proceeded to "seed" the archives on famous artists (such as Alberto Giacometti and a number of other luminaries in the European art world). Journal entries, sales, provenance of all kinds would be inserted for "new-old" works in the artist's archive. Sales flourished in this manner for nine years until the committee on Giacometti pulled the plug. Both Drewe and Myatt were given relatively modest sentences. Myatt was seen as a "tool" of Drewe and only got a year's sentence, of which he served four months. Myatt returned to creating "real fakes" for those who wanted a "Monet" in their dining room and to painting his own work. According to the account of Salisbury and Sujo (2009: 303),

> [Myatt] often thought about the dozens of pictures he'd made for Drewe, the ones that had vanished over the years. He knew that each time they changed hands; the provenance became more solid and detection less likely. Whenever he saw his work in a museum or auction catalog, he kept it to himself. Blowing the whistle wouldn't benefit anyone, he thought. If he were to reveal the true nature of the work, it could cost an innocent collector a lot of money.

Such practices may be multiplied a hundredfold, making Hoving's estimate that as many as 40 percent of the artworks in the marketplace and in museums are fakes a plausible reality.

But as art criminals—thieves and fakers—become more numerous and more clever, science has stepped up to the plate in the discovery of fakes. It must be said at the outset that the vast majority of fakes or forgeries are readily detectible—bad ones originating at garage sales are usually weeded out before reaching the big-time art market—but a small percentage are not, as we have seen in this chapter.[40] As fakes of the past create special problems—that

is, when fakes are created contemporaneously with Old Masters such as Rembrandt or in the early nineteenth century, as with Turner or Winslow Homer—materials are generally an issue. When detective work is required, museums, collectors, and others may have recourse to numerous scientific tools to examine art of all kinds. Generally, and from an economic perspective, scientific methods are expensive and are generally reserved for high-priced art, but, that said, there is an enormous scientific toolkit to aid in providing credence in questionable art (Bell 2009).

We have already seen, in the case of Georgia O'Keeffe's *Canyon Suite*, that the dating or watermarking of paper may be a key in establishing the date of a work (in that case, some of the work). The papers, or at least some of them, were not of the right age to fit the alleged provenance of the watercolors. The same is true of canvas, paint, wood, or backing. "In-painting," which is the term for "repairs" to a painting, is also readily detectable with a black light or an ultraviolet fluorescent apparatus, which reveals areas of a painting that are not original. Forgers may rub dirt into cracks in a painting to simulate *craquelure*—a natural cracking of the paint on a canvas as the paint or support dries—and paper may be immersed in tea to simulate age. But detection has become high-tech.

X-rays can reveal whether there are paintings or drawings beneath the surface of a canvas. Suspicion would fall on a Renaissance painting with a modern drawing underneath. Canvas or any other support may be dated. If the support (that which the work is painted on) is wood, dendrochronology may be used in some cases if there is enough wood to work with. The age of a work may be verified with a variety of techniques, including carbon dating. Stretchers may be examined and dated, but it is not unusual for collectors and others to "reline" a canvas—hot-press a new canvas on the back of an existing one to flatten and preserve it—at which time new stretchers may be attached. Chemical processes may be used to uncover the exact minerals in paints of various colors. It may be, for example, that a canvas purported to be an early Edward Hopper uses paints (e.g., lead white) that were not in use when the artist is alleged to have painted the picture. Most recently, a Canadian forensics expert employed a "fingerprint" test. It is the case that some artists inadvertently leave their fingerprints on their paintings. Forensics expert Peter Paul Biro claims to have invented a process for uncovering authenticity using this method, although the method has been challenged.[41]

Our purpose here is not to be exhaustive in identifying the science behind the authentication process, but rather to suggest that science can play a role in providing credence in the genuineness of a work of art. Accumulated evidence generally summarized in a *catalogue raisonné* is often considered definitive. Further, although science may play a role in verification, there is

probably nothing to match the "eye" of an "expert." This is said to be the practice of connoisseurship. A mature lifetime of examining the works of, say, William Merritt Chase, is apt to allow one to almost instantly identify a faked Chase. Drawing and painting style, brushstrokes and composition are often as unique to an artist as DNA. In fact, an *artist's* DNA may come to the rescue of fake detection if a new technique gains currency (see the conclusion of this chapter for details). One who has examined hundreds of paintings by particular artists has an expertise that often can identify a fake quicker and more efficiently than scientific evidence of any kind. Through time, this expertise is acquired and becomes known in the art world, and when something appears "too good to be true" to them, it usually is. Dealers/sellers of particular artists or authors of the artists' *catalogue raisonné* are called upon often to provide an opinion as to the authenticity of artworks by auction houses or collectors. However, *catalogues raisonnés* are certainly not infallible guides to authenticity and provenance. For example, who is qualified to put the stamp of authenticity on an artist's work? Certainly the artist is, if she or he is still alive. Deceased artists—some gone for many years—present problems. Ostensibly a dealer, close associate, or, ideally, a close family member would be qualified to decide what work is to be included or excluded. But that is not always the case, as the example of Amadeo Modigliani, alleged to be the most "faked" twentieth-century artist, reveals. There are five *catalogues raisonnés* claiming to contain the artist's complete works, and two more are in the offing (Finley 2004: 57). Obviously, inclusion or exclusion in a volume dramatically affects the value of a work. The highly respected Wildenstein Institute, which has sponsored such works for many years, planned to construct one for Modigliani's drawings. But it canceled the "planned publication" "as a result of pressure and menaces, including telephone death threats, leveled at the work's author, Marc Restellini, by art collectors and their representatives" (Finley 2004: 58). Apparently the highly significant financial fallout from having one's work excluded is sufficient to halt or deter compilers of an artist's "genuine" work.

Committees or groups of individuals are formed to assess authenticity in most cases. In some jurisdictions—for example, France—if a work is deemed a fake, it is destroyed—but that is not the case in the United States. In France, the law assigns a *droit moral* to relatives, associates, or others connected to the artist that gives them carte blanche to judge authenticity. These committees (and those in the United States as well) are not necessarily free of influence or of bias. But, of late, few scholars are willing to openly publicize their views (certainly not in writing). The Georgia O'Keeffe Foundation refrained from passing judgment on the authenticity of works by the artist. That fact increasingly applies to artistic verification for artists around the world, including

American artists. Fear of litigation, as we have discussed earlier in this chapter, is the key, as Jane Kallir of the Galerie St. Etienne in New York (Kallir 2013: 11) notes, using quotations from experts:

> "Anyone can say with impunity that a painting is an authentic work, based solely on personal opinion," notes Jack Flam, who as president of the foundation overseeing [Robert] Motherwell's catalogue raisonné was among the first to go public about the alleged fakes sold by Knoedler [see earlier discussion of Knoedler fakes]. "But if a scholar who specializes in that artist's work says the painting is not authentic, the threat of a lawsuit arises—even though the scholar's opinion is right is being offered gratis and in the public interest." After spending years and nearly $7 million defending itself against a suit by the disgruntled owner of a questionable silkscreen, the Andy Warhol Foundation for the Visual Arts recently announced that its authentication board would be dissolved. Plagued by similar lawsuits, the Pollock-Krasner Foundation suspended its authentication services in 1995. Last June, the Roy Lichtenstein Foundation did likewise. Though it has never been sued, the Lichtenstein Foundation felt that the risk of litigation and the cost of liability insurance constituted an unjustifiable drain on its resources.

Thus, one great bulwark against fakes and forgeries is falling with threatened litigation. It has not fallen completely, however. There is still room for expert opinion, but courts will consider expert opinion along with science and provenance. Some experts will not produce an opinion in writing but will give a verbal assessment. "Experts" of all kinds, including committees, are nonetheless hesitant to proffer an opinion on authenticity.[42] Although case law has given some protection for expert opinions in some cases where an expert requires a signature of a "hold harmless" document *prior* to the opinion, an acknowledged expert in the field of law and legal liability on attributions in art (Spencer 2004: 185) has this to say:

> A statement of an expert about the authenticity of a painting even if preceded by the phrase "I think," "I believe," or "In my opinion," is, at least a "hybrid" opinion . . . in that it intimates the existence of specific facts and conveys the author's judgment upon, or interpretation of, those facts. . . . As such, the expert's statement on the authenticity of attribution of a work of art will most probably not be protected as

opinion by the First Amendment, even though it is expressly stated to
be mere "opinion" or "belief."

Thus, authentication is often a combination of science and connoisseurship,
and objective certainty is sometimes simply not possible. A picture may pass
all objective scientific tests and have a reasonable provenance, but that does
not prove authenticity. A battery of scholars may say, in the majority, that a
work is by a certain artist, but there is always room for error (consider the
Georgia O'Keeffe case).[43] Paintings may thus indefinitely lie in limbo, and
there may be no way of obtaining objective certainty. They are not, in many
cases, simply credence goods (whose authenticity may be revealed in time);
they are meta-credence goods—those goods for which there will never be cer-
tainty and for which no objective valuation is possible.

Economists Predict That Theft and Fakes Will Continue

Art theft, fakery, and forgery may clearly be examined from an economic per-
spective. Art theft conforms to the late Gary Becker's conception of all theft.
The individual thief will equate the marginal cost of art theft to the marginal
benefits. The locale of art theft (dealers, museums, private collections) will
in part be determined by the probability of apprehension in each of these
domains—explaining why perhaps the majority of theft in the United States
is from private residences and a mass of theft in Europe is from churches.
Another factor that has led to increasing art theft is the low probability of
apprehension and repatriation of the art. For low- to medium-value art, that
rate is probably significantly less than 10 percent (and perhaps about 50 per-
cent for high-value art). Apprehension involves local, state, and national (e.g.,
the FBI) involvement, which is lackluster in effect, to say the least. Resources
are devoted to violent crime, drug enforcement, and terrorism rather than to
art crime, making the overall cost of this kind of crime lower. Reportage of
art crime may also be hindered by the interests of museums and individual
collectors. Major art crime is handled by private enterprise based in England
in the Art Loss Registry (and in other agencies such as Interpol) and in new
businesses that have arisen for the purpose. Private-enterprise recovery is
also sponsored by insurance companies privately or through funded agencies
for the purpose. Nevertheless, art recovery is expensive and success is prob-
lematic, limiting the costly and intensive searches to the truly valuable (e.g.,
the Isabella Stewart Gardner heist). How would an economist evaluate this

situation? In summary, there are a plethora of uncomfortable facts surrounding the art market:

- There is a lack of due diligence on the part of buyers and sellers.
- False credence is often provided to gullible buyers.
- The recovery rate on stolen art is only a tiny fraction of works stolen.
- Enforcement is lackluster at best, except for the highest-valued thefts and armed robberies.
- Punishment often involves short or no prison terms, except for violent heists.
- Currency controls increasingly characterize the international scene.
- Art is being used as barter or collateral for the drug trade and other illicit markets.

Combining these factors with the soaring value of art at auction, in collections, in galleries, and in museums, the economist might safely predict that art theft will continue to be the third-largest major criminal activity in the world. If costs of art theft remain at roughly constant levels and the benefits continue to *rise* in monetary terms, we may safely predict that there will be more theft.[44]

Likewise, fakery may be quite profitable for both multiples (prints, etchings, etc.) and paintings. There are extremely few artists who can develop convincing pastiches of works by great artists. For obvious reasons, only great artist-fakers take on adding to the oeuvre of extremely famous artists. Lesser talents are focused on less-known artists or obscure drawings of better-known artists. As pointed out in this chapter, more than 95 percent of fakes, typically entering the food chain in swap shops, junk stores, on eBay, and elsewhere, are so bad that even the less experienced discover them. Successful sale of a high-value fake also requires forms of credence provision, such as provenance of a piece, which itself can be faked by documents or elaborately spun tales. Often due diligence is thrown out the window in the rush to get in on a "good deal" (as in the Dow case discussed in this chapter). As Thomas Hoving (1996: 25) put it, "the world wants to be fooled." And, as the science of detecting fakes progresses, so do the methods of the faker. It is useful to recall, however, that buyers and sellers set value, not fakebusters.

An economist, viewing the world and institutions as it is and they are, might argue that the present arrangements are indeed optimal, *given* current incentives, regulations, art markets, and detection technology.[45] Reportage of art theft and the existence of fakes by museums and collectors is lackluster. Policing and prosecution of art crime are spotty and lacking in enthusiasm.

Assemblage of a unified database on art crime is hampered by rent-seeking from local and national agencies. Art crime conducted by individuals or small "rings" is evolving into large-scale international syndicates as perpetrators are providing increasing demand for "art as money" and art as a means of laundering money. Problems of establishing credence and authenticity of some art are increasing. In other words, the incentives to "supply and demand" art theft and forgeries are established by the existing states of institutions, and the states of those institutions explain much of what is happening in the art world generally. American art and its inflating values, especially of Contemporary works, should give pause to museums and collectors vis-à-vis general institutional conditions. Given the vagaries, secrecy, and opaque quality of the art marketplace—which some would describe as chaotic—prices should adjust to expected value. In those circumstances where a piece of art is a meta-credence good, price will adjust depending on the amount of credence that can be established in it by the seller and by research of the buyer. Experts are routinely fooled, so the doctrine of *caveat emptor* should apply not only to the novice, but also to the experienced collector or museum purchaser. Again to quote the late Thomas Hoving (1996: 333), bemoaning the great likelihood that what one might purchase is stolen or is a fake or a forgery, "the only solace is to live and learn, and never be swayed by need, speed, or greed. Above all, collect art the only way it should be collected, purely for love. Then if you get stung you won't really get mad. Unlike me." One might add that being familiar with the economics and market functioning of the art world would assist any market participant in making careful and discerning choices.

Chapter 7

The Impact of Death and Bubbles in American Art

CLEARLY THEFT AND fakery are two serious issues that confound art markets, including American art markets, as we have seen. But there are many others. Consider two of them, also part and parcel of the American art market: Does death have an impact on the prices experienced by an artist at auction? Are art bubbles, somehow defined, a feature of art markets, and, if so, how are they explained? While these two questions may seem to be unrelated, they may have more in common than one might think. The present chapter deals with death and art, specifically American art. We attempt to define and isolate a "death effect" for eighteen artists who died within our sample period. Naturally there must be qualifications put on the time of death—an artist in her nineties can hardly be expected to live another twenty years, so that anticipation may affect the discount rate attached to her work. And there may be other explanations for what does or does not happen on the occasion of an artist's passing.

Art bubbles, like real estate bubbles, are relatively easy to make passing reference to, but how are they to be defined? The present chapter considers the way economists have defined "bubbles"—such as "tulip mania" or the tulip bubble of the seventeenth century—and investigates whether, empirically, a bubble might exist for artists in our sample, or for Contemporary American art in general over the period.

The Death Effect in Art

Death is a certainty for all, but the exact date is always unknown, *a priori*. Does an artist's value rise or "cluster" *before*, *at*, or *after* death? Are any or all

of these phenomena consistent with or unique to a death effect for artists? Does her age at death matter? What about the artist's reputation and information about her on death? Does death affect the artist's price history? Many persons believe that death matters. Certainly the theoretical and empirical issue of a "death effect" for artists has been the subject of specific economic inquiry for several decades. *Why* would such an effect take place if it is found to matter empirically? Earlier researchers have, for example, identified the existence of such effects, but have failed to present a theoretical rationale for the observation.[1] Theoretical and empirical study of that question began a decade and a half ago in a paper by Ekelund, Ressler, and Watson (2000), as noted by Ursprung and Wiermann (2011: 697–698). These writers argued that, while many factors including age, reputation, and information affect the supply of and demand for an artist's work before, at, and after death, a unique market effect takes place. In analogy to Ronald Coase's durable-goods monopoly (1972), an artist's death provides an irrevocable guarantee that the artist's output will end and the market will not be "spoiled" by increasing supply and decreasing prices. A death effect is then defined as an increase in an artist's prices before, at, or around the time of death caused by the Coase conjecture. The question is whether any of these three possible effects are unique to the Coase conjecture if that is defined as analogous to a death effect for artists.

Several post-2000 papers have affirmed, criticized, redefined, or augmented the argument based upon Coase's famous idea. While developing important new ideas, many of these papers present arguments concerning the foundation of the death effect that conflict with those presented by Ekelund et al. (2000), as they do with each other. The purpose of yet more research on the death effect is basically twofold: (1) to review and evaluate the criticism and additions to the Coasian explanation for a death effect among artists; and (2) to employ a new sample of American artists who died between 1987 and 2013 to test for the presence of a death effect as interpreted as an analogy to Coase. Critically, however, while a change in price at, before, or after an artist's death may be consistent with the Coase conjecture, only one result is unique to the analogy—the pre-death increase in price. We begin by defining a death effect as based on the Coase conjecture, after which we consider possible additions to and criticisms of the idea. Next we present new econometric evidence on the presence of a death effect for Contemporary American artists and their art within the context of the conjecture and post-2000 additions to the literature. Finally, we assess the relevance of a potential death effect in the price history of an artist.

An Artist's Death and Economic Theory

A plethora of factors affect both supply of and demand for an artist's work during an artist's life and after her death. Information and other issues strongly affect demand and supply conditions. Flows of demand and supply are conditioned by many factors, including the current transacted price of a particular artist's work; demanders' income and income distribution in the relevant market; the price of alternative assets; the artist's reputation as reflected in critical reviews, gallery representation, museum shows, presence in distinguished collections, and appearance at auction; "hype" and advertising by dealers; and many other factors.[2]

Supply of an artist's output generally consists of all sellers' holdings of an artist's output (including the artist's), works in private collections, in dealers' hands, and sometimes in museums.[3] As a flow, an artist's "supply" is determined by her rate of output set against a sales rate by the artist, at auction or through dealers. Output rates are a function of many other variables—the health of the artist, her or his age, and so on. At death, however, barring the production of faked work, an artist's output ceases and supply becomes finite—that which is in the hands of dealers or possibly available at auction by collectors or the inheritors of the artist's atelier.

The Coase Conjecture

The demand for an artist's output through time is naturally a function of a multiplicity of factors, but one may analogize to the durable-goods monopolist as described by Ronald Coase in 1972. The theoretical argument is quite simple: If an individual or a cartel has monopoly control over all relevant property resources in a defined area, the owner or owners face a demand curve in the sale of the property. Given demand, they would sell a monopoly quantity of land at the monopoly price. But this would not be possible without some kind of guarantee from the owner that she would not move down the demand curve, selling enhanced quantities of land at lower than the monopoly price. To successfully maintain a monopoly, the seller must assure buyers that the value of their investment will be protected with buy-back warranties, with leasing arrangements, and by giving away some of the "excess" property as "green" areas, recreational facilities, parks, biking areas, and other amenities, which would help to establish the monopoly price. But beyond the ability to institute these features, a "durable-goods monopolist" cannot charge a monopoly price. In the limit, she could not charge anything for the land above the competitive price.

The analogy to artists is apt. An individual artist's demand and marginal-revenue curves are fashioned by many factors, including some expected "normal" rate of output through time. If, for simplicity, we assume that the output is highly substitutable and that for analytical purposes the work is homogeneous (as is assumed in some studies), the monopoly element is the *style* or *styles* of the artist. When production continues over time, "the producer [landowner or artist] must consider the effect his actions have on the expectations of consumers about his actions in future periods" (Coase 1972: 148). Restricted supply determines the value of an artist's work on the demand side. Artists optimize by restricting supply of their work when the gain from doing so is greater than the gain from increasing it. But as Coase correctly points out (1972: 148) with respect to the land monopolist, "there is no reason why conditions should not be such that it would always pay to disappoint consumers' expectations of a restriction in output (if they held such expectations) and in such circumstances, output in all periods would be such as to make marginal cost equal to price [that is, the *competitive* solution]." This result obtains if arrangements or promises to restrict supply cannot be made with the artist's demanders.

Artists, in exact analogy to the landowning durable-goods monopoly, can only make imperfect contractual arrangements with demanders of this art. But a few features of artistic supply may permit some of these arrangements. Artists creating "multiples" (woodcuts, lithographs, prints, linocuts, silkscreen, and so on) will typically limit the size of the "run," numbering the total edition. After printing the limited run, the plates, woodblocks, or linoleum blocks are destroyed, guaranteeing consumers that no additional prints will be made.[4] Artists may make public that a portion of their output will not enter traditional sales channels. This may be done through *intervivos*, or announced bequests to individuals, institutions, or museums, especially in the case of top artists, or through other means. Artists and/or their dealers often donate (or offer at reduced prices) works to museums. This serves a *dual* purpose—it helps establish the artist's brand, and it advertises that portions of the artist's output are being withheld from the market. Contemporary artists and their dealers may use self-enforced or dealer-mandated limitations in supply (a practice known to collectors) to manipulate and hopefully increase demand, although many such practices may not survive court challenge. Waiting lists kept by dealers for hot artists are a means of attempting, however imperfectly, to control supply, at least in the short term.[5] However, there are no enforceable and durable arrangements that can be made between artist and demanders to the effect that the artist will not "overproduce" her works, spoiling the market. For most artists, the prospect of this devaluation will, other things being equal

and for most artists in most circumstances, hold prices and returns at com-
petitive levels.[6] However, this factor will exist to some extent until the artist's
death since, barring the production of fakes, death signals the end of an art-
ist's supply and productivity.

A "death effect" hypothesis is that demand and prices will respond *in an-
ticipation of death* due to the certainty described in the preceding—that the
artist's values will not be lowered by increased artistic output—the supply
rate—of her works. This factor will depend on the age or health of the artist,
how closely these factors are monitored by demanders and, in all, how soon
the end is anticipated by demanders. As information concerning the age and
health (e.g., a diagnosis of terminal cancer) of an artist is advertised and the
probability of death or incapacity is calculated by buyers, the information is
capitalized in the price of the artist's work. In other words, the information is
captured in market values when the rationally expected range of age is capi-
talized in the demand function for the artist's work. Note that at the time of
death and after death, the impact of supply becomes relevant for other rea-
sons. Prices may rise, fall, or remain on a constant path, but at that time the
cessation of supply due to the Coase conjecture is internalized in the artist's
demand. An increase in price at or after death is consistent with the conjec-
ture, but that is neither necessary nor sufficient to empirically establish the
operation of it.

The "past, present and anticipated reputation among potential demanders,
the number of major shows and retrospectives relating to the artist's work,
reviews, death notices and so on" (Ekelund, Ressler, and Watson 2000) must
also be considered in any demand-death formulation.[7] The large pound of *ce-
teris paribus* in the death effect as durable-goods monopoly must be and has
been supplemented in the post-2000 literature, but several alternative expla-
nations for a "death effect" are spurious.

What a "Death Effect" Is Not

Since the analogy was proposed between the Coasian durable-goods monop-
olist and the death effect for artists, a number of alternative hypotheses for
a "price bump" at death have emerged. The most popular of these is the so-
called "nostalgia effect," which purportedly affects the demand for products
after death. According to Matheson and Baade (2004: 1152), "the media atten-
tion that surrounds the death of a prominent artist or another notable figure
increases the public interest in the person and the person's life and works.
This increased interest, which one refers to as a 'nostalgia effect,' will increase
demand for the collectibles and thereby increase their prices." Nostalgia is

generally regarded as a longing for a person, period, or place that is irretriev-able. The motivation for Matheson and Baade's analysis of nostalgia stems from the results of Ekelund et al.'s (2000) small empirical study of twenty-one Latin American artists, which found evidence of a death effect—a clustering of prices at death and then a tapering off of the increase after the artist's death. Matheson and Baade believe (2004: 1152) that this latter pattern is the result of a nostalgia effect that cannot be explained by the Coase conjecture.[8]

While there are a multiplicity of explanations for a (purported) fall-back in the price of art after an artist's death, the nostalgia analysis as "longing" for an irretrievable state or person cannot be used as an explanation or as an alterna-tive to the Coasian conjecture. While it is true that collectors of memorabilia—baseball cards or objects associated with movie stars, singers, or athletes, such as an Elvis guitar or Marilyn Monroe's articles of clothing—may experience nostalgia for objects created by certain individuals or in certain contexts, it is difficult to project "nostalgia" about the death of, say, Agnes Martin or Millard Sheets, onto a collector of their art.[9] The durable-goods monopoly theory, how-ever, *does* have implications for collectors' demands. Announcement of death, moreover, if the collector has not kept abreast of the artist's physical condition including age, may trigger that supply-side effect.[10] But that would have noth-ing to do with "nostalgia" for the artist or her passing.

Ekelund et al. (2000) note that the price "bump" at death may be followed by a quantity increase and a price decline, as it does for their small sample of Latin American artists. They propose that an intertemporal supply increase may help account for the reversion of prices to an earlier (possibly upward) path. Anticipated price increases may bring artists' works out of collections, museums, and the artist's atelier, *shifting* the supply curve rightward, rather than represent a movement along an initial supply curve, producing a (pos-sibly short-term) price decline after death. Price expectations are present in both the demand and supply curves.

The fundamental difficulty with the so-called nostalgia effect as a substi-tute for the durable-goods monopoly analogy in artistic creation is that the latter is based on a *changed* supply affecting demand created by the death of an artist. The Coasian death effect is not a "fixed supply" per se, but rather the *assurance that after death, demanders may be certain that a supply or a supply rate will be reduced to zero*. The artist's rate of production often, but not nec-essarily, slows with age, but death is a guarantee (absent fakery) of an end of the output. Other factors may and must play a role in the after-death price path of artists—critical assessments, museum shows, and so on. But a nos-talgia effect, which certainly may exist for certain celebrities, does not occur because supplies are affected, as in the example of baseball cards used by

Matheson and Baade (2004), but are due to psychological forces related to celebrity. A "death effect" in art prices paid at auction and to dealers would create an increase in prices, *ceteris paribus*, as the death of a living artist approaches. The price path after that would depend on a multiplicity of factors affecting demand and available *supply*. Nostalgia is unlikely to be one of them.[11]

Naturally the obituary of an artist providing information may trigger a "death effect," affecting the stock of information held by demanders and suppliers, in effect shifting curves. Later reassessments of the artist's works and news of the artist's standing in the pantheon—retrospectives, important acquisitions by museums or by famous collectors, and so on—may well have the impact of increasing demand for an artist's work through time, but that is not the effect promised by the Coase conjecture. In short, the Coase conjecture—an increase in demand for an artist's output premised on the irrevocable condition of supply—is consistent with an increase in prices before, at, and after an artist's death. But the only unique correspondence with that theory is a positive price rise *before* death.

Empirical Studies of the Death Effect

Use of the Coase conjecture applied to artists has stimulated empirical research on the relationship between the durable-goods monopoly problem and the course of art prices since the analogy was first raised and caveats concerning age and information about artists at death were issued.[12] Several important addenda have supplemented the "death effect" along these lines, using alternative methods and samples and some of the preceding suggestions, since 2000. Worthington and Higgs (2006) created a sample of sixty Australian artists using a large sample of paintings at auction between 1973 and 2003. Thirty-nine of them died before the auction date, creating a statistically significant price increase of about 1.15 percent. Danish artists dying between 1983 and 2003 are examined by Maddison and Pedersen (2008) using an interesting "conditional life expectancy" for Danes between 1990 and 1999 from a human mortality base. Using this conditional life expectancy and other variables in a hedonic regression, they determine that there is a positive relation between death and *current price* of paintings, and a negative relation between conditional life expectancy and current price. (There is much variance in the survival rate in the sample, with the youngest artist living only until thirty-eight and the oldest surviving until one hundred.) In a separate test (2008: 1791–1792) using "dead" and "years after death" variables, moreover, a death effect due to the durable monopoly is discerned with "the price of an artist's work ... [falling] ... significantly in the years following their [sic]

death," replicating the test results of Ekelund et al. and possibly suggesting an increase in supply in the immediate post-death period. The test combining the variables of conditional life expectancy, death, and years after death adds support to a death effect (*if conditional life expectancy is interpreted as a "death effect"*). However, the "date" of death itself loses significance in the combined test. If conditional life expectancy is equivalent to a "death effect," this study has uncovered one for Danish artists. Conditional life expectancy suggests that the death of an artist would be internalized as the artist ages, but it does not include other critical factors that affect demand or supply at the time of an artist's death. Further, it only suggests that age is internalized and discounted in art prices. A death effect means that prices rise at death because that internalization is *not* complete for artists owing to information and/or other problems.

An important and interesting study in the death-effect literature is that of Ursprung and Wiermann (2011). This study (a) recognizes that age is related to art prices for a large sample of artists through an "internalization" process; (b) that a Coase conjecture is applicable and relevant to art prices; and (c) that an artist's reputation must be combined with the durable-goods monopoly argument to understand how death applies to artists at different ages. The study does not use a simple and exclusively negative relation between "conditional life expectancy" and the price of artists' work. Rather, it adds the reasonable theoretical hypothesis that reputation plays an important role in explaining art markets, elaborated by Beckert and Rossel (2004). The main result of the paper is that, when reputation is added to the internalization mechanism (the durable-goods monopoly), the relation between the death effect and artists' age is an inverse U-shape. Further, they argue that this effect is more pronounced for top-level artists than for "accomplished artists" and is greater for accomplished artists than for "journeyman artists." They thus decompose the overall death effect into one where reputation dominates up to a point until the durable-goods internalization takes over, the summed impact reaching a peak and then diminishing as the artist reaches older ages. The critical addition here is the "reputation effect," which, for younger artists who die, means a *decline* in prices at death, the opposite of what one might possibly expect. Ursprung and Wiermann (2011: 698) describe how the reputation-induced demand for art works:

> At the beginning of their careers, artists have no far-reaching reputation to speak of. Nevertheless, collectors who happen to be familiar with the work of promising young artists might well pay a considerable price for their works of art since they expect these artists to eventually obtain

a reputation that justifies the price they pay for the fledgling's work. If such an artist dies an untimely death, her lifetime oeuvre might not be sufficiently substantial to generate the expected reputation, and the price drops. There are thus two mechanisms determining the death effect: the standard positive effect deriving from unexpected scarcity of supply and a negative effect deriving from frustrated demand-side expectations of artistic reputation. Both effects disappear from artists who die at a ripe old age. In conjunction, the scarcity and the reputation effect give rise to the identified inversely U-shaped relationship between death-related price changes at death.

Note that the authors believe that reputation is an *increasing function* of the size of the oeuvre of the artist. Using data assembled from Hislop's Art Sale Index (1980–2005) they find, with ordinary least squares (OLS) and quantile regressions, evidence (1) for a statistically significant death effect as they define it; (2) for price declines when artists die at younger ages but for price increases due to "scarcity" (Coase's conjecture) at older ages; (3) an inverse U-shaped relationship between a death effect and age at death; and (4) a death effect that is larger for "quality" (that is, high-priced) art. Ursprung and Wiermann find (2011: 708) that "the death effect is indeed negative if an artist dies at a young age. This negative impact decreases with increasing age at death, and the death effect completely disappears—depending on specification—between 63 and 75. If the artist dies after that critical age, the reputation effect is dominated by the scarcity or age internalization effect and the death effect becomes positive. The death effect is at a maximum for an age at death between 83 and 88 years and amounts to 5 percent–10 percent. At greater ages at death, the effect disappears" and may become negative.

Ursprung and Wiermann create a means of integrating reputation and death, but they do so by assuming that reputation is a monotonically (never decreasing) increasing function of age. Early death, in this scenario, eliminates the ability of an artist to achieve recognition and reduces the demand for her work at death. Thus two effects are conflicting in the study. Reputation is a function of a constant-flow and homogeneous production. Production is naturally a function of age, and therefore reputation is represented by age. Thus the death effect identified by Ursprung and Wiermann is an inverse U-shape, as described earlier. As they note, "the death of young artists actually decreases the price of their works of art, whereas the death effect is positive for older artists and disappears for artists who die at a very old age" (2011: 698).

Two possible problems exist with this analysis. It is not at all clear that artistic reputation is related in some linear fashion to production and production to age. Many artists (composers, poets, economists) create important reputations with small outputs so that age may not represent reputation in the manner posited. It may be argued that exalted reputations are being made at earlier and earlier ages due in part to the "innovative" character of contemporary art. Many artists who die young (Basquiat) or relatively young (Warhol) enjoyed skyrocketing prices at death. More important, even if the variable age does represent combined reputation and an internalized supply effect, the presentation develops a profile of how *age at death affects prices*, as opposed to how death affects prices, which we have identified as the "death effect." In the Ursprung-Wiermann conception, death is ancillary to, but not necessarily part of, the Coase conjecture because it deals with the effects of age at death on prices, but not how prices behave at or around the time of death. In the former, death is given; in the latter conception, death is stochastic—age at death is random.[13]

Empirical Issues in Studying a Death Effect

How one views the effect of an artist's death on art prices determines how one specifies the "death effect" empirically. The most fundamental and, we believe, narrow view of the death effect is simply that the prices of an artist's work rise after his or her death. Empirically, this effect is captured by a dummy variable that takes on values of zero prior to the artist's death and unity thereafter (see, e.g., Agnello and Pierce [1996]). A positive and significant dummy coefficient is taken to mean that an artist's death caused the price of his or her art to rise. This is, of course, a crude measure; depending on the heterogeneity of the sample and the sophistication of the hedonic specification, a significant dummy coefficient could be attributable to unmodeled factors contemporaneous to the artist's death, and not to the artist's death per se. Nevertheless, it is at least an attempt to take into account the effect of an artist's death on art prices.

This narrow view of the death effect need not, of necessity, imply a simple dummy-variable specification alone. Ursprung and Wiermann (2011) address the question of how age at death affects the magnitude and direction of the death effect by creating a (type of) death dummy (= 1 for the year of death and the two subsequent years; = 0, otherwise) and interacting it with a polynomial in age at death. Their results not only indicate the distinct presence of a death effect, but also provide evidence of an inverted U-shaped profile of how art prices respond to increases in artists' age at death. While this profile is

clearly the thrust of their investigation, their model also includes an additional death-effect variable Time Since Death (TSD), which they find to be negatively related to art prices. Thus their view is clearly broader than the simple death-dummy approach, but it remains limited since they offer no measure of the price response to the expectation of an artist's imminent demise.

If one accepts the notion that the Coase conjecture is a (if not *the*) theoretical underpinning of the death effect, then there are potentially three components to an empirical measure of the death effect: (1) the impact on prices in anticipation of the artist's death; (2) a measure of prices at the time of the artist's death; and (3) a measure of prices after the artist's death, *or* when it is clear that the supply of his or her paintings is fixed due to the internalization of the impact of demand induced by the absolute and guaranteed limit of supply due to death. (Note that major auctions for most genres of art take place during two seasons of the year—spring and late fall in the case of American art—so that the impact *at* death may not show up without a year—or less—lag.) Two studies have attempted to incorporate these three dimensions in their empirical specifications of the death effect. In their original study of the death effect in Mexican art prices, Ekelund et al. (2000) employ one variable, Years After Death Squared [YAD^2 = (year of sale–year of death)2], to capture all three dimensions. They find the coefficient on this variable to be negative and significant, implying that as death approaches (YAD^2 decreases) art prices rise, at death (YAD^2 = 0) the death-related portion of art prices is at a maximum, and in the years after death (YAD^2 increases) art prices fall. While clearly a parsimonious specification, this approach incorporates two implicit constraints that may or may not be justified: symmetry of the magnitude of the death effect about the year of death and the death-related portion of art prices maximizing at the year of death. Since these restrictions imply empirically testable hypotheses, this approach is not necessarily inappropriate *a priori*.

In a study of the death effect in Danish art prices, Maddison and Pedersen (2008) avoid these implicit parameter restrictions but may encounter other equally serious problems. In their specification labeled Model 3, they measure each potential component of the death effect with a separate variable. They use a traditionally defined death-dummy variable (DEAD) to measure the price effect at death, and Years After Death (not squared as in Ekelund et al.) to measure the price effect after the artist's demise. Their most innovative measure, however, is the use of Conditional Life Expectancy to measure the effect of the anticipation of the artist's death on prices. Initially, this may

seem precisely to mimic the decision-making calculus of the typical art buyer, but instead it is a source of potentially serious measurement error for two reasons. First, their conditional life-expectancy measure is based on life and death statistics for the general populace, not for artists per se. Since there is considerable anecdotal evidence that artists may live longer than the average person, this variable may result in a systematic underestimate of the actual time to the artist's death.[14] Second, the conditional life-expectancy variable is equivalent to the negative part of Ekelund et al.'s Years After Death variable before it is squared (i.e., Years Before Death). The difference is that the latter assumes clairvoyance on the part of the buyer (i.e., he knows how much longer the artist will live) and the former is a conditional expectation of how much longer the artist will live. Thus any difference between the two approaches arises from a statistically based measurement error and potentially may lead to inconsistent estimates. Maddison and Pedersen find negative and significant coefficients for Conditional Life Expectancy and Years After Death, indicating that prices rise until (expected) death and fall thereafter. The death dummy was negative but insignificant. Finally, it is worth noting that Maddison and Pedersen criticize the initial study for assuming symmetry of the death effect in their specification (2008: 1790), but a crude test of the equality of the Conditional Life Expectancy and Years After Death coefficients, based on the results presented in their Model 3, indicates that the null of a symmetric death effect (about the year of death) cannot be rejected ($t = 1.03$).[15] Thus, the symmetry restrictions implicit in the specification of Ekelund et al. may in fact be justified.

These observations suggest two alternative methods of specifying the death effect within the context of a traditional hedonic model of art prices:

$$\ln P_{im} = \beta_0 + \sum_{j=1}^{k} \beta_j X_{ijm} + \gamma_1 \text{YAD}^2_{im} + \gamma_2 \text{DD}_{im} + \gamma_3 \left(\text{DD}*\text{YAD}^2\right)_{im} + \varepsilon_{im} \quad (7.1)$$

and

$$\ln P_{im} = \beta_0 + \sum_{j=1}^{k} \beta_j X_{ijm} + \gamma_1 \text{YTD}_{im} + \gamma_2 \text{DD}_{im} + \gamma_3 \text{YAD}_{im} + \varepsilon_{im}, \quad (7.2)$$

where $\ln P_{im}$ is the natural logarithm of price of the ith painting sold at auction by the mth artist ($i = 1, \ldots, n_m$; $m = 1, \ldots, M$); the X_{ijm} are the j ($j = 1, \ldots, k$) hedonic characteristics of the ith painting by the mth artist; YAD^2_{im} = (year of sale of the ith painting by the mth artist—year of death of the mth artist)2;

$DD_{im} = 1$ if the mth artist was dead when his ith painting sold at auction; $= 0$, otherwise; $DD * YAD^2$ is an interaction term given by the product of the death dummy with YAD^2; $YTD_{im} =$ (year of death of the mth artist—year of sale of the ith painting by the mth artist) for year of death > year of sale; $= 0$, otherwise; and $YAD_{im} =$ (year of sale of the ith painting by the mth artist—year of death of the mth artist) for year of sale > year of death; $= 0$, otherwise.

Equation (7.1) is a specification that expands on the one posited by Ekelund et al. (2000) where a death dummy (DD) has been added to allow art prices in the year of death to rise above or fall below prices in the year prior to (or year after) death, and an interaction term $DD*YAD^2$ has been added to allow an asymmetric price response after death as compared to before death. In this model, the effect on (log) price in anticipation of the artist's death is given by γ_1, since DD and $DD*YAD^2$ are both zero for years prior to death. The one unambiguous component of Coase-conjecture-based price response *is that prices should rise as the artist approaches death, so based on the Coase conjecture γ_1 should be negative.*[16] The price response in the year of death is γ_2, actually $(e^{\gamma_2} - 1)$, since YAD^2 (and hence $DD*YAD^2$) equals zero for that year.[17] A pure Coase effect would suggest a positive value for γ_2 arising from the increased demand due to the certainty that the artist will produce no more works. But price is determined by both demand and supply. If the expected price increase arising from the artist's death also elicits an exogenous supply response that pulls the artist's work out of collections and galleries and onto the market (Ekelund, Ressler, and Watson 2000: 295), γ_2 could reasonably be negative if this resultant increase in supply more than offsets the potential increase in demand. Finally, the marginal effect on price of post-death-year increases in YAD^2 is given by $(\gamma_1 + \gamma_3)$ since DD = 1.[18] While the sign of this portion of the death effect is theoretically uncertain, it is clear that the direction of this effect is strictly demand-determined because at this point (absent fakes), supply can reasonably be viewed as fixed. If demand begins to fall back to pre-death anticipation levels, this effect will be negative; if demand continues to increase (perhaps because the artist's genre has gained a broader following), then this effect will be positive.

Equation (7.2) parallels a Maddison and Pedersen specification, where we assume clairvoyance on the part of buyers as to the date of the artist's death. Interpreting the death effect based on estimates of equation (7.2) is straightforward. The effect of the anticipation of the artist's upcoming death on price is given by γ_1 since DD and YAD both take on zero values when the artist is alive. The price effect of the death year per se is given by γ_2 since both YTD and YAD take on zero values in this case. The marginal effect of years after

the death year on price is given by γ_3 since YTD is defined to be zero for this period. For essentially the same reasons we discussed regarding equation (7.1), we anticipate γ_1 to be negative; γ_2 and γ_3 have theoretically ambiguous signs. These two alternative specifications may be used to estimate the death effect for the case of Contemporary American artists.

Contemporary American Art: An Idiosyncratic Death Effect?

Do Contemporary American artists exhibit a death effect, and if so, is it explainable by the Coase conjecture? We address this question by drawing a sample of paintings by American artists, born after 1900 and painting after 1950, which were offered at auction between 1987 and 2013 from the website askART.com. We confine our attention to auction data because they are publicly available; to artists born after 1900 because we are interested in "contemporary" as opposed to "early" American art; and to paintings executed after 1950 because that decade is typically taken as the beginning of a bifurcation in the market for American art, separating "early" from "contemporary" American art. The resulting sample was composed of 13,991 paintings by the forty-eight well-known American artists listed in Table 7.1, along with their life-span data. Since we aim to estimate hedonic price models that allow for a death effect, we require data on market prices of the various paintings. Consequently, we must eliminate paintings that were offered at auction but did not sell, alternatively termed "bought-ins" or "no-sales," from our sample. There were 3,766 such paintings; so their deletion leaves a sample of 10,225 Contemporary American paintings sold at auction between 1987 and 2012.

These paintings were executed by artists who were still alive as of January 1, 2014, who died prior to 1987, or who died between 1987 and 2013. We have noted earlier that only in its crudest form is the death effect taken to be the difference in painting prices for living versus dead artists, since such differences could arise from sources other than the death of the artist. If, however, we are interested in a more precise view of the death effect, which can be used to test the Coase conjecture, we need information on prices leading up to the artist's death, prices at the time of the artist's death, and price behavior after the artist's death. These data, in whole or in part, are neither available nor relevant to living artists or artists who died prior to the sample period. Utilizing data on such artists in the sample will only confound our death effect estimates and, at the minimum, reduce their statistical efficiency. Consequently, we confine our attention to only artists who died during the sample period, leaving us

Table 7.1 Forty-eight American Artists Born Post-1900 and Painting Post-1950

Artist	Life Span	Artist	Life Span
Philip Evergood	1901–1973	Robert Rauschenberg	1925–2008
Mark Rothko	1903–1970	Wolf Kahn	1927–
Hans Burkhardt	1904–1994	Alex Katz	1927–
Fairfield Porter	1907–1975	Helen Frankenthaler	1928–2011
Millard Sheets	1907–1989	Robert Indiana	1928–
Norman Lewis	1909–1979	Nathan Oliveira	1928–2010
Franz Kline	1910–1962	Cy Twombly	1928–2011
Romare Bearden	1911–1988	Claes Oldenburg	1929–
William Baziotes	1912–1963	Jasper Johns	1930–
Ida Kohlmeyer	1912–1963	Sam Gilliam	1933–
Agnes Martin	1912–2004	James Rosenquist	1933–
Jackson Pollock	1912–1956	Jim Dine	1935–
Philip Guston	1913–1980	Frank Stella	1936–
Ad Reinhardt	1913–1967	Red Grooms	1937–
Robert Motherwell	1915–1991	Larry Poons	1937–
Milton Resnick	1917–2004	Brice Marden	1938–
Andrew Wyeth	1917–2009	Bruce Nauman	1941–
Wayne Thiebaud	1920–	Susan Rothenberg	1945–
Richard Diebenkorn	1922–1993	Eric Fischl	1948–
Ellsworth Kelly	1923–2015	Julian Schnabel	1951–
Roy Lichtenstein	1923–1997	David Salle	1952–
Larry Rivers	1923–2002	Kenny Scharf	1958–
Kenneth Noland	1924–2010	Jean-Michel Basquiat	1960–1988
Joan Mitchell	1925–1992	Andy Warhol	1928–1987

Note: This table was current as of 2013.

with observations on 6,118 paintings sold by the seventeen artists listed in Table 7.2 (along with their age at death and date of death).

We gathered data on art prices (premium and hammer prices) and various painting and artist characteristics for these 6,118 paintings from askART.com and the information in Table 7.2. We used these data to create the following hedonic variables: (a) painting characteristics—AREA, the area of the painting in square inches; AREA SQUARED, the square of AREA; SIGNED, = 1 if the painting was signed by the artist, = 0, otherwise; MEDIA DUMMY = 1 if the painting is an oil, = 0, otherwise; (b) artist characteristics—AGE, age of the artist at the time the painting was created, and its square AGE SQUARE;[19] DIED YOUNG DUMMY = 1 if the artist died before age seventy, = 0, otherwise; and a set of sixteen artist dummies DA2–DA17, where $DA_{m,i}$ = 1 if artist m painted

<table>
<tr><td colspan="5" align="center">Table 7.2 Artists Who Died over Sample Period, 1987–2013</td></tr>
</table>

Artist	Birth/Death Year	Age at Death	Date of Death
Millard Sheets	1907–1989	82	3/31/1989
Romare Bearden	1911–1988	77	3/12/1988
Agnes Martin	1912–2004	92	12/18/2004
Robert Motherwell	1915–1991	76	7/16/1991
Milton Resnick	1917–2004	87	3/12/2004
Andrew Wyeth	1917–2009	92	1/16/2009
Richard Diebenkorn	1922–1993	71	3/30/1993
Roy Lichtenstein	1923–1997	74	9/29/1997
Larry Rivers	1923–2002	79	9/29/1997
Kenneth Noland	1924–2010	86	1/5/2010
Joan Mitchell	1925–1992	67	10/30/1992
Robert Rauschenberg	1925–2008	83	5/12/2008
Helen Frankenthaler	1928–2011	83	12/27/2011
Andy Warhol	1928–1987	59	2/22/1987
Nathan Olivera	1928–2010	82	11/13/2010
Cy Twombly	1928–2011	83	7/5/2011
Jean-Michel Basquiat	1960–1988	27	8/12/1988

painting i, = 0, otherwise;[20] (c) death-effect variables—YEARS AFTER DEATH SQUARED $(YAD)^2$ = (year of sale of the ith painting by the mth artist—year of death of the mth artist)2; DEATH DUMMY $(DD_{i,m})$ = 1 if the mth artist was dead when his ith painting sold at auction; = 0, otherwise; $(DD*YAD^2)$, an interaction term given by the product of the death dummy with YAD^2; YEARS UNTIL DEATH (YTD_{im}) = (year of death of the mth artist—year of sale of the ith painting by the mth artist) for year of death > year of sale; = 0, otherwise; and YEARS AFTER DEATH (YAD_{im}) = (year of sale of the ith painting by the mth artist—year of death of the mth artist) for year of sale > year of death; = 0, otherwise.

These variables were used to estimate two versions each of the two hedonic equations specified in the previous section; the OLS results for estimating equations (7.1) and 7.2), are presented in Appendix Table 7A.1 (see Appendices); those results and their implications are discussed in the following. The second and fourth columns of Table 7A.1 present parameter estimates for equations (7.1) and (7.2), respectively, assuming that price is measured as the natural logarithm of real (i.e., price-deflated) premium price.[21] This is the price measure that we believe is most relevant for hedonic estimation because

it includes the buyer's premium, which is sufficiently large that it must enter into any potential purchaser's decision calculus. However, many prior studies employ the Hislop data, which include only hammer prices. Consequently, for comparability with other studies, the third and fifth columns of Table 7A.1 present parameter estimates for equations (7.1) and (7.2), respectively, if price is measured as the natural logarithm of real (i.e., price-deflated) hammer price.[22]

The first twenty-four rows of Table 7A.1 present parameter estimates for the hedonic variables—that is, the painting and artist characteristics (the X_{ijm} of equations [7.1] and [7.2]). With the possible exception of those for DIED YOUNG DUMMY, these estimates appear remarkably robust, both with respect to the specification of the price variable and the specification of the death effect. Thus we will discuss these results in general terms that apply broadly to all four models. The AREA and AREA SQUARED estimates are both statistically significant, and their sign pattern suggests price-maximizing area of about 53,840 square inches. Since this size is over thirty times the sample mean area, it seems reasonable to simply conclude that art prices increase at a decreasing rate with increased area of the painting. The coefficient on SIGNED is positive and statistically significant, indicating that an artist signing the painting increases its value by about 51 percent, *ceteris paribus* (the average of the SIGNED coefficient across models is about 0.415, and exp(0.415) −1 = 0.514). Similarly, the coefficient on MEDIUM DUMMY is positive and significant; this result suggests that a painting in oil fetches about a 90 percent premium, *ceteris paribus* (the average MEDIUM DUMMY coefficient across models is about 0.655, and exp(0.655) − 1 = 0.925). AGE and AGE SQUARED are both significant and exhibit a sign pattern, suggesting that the average artist will attain maximum price for his work at about age forty-seven. DIED YOUNG DUMMY is negative and significant in all four models, but its magnitude is about 50 percent larger in the equation (7.2) estimates. The significance of this difference is not great, however, since both equation (7.1) and equation (7.2) estimates indicate a substantial, and quite similar (−96 percent for equation [7.1] and −99 percent for equation [7.2]), drop in price below what it would have otherwise been had the relevant artists not died before age seventy.[23] All but one of the artist dummies (DA2–DA17) are positive, and all but two are statistically significant in each model. Additionally, the magnitudes across models for each artist are remarkably similar.[24] Apparently all artists in the sample except Resnick and Olivera receive a price premium for their work vis-à-vis that of Millard Sheets, the base artist (DA1).

The remaining results constitute the *raison d'être* for this section; they are the estimates that specify the death effect and hence test the Coase conjecture. Let us consider first the estimates of the death effect as specified in equation

(7.1). We begin by noting the high degree of similarity between the corresponding estimates regardless of whether the model is explaining (ln real) premium price or (ln real) hammer price. In both models, the coefficient on YAD^2 is negative and statistically significant, and the magnitudes are quite similar: –0.003 versus –0.0028. Thus, as the artist nears death (YAD^2 decreases), art prices increase, a result that uniquely supports the Coase conjecture. Perhaps the leveling off of the rise in price in the vicinity of death mitigates the price effect in the year of death in this specification, because the death dummy is positive but statistically insignificant. This is not inconsistent with a rational-expectations view of the death effect discussed in Ekelund et al. (2000). Finally, note that the hypothesis of a symmetric death effect about the year of death can be rejected in both models because ($DD*YAD^2$) is positive and statistically significant.[25] Furthermore, the behavior of prices after death in the premium price model is given by 0.0014 (= –0.003 + 0.0044) × YAD^2, which is positive and statistically significant (a test of H_0: $\gamma_1 + \gamma_3 = 0$ produces a $t = 31.3$).[26] This result is atypical; most studies find that prices fall after death—if not immediately, then certainly after a year or two. However, our result suggests that prices for Contemporary American art rise after the artist's death and can be expected to continue to do so for some time afterward. Why would we observe this result? One explanation lies in the Coase conjecture: Worldwide demand for Contemporary American art has been dramatically increasing over much of the sample period. This, coupled with the after-death certainty that supply is fixed, is certainly consistent with a rising-after-death price profile.[27]

Now let us consider the estimates of the death effect from the equation (7.2) results. Again, the results are similar, both in sign and magnitude, regardless of whether we are explaining (ln real) premium prices or (ln real) hammer prices. The YTD coefficients are negative, statistically significant, and of similar magnitude in both models. Since YTD decreases as the artist nears death and the coefficient is negative, prices will rise as the artist nears death, as required by the Coase conjecture. Also, the YAD coefficients are both positively signed, statistically significant, and of similar magnitude. This means that after death, prices continue to rise, ostensibly for the same reasons that were proffered to explain this result in the alternative specification. The major difference in the two specifications arises in the estimated price effect in the year of death. Equation (7.1) estimates indicate a positive, but insignificant, price effect associated with the DD coefficient, but both estimates of equation (7.2) imply an autonomous 26 percent drop in price during the year of death (both DD coefficients are statistically significant and equal about –0.3[exp (–0.3) – 1 = –0.259]. It would seem that the anticipation of rising prices as death approaches elicits paintings from collections and (especially) galleries,

often with better flows of information, onto the market that might not have been offered for sale at lower price expectations, thereby increasing supply and lowering market price. And it is worth noting that, other things being equal, it may take time to evaluate a particular artist's position in the pantheon—five, ten, or more years may be necessary to evaluate the lasting impact of an artist's output, but that will affect the after-death path of the artist's prices, long after the death effect (as we have defined it) is "baked in the cake."[28]

Although there are important similarities between the alternative specifications of the death effect, there are also important differences. We have noted the difference in the price effect for the year of death in both specifications. It is also important to note that the marginal effects of an extra year away from death are considerably larger in specification 2. This begs the question: Which specification is more appropriate? On a purely statistical basis, the residual-variance criterion (see Theil [1970]) favors the equation (7.2) specification, but only slightly.[29] However, we favor the equation (7.2) specification on theoretical grounds as well. The implicit restrictions in the curvilinear price behavior imposed by the equation (7.1) specification may render an unbiased estimate of the price effect in the year of death untenable. In other words, the fact that the equation (7.1) specification requires the price effect to "flatten out" in the vicinity of the year of death may prevent that specification from identifying a dramatic fall or jump in prices at the year of death. On the other hand, the linear-approximation nature of the equation (7.2) specification is always defensible as a first approximation of the true effect. In any event, the most important point to glean from this investigation is that both specifications provide strong support for the Coase conjecture as a driving force behind the existence and empirical specification of the death effect in art prices.

Is There a Bubble in the American Art Market?

The idea and definition of bubbles, like that of a "death effect," is a matter of some contention and conjecture in economics. Economists, in general, believe in "rational behavior"—that is, individuals calculate as of any given moment the costs and benefits of their actions—for example, buying a new car, visiting a restaurant, or acquiring a piece of art—and act accordingly. When prices fall, we generally expect quantity demanded of the item to rise, and vice versa when prices rise. However, problems immediately arise when the matter of "consumer information" is brought in. Only in the most stripped-down models of a competitive system do we assume *perfect* information. Information is costly to acquire, both in resource terms and time, so that "rationality" may be

redefined as decisions based on all of the costs and benefits to an action given that *all* costs, including information costs, are included in a decision.[30]

This expanded definition seems straightforward enough, but wild gyrations in some markets appear to present exceptions to the general rule of "rationality." In the midnineteenth century Charles Mackay published a book entitled *Extraordinary Popular Delusions and the Madness of Crowds* (1841) bringing to light the possibility that irrational behavior could explain certain price/ economic episodes such as the supposed "tulip mania" (1634–37), wherein the price of tulips in the Netherlands market was supposedly under the influence of irrationality and speculative behavior. The term "bubble" is often used to describe these fits of boom and bust in markets (Rooney 2013).

This word is currently being used in *press reports particularly* to describe the art market or certain segments of that market. Many factors have been used to describe the fuel that feeds this market. We would argue that the ups and downs are in large part related to the wealth of collectors, new and more recent. The phenomenal growth of wealth over the past several decades is often cited as causal. The aggregate net worth calculated in the March 2016 *Forbes* list of the wealthiest 1,810 *world* billionaires was $6.5 trillion, up by $0.1 trillion from 2015. As Petterson (2014) argues, many billionaires are art buyers. As he notes, "it takes only a tiny percentage of this population's wealth [of those interested in art] to have a dramatic impact on the art market, i.e., if the world's billionaires alone decided to spend 0.1 percent of their wealth on art, this would add $6.4bn to the art market" (2014: 2). The New York May 2014 post–World War II and contemporary sales at Christie's, Sotheby's and Phillips auction houses brought in more than $1.1 billion, a record that has only been surpassed since then. Economist Clare McAndrew, who formed a Dublin-based consulting firm, compiles a report on the global art market with data from auction houses, collectors, financial databases and experts (Kinsella 2016). She found a decline in *global* sales in 2015 of about seven percent (from $68.2 billion in 2014 to $63.8 billion in 2015), *but* the US market actually grew (to $27.3 billion) while other markets in other countries declined.[31] Thus, how do we explain the general boom? Some possibilities include speculation, or a Ponzi scheme, a pyramid or "greater fool" explanation whereby irrational speculation is generated until those "in the know" pull out, leaving the greater fools holding the bag. Or can such behavior, in particular segments of the art market such as contemporary art, be described from an economic perspective as "rational behavior" based on rational expectations concerning the future? The remainder of this chapter tackles these interesting issues with respect to the art market.

What Is a Bubble, and How Does It Relate to the Art Market?

The term "bubble," as suggested earlier, applies to some kind of speculative behavior that is in some way not based on rational calculations. The term has been applied to numerous markets throughout history, including the British South Sea "bubble" of 1711–1720, stock market trading in America over the 1920s (and other such episodes), the US Great Housing Bubble of the early part of the twenty-first century, and of course the tulip mania described earlier. In all cases, the description suggests that somehow prices are driven up by "amateurs" or by those who somehow do not understand the "intrinsic" value of items, a case where prices are driven to levels not based on "the fundamentals."

A hypothetical possibility in the art market might be instructive. Everyone in the art market knows that some (if not the most valuable) of Picasso's paintings come from his Blue and Rose Periods painted early in the twentieth century. Since most of these pictures—certainly the best of them—are currently in museums or in well-established collections, the market for almost any of these paintings or drawings is rationally "hot" when offered at auction or by galleries or private sales. Why? If one pays $15 million for a first-rate Blue Period drawing or $60 million for a painting, it is perfectly rational to expect a relatively good return in five, ten, or fifteen years or less. Picasso is a known quantity; his work is the "gold standard" of international art, and the probability that his market would take a precipitous decline (especially for a Blue Period piece) is very low.[32] Thus the fundamentals regarding such a purchase and the expectation of the future performance of the asset are clear. It would be considered "rational," according to some, to pay a high price for such a drawing.

However, consider recently discovered artists who have been "hyped" by galleries in Europe (London in particular) and in the United States (New York City). New artists are often promoted by galleries and at art fairs at which they receive representation. Galleries, which often use exclusive dealing arrangements with artists, will sometimes attempt to reduce the supply of an artist's work by creating a "waiting list." The lucky buyers will then attempt to "flip" the work at auction for profit. Consider an analysis of the November 2014 New York sales of postwar and Contemporary art:

> In a booming market which continues to see remarkable totals for Post-War and Contemporary auctions (Christie's $852,887,000) and Sotheby's ($343,677,000) sales reports tend to highlight results for the

work of hot young artists selling out at gallery shows and subsequently being "flipped" at auction for many times a gallery price. Reports are further dominated by the spectacular success of masterpieces and the degree to which fresh appearance on the market contributes to record prices. (Pollen, Artbanc: 30)

Such activity, which often generates spectacular returns, has the potential of creating a kind of "bubble" for particular artworks and genres of art. The annualized return on American art, at least according to calculations by a New York dealer in American art, is negative with almost half of the identical paintings resold. Contemporary artists may also go through "bubble-like" phases. Consider the price history of forty-six-year-old semiabstract UK artist Cecily Brown, now based in New York City and represented by the prestigious contemporary Gagosian Gallery in New York. A Brown painting sold at auction in New York for $1,608,000 on June 16, 2007, prior to the US downturn and a record for the artist. However, that record was not matched since then, with no works sold being over a hammer price of $1 million and eight out of fifteen works not selling between 2014 through February 12, 2015 (data from Artprice.com). This example, which could be multiplied many times for contemporary artists, reveals the possibility of rapid price rises, permanent or temporary, for particular artists. Artists who reach price heights before they are fifty are perhaps candidates for investment, but certain "fundamentals" are not present. The world has had time to assess the ultimate place of older living and dead artists in the "pantheon" of painters of a style or genre. That may not be so for investors or collectors dealing in artists whose fame comes at an early age from advertising by dealers (e.g., Gagosian or Saachi), from collecting by famous collectors, or by the assessments of critics in and out of museums. The question is: Does the purchase of these works or, rather, "getting on the bandwagon" of these artists, driving their prices up (at least temporarily), constitute a "bubble" in an economic sense?[33]

Economic Conceptions of "Bubbles"

The matter of the possibility of *irrational* bubbles emerged from the aforementioned book by Charles Mackay in 1841. He argued that the extraordinary spike in Amsterdam tulip prices in 1634–1637 constituted some kind of "irrational madness" on the part of market participants. They got caught up in some kind of behavior that belied all rationality as to the fundamentals of the market, much as is analogized by the Contemporary art market today (or the

recent boom-bust-modest recovery in real estate prices). The idea emerged from so-called "tulip mania," which emerged from increased demand in Europe (especially France). At the height of this mania, a single tulip bulb was said to be worth ten times the annual salary of a skilled laborer.

An important aspect of the tulip trade is that tulips at the time were best propagated through the buds formed with female bulbs. Further, there was a lag because tulips were planted in September, bloomed in spring, and were dug up with the "buds" or new bulbs in June. From June to September the bulbs were kept dry and in a cool place (today often in the refrigerator). Thus, a tulip futures market developed, and bulbs would be purchased via contract to be delivered at some point in the future.

Economists are naturally interested in this phenomenon. However, as one might imagine, data on tulip markets and prices from the early seventeenth century are sparse indeed. Alternative implications have been drawn from this (supposed) mania. Economist Peter M. Garber (1989), considering existing evidence, provides little support for some kind of irrational speculation or mania, except possibly in the latter part of the period, noting that "the only facet of the speculation for which an explanation does not emerge from the evidence is the 1-month price surge for common bulbs in January 1637, which prices rose up to twentyfold" (1989: 556). Others discount a mania completely, noting other factors for the precipitous increase in demand for tulips. Thompson (2006), for example, notes that rather than require investors (speculators?) to repay futures contracts, the Amsterdam government converted futures contracts to option contracts with a limit on the amount that had to be paid. This action provides an explanation for the run-up in tulip prices and is a primary explanation for the so-called "mania." (Note that rationality is preserved in the latter explanation.)

The problem is that economists are not settled on whether this behavior—which we might extrapolate to the art market—is based on rational or non-rational behavior. Further, there is an issue as to "causation." French (2009) argues that "panics," "manias," "delusions," and other kinds of irrational phenomena are always preceded by a rapid increase in monetary expansion. In the tulip case, French argues that while the Amsterdam banks did not employ a fractional reserve system (which could increase leverage in the monetary system), they did accept the deposits of other European banks and allowed free coinage in Amsterdam. The impact was, in effect, monetary expansion, which, when combined with governmental changes in the nature of futures contracts for tulips, can explain the rapid rise in the price of tulips throughout the so-called mania period. The idea that monetary expansion can help explain other so-called bubbles, such as the well-known housing bubble of the

early twenty-first century, is used as an explanation for other historical episodes, such as the Mississippi and South Sea stock-investment bubbles.

This conception is closely related to the whole issue of macroeconomic business cycles. Ups and downs in the real value of gross domestic product (GDP) and associated fluctuations in employment are the stuff of business cycles. Are art and other prices associated with these cycles? The answer, unfortunately, is "it depends." The real business cycle (RBC) is created by a number of real factors, such as risk preference on the part of suppliers and demanders, technology, inventions, institutions, and so on. When there is a downturn in the RBC, the Keynesian prescription is to make short-run adjustments in monetary and fiscal policy. A neoclassical or traditional economist would urge that such policies make matters worse. The neoclassical-rational-expectations view of the cycle is to let market equilibrate without tinkering with the money supply or the interest rate.[34] Equilibration will occur naturally in markets for consumables and investment goods without manipulations by government or monetary authorities (in the United States, the Federal Reserve System), whose job, in this scenario, is to maintain stable interest rates.

But what has all this to do with the possibilities of bubbles in the art market? Interpretation of "bubbles" is the key factor in providing an answer to this question. Clearly, some demand changes will be associated with income changes that occur with alterations in macroeconomic variables, such as GDP and employment. The art market is part of interrelated auction markets for many types of goods (wines, jewelry, antique automobiles, etc.) and genres of art (Chinese, early American, Contemporary). Some categories, including art price categories, may be expected to follow the business cycle, but others may not. If it is correct that certain kinds of goods—Contemporary art masterpieces, very rare masterpieces from earlier periods, rare and unusual gems, and so on—are purchased and competed for by the relative handful of billionaires in the market, there is no reason that a downturn in the aggregate economy would not correspond to an *increase* in the price of these items. There are, in effect, segmented markets in the art world—markets at the low and middle end, and markets for the highest-priced materials. There is no reason for them to behave in the same manner, and, demonstrably, they do not.

Likewise, rapid increases in the demand for Contemporary art, as described earlier, need not constitute a bubble, if by "bubble" we mean prices well above "fundamentals" or "intrinsic value" (whatever one understands that two-word phrase to mean). The speculation, partly engendered by critics, galleries, and museum curators, for the new and "hot" artists, creating a rise in prices, is not necessarily "irrational" on the part of investors. Market participants are

driven, at least partly, by risk profiles and preferences. If a buyer follows the crowd and purchases a piece by an artist just before the market for the artist nose-dives, is that an irrational purchase, or merely one that is rational based upon the amount of risk and anticipated return faced? Prices are determined by supply and demand in the market for art, as well as in the market for fruits and vegetables. A purchase of a work by a particular artist may be based upon one's own research concerning the fundamentals, including past performance, or on the emulation ("Veblen effect") of famous collectors or dealers who are supposedly "in the know." A purchase based on the latter is cheaper to the demander in terms of information costs, but is it *irrational* and therefore the stuff of a bubble? This will depend on how a bubble is defined.

Generally we are agnostic over the issue of whether bubbles, defined as *irrational* behavior, are possible, particularly when bubbles are determined by money supply or other enabling criteria. Even when one is caught up in speculative moments, investment in art or tulips can be interpreted as rational. Those caught up can be thought of as making decisions on the probability that others have made rational calculations concerning the fundamentals of the investment. They are simply not willing to spend the transactions costs of determining whether the fundamentals are present or not. They may be "fools" in the P. T. Barnum sense, but to the economist they in all likelihood are "rational fools."

Do Bubbles Characterize American Art?

A definition of an "art bubble" must be established in order to analyze the phenomenon, and we propose the following: a bubble in the art market may be said to exist if prices rise above *their long-run trend for no fundamental reason and remain there for a distinct period of time before returning to trend*. Often, when one hears about a bubble in the art market, the buzz typically refers to the short-term gallery-based manipulation of prices of works by a particular artist. While we did find the occasional out-of-line price in our analysis of individual American artists in Chapter 3, we found no evidence of systematically inflated auction prices (even for a short term) for any of the individual artists studied. For example, artist Fischl's value/age profile exhibits a modest upward trend throughout his career, interrupted in mid-career by a spike in price for *one painting*. If that spike had been accompanied by a half-dozen or more out-of-line prices, we might have had some basis for alleging a bubble in Fischl's work, but one observation does not a systematic aberration make. Consequently, while that one spike may have been a bit of good luck for Mr. Fischl, it was not a bubble. This type of reasoning holds for all our individual artists.

As suggested in previous discussion, contemporary art, and perhaps mainly Contemporary American art, is the most active market today. It has been to one degree or another in the twenty-first century thus far. A burgeoning number of collectors come from China, India, Russia, in addition to American and European collectors, fueled by enormous increases in income, creating growing numbers of billionaires. Although the period 2013–2014 is not covered in our sample, between July 2013 and July 2014 sales of contemporary art at public auctions were $2.046 billion, much of it American art (Froidefond 2014). In the May sale of postwar and contemporary art in New York alone, auction houses Christie's, Sotheby's and Phillips raised $1.1 billion, a record amount and up 43 percent from May 2013 (Petterson 2014), and *the price trends continued.* So, if bubble-like behavior exists in the "contemporary" area, one is apt to find it in Contemporary American art. Granted, the artists in our sample do not include many of these "hot" young artists, but it includes enough of them to at least hint at the relation between the aggregate price index for contemporary art and the business cycle.[35]

Therefore, if we wish to consider potentially anomalous art-price behavior (the possibility of an art bubble), we must turn our attention to the market or aggregate level. To this end, we averaged (nominal) auction prices (premium and hammer), by year, for each year in our sample.

The results can be found in the first three columns of Table 7.3, and the number of observations upon which the averages are based is given in column 6. Our full sample covered the years 1987–2013; of the 14,000+ paintings in our sample, 10,400 were sold at auction during that period. As is clear from column 6, however, the artists we consider sold relatively few paintings during the first four years of the sample. Since it is risky to base inferences on sample averages computed with few observations,[36] we arbitrarily set a minimum sample size of 100 for our yearly averages. This effectively eliminates the first four years from our sample, so that the subsequent analysis is based on average yearly art prices for the 1991–2013 period. To complete the table, columns 4 and 5 are indices for premium and hammer prices, respectively, found by normalizing each year's average price on 1991 average price. Columns 7 and 8 are nominal and real GDP, respectively, presented here as a standard of comparison regarding what price changes are "justified."

We begin by estimating a simple exponential trend for nominal GDP and considering the deviations of the actual about the predicted values. The trend estimate is

Table 7.3 Average Art Prices and Art Price Indices: 1987–2013

Year	Average Premium Price (in $1,000s)	Average Hammer Price (in $1,000s)	Premium Price Index	Hammer Price Index	Number of Observations	Nominal GDP (in billions of current dollars)	Real GDP (in billions of 2009 dollars)
1987	55.869	50.79			30	4,870.2	8,132.6
1988	47.681	43.3462			39	5,252.6	8,474.5
1989	973.532	885.029			18	5,657.7	8,786.4
1990	269.427	244.934			53	5,979.6	8,955.0
1991	191.865	191.865	100	100	133	6,174.0	8,948.4
1992	126.703	115.185	66.03758	60.0344	379	6,539.3	9,266.6
1993	123.575	111.842	64.40727	58.29203	301	6,878.7	9,521.0
1994	107.453	97.1522	56.00448	50.63571	325	7,308.8	9,905.4
1995	109.803	99.2718	57.2293	51.74044	348	7,664.1	10,174.8
1996	122.78	111.157	63.99291	57.93501	403	8,100.2	10,561.0
1997	243.609	220.972	126.969	115.1706	392	8,608.5	11,034.9
1998	210.041	190.415	109.4733	99.24426	357	9,089.2	11,525.9
1999	310.226	281.525	161.6897	146.7308	361	9,660.6	12,065.9
2000	275.682	249.602	143.6854	130.0925	374	10,284.8	12,559.7
2001	303.641	275.069	158.2576	143.3659	346	10,621.8	12,682.2
2002	374.025	339.071	194.9418	176.7237	340	10,977.5	12,908.8
2003	328.525	297.777	171.2272	155.2013	437	11,510.7	13,271.1
2004	539.835	469.304	281.3619	244.6012	480	12,274.9	13,773.5

2005	434.411	385.508	226.4149	200.9267	514	13,093.7	14,234.2
2006	399.656	353.944	208.3006	184.4755	636	13,855.9	14,613.8
2007	662.159	587.365	345.1171	306.1345	689	14,477.6	14,873.7
2008	556.68	490.557	290.1415	255.6782	536	14,718.6	14,830.4
2009	320.319	278.395	166.9502	145.0994	439	14,418.7	14,418.7
2010	626.468	550.444	326.515	286.8913	598	14,964.4	14,783.8
2011	628.595	552.114	327.6236	287.7617	656	15,517.9	15,020.6
2012	1291.57	1143.73	673.166	596.1118	557	16,155.3	15,354.6
2013	1143.73	1028.93	596.1118	536.2781	659	16,663.2	15,583.3

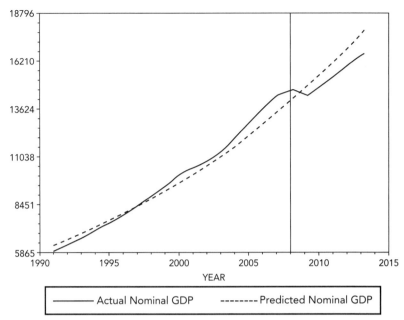

FIGURE 7.1 Differences between actual and predicted GDP.

$$\log(\text{GDP}) = 8.7322 \quad + 0.0461 \text{ TIME.} \qquad (7.3)$$
$$(549.86) \quad (31.66)$$
$$R^2 = 0.982 \quad F = 1166.52$$

Nominal GDP grew at about 4.6 percent per year during the period, and the model's fit is quite good. The predicted (dashed line) and actual (solid line) values are graphed in Figure 7.1; the vertical reference line marks 2008, the beginning of the Great Recession. Although the predicted and actual values are quite close, Figure 7.1 shows three distinct regimes: prior to 1997, the model overpredicts GDP; between 1997 and 2008, the model underpredicts; and after 2008, the model again overpredicts GDP. For the first two regimes, discrepancies appear to eventually return to trend; not so for the third regime, where the divergence between actual and predicted values appears to grow. It may be that the Great Recession caused a regime shift, changing both the slope and intercept of the long-run relationship.

Now consider the behavior of American art prices over that same period. Estimating a simple exponential trend for premium art prices[37] (column 2 of Table 7.3),

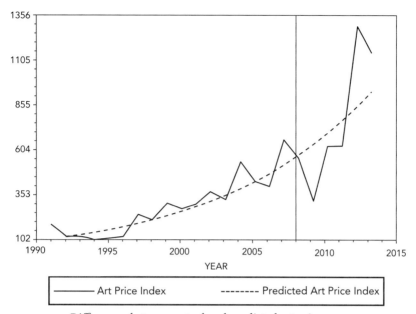

FIGURE 7.2 Differences between actual and predicted art prices.

$$\log(\text{Premium Price}) = 4.6084 + 0.0970 \text{ TIME.} \tag{7.4}$$
$$(33.47) \quad (9.34)$$
$$R^2 = 0.824 \quad F = 112.02$$

Nominal premium prices grew at about 9.7 percent per year during the period, and the model's fit is good. The predicted (dashed-line) and actual (solid-line) values are graphed in Figure 7.2; again, the vertical reference marks 2008. The predicted and actual values are close in this case as well, although price behavior is a bit more volatile than GDP. Consider price behavior in the three distinct time regimes of Figure 7.1: prior to 1997, the model generally (but not always) overpredicts premium prices; between 1997 and 2008, the model generally (but not always) underpredicts; but after 2008, the behavior of art prices differs considerably from that of GDP. There is nothing suggesting a regime shift for prices: after three years of the trend overpredicting, prices recover completely and overstate trend in the final two years of the sample.

The price-GDP comparison may be seen more easily in Figure 7.3. There we graph the discrepancies between predicted and actual GDP (dashed line) and premium prices (solid line). The horizontal reference is at 0, which can be thought of as being on trend (predicted – actual = 0), and the vertical

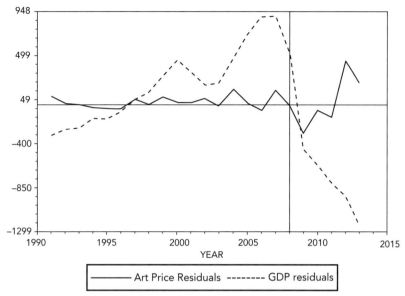

FIGURE 7.3 Differences between predicted/actual GDP and predicted/actual art prices.

reference is 2008. Prior to 1997, the discrepancies in both models (uniformly, for GDP, and generally, for prices) are negative. Between 1997 and 2008, the discrepancies in both models (uniformly, for GDP, and generally, for prices) are positive. But after 2008, the models differ fundamentally. After being below trend for 2009–2011, prices recover and surpass trend for 2012 and 2013. However, for GDP, actual value drops below trend for 2009 and diverges further from trend in each subsequent year. If we define recovery as returning to the pre-recession trend, art prices recovered relatively quickly from the Great Recession, but GDP had shown no signs of recovering by the end of the sample. It seems clear that after 2008, art prices were affected by factors other than those affecting the economy as a whole, such as changes in income distribution or substitution of art for other items in demand.

The Contemporary Boom for Artists Born Post-1950: A Bubble?

The boom in Contemporary art prices has, as the third segment of Figure 7.3 clearly reveals, been experienced by the "contemporary" artists in our sample. The soaring prices are experienced not only by the artists in our sample, however, but also by a large coterie of younger artists born soon after 1950. Most are living artists, some in mid- or even early careers, and the number of art

fairs and galleries dealing in that art has grown enormously. (The German artist Gerhard Richter, who is in his eighties, is the undisputed master contemporary painter having $1 billion, $185 million worth of art traded between 2011 and 2015.) In a world with about 1,800 billionaires, it only takes a few as art collectors to drive art prices of the "latest finds" to astronomical levels. Recessions, stock market declines, and turmoil in international affairs and financial markets rarely contain the fight among these collectors for the best of the best in all forms of art, especially Contemporary art. Granted, the artists in our sample do not include many of these "hot" young artists, but the sample includes enough of them to at least hint at the relation between the aggregate price index for Contemporary art and the business cycle, and that average art prices are clearly outpacing changes in GDP. Further, it is instructive to note that of the fifty top contemporary artists by annual sales (2014–2015), fourteen were Americans. To give the reader some indication of their returns, consider Table 7.4, naming the fourteen Americans, their birth year, their total sales 2014–2015, and their top hammer price at auction.

Table 7.4 Contemporary American Artists Born Post-1949, Auction Sales, July 2014–June 2015

Rank	Artist (Birth-Death Dates)	Total Auction Sales (in $)	Number of Lots Sold	Top Hammer Price (in $)
1	Basquiat, Jean-Michel (1960–1988)	125,821,223	79	33,000,000
2	Wool, Christopher (1955)	112,993,962	48	26,500,000
3	Koons, Jeff (1955)	$81,875,747	83	23,000,000
7	Prince, Richard (1949)	32,890,935	70	5,000,000
9	Haring, Keith (1958–1990)	24,562,694	295	2,600,000
13	Sherman, Cindy (1954)	17,044,008	81	5,900,000
15	Grotjahn, Mark (1968)	15,917,355	11	5,600,000
18	Guyton, Wade (1972)	14,949,549	22	4,000,000
19	Tansey, Mark (1949)	14,236,400	8	5,000,000
22	Bradford, Mark (1961)	13,672,037	16	3,700,000
31	Noland, Cady (1956)	8,632,019	3	8,600,000
32	Ligon, Glenn (1960)	8,476,248	24	3,400,000
41	Auerbach, Tauba (1981)	6,449,643	19	1,900,000
48	Bradley, Joe (1975)	5,796,613	12	1,305,768

Extracted from Maneker (2015), http://www.artmarketmonitor.com/2015/10/08/artprices-top-50-contemporary-artists-2/;

Source: Artprice calculations. ©ArtPrice (with permission).

A number of important points should be noticed in Table 7.4. With only two exceptions, Basquiat and Haring, all of the artists are living and all are less than sixty-six years old, with a number fifty years old or younger (Auerbach was thirty-four years old in 2015). Also notice the predominance of American artists in the top twenty-five artists—40 percent are in the top half of Contemporary sales worldwide, and three Americans hold the top three spots—a signal that Americans still appear to dominate the art market since the "shift" in the postwar period, although the contemporary field is truly international in scope. It is small wonder that Contemporary art has become the object of investors, hedge funds, and banks as well as collectors (see Chapter 5). However, some believe that the "bubble-like" prices of *some* Contemporary American art cannot last and that there is a real estate–like "bubble" in the art markets. Indeed, some reputable galleries specialize in American art painted prior to, say, 1950—art that has stood the test of time. According to one gallery owner, "collectors are beginning to understand that nineteenth- and early twentieth-century American paintings are far more conservative values than those offered in the hyperinflated contemporary market. These historic works have stood the test of time, something that cannot be said for paintings by living artists that sell at prices well beyond those of established masters" (Brent L. Salerno, in Salerno and Salerno 2015). But given the kind of results shown in Table 7.4, the boom is clearly related to Contemporary artists—some of whom, like Gerhard Richter (not an American) and Andy Warhol (who is not in the table due to an age cutoff for Artprice.com calculation) or Jeff Koons or Christopher Wood (who are American), show clear staying power. Unfortunately, one cannot predict what will happen to many of these reputations in fifty or one hundred years. Perhaps that has always been the case in art and other markets.

As suggested in the preceding discussion, Contemporary art, and perhaps mainly Contemporary American art, is the most active market today.[38] It has been to one degree or another in the twenty-first century thus far. Although the period 2013–2014 is not covered in our formal sample, between July 2013 and July 2014 sales of contemporary art at public auctions were $2.046 billion. Much of this art was American (Froidefond 2014). In the May sale of postwar and Contemporary art in New York alone, auction houses Christie's, Sotheby's, and Phillips raised $1.1 billion, a record amount and up 43 percent from May 2013 (Petterson 2014). So, if bubble-like behavior exists in the "contemporary" area, one is apt to find it in Contemporary American art.

Naturally there are caveats that must be attached to our suggestion that boom-like behavior attends our aggregate results. The income elasticity of demand is different for the works of alternative groups of artists in the

sample. Again, pre-1950 art is "settled" to the extent that those artists, all deceased, remain in the group of artists collected at the end of the twentieth century and the beginning of the twenty-first. These artists are known quantities and have auction and sales records to prove it. Alternatively, many Contemporary artists—not only dead Contemporary artists, but younger and live artists—have not been established in the pantheon of those whose quality is accepted. If bubbles (irrational or rational) exist, it is with these artists that we would likely expect to find them. It is noteworthy that sales of postwar and Contemporary art at auction at Christie's declined by 14 percent in 2015 over 2014, and total sales of art and collectibles declined as well. The so-called boom is not certain to continue as both academics and other observers believe that the so-called bubble might be expected to burst—or, more simply, that reductions in economic growth or zero growth reduces certain luxury expenditures, including art. Interestingly, *neither of these things happened in the United States, which had a positive growth rate in 2015.*[39] If there is an art bubble, there is only a slow leak, possibly other than in the United States. What are some of the implications of this booming market for the best art?

Soaring Art Prices at the Top: A Digression on the "Museum Externality"

We have already noted the fact that there are about 1,800 billionaires, with tens of thousands of millionaires in a world of skewed and possibly skewing income distribution. Further, there is some evidence (Kinsella 2016 from a report from The European Fine Arts Foundation [TEFAF] compiled by art consultant Clare McAndrew) that the highest single segment of the art market is for work priced over $10 million. It constitutes 28 percent of sales expressed in value terms (with a small number of transactions, of course). The mass of the art market contains items with prices less than $50,000 but are only 12 percent of total sales. The fastest growing market is the range of works between $1 million and $10 million. These statistics underscore the fact of a segmented art market and the possibility that if there is a "bubble" of ever-rising prices for the "best of the best," it exists primarily due to the existence of growing number of billionaire and millionaire collectors. What is the impact of this development on the general appreciation of these treasures in American and other museums as well?[40]

Americans are a museum-going people, with attendance at an all-time high. Out of approximately 17,500 museums in the United States, approximately 1,575 are devoted to fine arts. Financing mechanisms of these museums, large

and small, vary tremendously, but the current boom in Contemporary art has exacerbated problems for a number of big-city institutions. There are many financial balls to juggle for museum directors, but the effects of the boom in Contemporary art present some new and important economic issues directly related to our discussion of "bubbles." These "bubbles" are creating an externality of sorts and an entry barrier for art museums.

The vast majority of museums are presented with financial problems at one time or another, but that problem has become acute with *shifts in taste and soaring prices*, the growing attendance and popularity of many major art-oriented institutions, and evolving demographics. Two of the leading museums in the United States—the Museum of Modern Art (MoMA) and the Metropolitan Museum of Art (the Met), both in New York City—are excellent illustrations of some of the financing problems facing museums today. The Met, one of the most comprehensive museums in the world except for a dearth of holdings in modern-contemporary art, has an annual budget of approximately $300 million (circa 2015). The Met, however, faced a deficit of about $14 million in 2016 and laid off personnel, putting a hold on expansion of modern-contemporary art exhibition space, such as the expansion to the Breuer building, to focus on contemporary art. (Indeed, the Met's director Thomas Campbell, in February 2017 under pressure, announced his resignation.) Meanwhile, the competition for patrons has become fierce in the Contemporary field. Besides MoMA, which has financing issues of its own (see the following discussion), the Met must compete locally with the Whitney, the Guggenheim expansions, and by extension, among major cities, a new downtown Los Angeles Contemporary museum (the Broad) and a multitude of museums in the United States that have amassed large Contemporary collections for viewing.

Meanwhile, MoMA experienced its own, unique issues. MoMA's $400+ million expansion plan (aided by a $100 million gift from billionaire David Geffen) offered buyout plans for some employees in 2016 who will not be needed as the museum reduces services while under renovation. The layoffs would be largely voluntary, unlike those at the Met. These problems will resolve themselves as financing or lack thereof evolves, but the fundamental issues raised in that situation underscore some critical economic issues facing many art museums in the United States today. Economic principles, unable to solve such problems, of course, *are* capable of providing insight into some of the "new" problems and possible solutions confronting art museums today. Consider three interrelated issues.

First, underlying the Met's problem described earlier is a perennial problem of all museums. It relates to acquisitions policy. Recent directors of the Met amassed a treasure trove, creating a museum of truly enormous

and international scope, *except* in the areas of modern and contemporary post-1950 art. The late Thomas Hoving (director from 1967 to 1977) focused acquisitions to a large extent on Renaissance and Old Masters. (He also developed the now-popular concept of the traveling "blockbuster" exhibition, which carried special charges to the museum goers). His successor Phillipe de Montebello (director from 1977 to 2008) did not add significantly to the modern/contemporary area of the Met's collection (although he did acquire a masterwork by Jasper Johns) believing, it would seem, that MoMA and other museums in New York City provided such services and/or that acquisition of contemporary art by living artists (some at mid-career) was problematic and risky. (The Contemporary collection has grown somewhat in recent years to include important pieces.) But the portfolio of the Met, incredibly rich as it is, has been unable to quickly adjust to the *changing tastes* of museum-goers, putting the institution in an undesirable competitive situation. MoMA, on the other hand, has never competed on this margin, indicating its specialty in its name—modern and Contemporary art—from the beginning.

The important economic point to be made is that some of the revenue problems of many museums may be based in the inability to rapidly and efficiently alter their "portfolio" of holdings to the changing taste of their customers. That lacuna in museum services may be partially mitigated by traveling exhibitions, but they may represent a significant cost to the museum in terms of monetary and labor expense. They may not "break even" if inaccurate or poor choices are made. Short of increased attendance and possible profit, the average museum may have little to show for numerous rounds of "visiting exhibitions."

The alternative, other than gifts, is to acquire a distinguished collection of works in particular areas. That alternative is open to few, *if any*, museums in the United States over the past several decades. That fact leads to a critical issue—the *changing distribution of U.S. and world income* and its effects on museum finance and operation. Since tastes currently run to Contemporary art, consider the possibilities of selecting a set of contemporary works by modern artists. We are living in a boom period of that art, as demonstrated earlier in this chapter—both by established artists, many of whom are living, some in mid- or even early careers, and by modern artists who have stood the test of time. The number of auctions, art fairs, and galleries dealing in that genre has grown enormously to accommodate this burgeoning market. In a world with so many billionaires, it only takes as few as one percent of them to drive high-end art prices to astronomical levels, as we have seen. Recessions, stock market declines, and turmoil in international affairs

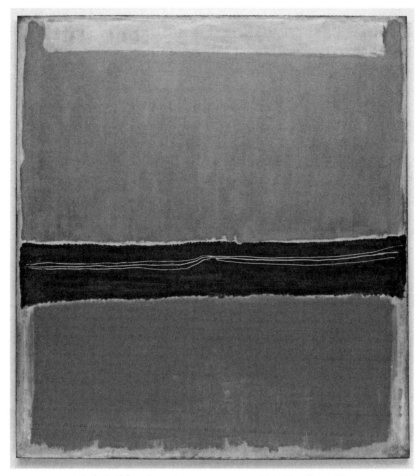

FIGURE 7.4 Mark Rothko, American, 1903–1970, *Painting No. 5/No. 22*, 1950. Oil on Canvas. © The Museum of Modern Art/Licensed by SCALA/Art Resource, New York. Copyright © Kate Rothko Prizel & Christopher Rothko/Artists Rights Society (ARS), New York.

and financial markets rarely contain the fight among these collectors for the best of the best, especially Contemporary art.[41] In addition to such vaunted names as Jackson Pollock, Mark Rothko (see Figure 7.4), or Agnes Martin (see Figure 7.5), "hot" young artists born post-1955 are earning top auction prices. Private individuals are driving these astronomical prices, and bereft museums must depend upon donations to assemble a portfolio of the best work. Few are able to keep up. Museums are simply priced out of the market for the best Contemporary art.

FIGURE 7.5 Agnes Martin, American, 1912–2004, *The Tree*, 1965. Acrylic and graphite on canvas. © Albright-Knox Art Gallery/Art Resource, New York. Gift of Seymour H. Knox, Jr. Copyright © ARS, New York.

A third interrelated problem is that *demographic issues* have exacerbated the problems of museum finance and operations by putting pressure on the *revenue* side of the equation. Unemployment, early retirements, and the aging of the population in the United States have all contributed to increased attendance at museums of all types. These factors, in addition to a long-standing movement to "free" entry sponsored by individuals and businesses, have put pressure on the cost side of museum finance. (When subventions for "free admission" are reduced, museums must either pick up the tab or lose patrons with the fee.) Additionally, there is empirical evidence that museum attendance is *counter-cyclical*; attendance increases when GDP falls (Skinner, Jackson, and Ekelund 2009). Recessions are good for museum attendance records, but affect the bottom line of museums by adding to cost if museum

entry fees are gratis. That, plus the externality to museums of astronomical prices for top-level art, adds new levels of difficulty for museums and their importance for cultural advance. Solutions are hard to come by, but museums, as not-for-profit or for-profit institutions, must carefully weigh the economic aspects of their policies.

Art "Bubbles," Ponzi Schemes, and Economic Rationality

We have argued that boom and bust are as much a part of the art market—and especially particular segments of that market—as is the impact of the business cycle on art and all other goods and services. But are other phenomena at work in the art market, as some say they are in the real estate and stock markets? Naturally, it again depends on what is meant by an art bubble. A bubble is suggested as a "madness of crowds" by the popular press, but the term apparently means something entirely different from an economic perspective. The economist, as we have mentioned more than once in the present chapter, supports the idea that people generally behave rationally—and that includes art purchasers. Thus, at the risk of repetition, consider the "popular" notion of an art (or any other kind of) bubble.

The term "bubble" is, as art prices continue to rise, more and more commonly used to describe that market (Bamberger 2014; Tarmy 2014). Importantly, the art market, unlike the real estate or financial markets, is not tied to interlocking sectors of the general economy, so that a burst of that bubble (if we consider it a bubble in the entire art market) will not cause a meltdown of entire economies. Rather, contemporary use of the term "bubble" applies only to sectors of the art market or to the price history of artists themselves. To complicate matters, the performance of certain sectors of the art market has enlivened investors to the point where art funds are becoming objects of portfolio diversification, and a smallish class of billionaires compete for the latest master. But where do the "latest masters" come from? According to some observers, as we noted in Chapter 5, they are the product of hype and advertising by critics, museum curators, collectors, and, most especially, by galleries and auction houses.

A bubble may be analogized to "pyramid" or Ponzi schemes, according to some observers. Consider the description of them provided by an art-advisory agency, ArtBusiness.com (Bamberger 2014). The art-advisory organization distinguishes between buying art based on "past performance" and purchases based on "future expectations." (Note that there is no difference between buying art in this manner or buying other goods—tulips, housing, stocks,

or dot-com companies.) The sequence naturally involves speculation based upon the "word" of so-called experts at auction houses or galleries. Little or no reason is given to the gullible for rising art prices (in a genre or for a particular artist) other than "that's the way it is going to happen." As new artists are lionized by the art establishment, they enjoy gallery success, but soon items purchased by an artist are put to auction, where more hype may bring in even higher prices, which makes the gallery's inventory worth more. (Sometimes gallery owners will themselves bid on pieces at auction by the artists they handle to maintain prices of inventories.) An artist's reputation spreads as long as demand and demanders increase. But, as suggested in Chapter 5, galleries must come up with a continuous supply of "new" masters. And for this the hunt is on for younger artists, often found in university and other art programs around the country. Within this scenario, fortunate young artists find early success—success that may or may not be lasting. It is simply no longer the case that the only good artists are dead and gone. Live artists, younger and older, are in the same boat and receive similar assessments by buyers and speculators. Many who put art funds into an investment portfolio know little or nothing about the artists selected, but the same may be said of other investments. In general, serious collectors and museums buy art to keep and pass on to family or institutions.

Great art will "out"—the truly gifted will become part of the pantheon over time. But it is instructive to consider catalogs for contemporary art from, say, 1985 through 1995. How many of these artists come to auction today? In Chapter 2 we discussed the course of the market for American art. Part of that was the selection by the US Department of State of representative "major artists" for a tour of Europe and Latin America to advertise the ascendance of American culture in the postwar period. A large compendium of art (oils and watercolors) was assembled by art expert Joseph Leroy Davidson to highlight the major living artists and trends underway in the United States. It is instructive to inquire what the fate of the artists was (all except one was living in 1946). Naturally, the truly major ones survived the test of time and criticism—Hopper, O'Keeffe, Hartley, and so on—but a large percentage did not thrive. Listed among the artists are Joseph De Martini (1896–1984), with a high-valued painting at auction in 2014 of $9,600; Karl Zerbe (1903–1972), high value of $6,250; and Douglas Brown (1907–1970), high value $657.00.[42] So the fate of living artists represented at auction today is far from guaranteed from past experience. There is no reason that one should not expect the same experience in the present art world.

Death and Bubbles

This chapter has plumbed the nature of two important phenomena attached to the art market generally and to the American art market in particular. While there is some debate concerning the nature of a "death effect," we have shown that, under reasonable assumptions, there is in fact a statistically significant increase in an artist's real prices as the time of his or her death approaches. Although our conclusions regarding death as a signal to demanders that there will be no further supply from an artist are firm, the issue of "art bubbles" is far more intractable. While the popular press would have the interested public believe that there is "a bubble in the art market," the economic analyst is skeptical, we believe. Surely, local boom and busts exist for certain sectors of the overall art market (or for all "treasure assets," for that matter), but the economist does interpret "bubbles" as rational behavior.

The durable-goods monopoly analogy to a producing artist is exact—prices charged for her art must reflect some kind of guarantee that additional objects of identical or similar nature will not be forthcoming. While some mechanisms (for multiple prints, for example) to create this "guarantee" are possible, generally the only certain guarantee is the artist's death. The death effect may be divided into three components: (1) the impact on prices as death approaches; (2) the effect on price at death; and (3) the effect on prices after death. Thus, as death approaches, demand for an artist's work may be stimulated by the knowledge that the artist's supply rate will be reduced to zero. That does not mean that at the time of death and after death all supply of the artist's work is fixed. Works may enter the market through galleries, collectors, and museums, and through the artist's families or agents. Age and level of reputation of the artist at death will also have an impact on the price profile of the artist. The unique aspect of a death effect is then the rise in values as death approaches. A rise, fall, or constant average price at or after death is consistent with an artist's death effect, but is not unique to it.

Out of a sample of forty-eight American artists born after 1900 and painting in the post-1950 period, we focused upon seventeen Contemporary artists who died within the period 1987 to 2013. We have attempted to account for reputation, certainly already established for the artists who died over this period, and age in a sample of more than 6,000 paintings sold at auction within this period. Using test equations for both premium and hammer prices, we find that prices rise as the artist nears death, as required of the Coase conjecture, fall during the year of death (possibly due to a supply effect), and, in the case of Contemporary American artists, appear to continue to rise thereafter. Specifications used in this study all point to the Coase conjecture

as the essential motivation for the empirical observation of a "death effect" in art prices, but indicate that a price rise is the only unique indicator of internalization using the conjecture. Naturally, a caveat should be issued that these results apply only to the artists and period used in our sample, as is true of all studies of death effects for artists.

As far as bubbles are concerned, speculation has attended and continues to attend the art market. Drifting from fundamentals—experience and knowledge of a wide agreement of the quality of an artist's work, dead or alive—may bring new demanders who bank on "faith." Whether this is rational or irrational from an economic perspective is another issue. Clearly, "local bubbles" for artists take place as shown earlier—there is boom and bust for art and all kinds of other items. Highly skewed income distribution with a larger number of billionaire and millionaire demanders vying for new and "in fashion" works fuels the process. But being out of joint with fundamentals does *not* necessarily mean that speculation will not pay off in the future. Being "the last man or woman standing" in a speculative pyramid or an unrigged market (such as in the Bernie Madoff scandal) is disastrous to the loser, whether one identifies the process as a "bubble," rational expectations, or a shift in supply and demand. Crashes of this type provide information for a time, but the truth is that "death effects" and art "bubbles" or cycles have punctuated the history of art, and they will continue to do so.

Chapter 8

The Ongoing Evolution of the Market for American Art

A STUDY OF the interface between economics and art reveals that, far from cre-
ating "dismal conclusions," we gain additional appreciation for the power and
force that underlies one of the defining and most uplifting aspects of art and
culture. But there is an undeniable "commercial" quality to the making and
selling of art—clearly, an artist must eat and make a living in some manner,
making her a kind of "entrepreneur"—and there must therefore be market
institutions through which this becomes possible. Artists produce products
that have both aesthetic and monetary value, and economics can help explain
how commercial (not aesthetic) value is realized and how it grows or declines
over time.[1] Furniture shops in early America, we have seen, filled that role,
as did the introduction of art galleries in the nineteenth century, as do many
institutions such as specialized galleries, auction houses, and the Internet that
deal in American art today. While this applies to all art and artists around the
world, we have made a special application of these institutions to the "mar-
keting" and many other aspects of American art, a study that has not received
exclusive focus before. We have developed both specific and more far-reaching
general conclusions concerning the production and sale of American art.

Central Issues in the Art Market

Our study of American art has showed, with respect to our sample of Americans,
that artists are not of a single type, but are molded by their own artistic inter-
ests and by the artistic interests of their associates and their generation. This
means not only that art influences culture, but also that culture, broadly con-
sidered, influences the subjects and methods developed by artists. An attempt
to discern the relation between the types of artistic productions—innovative

versus experimental—and the age at which artists reach "peak value" at auction is therefore relevant to American artists. Chapter 3 has provided tests of this proposition and has found that, statistically, while artists in general have become more innovative in the twentieth and twenty-first centuries, there is no hard delineation between types of art produced and age. There is no question, however, that art production is age- and style-related, trending toward younger artists, but this fact is created by other factors, especially art marketing and the state of aesthetics in the art market (see further discussion in this chapter). That is also the case when an artist ages and approaches her or his death. There is in fact a "death effect" attached to an artist's price with age; we have found that to be so in our sample of American artists (Chapter 7) who died during our sample period 1987–2013.

An understanding of the factors affecting credence in exchange between buyers and sellers is vitally important in the sale of American art and, indeed, all art. That applies to all manner of exchange in art—private sales, sales through galleries or at art fairs, and sales through auction houses. The "commoditization" of art has put the spotlight on the soaring prices over the past decade (excepting 2007–2008 and some post-2015 experience) and participation in the American art market by auction houses, especially for Contemporary art. This leads to an empirical question of whether "credence" is practiced by auction-house experts in the information provided to potential buyers. Auction-house estimates should provide, given provenance, condition, past records for an artist, and other factors, a "fair" low/high estimate for particular works as information to buyers. We have found it likely that in order to maximize their own revenues and profits, auction houses likely create *strategic* estimates—low estimates for lower priced artworks and higher-than-mean estimates for "masterpieces." Our statistical results show a bias to low estimates, however, since the high-price works were not numerous in our sample.

Soaring art prices have brought big money into the American art market, most particularly the Contemporary market and spilling over broadly to the general (pre-1950) market. First, our results do indicate that early and Contemporary art are *different* markets. If hammer prices are used, we find a difference in return between early and Contemporary American art (using resale data) that is *triple* that for pre-1950 art. When paired sales are used, that difference is 15 percent versus 44 percent. With buyers' premia added, the difference is 3 percent return for early American art versus 28 percent for Contemporary art.[2] When buyers' and sellers' premia and *holding time* were included in the model for our pre-1950 sample, negative returns of more than 2 percent were calculated. However, there are two points here: (1) we have

shown that American art—pre-1950—still may be part of a balanced portfolio of investments, and (2) there is likely a large "utility" premium from holding and "consuming" such art for collectors and other buyers. In other words, aesthetics trumps investment-return percentages when it comes to collecting and holding art.[3]

Our study also contains several original extensions. For example, none of the analysis, results, or conclusions based on our sample of *Contemporary American artists* throughout the book has been developed in previous studies.[4] We have, moreover, raised the level of analysis of changing artistic innovation through time, suggesting (in Chapter 3) that innovative success for artists at younger and younger ages is related to innovation in profit-maximizing marketing techniques adopted by galleries, collectors, and others (such as museum curators and directors). Further, in Chapter 4, we have examined the role of auction expert estimates of *American* paintings on the probability of sale and the effect of "burning" a painting—paintings that receive a lower price when no sale is obtained on a first outing. Importantly, we have established empirically the fact (in Chapter 5) that early American and Contemporary American art are two separate and distinct investment markets. Analysis of American art and illegal activity specifically as it relates to economic principles has not been developed (to the best of our knowledge) with an economic interpretation as we have developed it in Chapter 6. Our empirical interpretation of the Coase conjecture and the price impact of the death of an artist and the proposed development and definition of art bubbles, both discussed in Chapter 7, are unique, to the best of our knowledge.

But these specifics are only a précis of the central questions discussed in this book. More fundamental issues underlie these technical conclusions and place them in context. They relate to credence, transparency in the art market, and the fact that, next to drug sales and money laundering, "hot" art is becoming the legerdemain of criminals. Beyond this, there is an intersection developing between the aesthetics of art and art as commerce—an intersection that developed as market (or capitalist) institutions emerged. Finally, we query whether the art market, as it is evolving, may be said to be "efficient" in finding "the best" in this specific area of human culture.

Credence, Fakes, and Opacity in the American Art Market

As noted throughout this book, credence is an especially important and useful concept in explaining the art market. Degrees of risk—a risk of not getting what you believe you are buying—attend transactions where credence is not fully established, but such risk is often disregarded or built into the price

transacted. Ordinarily, the higher the risk, the lower the price. But fakes, forgery, and fraud riddle the American and other art markets. Some economists are pointedly negative concerning the market for several reasons. According to economist Tyler Cowen, "I believe the art world to be one of the more corrupt sectors of the American economy, once you consider the prevalence of fakes, the amount of looking the other way, and also the use of high appraisals to get favorable tax breaks on donations" (Cowen 2015). We have seen (in Chapter 6) that this view is not far off the mark given the multiplying examples of the sale of forged American art, the difficulty of establishing authenticity (credence) in fakes, forged or unquestioned provenance, and the sale of stolen art.

All of these factors, combined with a general benign neglect in the identification and pursuit of stolen art, means, as we conclude, that many pieces of art are meta-credence goods whose authenticity (full credence) can never be established. The evolution of the expert has had little to contribute to a remedy to this situation, as "experts" or "validation committees" refuse to provide credence (or noncredence) in pieces of art due to the threat of lawsuits. Other than "new" methods to detect fakes—and there are some in the works, such as implanting the DNA of an artist into a painting or developing general and relatively inexpensive theft detection—the "corruption" alluded to in the art market is not likely to disappear. To the economist, any changes in the benefits or costs of fraud or theft would signal the appearance of less or more theft. Further, a general disinterest in rooting out theft or fakes often attends prosecution, with victims regarded by police and authorities as essentially "victimless"—usually wealthy collectors, museums, and insurance companies. These groups do not garner much sympathy when other, violent crimes—drug and human trafficking and the like—are commanding attention.[5] Perhaps as art becomes involved in activities such as money laundering or serves as collateral for drug deals, more attention will be paid to effective and aggregate enforcement. However, an economist would argue that, *given the present constraints, punishments, and incentives in art crime*, the results do not conflict with rational behavior or what one would expect to be the case.

American Art Aesthetics and the Evolution of Market Institutions

The American art market has unquestionably shaped and been shaped by the evolution of artistic encounters, of buyers' tastes, and of institutions, including political institutions and, most particularly, institutions surrounding the buying and selling of art. The collision between the first American painters and the vast and majestic landscape of the United States led to the

first genuinely American school of painters (the Hudson River school). In the earliest days, genuine American masters were included in collections with those imported from Europe. American painters began to evolve in numerous ways—primarily through experimentation based on European styles (Barbizon painting and later French and other European work). Then came the move to develop a uniquely American art—made possible in part by the cascade of venues, promoters, and collectors of that art, particularly among the wealthy and especially in New York City. Americans gravitated to that hub of culture and artistic challenges, creating "schools," some distinctly American (ashcan school, American modernists) and many with the flavor of European trends.

Most artists are frequently "starving," but the situation became dire over the depression of the 1930s. Many artists received grant money from a WPA-related project, working in effect for the government by painting post offices, government buildings, and individual canvases (as many, it is said, as two hundred thousand artworks). Much of this work was derivative of trends established in the earlier decades of the twentieth century: some of it was abstract, a trend that continued into the war years (e.g., Stuart Davis), but most of it might be termed "American scene" art. This art depicted the disdain for fascism that appeared to be overtaking the world, but it also in part presented an unvarnished look at the suffering from poverty created by the "capitalist debacle" of the Depression, depicted by many of the WPA artists. As noted in Chapter 2, the progress of this art collided with "politics" when the State Department recalled a traveling collection of "communist art"—which did not, according to the Republicans in the Senate, demonstrate "American values."

One response to this political situation was to develop a purely abstract and "nonpolitical" art—one that was neutral in terms of "social commentary." That art, first sponsored by artists such as Barnett Newman, Jackson Pollock, and Willem de Kooning, became abstract expressionism, which actually had a short life as various forms of "innovative" art began to dominate the art scene. That scene had moved from Paris to New York in the postwar era. Pop art, op art, land art, installation art, and many other variants have been produced, leading some to argue that there is "disarray" in the market. That disarray, it is claimed, is found on both the supply and the demand sides of the art market. As Peter Watson argued a quarter-century ago, dealers of the nineteenth and twentieth centuries were less speculators than critics, writers, and connoisseurs of art, including "modern art." Most of these great dealers (such as Kahnweiler, Frick, and the Wildensteins), despite differences in aesthetic opinion, believed that scholarship rather than investment potential surrounded great art and that art and quality were positively related.

As we have seen throughout this book, particularly in our discussion of the possibility of "art bubbles," that is no longer the case. Twenty-five years ago Watson (1992: 479–481) was already able to discern the trend:

> The auction houses have always said that they reject any notion that art should be looked upon as an "investment." This is blatantly disingenuous. They reject the notion on the surface while doing everything to promote it underneath. What other reason could Sotheby's have for inventing, and continuing to publish, the *Art Market Index?* . . . the number of people in the U.S.A. who engage in collecting as a hobby has grown at an estimated rate of 10–12 percent per annum since 1980. . . . In effect, art prices have become a function of the number of millionaires in the world, rather than of the quality of the art . . . in the art market today the tail is wagging the dog. High prices define what is great art, not the other way around.

A full quarter-century later, it is billionaires, in addition to millionaires, who are driving the market for new and (potentially) investment-worthy "art." And the market has responded. Dealers, galleries, and auction houses, in an ever-present search for hot and *remunerative* new artists, deal in artists in mid- or even early career.

Some contrarians call the barrage of new and continually "innovative" art "fashion art," as opposed to art that has proved its staying power. Here we encounter the idea of "fundamentals," or art that has stood the test of time. If we glance back at Table 7.4 in Chapter 7, it is evident that the Americans who were in the top auction-sales brackets were virtually all born after 1950, with six of them born after 1960. This means that several American Contemporary artists were turning millions of dollars at auction while in their forties, fifties, and sixties, with one in her thirties (Tauba Auerbach). Top galleries dealing in contemporary art, such as the Gagosian in New York City, routinely handle and are on the lookout for young rising stars. Critics, such as journalist and historian Paul Johnson, see the modern art establishment (critics, museum curators, powerful collectors, galleries, auction houses) as fundamentally corrupt, with the power to make or impoverish young artists who do not conform to "fashion" or criteria established within these groups. Johnson (2003: 730) writes,

> Fashion art, by its nature, is constitutionally corrupt. The way in which it operates is as follows. X, a professional collector [or gallery owner] spots a likely young artist, and buys up his or her early work. He enlists

the support of Y, a dealer-gallery owner, and Z, a museum director. Together the three "create" the artist who, let us say, produces collages of artificial cat-skins. He/she is given grants and prizes, and a highly successful show at Y's gallery, followed by purchases for Z's museum. At that point X is free to unload his purchases to finance his next operation; Y makes a handsome profit too; Z does not (as a rule) make money but is paid in power.

Thus, viewed in this manner at least, the evolution of the American art market has followed the path of methods of marketing in capitalist institutions. Postmodernist, postconceptual, demonstration art, and every other manner of innovation have become part of constant "innovation." The profit motive is foremost in this scenario, and ever-willing demanders (some "keeping up with the competition") follow suit. Money, in increasing amounts, feeds this art market, and an ever-eager market is produced by expanding numbers of high-level collectors. Despite its problems, and there are many, the market for art has never been more robust, certainly in the United States, but around the world as well. Some of the art produced—perhaps a great deal of it—will end up ultimately in collectors' and museums' basements, and "fundamentals" for many (not all) such speculative purchases in the present will disintegrate in thirty, fifty, or one hundred years. *Or not.* We must never forget what economists call "the taste parameter." Tastes and "fashions" in art are in a state of frequent and unpredictable flux. Such present "wonders" who find themselves in decline may perhaps rise Dracula-like at another time. Consider Tarmy's description (2014) of the work of Victorian painter Lawrence Alma-Tadema: "Fluctuation has always characterized the art market. Take the tale of Lawrence Alma-Tadema, a pinnacle of the Victorian-era Academic Style whose painting 'The Finding of Moses' sold for $25,000 in 1905. In 1942, his art was so passé that the same painting sold for $682. In 2010 it sold again for $23.5 million." Such rollercoaster price experience can occur during the artist's lifetime. American artist Sam Gilliam, born in 1933 and one of the artists in our sample, was the rage in the 1960s and 1970s (known for hanging drape and twisted canvas paintings) and had shown at the Whitney, MoMA, and the Venice Biennale (1972). He then fell out of favor—in 1986 a canvas could be had for less than $1,500. But he was "rediscovered" when a dealer and artist friend gave him a curated show in Los Angeles in 2013. By November 2015, a Gilliam canvas sold for $317,000 at Christie's in New York. (Part of the relatively sudden demand change might be attributable to the increased popularity of art by African Americans.) So perhaps artists should not want to give up so easily and should look to the long run, and art buyers should take

notice.[6] The taste for "art" might be steady year to year, but the content is quite variable. It is a market that is *never* in long-run equilibrium.

Is the American Art Market Free and Efficient in an Economic Sense?

The past is prologue in everything, it seems. Art is no exception. Artists barely known today may be the masters of tomorrow. (It is worthwhile to think of Van Gogh's almost total lack of sales in his lifetime as we witness, today, a mediocre painting by the artist selling for over $60 million.) American artists, as all others, have gone through different styles and genres, and the demand for this work has ebbed and flowed over time. As Hippocrates wrote, "Ars longa, vita brevis" (life is short, art is long). The cynic would argue, perhaps, that today, given the general corruption and some ginned-up contemporary "masters," that art is "shorter." This begs the central question: Do the market process, contemporary marketing, and the nature of contemporary American art mean that the market is inefficient at producing and rewarding the best? The answer is complex to a degree, but it is the case that quality and longevity are continually tested in the American art market. A free and open market assures that. It may take a good deal of time to establish real credence in the value of the $12 million shark, graffiti art, cake slices, Coca-Cola bottles, balloon dogs, and all-white paintings. The point is that some, perhaps many, may fail. But failure is and must be part of the market process—winners cannot exist without losers, as Cowen (1998) has argued. Tastes differ, but the market rules. Some viewers will believe that a degenerating shark in a vat of formaldehyde or an inflatable dog are ridiculous jokes; others will find enormous artistic or spiritual consolation in the objects. The market will, in the present and in the future, decide who is "right." And tastes, backed by demand, will ensure that innovation will take place.

It is useful in this regard to recall (from Chapter 1) the argument of Joel Mokyr (1992) regarding technology. Mokyr argues that decisions concerning technology are made when new techniques are offered—firms make an "adopt" or "not adopt" decision. Seemingly, if the new technique is profitable, it will be adopted, and vice versa. While Mokyr goes on to elucidate the problems of non-market or government impediments to technological absorption, the artist and her market do not really contain such regulations. Naturally it is difficult for any artist to enter the "big time" markets in New York and London, but generally the market is ultra-competitive. An artist may appear with a new "technique" (style, material, idea, and so on), but, so long as laws are enforced against forgery or fraud and intellectual property rights are

enforced, that art enters a market wherein buyers have a chance to purchase, leading to artistic success. While an artist or "school" may have a temporary "monopoly" (*everyone* wants to monopolize!), the short-term monopoly of the artist will be competed away. Competition is the expected result in all fields, unless there are artificial barriers to entry. The idea (pop art, for example) had its start with Andy Warhol, but the concept soon spread to others, with many variations offered along the way. Thus, a free and open art market leads to the match of suppliers and demanders, who are free to accept or reject artists' "technological innovations."

Technology, moreover, with price-lowering reduced information costs, may actually favor the introduction of younger artists in the market, giving them a higher probability of success. For example, consider the appearance of Internet search engines that constantly survey auction markets and the results of sales. The search engine Askart.com (used to collect auction data for this book) records every trade at auction, providing the auction estimate, whether or not the piece sold, and (if sold) the price. This resource naturally helps buyers who are interested in purchasing art, either at auction or through galleries or individuals. It reduces information cost so that buyers of the same or similar works know the price at which a painting was last transacted. If a particular piece, so recorded, winds up in the hands of a dealer, that knowledge will limit the "markup" a dealer can charge, naturally given the possibility of given demand changes. As we have shown in Chapter 4, that knowledge could also affect the price of a work that returned to auction, again given that there have been no dramatic demand changes. These lowered information costs and their effects may well encourage the marketing and sale of "new" artists by galleries, spurring auction houses to also offer younger artists. It also favors the sale of pieces long buried in collections—items favored are those "fresh to the market." The Internet itself and its facilitation of reduced transactions cost thus may be expected to affect the American (and other) art markets.

The truth is that there has never been, at any time in history, more art demanded and consumed per capita in the entire world. A primary source originated in the United States, and economics has much to contribute to understanding the institutions surrounding that art. We modestly propose that everything has an "economic" aspect that can be considered. The artist is like an entrepreneur—she works in a milieu of prices and markets and discovers images and techniques previously not seen. This is the way art, as well as all of society, progresses. Normally, economics approaches issues as some sort of "maximization" problem. We have portrayed the economics of art as part of the art of a "new" economics. The economics of the American art market, in addition to matters of money, price, and the data surrounding the market,

must include history, psychology, aesthetics, and biography—aspects that cannot be easily measured (if at all) in terms of money. Further, there is much to know and discover in this realm—hopefully a far richer one than the standard economic approach could ever be. So much remains to be studied and refined. What, for example, determines the pace of artistic activity in a world of ever-changing technology? How would good and reliable data on gallery sales and activity alter our conclusions, based almost solely on auction data? Would different artists and data samples alter results? Are taste changes for individuals or genres of art capable of analysis?

Growing interest in these and so many other complex issues is aided by new forms of economics applied to art and artists. We have applied it to *some* of the issues related to American art. Fortunately, cultural economics, along with many other areas of inquiry, is alive and well to help push that study forward. It is useful to remember that there is no labor theory of value in making art or anything else, but artists in America and around the world must survive. Ultimately, however, as the great American artist James McNeill Whistler once observed, "An artist is not paid for his labor but for his vision."

.

Appendices

Appendix to Chapter 3

In this appendix we (1) provide a tutorial on how to follow along with our behavioral analyses of our empirical results throughout this book, and (2) present the explicit estimation results that are summarized in Tables 3A.1 and 3A.2 for early American artists and Tables 3A.3 and 3A.4 for Contemporary American artists.

Appendix 3.1: Interpreting Behavioral Relationships in Statistical Models

This Appendix is intended for readers who have little or no background in statistics but would like to understand how we were able to obtain the behavioral inferences we present in this book from the empirical results also presented there. One does not need a degree in mechanical engineering to understand how to use a screw-driver. Likewise, one does not need to be a statistician to understand how we arrive at our empirical results, and how we extract behavioral content from them. We hope that this short tutorial will help demystify that process for those readers who are not technically oriented.

We begin with the notion that there is some relationship between a dependent variable (y) and a number of explanatory (or, independent) variables (the X's). We can observe data on these variables (say, we have n observations on y and each X), and we would like to use this information to quantify the relationship in question (i.e., to determine how much and in what direction each X affects y). If the relation is linear in its parameter,[1] it can be written for the ith observation as

$$y_i = \beta_1 + \beta_2 X_{2i} + \beta_3 X_{3i} + \beta_4 X_{4i} + \ldots + \beta_k X_{ki} + \varepsilon_i \quad i = 1, \ldots, n \qquad (3A.1)$$

where y_i denotes the ith observation on the dependent variable; X_{ji} denotes the ith observation on each of our k explanatory variables ($j = 1, \ldots, k$)[2]; the β_j ($j = 1, \ldots, k$) are the unknown parameters of the model (constant coefficients that are unobservable); and ε_i is the random disturbance term associated with the ith observation, included to allow the relationship between the y's and X's not to be exact.

Note that the behavioral content of this model is found in the sign and mag-nitude of the unknown coefficients, the β_j ($j = 1, \ldots, k$). Behavioral experiments ask, in their simplest form, "What is the change in the dependent variable caused by a change in one of the independent variables, all other independent variables held constant?" Since the β_j's are constants (albeit unknown), it follows from (3A.1) that

$$\Delta y_i = \beta_1 + \beta_2 \Delta X_{2i} + \beta_3 \Delta X_{3i} + \beta_4 \Delta X_{4i} + \ldots + \beta_k \Delta X_{ki} \quad i = 1, \ldots, n \qquad (3A.2)$$

Allowing only X_j to change (i.e., setting $\Delta X_m = 0$, $m = 1, \ldots, k$, $m \neq j$), we see that

$$\Delta y_i = \beta_j \Delta X_{ji} \qquad (3A.3)$$

So that the change in y caused by a change in X_j, all other X's held constant, is

$$\frac{\Delta y}{\Delta X_j}\bigg|X_2 = \Delta X_3 = ... = \Delta X(j-1) = \Delta X(j+1) = ... = \Delta Xk = 0 = \beta_j \qquad (3A.4)$$

Thus if $\beta_j > 0$, increases in X_j increase y, and decreases in X_j decrease y; if $\beta_j < 0$, increases in X_j decrease y, and decreases in X_j increase y. Furthermore, for a given change in X_j, the larger the magnitude of β_j, the larger the resultant change in y. Importantly, if $\beta_j = 0$, changes in X_j do not affect y, implying that X_j should not have been included in the model.

Quantifying the relationship in (3A.1) amounts to estimating values for the unknown β_j's, based on the observed data on y and the X's. Ideally, these estimates should result in a model that somehow "best fits" the data. How we define "best fit" determines the method that we use to compute the estimates. The method of ordinary least squares (OLS) produces estimates that result in a fitted model that minimized the sum of the squared deviations of the actual data from the corresponding values predicted by the model.[3] This is the estimation technique that we employ in 95 percent of the empirical work presented in this book. When the formulas implied by the least squares approach to estimation are applied using the data on y and the X's, the estimated version of (3A.1) becomes

$$y_i = b_1 + b_2 X_{2i} + b_3 X_{3i} + b_4 X_{4i} + ... + b_k X_{ki} + e_i \quad i = 1, ... , n \qquad (3A.5)$$

where the b_j's are the estimated values of the corresponding β_j's, computed using the formulas arising from the least squares method, and e_i is called the least squares residual.

Note that the b_j's are computed from sample data on y and the X's. In principle, we could have drawn many other such samples of data and computed (a set of) b_j's for each sample. The set of all possible values we could have computed for the b_j's forms a statistical distribution (called a sampling distribution), which has a mean and variance. Under certain assumptions,[4] the mean of this distribution is β_j, its variance [the square root of which is the standard error of the estimator and denoted by $S(b_j)$] is minimum, and b_j will converge to β_j as sample size increases without bound. Taken together, these results imply that b_j is as good an estimator of β_j as we can come up with. If we add the assumption that the ε_i of (3A.1) follow a normal distribution (bell curve), then b_j and $S(b_j)$ follow known statistical distributions, which can be used to construct statistical hypothesis tests regarding the β_j's.

As noted earlier, an important question to address in interpreting model esti-
mation results is whether the true coefficient associated with the jth variable (i.e.,
the β_j) differs from zero. If it does not differ from zero, changes in X_j do not affect
y, and the variable might be dropped from the model with no loss in explana-
tory power. If it does differ from zero, then we can draw behavioral inferences
regarding the direction and magnitude of the effect of X_j on y. Without going into
the statistical theory behind the test or the theory of statistical hypothesis testing
in general, a statistic constructed by taking the ratio of the estimated coefficient
to its standard error, that is, $t^* = b_j \,/\, S(b_j)$, can be used to test the null hypothesis
(H_0) that the true underlying parameter (β_j) differs from zero, that is, $H_0: \beta_j = 0$.
This statistic follows a Student's t distribution, and if we employ an approximate
significance limit of 2.0, then the test is easy to interpret: *If (the absolute value of)*
the computed value of the test statistic exceeds 2.0 (i.e., $t^ > 2.0$), then the underlying*
parameter is said to be statistically significantly different from zero at the 0.05 level
of significance (i.e., at the $\alpha = 0.05$ level).[5] In other words, we can be 95 percent
sure that the underlying parameter is not 0. Thus, when we scan the empirical
results in a particular estimated model, for those independent variables whose
parameter estimates have computed t values in excess of 2.0 (in absolute value),
we can make meaningful behavioral inferences on the direction (sign of the esti-
mator) and magnitude (size of the estimator) of the effect of that variable on the
dependent variable.

Another statistic that is commonly reported for estimated models is an F statistic
used to test the significance of the model, taken as a whole, in explaining variations
in y.[6] If all of the slope parameters of model (3A.1) are zero, $\beta_1 = \bar{y}$, the mean of y; in
this case, our best prediction of y_i for any observation is its mean \bar{y}—knowing the
values of the various X's does not help predict y. Thus, to the extent that any or all of
the β_j's differ from zero, knowing the values of the corresponding X's helps explain
variations in y over and above its mean. The F test is therefore a test of the joint
significance of all of the slope parameters of the model, i.e., $H_0: \beta_2 = \beta_3 = \ldots = \beta_k =$
0. The F statistic (F^*) is computed as the ratio of the variance in y, explained by the
regression to the variance in y left unexplained; large values of F^* indicate rejection
of H_0, which in turn implies that the regression taken as a whole is statistically sig-
nificant in explaining variations in y.

It is also conventional to report a descriptive statistic R^2 that measures how well
the estimated model fits the data. R^2 is defined as the percent of the variation in y
explained by the fitted model [i.e., $R^2 =$ (explained variation)/(total variation)]. Since
the least amount of variation in y that a model can explain is none of it, and the most
a model can explain is all of it, R^2 must fall between 0 and 1—the closer R^2 to 1, the
better the fit, *ceteris paribus*.[7] There is a danger in jumping to the conclusion that all
low R^2 values are bad and all high R^2 values are good. R^2 values depend on, among

other things, sample size (n), the number of explanatory variables (k), and the level of aggregation of the data. Some wage equation estimates in labor economics, based on individual level micro data, view an R^2 value of 0.20 as quite good (since such data is characterized by a high degree of randomness), while some macroeconomic consumption function estimates, based on yearly aggregate data, view R^2 values of 0.90 as poor. It is also important to note that R^2 can never be decreased by adding additional explanatory variables (since adding variables, even if they contribute nothing to the model's explanatory power, cannot decrease the explained variation of the model and may increase it due to spurious correlation with the already included variables). This means that maximum R^2 is a particularly bad model selection criterion, since it mitigates against parsimonious model specification—we could always increase R^2 by adding every possible extraneous variable, including the "kitchen sink," to the model. Thus, if we wish to select a "best" model based on its goodness of fit, we need to modify the R^2 measure to penalize for adding extraneous variables to the model. "Adjusted R^2" is such a measure.

Adjusted R^2, sometimes denoted as \overline{R}^2, adjusts R^2 for losses in degrees of freedom (increases in k relative to n). The difference between R^2 and \overline{R}^2 can be most easily seen in the differential effect of adding an additional variable to the model: Adding an additional variable will increase R^2 to the extent that it increases the explanatory power of the model, but it will never decrease R^2. Adding an additional explanatory variable has two effects on \overline{R}^2: (1) it will increase to the extent that the new variable increases the explanatory power of the model; (2) it will fall because the new variable uses up a degree of freedom (k rises relative to n). If the reduction in \overline{R}^2 due to lost degrees of freedom exceeds the gain in \overline{R}^2 due to increased explanatory power, \overline{R}^2 will decrease in value. In fact, if the model is very poorly specified, \overline{R}^2 could be negative.

This interplay between reduction in value due to lost degrees of freedom and increases in value due to increased explanatory power makes \overline{R}^2 a considerably better model selection tool than R^2 for two reasons: (1) It provides a purely statistical criterion for determining whether an additional variable should be included in the model. Presumably, if that variable increases \overline{R}^2 it should be included. (2) Henri Theil (1970) addressed the problem of selecting a "best" specification from competing alternatives attempting to explain a given dependent variable y. He showed that if one of the competing specifications is the "true" model, it will have the smallest residual variance. Operationally, this implies that of all the competing specifications, the one with the smallest residual variance is most likely to be the best estimate of the true model. Since minimum residual variance is equivalent to maximum \overline{R}^2, this "residual variance criterion" for model selection can be rephrased as follows: Of all the competing specifications, the one with the highest \overline{R}^2 is most likely to be the best estimate of the true model. This is the model selection philosophy employed by

Galenson in his age/productivity analysis, and since Chapter 3 of this book is in part an attempt to apply his procedures to an alternative data set, it is the model selection criterion we employ there as well.

When we pool the data on all artists and all time periods in our sample, we employ a statistical model known as a "fixed effects" model. Such models are just OLS models using pooled data (sometimes called "panel data") to estimate the parameters of the model with dummy variables added to indicate each cross-sectional group (artists in our case) and time period (typically five-year time intervals in our case). When we specify only dummies for cross-sectional effects, the model is called a "one-way fixed effect" model; when we specify cross-section and time series sets of dummies, the model is called a "two-way fixed effects" model. The implicit assumption underlying all fixed effects models is that the intercept [β_1 of equation (3A.1)] differs across groups and/or over time, but the behavioral coefficients on the X's do not. In any event, since it is fundamentally an OLS model, all of the procedures for making behavioral inferences based on the estimation results of the model discussed earlier apply to fixed effects models, as well.

A final statistical estimation technique that we utilize in this book is (dichotomous or two-category) probit analysis. Probit analysis is a maximum likelihood, not least squares, estimation technique. Maximum likelihood estimation picks the estimates for the coefficients of the model that would maximize the probability of the current sample being drawn. Specifically, probit analysis estimates the extent to which various explanatory variables (X's) affect the probability of an event occurring. The ex ante probability of the event is assumed to be normally distributed. *Without going into detail regarding the estimation theory or mechanics, probit estimation produces coefficient estimates attached to each of the X's and standard errors of those estimates. The signs of the coefficients can be used to determine whether the probability of the event varies directly or inversely with the respective X (e.g., a positive coefficient indicates that increases in that variable increase the probability of the event occurring), and the ratio of the coefficient estimate to its standard error can be used to test the statistical significance of that effect (naively using the critical value of 2.0) just as in the preceding OLS discussion.* There is a major difference in the interpretation of the coefficient estimates in probit versus OLS: in probit the estimated magnitude of the effect of changes in X on the probability of the event cannot be read directly from the coefficient estimate alone, as it can in OLS estimation. However, such inferences concerning magnitude are secondary to those regarding sign and significance, as is typically the case in this book.

Appendix 3.2: Statistical Results

Table 3A.1 Value/Age Profiles of Early American Artists

Artist	Intercept	Age	Age2	Age3	Age4	Age5	Size	Support	R^2	N	Age sig
INNESS	-27.1414	2.1903	-0.6688469	0.00088255	-.429542D-05		0.80206616	0.1180259	0.3985081	110	F = 1.925
	[-1.709]	[1.495]	[-1.345]	[1.21]	[-1.098]		[6.479]	[0.287]			a = 0.112
HOMER	-68.0099	6.1606	-0.1991234	0.0028055	-.145529D-04		0.62607254	1.087402	0.3916152	104	F = 3.07
	[-2.147]	[2.183]	[-2.14]	[2.175]	[-2.264]		[1.043]	[-1.53]			a = 0.020
CASSATT	-7.499974	0.5211	-0.0049217				1.5931946	0.5278583	0.7995931	23	F = 3.545
	[-3.530]	[2.909]	[-2.805]				[6.866]	[1.387]			a = 0.053
CHASE	84.451841	-9.757842	0.44220947	-0.0093205	.91286D-04	-.328926D-06	0.0348051	-0.5926623	0.3570095	43	F = 1.346
	[1.765]	[-1.716]	[1.752]	[-1.783]	[1.805]	[-1.813]	[0.188]	[-1.083]			a = 0.271
ROBINSON	140.417699	-12.986123	0.3909719	-0.003839			0.6645628	1.8378435	0.8003618	43	F = 3.828
	[2.099]	[-2.096]	[2.08]	[-2.052]			[1.631]	[2.951]			a = 0.0186
TWACHTMAN	-3.4653341	0.05779299					0.9263514	0.0736054	0.8423374	18	F = 4.232
	[-3.403]	[2.654]					[5.698]	[0.124]			a = 0.067
SARGENT	-159.16157	21.180873	-1.05718744	0.0250657	-0.00028295	.123128D-05	0.73099821	1.0061729	0.5505785	77	F = 3.337
	[-3.668]	[3.583]	[-3.465]	[3.352]	[-3.245]	[3.144]	[3.478]	[1.772]			a = 0.0096
HASSAM	-62.519005	6.77794575	-0.27543384	0.00534774	-.500179D-04	.180892D-06	0.57247416	0.985757	0.5291587	278	F = 14.35
	[-2.319]	[2.057]	[-1.768]	[1.513]	[-1.296]	[1.113]	[5.491]	[5.57]			a = 0.0000
REMINGTON	-114.22	14.398743	-0.66540369	0.0319474	-.946476D-04		0.85997288	0.679254	0.7252525	75	F = 6.321
	[-3.78]	[3.53]	[-3.346]	[3.16]	[-2.962]		[5.322]	[1.965]			a = 0.0002
KUHN	-4.1415789	0.00419505					0.8305898	1.6514907	0.6087386	121	F = 0.135
	[-2.383]	[0.2]					[3.656]	[5.147]			a = 0.714
WEBER	-50.857052	4.3616 0637	-0.13537632	0.0017701	-.834869D-05		0.68803065	0.541847	0.5873162	86	F = 10.365
	[-2.621]	[2.752]	[-2.862]	[2.913]	[-2.93]		[4.954]	[1.683]			a = 0.0000

(Continued)

Table 3A.1 Continued

Artist	Intercept	Age	Age²	Age³	Age⁴	Age⁵	Size	Support	R²	N	Age sig
BELLOWS	0.740309 [0.554]	-0.13132 [-4.173]					1.32902 [5.333]	0.13563 [0.181]	0.6407	50	F = 14.85 a = 0.0000
HOPPER	-34.363401 [-2.033]	4.836705 [1.861]	-0.27402763 [-1.875]	0.0074075 [1.936]	-.93947D-04 [-1.993]	.446698D-06 [2.031]	0.8731294 [3.83]	2.2925371 [4.333]	0.8203546	42	F = 7.839 a = 0.0001
AVERY	97.4838351 [1.544]	-10.757147 [-1.515]	0.41839973 [1.426]	-0.0076281 [-1.329]	.66517D-04 [1.233]	-.224828D-06 [-1.143]	0.88168112 [15.493]	1.2505954 [1.652]	0.8027963	400	F = 9.949 a = 0.0000
O'KEEFFE	0.7496 [0.688]	0.044 [0.758]	-0.0007 [-1.421]				0.7282 [8.332]	0.6854 [1.917]	0.68794	64	F = 14.64 a = 0.0000
WOOD	-37968.42 [-1.558]	4803.275 [1.569]	-241.64 [-1.579]	6.0407 [1.588]	-0.0750347 [-1.596]	0.00037054 [1.603]	0.8704327 [2.267]	5.6802087 [2.379]	0.5415765	24	F = 1.756 a = 0.197
DAVIS	135.9951 [5.223]	-18.408 [-5.134]	0.92059 [4.915]	-0.0217 [-4.65]	0.00024492 [4.385]	-.10638D-05 [-4.139]	0.83265 [3.204]	1.2351 [3.585]	0.75452	65	F = 15.23 a = 0.0000
BURCHFIELD	-69.2539 [-2.491]	8.4164 [2.423]	-0.4459 [-2.489]	0.00971 [2.508]	-0.00010772 [-2.489]	.45815D-06 [2.448]	1.28071 [12.389]	-0.5268 [-1.248]	0.6742	208	F = 23.49 a = 0.0000
HENRI	-2.96729 [-1.27]	0.04666 [2.88]	0.0008 [0.437]	-0.0003 [-0.755]	.98167D-05 [0.942]	-.87969ID-07 [-1.067]	0.49954 [3.549]	2.37205 [2.963]	0.62324	85	F = 7.632 a = 0.0000
DAVIES	-7.44464 [-5.524]	0.03471 [0.499]	-0.0018 [-0.609]	0.00032 [1.919]	-.543937D-05 [-2.81]		0.72403 [1.432]	1.6127 [2.034]	0.538	21	F = 2.303 a = 0.1136
SHINN	-0.99198 [-0.39]	-0.023 [-2.598]	-0.001 [-0.348]	0.00031 [0.739]	-.87031D-05 [-0.842]	.60u98D-07 [0.915]	0.63204 [3.446]	1.02097 [2.53]	0.26382	184	F = 3.207 a = 0.0086
GLACKENS	-7.37295 [-4.893]	0.00606 [0.276]					1.89006 [7.136]	0.4492 [1.059]	0.77935	32	F = 0.069 a = 0.795
LAWSON	104.0383 [2.999]	0.0134 [1.106]	0.13634 [3.298]	-0.0258 [-3.455]	0.00081412 [3.558]	-.74248D-05 [-3.656]	1.55889 [5.088]	0.26973 [0.538]	0.7878	25	F = 0.564 a = 0.726

									R^2	n	F	a
LUKS	-13.6314 [-1.21]	0.0002 [0.015]	-0.0094 [-0.644]	0.00164 [0.786]	-.4542D-04 [-0.865]	.351970D-06 [0.928]	1.2998 [4.356]	0.8315 [1.082]	0.6877	42	1.642	0.179
PRENDERGAST	-0.52543 [-0.346]	-0.0433 [-3.162]					1.27024 [5.337]	0.50632 [1.338]	0.46829	41	4.125	0.049
DOVE	2333.287 [2.275]	-220.95 [-2.138]	8.25576 [2.002]	-0.1527 [-1.876]	0.00140111 [1.763]	-.5109D-05 [-1.664]	0.91349 [4.118]	0.72107 [1.136]	0.807	52	8.45	0.0002
HARTLEY	-255.732 [-4.264]	22.8024 [4.367]	-0.7473 [-4.511]	0.0106 [4.619]	-.5514D-04 [-4.699]		0.8707 [5.28]	2.39856 [12.794]	0.84803	74	10.54	0.0000
MARIN	-23.3882 [-1.787]	2.52557 [1.554]	-0.1158 [-1.574]	0.00251 [1.617]	-.25722D-04 [-1.658]	.1004D-06 [1.685]	0.99669 [11.399]	1.19124 [5.214]	0.68839	22	6.913	0.0000
										8		0.0000
STELLA	132.8919 [1.53]	-17.322 [-1.546]	0.82487 [1.493]	-0.0185 [-1.411]	0.00019771 [1.309]	-.8085D-06 [-1.199]	0.94126 [6.064]	1.09664 [2.985]	0.55889	64	4.869	0.0010
DEMUTH	-52.2048 [-1.052]	6.85016 [1.16]	-0.3287 [-1.288]	0.00684 [1.429]	-.5144D-04 [-1.564]		0.53059 [1.107]	1.22239 [1.599]	0.48737	61	0.327	0.8270
EAKINS	1755.342 [2.803]	-198.81 [-2.737]	8.78293 [2.657]	-0.189 [-2.563]	0.0019853 [2.455]	-.81537D-05 [-2.339]	0.67022 [2.82]	-.1353 [-1.142]	0.90002	17	1.846	0.2587
WHISTLER	19.69435 [1.95]	-2.3293 [-2.961]	0.06155 [3.252]	-0.0005 [-3.544]			2.42757 [16.641]	-0.2367 [-0.687]	0.90621	12	1.326	0.4572

Notes: The numbers in brackets are *t*-statistics.

The notation $D\text{-}0x$ means 10^{-x}. Thus a coefficient estimate written $0.zzzD\text{-}04$ means $0.zzz \times 10^{-4}$, or $0.0000zzz$.

For brevity, we do not include estimates of the DY coefficients in the table.

Table 3A.2 Linear Trends in the Value/Age Profile, Early American Artists

Artist	Intercept	Age	Size	Support	R²	Overall Inference
Inness	-0.5416 [-0.74]	-0.010574 [-0.902]	0.69571 [5.285]	0.38492 [0.892]	0.363	Neg. & Insig.
Homer	0.36252 [0.552]	0.007981 [0.352]	0.7631 [1.835]	1.0054 [2.324]	0.313	Pos. & Insig.
Cassatt	-5.44352 [-2.387]	0.021497 [0.658]	1.6451 [6.184]	0.0636 [0.162]	0.724	Pos. & Insig.
Chase	3.5157 [2.021]	0.011102 [0.54]	-0.1436 [-0.839]	0.3430 [0.434]	0.227	Pos. & Insig.
Robinson	-3.3987 [-1.854]	0.09064 [1.962]	0.6820 [1.405]	1.5932 [2.47]	0.766	Pos. & Sig.
Twachtman	-3.4653 [-3.403]	0.057793 [2.654]	0.9263 [5.698]	0.0736 [0.124]	0.842	Pos. & Sig.
Sargent	1.7455 [1.293]	-0.03748 [-2.176]	0.7911 [2.822]	0.8894 [1.34]	0.472	Neg. & Sig.
Hassam	1.34796 [2.08]	-0.02296 [-3.929]	0.5873 [5.867]	1.0399 [5.669]	0.450	Neg. & Sig.
Remington	-2.1918 [-2.284]	0.060414 [2.344]	0.7345 [4.289]	1.0824 [3.21]	0.652	Pos. & Sig.
Kuhn	-4.1416 [-2.383]	0.00420 [0.2]	0.8131 [3.656]	1.6515 [5.147]0	0.609	Pos. & Insig.
Weber	0.41376 [0.524]	-0.04158 [-6.466]	0.7090 [4.948]	0.4881 [1.583]	0.554	Neg. & Sig.
Bellows	0.74031 [0.554]	-0.1332 [-4.173]	1.3290 [5.333]	0.1356 [0.181]	0.641	Neg. & Sig.

Hopper	-2.5348 [-1.803]	0.05654 [2.162]	0.8195 [2.19]	2.1262 [4.884]	0.697	Pos. & Sig.
Avery	-1.6851 [-2.34]	-0.01761 [-2.083]	0.9500 [16.38]	1.2133 [10.892]	0.837	Neg. & Sig.
O'Keeffe	2.5722 [4.521]	-0.03380 [-6.777]	0.7282 [8.877]	0.8114 [2.685]	0.672	Neg. & Sig.
Wood	-14.8507 [-2.532]	0.26561 [2.158]	0.9721 [3.74]	3.1590 [1.569]	0.342	Pos. & Sig.
Davis	-3.9604 [-1.998]	0.05570 [3.995]	1.0107 [3.161]	1.1803 [2.674]	0.550	Pos. & Sig.
Burchfield	5.0766 [-10.813]	0.0070 [0.97]	1.2839 [12.439]	-0.7941 [-3.592]	0.640	Pos. & Insig.
Henri	-5.0284 [-3.802]	0.0685 [2.973]	0.6918 [4.386]	1.4676 [2.201]	0.521	Pos. & Sig.
Davies	-4.0865 [-3.137]	-0.0159 [-0.569]	0.9181 [2.158]	0.7728 [0.535]	0.223	Neg. & Insig.
Shinn	-0.5035 [-0.431]	-0.0223 [-2.406]	0.6682 [3.586]	1.0489 [2.416]	0.236	Neg. & Sig.
Glackens	-7.3730 [-4.893]	0.00601 [0.276]	1.8900 [7.136]	0.4492 [1.059]	0.779	Pos. & Insig.
Lawson	-6.7995 [-4.536]	0.01021 [1.297]	1.544 [5.553]	0.0979 [0.113]	0.699	Pos. & Insig.
Luks	-5.184 [-3.635]	-0.0098 [-0.564]	1.2886 [6.207]	0.5497 [0.934]	0.601	Neg. & Insig.
Sloan	-2.1106 [-1.996]	-0.0329 [-2.615]	1.0086 [5.906]	1.5816 [5.622]	0.653	Neg. & Sig.

(Continued)

Table 3A.2 Continued

Artist	Intercept	Age	Size	Support	R^2	Overall Inference
Pendergast	-0.5254	-0.0433	1.2702	0.5063	0.468	Neg. & Sig.
	[-0.346]	[-3.162]	[5.337]	[1.338]		
Dove	-5.9807	0.10450	0.7356	1.287	0.776	Pos. & Sig.
	[-2.28]	[2.576]	[3.393]	[1.9]		
Hartley	-0.5302	-0.0450	0.8731	2.4436	0.795	Neg. & Sig.
	[-0.548]	[-3.56]	[5.885]	[10.855]		
Marin	-2.4201	-0.0057	1.0386	1.1164	0.645	Neg. &Insig
	[-4.32]	[-1.285]	[11.86]	[4.439]		
Stella	-1.3661	-0.0268	0.7692	0.9997	0.386	Neg. & Insig.
	[-1.073]	[-1.176]	[5.706]	[2.222]		
Demuth	-3.0237	0.0568	0.9780	0.7873	0.429	Pos. & Sig.
	[-2.755]	[3.217]	[3.852]	[0.977]		
Eakins	2.3220	-0.0230	0.986	-2.0916	0.726	Neg. & Insig.
	[1.104]	[-1.338]	[2.568]	[-4.25]		
Whistler	1.3466	0.0370	-0.1224	0.4093	0.763	Pos. & Insig.
	[0.572]	[1.405]	[-0.211]	[0.633]		

Table 3A.3 Value/Age Profiles for American Artists Born after 1900

Artist	Intercept	Age	Age2	Age3	Age4	Age5	ln(Size)	Support	Adj. R^2	N	Age sig.
Evergood	18.296	-1.952	.076	-0.0012	.68D-05		1.0736	1.4587	0.704	73	F = 4.783
	[2.22]	[-2.41]	[2.62]	[-2.72]	[2.73]		[7.37]	[7.36]			a = 0.003
Porter	.2681	.0484					.9788	.9901	0.712	85	F = 16.85
	[0.347]	[5.80]					[11.6]	[5.05]			a = 0.000
Sheets	1.7059	-0.0815	.0007				1.2811	-0.1462	0.490	113	F = 3.870
	[1.63]	[-2.79]	[2.69]				[7.56]	[-0.57]			a = 0.024
Burkhardt	8.546	-0.1944	.0016				.5491	.9939	0.556	69	F = 6.973
	[5.06]	[-3.82]	[3.45]				[3.16]	[3.76]			a = 0.002
Rothko	55.502	-4.847	.1612	-0.0022	.11D-04		.7825	.1565	0.886	121	F = 19.26
	[3.37]	[-3.00]	[2.86]	[-2.63]	[2.37]		[13.7]	[1.13]			a = 0.000
Reinhardt	135.441	-14.002	.5619	-0.0098	.62D-04		.3548	.7819	0.442	76	F = 2.442
	[2.87]	[-2.69]	[2.64]	[-2.59]	[2.54]		[2.85]	[3.08]			a = 0.056
Martin	-52.606	3.3217	-0.0679	.0006	-0.19D-05		.6730	.2748	767	138	F = 10.81
	[-5.62]	[4.63]	[-3.44]	[2.60]	[-1.98]		[16.34]	[0.94]			a = 0.000
Katz	-34.288	4.2045	-0.1753	.0035	-0.34D-04	.126D-06	.6028	.8424	0.771	278	F = 6.371
	[-2.29]	[2.55]	[-2.54]	[2.52]	[-2.51]	[2.49]	[30.7]	[4.62]			a = 0.000
Wyeth	.1500	.0919	-0.0009				1.4179	.1839	0.488	193	F = 7.936
	[0.14]	[3.06]	[-2.53]				[11.02]	[0.65]			a = 0.000
Marden	40.855	-2.4859	.0554	-0.0004			.08103	.0957	0.749	96	F = 14.84
	[5.31]	[-4.37]	[3.95]	[-3.46]			[10.08]	[0.27]			a = 0.000
Oldenburg	-333.69	36.6188	-1.5309	.0311	-0.0003	.12D-05	.7256	-1.2247	0.502	203	F = 6.577
	[-2.38]	[2.46]	[-2.48]	[2.48]	[-2.47]	[2.46]	[12.37]	[-1.36]			a = 0.000

(Continued)

Table 3A.3 Continued

Artist	Intercept	Age	Age²	Age³	Age⁴	Age⁵	ln(Size)	Support	Adj. R^2	N	Age sig.
Twombly	-17.582 [-1.31]	2.2736 [1.95]	-0.0800 [-2.17]	.0012 [2.32]	-0.58D-05 [-2.392]		1.0403 [13.04]	.1918 [0.72]	0.533	219	$F = 6.531$ $a = 0.000$
Salle	65.0578 [3.06]	-9.5728 [-2.89]	.5547 [2.85]	-0.0152 [-2.79]	.0002 [2.73]	-0.101D-05 [-2.66]	.8331 [22.63]	.0513 [0.44]	0.779	191	$F = 5.667$ $a = 0.000$
Kelly	11.5828 [7.61]	-0.23877 [-3.73]	.0021 [3.62]				.7548 [8.48]	1.4469 [5.82]	0.689	112	$F = 6.611$ $a = 0.000$
Fischl	-138.482 [-2.45]	13.7360 [2.44]	-0.4897 [-2.36]	.0077 [2.29]	-0.44D-04 [-2.24]		.6920 [17.41]	.9698 [7.09]	0.773	170	$F = 1.564$ $a = 0.187$
F. Stella	-149.339 [-4.4]1	21.0603 [4.93]	-1.0834 [-5.16]	.0266 [5.33]	-0.0003 [-5.45]	.142D-05 [5.54]	.7689 [16.08]	.5743 [2.39]	0.492	317	$F = 21.88$ $a = 0.000$
Kline	-316.38 [-3.123]	51.483 [3.25]	-3.1600 [-3.33]	.0929 [3.38]	-0.0013 [-3.40]	.721D-05 [3.38]	.7617 [15.07]	.5218 [3.53]	0.789	180	$F = 6.583$ $a = 0.000$
Frankenthaler	-147.458 [-2.40]	17.9876 [2.34]	-0.8235 [-2.20]	.0184 [2.06]	-0.0002 [-1.95]	.864D-06 [1.84]	.6823 [17.76]	-0.0630 [-0.36]	0.698	192	$F = 2.452$ $a = 0.035$
Kohlmeyer	195.41 [1.68]	-12.191 [-1.62]	.2844 [1.58]	-0.0029 [-1.53]	.108D-04 [1.46]		.5137 [8.91]	.3108 [1.68]	0.658	74	$F = 2.804$ $a = 0.033$
Pollock	109.735 [2.72]	-13.989 [-2.57]	.6562 [2.48]	-0.0129 [-2.35]	.903D-04 [2.19]		1.0674 [9.16]	.9382 [2.78]	0.827	53	$F = 10.26$ $a = 0.000$
Rosenquist	7.4704 [6.22]	-0.1336 [-3.08]	.0011 [2.40]				.6976 [7.10]	1.6392 [8.33]	0.687	148	$F = 10.11$ $a = 0.000$
Johns	71.2028 [3.56]	-4.8347 [-2.83]	.1352 [2.60]	-0.0016 [-2.40]	.73D-05 [2.25]		.6558 [4.08]	.7443 [1.82]	0.347	83	$F = 4.981$ $a = 0.001$

Dine	-62.778 [-2.43]	7.8227 [2.56]	-0.3367 [-2.41]	.0069 [2.26]	-0.69D-04 [-2.09]	.26D-06 [1.92]	.4686 [7.31]	.6698 [3.48]	0.438	210	F = 4.565	a = 0.001
Basquiat	5531.042 [4.32]	-1245.9 [-4.31]	111.348 [4.29]	-4.9354 [-4.26]	.1085 [4.23]	-0.0009 [-4.20]	.9831 [27.85]	-0.4402 [-3.93]	0.785	597	F = 96.79	a = 0.000
Mitchell	-28.4547 [-2.23]	3.0663 [2.58]	-0.1039 [-2.58]	.0015 [2.56]	-0.80D-05 [-2.54]		.7818 [20.78]	.7702 [5.12]	0.854	210	F = 5.596	a = 0.000
Schnabel	111.8624 [2.48]	-15.803 [-2.39]	.8936 [2.40]	-0.0245 [-2.41]	.0003 [2.42]	-0.17D-05 [-2.44]	.7862 [16.93]	.0088 [0.06]	0.583	189	F = 1.199	a = 0.312
Noland	-280.690 [-3.92]	27.0158 [3.71]	-0.9838 [-3.41]	.0174 [3.11]	-0.0002 [-2.84]	.51D-06 [2.60]	.4364 [9.25]	.0390 [0.24]	0.630	235	F = 39.85	a = 0.000
Scharf	25.8616 [3.98]	-1.8614 [-3.3][1]	.0503 [3.28]	-0.0004 [-3.20]			.6312 [13.80]	.3075 [2.7][2]	0.499	170	F = 3.303	a = 0.022
Poons	-377.667 [-2.89]	51.8424 [3.01]	-2.7223 [-3.09]	.0696 [3.15]	-0.0009 [-3.20]	.42D-05 [3.24]	-0.3562 [4.03]	-0.2305 [-0.89]	0.477	73	F = 4.825	a = 0.001
Rivers	-64.606 [-4.25]	5.8705 [4.47]	-0.1766 [-4.31]	.0023 [4.17]	-0.11D-04 [-4.07]		.4989 [8.95]	1.2984 [7.93]	0.618	187	F = 9.632	a = 0.000
Resnick	4.5729 [8.72]	-0.0429 [-7.07]					.7584 [13.09]	.6503 [1.96]	0.717	88	F = 46.81	a = 0.000
Oliveira	32.976 [2.84]	-1.8314 [-2.26]	.0382 [2.05]	-0.0003 [-1.86]			.5127 [6.90]	.9774 [4.15]	0.636	98	F = 5.700	a = 0.001
Lewis	-368.961 [-4.56]	42.2402 [4.65]	-1.8938 [-4.75]	.0416 [4.87]	-0.0004 [-5.00]	.191D-05 [5.14]	1.4612 [9.17]	.6413 [2.62]	0.712	62	F = 5.828	a = 0.000
Guston	-165.691 [-2.97]	14.6877 [3.00]	-0.4631 [-2.94]	.0063 [2.89]	-0.32D-04 [-2.83]		.7789 [9.69]	1.3812 [7.92]	0.710	157	F = 6.944	a = 0.000

(Continued)

Table 3A.3 Continued

Artist	Intercept	Age	Age²	Age³	Age⁴	Age⁵	ln(Size)	Support	Adj. R2	N	Age sig.
Grooms	1.5192 [1.26]	.1661 [3.51]	-.0018 [-3.15]				.5340 [5.46]	.6945 [2.42]	0.511	83	F = 4.256 a = 0.018
Diebenkorn	-38.0164 [2.01]	3.8736 [2.30]	-0.1263 [-2.29]	.0018 [2.29]	-0.92D-05 [-2.28]		.7159 [7.21]	1.223 [4.84]	0.754	156	F = 7.030 a = 0.000
Motherwell	54.652 [3.26]	-4.2763 [-2.98]	.1349 [3.04]	-.0018 [-3.06]	-.88oD-05 [3.06]		.6328 [14.27]	.7289 [5.52]	0.535	286	F = 6.084 a = 0.000
Rauschenberg	-213.078 [-2.73]	23.9823 [2.78]	-0.9833 [-2.66]	.0192 [2.48]	-0.0002 [-2.30]	664D-06 [2.12]	.7892 [11.01]	.4217 [1.00]	0.666	225	F = 62.90 a = 0.000
Bearden	288.384 [4.26]	-21.590 [-4.23]	.5970 [4.23]	-0.0071 [-4.21]	.312D-04 [4.17]		.5776 [8.21]	-0.3137 [-0.66]	0.475	72	F = 7.512 a = 0.000
Lichtenstein	-191.455 [-2.48]	20.2342 [2.41]	-0.8217 [-2.33]	.0166 [2.31]	-0.0002 [-2.32]	.652D-06 [2.36]	.6876 [14.36]	1.1549 [6.42]	0.514	394	F = 9.894 a = 0.000
Gilliam	344.988 [1.66]	-36.257 [-1.72]	1.4972 [1.78]	-0.0300 [-1.82]	.0003 [1.85]	-0.112D-05 [-1.87]	.4803 [5.45]	.3136 [1.13]	0.426	65	F = 1.423 a = 0.231
Rothenberg	60.955 [5.85]	-3.6206 [-5.10]	.0755 [4.67]	-0.0005 [-4.30]			.7961 [8.63]	.5318 [2.84]	0.795	82	F = 33.12 a = 0.000
Thiebaud	-20.672 [-1.74]	4.332 [2.64]	-0.2382 [-2.81]	.0060 [2.92]	-0.7D-04 [-2.98]	.303D-06 [3.01]	.3375 [5.13]	1.7152 [8.87]	0.442	199	F = 5.134 a = 0.000
Baziotes	3.1698 [4.94]	.0327 [4.26]					.7798 [10.19]	.7935 [4.60]	0.780	62	F = 10.82 a = 0.002
Kahn	2.9495 [5.04]	.0072 [2.10]					.5563 [11.05]	.8593 [8.53]	0.803	159	F = 3.365 a = 0.069

Table 3A.4 Linear Value/Age Profiles for American Artists Born after 1900

Artist	Intercept	Age	Size	Support	Adj. R^2	N	Trend Sig. at $a = .10$
Evergood	1.461	−0.0189	1.138	1.484	0.657	73	Negative
	[1.58]	[−2.11]	[7.89]	[7.38]			
Porter	.2681	.0484	.9788	.9901	0.712	85	Positive
	[0.347]	[5.80]	[11.6]	[5.05]			
Sheets	.8828	−0.0052	1.151	.1642	0.452	113	Insignificant
	[0.730]	[−1.22]	[5.84]	[0.741]			
Burkhardt	3.9409	−0.0161	.5176	.9837	0.493	69	Negative
	[3.07]	[−1.82]	[2.90]	[3.60]			
Rothko	3.0529	.0429	.9721	.5395	0.7815	121	Positive
	[5.91]	[5.06]	[19.32]	[3.11]			
Reinhardt	6.5681	.0366	.4414	.6877	0.424	76	Positive
	[8.29]	[2.86]	[4.38]	[2.77]			
Martin	7.0947	.0013	.5912	−0.1886	0.603	138	Insignificant
	[17.5]	[0.10]	[7.72]	[−0.46]			
Katz	4.3588	−0.0053	.5994	.8752	0.757	278	Negative
	[8.96]	[−1.64]	[29.14]	[4.56]			
Wyeth	1.880	.0159	1.3826	−0.2141	0.474	193	Positive
	[2.18]	[3.47]	[10.38]	[−0.81]			
Marden	3.5782	.0430	.8859	.0407	0.658	96	Positive
	[3.81]	[3.07]	[11.48]	[0.11]			
Oldenburg	7.2255	−0.0269	.7332	−1.1859	0.453	203	Negative
	[11.89]	[−2.86]	[10.88]	[−1.45]			
Twombly	5.3746	−0.0092	.9610	.3304	0.484	219	Insignificant
	[7.61]	[−0.92]	[12.18]	[1.25]			
Salle	3.0016	.0261	.8307	−0.0070	0.767	191	Positive
	[5.53]	[3.70]	[22.22]	[−0.06]			
Kelly	6.5410	−0.0156	.6918	1.5718	0.659	112	Negative
	[7.29]	[−1.45]	[8.96]	[6.79]			
Fischl	3.7031	.01619	.6849	1.0287	0.772	170	Positive
	[6.46]	[1.54]	[17.72]	[7.59]			
F. Stella	8.1634	−0.0554	.6602	.9738	0.409	317	Negative
	[17.04]	[−6.13]	[13.35]	[3.85]			
Kline	−0.4709	.1537	.7410	.2571	0.737	180	Positive
	[−0.64]	[11.95]	[13.25]	[1.67]			
Frankenthaler	5.5325	−0.0136	.6774	.1879	0.690	192	Negative
	[13.59]	[−1.72]	[17.67]	[1.30]			

(Continued)

Artist	Intercept	Age	Size	Support	Adj. R^2	N	Trend Sig. at a = .10
Kohlmeyer	2.8624 [2.95]	.0129 [1.09]	.5628 [8.27]	.1788 [0.94]	0.623	74	Insignificant
Pollock	1.8586 [1.52]	.1103 [2.89]	1.2492 [8.30]	1.1654 [3.41]	0.751	53	Positive
Rosenquist	5.2139 [6.54]	−0.0300 [−3.90]	.6758 [6.87]	1.7291 [9.20]	0.679	148	Negative
Johns	11.7572 [11.34]	−0.0255 [−1.59]	.5144 [3.18]	1.0350 [2.40]	0.224	83	Negative
Dine	6.2676 [12.90]	.0212 [3.13]	.4453 [6.62]	.6454 [3.26]	0.415	210	Positive
Basquiat	4.1268 [8.38]	−0.0766 [−4.24]	1.0111 [31.87]	−0.3289 [−2.99]	0.775	597	Negative
Mitchell	4.9112 [16.12]	−0.0162 [−4.12]	.7806 [21.07]	.7773 [5.03]	0.852	210	Negative
Schnabel	3.5481 [6.56]	.0071 [0.80]	.8063 [17.39]	.0616 [0.42]	0.580	189	Insignificant
Noland	7.9278 [10.30]	−0.042 [−3.87]	.4821 [7.17]	−0.1221 [−0.59]	0.401	235	Negative
Scharf	4.0288 [8.72]	−0.0011 [−0.13]	.5996 [13.09]	.3139 [2.65]	0.474	170	Insignificant
Poons	7.1353 [10.89]	−0.0281 [−1.90]	.3090 [3.56]	−0.4333 [−1.40]	0.371	73	Negative
Rivers	6.8974 [14.66]	−0.0212 [−3.54]	.5274 [8.83]	1.3412 [8.20]	0.564	187	Negative
Resnick	4.5729 [8.72]	−0.0429 [−7.07]	.7584 [13.09]	.6503 [1.96]	0.717	88	Negative
Oliveira	5.2366 [8.34]	−0.0257 [−2.41]	.5631 [7.21]	.9237 [3.06]	0.601	98	Negative
Lewis	1.4840 [1.46]	−0.0493 [−3.00]	1.2789 [7.71]	.9561 [3.89]	0.658	62	Negative
Guston	3.0717 [3.64]	.0164 [1.49]	.8237 [8.91]	1.400 [7.14]	0.667	157	Positive
Grooms	4.4988 [7.02]	.0155 [1.94]	.5583 [5.14]	.3643 [1.14]	0.461	83	Positive
Diebenkorn	4.5607 [9.30]	.0367 [4.27]	.6659 [6.98]	1.3313 [5.48]	0.747	156	Positive
Indiana	8.2565 [18.68]	−0.0329 [−5.19]	.6400 [8.17]	.3742 [2.04]	0.556	170	Negative

Artist	Intercept	Age	Size	Support	Adj. R^2	N	Trend Sig. at $a = .10$
Motherwell	6.2087	−0.0112	.6800	.7037	0.507	286	Negative
	[16.37]	[−2.12]	[14.97]	[5.65]			
Rauschenberg	10.608	−0.0835	.6175	.9095	0.419	225	Negative
	[15.83]	[−9.07]	[7.95]	[2.20]			
Bearden	2.7599	.0372	.6234	−0.3472	0.379	72	Positive
	[2.84]	[3.91]	[6.92]	[−0.66]			
Lichtenstein	7.0168	−0.0136	.6671	.9759	0.454	394	Negative
	[13.69]	[−1.67]	[13.53]	[4.86]			
Gilliam	3.7273	−0.0067	.4950	.3606	0.399	65	Insignificant
	[4.91]	[−0.74]	[5.26]	[1.37]			
Rothenberg	7.7979	−0.0912	.7760	.5035	0.676	82	Negative
	[5.67]	[−5.65]	[5.78]	[1.89]			
Thiebaud	8.2678	−0.0083	.3079	1.7124	0.382	199	Negative
	[15.32]	[−1.55]	[4.38]	[7.99]			
Baziotes	3.1698	.0327	.7798	.7935	0.780	62	Positive
	[4.94]	[4.26]	[10.19]	[4.60]			
Kahn	2.9495	.0072	.5563	.8593	0.803	159	Positive
	[5.04]	[2.10]	[11.05]	[8.53]			

Appendix to Chapter 4

Appendix 4.1: Relations between Hammer and Premium Prices

We argue in Chapter 4 that the difference between hammer and premium price in dealing with art auction results is important to conclusions regarding sales and other issues. Since alternative sources use different reporting, the conversion from one to the other must be understood. (Our data source, askART.com, and other sources typically provide premium prices).

As the text of Chapter 4 shows, we know that PP = HP + BPP or that the premium price (PP), that actually paid by the buyer of a painting, equals the hammer price (the one heard in the sales room) plus some buyer premium (BPP)—that percentage of hammer price charged by the auction house. The total buyer's premium paid, in turn, is determined by a set of block marginal rates published by the auction house (see Table 4.2 in Chapter 4), and the hammer price of the painting. While the auction house may change the marginal rates and their structure from time to time, for a given time period a typical rate structure is given by R_1 percent of hammer price for paintings whose hammer price is less than MAX_1 dollars; R_2 percent for paintings whose hammer price is between MAX_1 and MAX_2 dollars; and R_3 percent of any excess of hammer price over MAX_2 dollars. To be clear, the computation of BPP is cumulative across these rates. For example, suppose a painting sold for a hammer price of \$HP > \$MAX_2$. The total buyer's premium paid on that painting would be BPP = $[R_1 * MAX_1] + [R_2 * (MAX_2 - MAX_1)] + [R_3 * (HP - MAX_2)]$.[8] Note that the rates R_1, R_2, and R_3 are marginal rates and the structure behaves much like the US income tax structure. However, we often wish to analyze "buyer's premium expressed as a percent of hammer price." This measure can be thought of as average (or effective) buyer's premium (AVP = BPP/HP). This measure appears impossible to compute: we have no information on hammer prices, and without them we cannot compute the total buyer's premium paid. Thus our problem is to compute hammer prices and average buyer's premium from data on premium prices and the buyer's premium structure (i.e., the R_i and the MAX_j, $i = 1, 2, 3; j = 1, 2$).

Let us first consider a couple of simple cases. Suppose we have only one flat marginal rate R_1, as was in fact the case for Sotheby's in 1975–1992, so that BPP = $R_1 * HP$ (regardless of the magnitude of HP) and hence PP = $HP + (R_1 * HP) = (1 + R_1) HP$. In this case, computing HP and AVP is easy: $HP = PP / (1 + R_1)$ and $AVP = BPP / HP = (R_1 * HP) / HP = R_1$ so that the marginal buyer's premium equals the average buyer's premium.

Next consider a slightly more complicated rate structure in which there are two blocks, as was in fact the case for Sotheby's for the periods 1993–1999, 2004,

and January 2005–September 2007. The buyer pays marginal rate R_1 on hammer prices less than or equal to some boundary hammer price value, call it MAX_1. For hammer prices greater than MAX_1, the buyer pays a marginal rate of R_2 on the difference between hammer price and MAX_1. Thus we have two regimes, each requiring different computations for hammer price (and AVP, as well). In the first regime where $HP \leq MAX_1$, the computation works just as it did in the single rate case: $BPP = R_1*HP$ so that $PP = HP + R_1*HP$ and hence $HP = PP/(1 + R_1)$ and $AVP = R_1$. However, in the second regime where $HP > MAX_1$, the buyer must pay the maximum premium from the first regime (R_1*MAX_1) plus the marginal rate R_2 on any excess if HP over MAX_1 [$R_2* (HP - MAX_1)$]. In this case $BPP = (R_1*MAX_1) + [R_2* (HP - MAX_1)] = [MAX_1*(R_1 - R_2)] + R_2HP$. Since $PP = HP + BPP$, it follows that $PP = [MAX_1*(R_1 - R_2)] + (1 + R_2)*HP$ and hence $HP = \{PP - [MAX_1*(R_1 - R_2)]\}/(1 + R_2)$. Note that HP is a linear function of PP where the constant is $\{- [MAX_1*(R_1 - R_2)]/(1 + R_2)\}$ (since the auction house sets all of the parameters) and the slope is $[1/(1 + R_2)]$. This result gives a bit of uniformity to the rate structure—in regime one, the constant is zero and the slope is $[1/(1 + R_1)]$. A question remains to be answered: How do we know if we are in the first or second regime if we can only observe premium price? Note that at the boundary, $HP = MAX_1$ and $BPP = R_1*MAX_1$, so that the value of premium price at this cusp (PP_1*) is $PP_1* = (1 + R_1)*Max_1$. Thus, for the two-block-rate case, we have:

$$\text{If } PP \leq PP_1*, \ HP = PP/(1 + R_1);$$
$$\text{If } PP > PP_1*, \ HP = \left\{PP - \left[MAX_1*(R_1 - R_2)\right]\right\}/(1 + R_2)$$

It goes without saying that once we know HP, we can compute $AVP = (PP/HP) - 1$.

The most complicated rate structure that we encounter here is a three-block format, as was used by Sotheby's during the periods 2000–2003, Sept 2007–May 2008, June 2008–2013, and 2014–present. This structure is more complicated due to the third block; the first and second blocks are strictly analogous to the two-block case. The first block is relevant for hammer prices less than or equal to MAX_1 dollars. In this block the buyer pays a premium of R_1*HP as before. Thus, again as before, in block one, $HP = PP/(1 + R_1)$. The second block is relevant for hammer price greater than MAX_1 but less than or equal to MAX_2, the upper hammer price limit for category two. If hammer prices fall in this category, the buyer must pay the maximum premium from the first regime (R_1*MAX_1) plus the marginal rate R_2 on any excess if HP over MAX_1 [$R_2* (HP - MAX_1)$]. In this case $BPP = (R_1*MAX_1) + [R_2* (HP - MAX_1)] = [MAX_1*(R_1 - R_2)] + R_2HP$. Since $PP = HP + BPP$, it follows that $PP = [MAX_1*(R_1 - R_2)] + (1 + R_2)*HP$ and hence $HP = \{PP - [MAX_1*(R_1 - R_2)]\}/(1 + R_2)$. The third block is relevant for hammer prices in excess of MAX_2. If hammer prices fall in this category, the buyer must pay a premium equal to

the maximum for block one $(R_1*\mathrm{MAX}_1)$ plus the maximum premium for block two $[R_2*(\mathrm{MAX}_2 - \mathrm{MAX}_1)]$ plus the marginal rate R_3 times any excess of hammer price over MAX_2—that is, $[R_3*(\mathrm{HP} - \mathrm{MAX}_2)]$. In this block, $\mathrm{BPP} = [R_1*\mathrm{MAX}_1] + [R_2*(\mathrm{MAX}_2 - \mathrm{MAX}_1)] + [R_3*(\mathrm{HP} - \mathrm{MAX}_2)] = \{[\mathrm{MAX}_1(R_1 - R_2)] + [\mathrm{MAX}_2(R_2 - R_3)]\} + R_3*\mathrm{HP}$. And since $\mathrm{PP} = \mathrm{HP} + \mathrm{BPP}$, it follows that $\mathrm{PP} = \mathrm{HP} + \{[\mathrm{MAX}_1(R_1 - R_2)] + [\mathrm{MAX}_2(R_2 - R_3)]\} + R_3*\mathrm{HP}$, and hence in this block $\mathrm{HP} = \{\mathrm{PP} - [\mathrm{MAX}_1(R_1 - R_2)] + [\mathrm{MAX}_2(R_2 - R_3)]\}/(1 + R_3)$. Again, note the linear relationship between HP and PP. Again to determine which category is relevant based on premium price, we first consider the value of PP if HP takes on its maximum value in block one (PP_1*)—that is, $\mathrm{MAX}_1 = \mathrm{PP}/(1 + R_1)$ so that $\mathrm{PP}_1* = (1 + R_1) * \mathrm{MAX}_1$. Similarly, if HP takes on a value of MAX_2 in block two, $\mathrm{PP}_2* = [\mathrm{MAX}_1*(R_1 - R_2)] + (1 + R_2)*\mathrm{MAX}_2$. Thus, for the three-block-rate case, we have:

$$\text{If } \mathrm{PP} \leq \mathrm{PP}_1*, \ \mathrm{HP} = \mathrm{PP}/(1+R_1);$$
$$\text{If } \mathrm{PP}_1* < \mathrm{PP} \leq \mathrm{PP}_2*, \text{ hence } \mathrm{HP} = \left\{\mathrm{PP} - \left[\mathrm{MAX}_1*(R_1 - R_2)\right]\right\}/(1+R_2)$$
$$\text{If } \mathrm{PP} > \mathrm{PP}_2*, \ \mathrm{HP} = \left\{\mathrm{PP} - \left[\mathrm{MAX}_1(R_1 - R_2)\right] + \left[\mathrm{MAX}_2(R_2 - R_3)\right]\right\}/(1+R_3).$$

We reiterate, once we have found HP, the average or effective buyer's premium is easy to compute: $\mathrm{AVP} = \mathrm{BPP}/\mathrm{HP} = (\mathrm{PP}/\mathrm{HP}) - 1$.

To summarize, we convert premium prices to hammer prices (and when required, compute average buyer's premium) according to the following procedure: (1) Compute the critical values of premium price (PP_1* and possibly PP_2* in a three-block scheme). (2) Compare actual PP to its critical values to determine which block of the rate structure is relevant. (3) Based on the rate structure and the appropriate block, employ the appropriate formula from the preceding to compute HP. (4) Once HP has been determined, compute buyer's premium as a percentage of hammer price (AVP) as the ratio of premium price to hammer price minus unity.

Appendix to Chapter 5

In this appendix we present the hedonic estimation results regarding the investment return to early American art (Tables 5A.1 and 5A.2) and to contemporary American art (Table 5A.3), whose behavioral implications are discussed in detail in Chapter 5.

Appendix 5.1: Statistical results

Table 5A.1 Hedonic Coefficient Estimates, Early American Artists

Variable	Model I Dep. Var. = ln (Premium Price)	Model II Dep. Var. = ln (Premium Price)	Model III Dep. Var. = ln (Hammer Price)	Model IV Dep. Var. = ln (Hammer Price)
Constant	0.28326914	−3.70904976	0.00164294	-3.86584348
	(0.485)*	(−4.389)	(9.231)	(-4.543)
SIZE	0.00162415	0.00132622	−0.212020D-06	0.00134043
	(9.197)	(7.620)	(−6.232)	(7.649)
SIZE2	−0.21D-06**	−0.173637D-06	0.07175712	-0.175501D-06
	(−6.210)	(−5.342)	(2.854)	(-5.362)
AGE	0.07164792	0.07969559	−0.00087427	0.07992863
	(2.872)	(3.365)	(−3.369)	(3.352)
AGE2	−0.00087207	−0.00092026	0.70355382	-0.00092320
	(−3.387)	(−3.769)	(5.636)	(-3.755)
DMED	0.69903877	0.64323795	3.05350593	0.64689430
	(5.644)	(5.463)	(8.637)	(5.456)
DA2	3.01781205	2.51838725	3.18892634	2.54639557
(Homer)	(8.603)	(7.365)	(4.410)	(7.396)
DA3	3.16878276	2.20470201	0.26560357	2.21000952
(Cassatt)	(4.416)	(3.162)	(0.568)	(3.147)
DA5	0.25925454	−0.77068889	1.54192990	-0.78018948
(Robinson)	(0.559)	(−1.642)	(3.010)	(-1.651)
DA7	1.51671818	2.43146755	1.05801331	2.47075620
(Sargent)	(2.984)	(4.829)	(6.717)	(4.873)
DA8	1.04591576	2.84718737	1.31336907	2.88700439
(Hassam)	(6.692)	(8.790)	(2.824)	(8.851)
DA9	1.29779956	1.81307456	−1.22203902	1.83657355
(Remington)	(2.812)	(4.074)	(−3.526)	(4.098)
DA10	−1.21933798	−3.28128169	−0.65178936	-3.31571362
(Kuhn)	(−3.546)	(−7.077)	(−1.916)	(-7.102)
DA11	−0.64628827	−2.82263693	0.89925398	-2.86162948
(Weber)	(−1.914)	(−5.970)	(2.083)	(-6.011)
DA12	0.88516814	2.67194088		2.71352306
(Bellows)	(2.067)	(5.382)		(5.428)
DA13	2.94377710	5.72362290	2.97798922	5.80061359
(Hopper)	(6.480)	(9.248)	(6.504)	(9.308)
DA15	2.77500812	.96509022	2.83066806	0.99289765
(O'Keeffe)	(2.765)	(0.971)	(2.799)	(0.992)
DA16	0.84087770	−0.61918963	0.86004042	-0.62249563
(Wood)	(1.434)	(−1.027)	(1.455)	(-1.025)
DA21	−0.28463750	−1.03074312	−0.28249868	-1.04008598
(Shinn)	(−1.442)	(−4.645)	(−1.420)	(4.654)

(Continued)

Variable	Model I Dep. Var. = ln (Premium Price)	Model II Dep. Var. = ln (Premium Price)	Model III Dep. Var. = ln (Hammer Price)	Model IV Dep. Var. = ln (Hammer Price)
DA22	1.58233876	3.09918201	1.60451958	3.14470528
(Glackens)	(3.444)	(6.217)	(3.465)	(6.265)
DA24	−0.87874540	−0.99689204	−0.88215871	-1.00212349
(Luks)	(−3.011)	(−3.595)	(−2.999)	(-3.589)
DA26	1.23261836	1.10814905	1.25061532	1.12423058
(Prendergast)	(3.519)	(3.332)	(3.543)	(3.357)
DA29	0.34573870	1.27166599	0.34924432	1.28942055
(Marin)	(1.806)	(5.429)	(1.810)	(5.467)
DA30	−0.34527397	−1.79655500	−0.3506099	-1.82422450
(J. Stella)	(−0.878)	(−4.093)	(−0.885)	(-4.127)
WINTER	0.64569794	−0.16915244	0.64946291	-0.17792706
	(3.000)	(−0.699)	(2.994)	(-0.730)
SPRING	0.86312792	.15682421	0.86900416	0.15183127
	(4.396)	(0.720)	(4.391)	(0.693)
FALL	0.44445804	−0.49309391	0.44450008	-0.50747970
	(2.136)	(−1.990)	(2.120)	(-2.034)
TREND	0.617421D-04**	−0.744260D-04	.474797D-04	-0.907838D-04
	(2.604)	(−2.378)	(1.987)	(-2.881)
IMR		8.34491300		8.47333143
		(6.253)		(6.306)
R^2	0.6438684	.6809942	.6438588	.6815434
F	22.57	25.62	22.56	25.68
N	365	365	365	365

Notes:

* t-statistics in parentheses

**The notation $YYYYDXXX$ indicates that the coefficient estimate $YYYY$ should be multiplied by 10^{xxx}. For example, $0.617D-4 = 0.617 \times 10^{-4} = 0.0000617$.

Table 5A.2 Additional Hedonic Estimates, Early American Artists

Variable	Model V Dep. Var. = ln (RP)***	Model VI Dep. Var. = ln (RP)***	Model VII Dep. Var. = ln (RP1)****	Model VIII Dep. Var. = ln (RP1)****
Constant	0.30882708	−3.66513970	0.00163401	−3.63238845
	(0.455)*	(−2.388)	(5.320)	(−2.413)
SIZE	0.00163171	0.00133516	−0.209499D-06	0.00133983
	(5.308)	(4.387)	(−5.169)	(4.389)
SIZE2	−0.21D-06**	−0.173937D-06	0.07363943	−0.173986D-06
	(−5.188)	(−4.263)	(2.533)	(−4.239)
AGE	0.07272094	0.08073161	−0.00089874	0.08158587
	(2.488)	(2.950)	(−2.937)	(3.000)
AGE2	−0.00088760	−0.00093557	0.69551973	−0.00094632
	(−2.877)	(−3.194)	(4.227)	(−3.260)
DMED	0.69810243	0.64255812	3.02613201	0.64042079
	(4.199)	(3.949)	(7.768)	(3,982)
DA2	3.02594378	2.52881477	3.28596896	2.53298907
(Homer)	(7.676)	(5.956)	(12.470)	(6.079)
DA3	3.24451059	2.28486158	0.33897919	2.33401458
(Cassatt)	(12.355)	(4.599)	(0.812)	(4.772)
DA5	0.30778882	−0.71742011	1.56474783	−0.67800944
(Robinson)	(0.746)	(−1.412)	(9.274)	(−1.342)
DA7	1.55051710	2.46106151	1.02084071	2.46799134
(Sargent)	(9.085)	(6.309)	(4.903)	(6.378)
DA8	1.03068642	2.82367784	1.32271511	2.79945564
(Hassam)	(4.924)	(3.956)	(4.026)	(4.006)
DA9	1.3124620	1.82715256	−1.21377399	1.83150890
(Remington)	(4.055)	(5.800)	(−2.379)	(5.822)
DA10	−1.21851348	−3.27097873	−0.58973664	−3.24978223
(Kuhn)	(−2.471)	(−3.686)	(−0.962)	(−3.689)
DA11	−0.61234600	−2.77869030	0.85084795	−2.73671083
(Weber)	(−0.918)	(−2.746)	(0.826)	(−2.766)
DA12	0.86349589	2.64205509	2.91263382	2.61514637
(Bellows)	(0.838)	(2.767)	(17.335)	(2.762)
DA13	2.92838619	5.69545344	2.84323394	5.65751427
(Hopper)	(17.213)	(5.086)	(15.512)	(5.143)
DA15	2.81607001	1.01447204	0.89234177	1.05608149
(O'Keeffe)	(15.322)	(1.484)	(1.601)	(1.581)
DA16	0.87202292	−0.58133269	−0.25854950	−0.54936059
(Wood)	(1.551)	(−0.778)	(−1.101)	(−0.748)
DA21	−0.26864872	−1.01132459	1.55746755	−0.99527048
(Shinn)	(−1.126)	(−2.814)	(4.610)	(−2.838)

(Continued)

Variable	Model V Dep. Var. = ln (RP)***	Model VI Dep. Var. = ln (RP)***	Model VII Dep. Var. = ln (RP1)****	Model VIII Dep. Var. = ln (RP1)****
DA22	1.56532888	3.07519943	−0.89727387	3.05523170
(Glackens)	(4.589)	(4.800)	(−2.631)	(4.858)
DA24	−0.89250600	−1.01010953	1.25254332	−1.01393444
(Luks)	(−2.605)	(−2.966)	(2.936)	(−2.990)
DA26	1.24678932	1.12289217	0.31578568	1.12963961
(Prendergast)	(2.928)	(2.942)	(1.875)	(2.953)
DA29	0.32593892	1.24760986	−0.34994915	1.23006650
(Marin)	(1.917)	(3.210)	(−0.666)	(3.221)
DA30	−0.34050420	−1.79511390	0.62554200	−1.78297573
(J. Stella)	(−0.665)	(−2.426)	(2.385)	(−2.445)
WINTER	0.63275151	−0.17835311	0.83194164	−0.17905906
	(2.416)	(−0.446)	(3.166)	(−0.452)
SPRING	0.84484745	.14182052	0.41298091	0.13452194
	(3.221)	(0.387)	(1.480)	(0.371)
FALL	0.42448572	−0.50875643	.427377D-04	−0.51277836
	(1.522)	(−1.140)	(1.397)	(−1.164)
TREND	0.490750D-04**	−0.864671D-04		−0.917176D-04
	(1.613)	(−1.519)		(−1.635)
IMR		8.30655265	.6484086	8.23994932
		(2.712)		(2.754)
R^2	0.6474139	.6844438	23.02	.6850219
F	22.92	26.03	365	26.10
N	365	365	365	365

Table 5A.3 Hedonic Coefficient Estimates, Contemporary Artists

Variables	Model 1 Dep. Var. = ln (Premium Price)*	Model 2 Dep. Var. = ln (Premium Price)	Model 3 Dep. Var. = ln (Hammer Price)	Model 4 Dep. Var. = ln (Hammer Price)
Constant	3.4277	3.35314	3.35368	3.2736
	(6.58526)	(6.40489)	(6.37882)	(6.19124)
SIZE	0.000464068	0.000461506	0.000469088	0.000466337
	(13.3892)	(13.2978)	(13.3992)	(13.3044)
SIZE2	−1.8510e−008**	−1.84281e−008	−1.86797e−008	−1.85914e−008
	(−7.8086)	(−7.7736)	(−7.80149)	(−7.76508)
AGE	−0.0900699	−0.0761806	−0.0910368	−0.0761179
	(−4.36498)	(−3.27585)	(−4.36785)	(−3.24085)
AGE2	0.000815188	0.000676115	0.000823661	0.000674279
	(3.61795)	(2.70892)	(3.6191)	(2.6749)
DMED	0.476189	0.445125	0.479378	0.446011
	(4.36364)	(3.98485)	(4.34906)	(3.95338)
DA38	2.85746	2.84417	2.89857	2.8843
(Rothko)	(7.37112)	(7.3366)	(7.40263)	(7.36668)
DA54	2.64627	2.64047	2.67682	2.67059
(Pollock)	(4.77623)	(4.76711)	(4.78321)	(4.77391)
DA56	3.40988	3.40024	3.45533	3.44497
(Johns)	(6.8069)	(6.78904)	(6.82886)	(6.81048)
DA60	−1.59441	−1.59547	−1.61365	−1.61479
(Schnabel)	(−5.30717)	(−5.31236)	(−5.31766)	(−5.32362)
DWIN	−0.168703	−0.168136	−0.173643	−0.173034
	(−0.659688)	(−0.657676)	(−0.672237)	(−0.670157)
DSPR	0.497651	0.493325	0.49829	0.493644
	(2.23681)	(2.21781)	(2.21735)	(2.19734)
DFALL	0.386672	0.383871	0.386702	0.383694
	(1.75785)	(1.74558)	(1.74046)	(1.72756)
TREND2	0.000254051	0.000258404	0.000242126	0.000246801
	(11.0022)	(11.0771)	(10.3812)	(10.4753)
IMR		−0.555772		−0.596971
		(−1.2935)		(−1.37577)
R^2	.346	.347	.341	.342
F	45.53	40.56	42.53	39.66
N	1084	1084	1084	1084

Notes: t-statistics in parentheses

* Price refers to the second sale price in a paired offer sample.

** The notation *YYYYDXXX* indicates that the coefficient estimate *YYYY* should be multiplied by 10xxx. For example, 0.617D-4 = 0.617 9 10^{-4} = 0.000061.

Appendix to Chapter 7

In this appendix we present estimates of several models incorporating various specifications of the effect of an artist's death on the prices received for his or her paintings.

Appendix 7.1: Statistical Results

Table 7A.1 Modeling the Death Effect for Contemporary American Artists

Variable	Equation (7.1) Estimates		Equation (7.2) Estimates	
	Dep. Var. = ln (real premium price)	Dep. Var. = ln (real hammer price)	Dep. Var. = ln (real premium price)	Dep. Var. = ln (real hammer price)
Constant	5.92350797	5.82347187	5.88121592	5.78117546
	(22.193)	(21.595)	(18.007)	(17.498)
Area	0.00033398	0.00033819	0.00033526	0.00033945
	(22.383)	(22.402)	(22.551)	(22.563)
Area Squared	−0.308854D-08[b]	−0.312888D-08	−0.310184D-08	−0.314213D-08
	(−6.911)	(−6.914)	(−6.380)	(−6.385)
Signed	0.42225064	0.42564185	0.40924767	0.41357832
	(6.360)	(6.352)	(6.233)	(6.234)
Media (Oil) Dummy	0.65612319	0.65965507	0.64944728	0.65354717
	(10.884)	(10.826)	(10.953)	(10.896)
Age	0.07362227	0.07324349	0.07485951	0.07436634
	(6.595)	(6.499)	(6.706)	(6.594)
Age Squared	−0.00080427	−0.00080315	−0.00082344	−0.00082088
	(−6.904)	(−6.829)	(−7.071)	(−6.977)
Died Young Dummy	−3.24553653	−3.27722203	−4.94158016	−4.87695817
	(−18.427)	(−18.400)	(−9.182)	(−8.951)
DA2 (R. Bearden)	0.61824632	0.62431976	0.60856504	0.61276024
	(3.379)	(3.389)	(3.264)	(3.263)
DA3 (A. Martin)	3.54777945	3.51959117	3.78109070	3.74053327
	(23.804)	(23.335)	(24.885)	(24.327)
DA4 (R. Motherwell)	1.49947143	1.49921869	1.50314496	1.50316885
	(13.344)	(13.214)	(13.057)	(12.933)
DA5 (M. Resnick)	−0.17564731	−0.23831495	.06387953	−0.01183212
	(−1.212)	(−1.626)	(0.431)	(−0.079)
DA6 (A. Wyeth)	3.14474253	3.08422292	3.40087991	3.32583275
	(20.876)	(20.239)	(22.148)	(21.406)
DA7 (R. Diekenborn)	2.80517315	2.80796947	2.86277730	2.86378024
	(20.835)	(20.624)	(21.154)	(20.906)

(Continued)

Table 7A.1 Continued

Variable	Equation (7.1) Estimates		Equation (7.2) Estimates	
	Dep. Var. = ln (real premium price)	Dep. Var. = ln (real hammer price)	Dep. Var. = ln (real premium price)	Dep. Var. = ln (real hammer price)
DA8 (R. Lichtenstein)	2.95186074 (22.418)	2.94338806 (22.087)	3.04987160 (22.737)	3.03791784 (22.384)
DA9 (L. Rivers)	0.67587370 (5.038)	0.62704351 (4.622)	0.87606082 (6.300)	0.81691556 (5.814)
DA10 (K. Noland)	1.01962539 (6.925)	0.93547784 (6.288)	1.27402836 (8.507)	1.17523558 (7.765)
DA11 (J. Mitchell)	5.29051382 (20.618)	5.32421695 (20.517)	7.00661477 (23.268)	6.94358467 (22.795)
DA12 (R. Rauschenberg)	2.04668900 (12.581)	1.98283623 (12.069)	2.29005280 (13.857)	2.21272578 (13.257)
DA13 (H. Frankenthaler)	1.80137583 (12.556)	1.71619954 (11.839)	2.05329048 (13.970)	1.95354978 (13.153)
DA14 (A. Warhol)	5.23491647 (23.708)	5.29163479 (23.679)	6.86625642 (21.803)	6.82640876 (21.420)
DA15 (N. Oliveira)	0.10300125 (0.655)	0.01538306 (0.097)	0.36741833 (2.287)	0.26443394 (1.633)
DA16 (C. Twombley)	3.72986843 (24.883)	3.67128390 (24.195)	4.00297531 (25.957)	3.92829748 (25.168)
DA17 (J.-M. Basquiat)	5.87985453 (21.235)	5.92955115 (21.174)	7.54833739 (22.920)	7.50194994 (22.512)
YAD Squared	−0.00303294 (−8.330)	−0.00281514 (−7.673)		
Death Dummy	0.10094932 (1.333)	0.07291026 (0.954)	−0.29840560 (−3.504)	−0.29652468 (−3.446)
Interaction Term (DD*YAD²)	0.00438862 (11.167)	0.00402577 (10.161)		
YTD			−0.06161014 (−9.214)	−0.05715817 (−8.460)
YAD			0.05411297 (13.427)	0.04959402 (12.172)
Adjusted R^2	0.3515	0.3497	0.3593	0.3566
F	128.52	127.54	132.93	131.42
N	6118	6118	6118	6118

Notes:

[a] The standard errors used to compute the *t*-statistics are White's heteroscedasticity-consistent standard errors.

[b] The notation *XXX*D-08 indicates that the coefficient *XXX* should be multiplied by 10^{-8}.

Notes

CHAPTER 1

1. A "new" Modigliani, one of the most "faked" of major artists (though not American), has purportedly been discovered and was looking for a buyer by a Rome firm in 2016 (see Winfield 2016 and Chapter 6 for details).

2. http://www.economist.com/blogs/graphicdetail/2013/11/daily-chart-7. Rumor has it that a Gauguin painting traded privately for $300 million. The Bacon, in real terms, is not the most expensive price of art ever sold at auction—that honor went to Van Gogh's *Portrait du Docteur Gachet* in 2013. The painting sold for $82.5 million in 1990, and it was worth $148.6 million in 2013 prices. But that record has been broken. Since 1990, more than eleven paintings have been sold for more than $100 million in real terms (in current dollars). In contrast to the constant dollar figures of the *Economist*, an interesting paper on record prices by Spaenjers, Goetzmann, and Manmonova (2015) provides a list of record prices for art since 1701, reckoned in nominal British pounds. Since 2000, in those terms, Rubens, Picasso, Giacometti, Picasso, Munch, and the Bacon (mentioned in the text) have bested Van Gogh's *Portrait of Dr. Gachet*. A former taxi driver in China paid $170.4 million for a Modigliani nude at Christie's in late 2015. As noted earlier, Picasso now (in June 2016) holds the record of $179 million *at auction*.

3. Nineteenth-century American works have sold at high prices as well, with Asher Durand's *Progress (The Advance of Civilization)* selling for $40 million in 2011.

4. Art galleries have made use of this data in advertising and sales. See "Art vs. Stocks and Bonds: A Comprehensive Analysis of the Investment Potential of American Art," Questroyal Fine Art, LLC (New York: n.d.). Investors are advised of the vagaries and capriciousness of the art market as a monetary investment as well.

5. A list of thirty-five art investment funds, at least those prior to the "Great Recession" of 2008, is provided by Horowitz (2011: appendix C). Credence in art-investment advice is naturally variable and dependent on the quality of sellers of such advice.

6. Reputedly there are about 1,700 to 1,850 billionaires in the world and many more worth mega millions of dollars. If only 1 percent of them collect art or buy it for investment purposes, that means that eighteen billionaires or some of them may be fighting over the highest-quality art at any given time, shutting out almost all museums and collectors of more modest means. For example, in February 2016, billionaire collector Ken Griffin spent half a billion dollars on two paintings in a private (that is, non-auction) transaction (one painting each from abstract expressionists Willem de Kooning and Jackson Pollock). The purchase was from billionaire collector David Geffen. Sans gifts, museums are fundamentally priced out of the market by such lofty prices (see Chapter 7 for further discussion).

7. Let us admit immediately that the vast majority of those proclaiming art as a profession (exceeding perhaps 200,000 to 250,000 in the United States alone in 2016) earn a median income of less than $20,000 per year. These individuals must often, perhaps most often, find work in related or unrelated professions to survive. Failure, if that means making a middle or high income from art, is overwhelming. The meme of the "starving artist" is quite accurate, according to an important study of local art markets (see the excellent discussion of Plattner 1996). Many believe, as we do, that "success" in the art world is signaled by having one's art traded in a "secondary market," such as appearing at auction or trading after an initial sale. Representation by a local gallery does not guarantee that this will occur, but representation by a major gallery in a large city is some evidence of an emerging artist. Representation by a prestigious New York or London gallery and being shown in the hundreds of art "fairs" around the world are of course better evidence that an artist is on the road to success. The artists we discuss in this book were or are all highly successful and represented at the leading galleries in New York, Christie's and Sotheby's, Bonham's, and elsewhere, both in New York and around the United States.

8. Some influential economists (Cowen 2015), not without some good reasons, portray the art market as a nest of thieves, fraud, and obfuscation. We will investigate these and related issues in Chapter 6.

9. Art has also become the business of businesses. A particularly interesting new book by Iain Robertson (2016) explains how art markets function in a grand historical and global discussion. He focuses on topics such as the new global (especially Asian) markets, on how markets value goods, and on the markets for various kinds of international and historical art and art movements. It is an excellent book for an arts management course. Our book has a far more specific and directed aim, primarily that of looking at the market for American art

and its analysis as a semi-contained market. We argue that while Contemporary American art is a large part of global markets, American art painted pre-1950 is a fairly contained market. Americans produced art and Americans (by and large) purchased art over this period. The aims of the Robertson book and ours are quite different. While further reading into this massive and growing literature would be of great value, these broader issues are not the aim of our investigation.

10. A number of contemporary economists, Gary Becker, George Stigler, Ronald Coase, and James Buchanan (Nobel laureates all), have brought economics into the modern world—and perhaps back to Adam Smith's emphasis on social science as holistic—by introducing such concepts as full price (price plus the value of time as one incarnation of this idea), asymmetric information between buyers and sellers, information costs, property rights, and many other concepts. These new tools have been applied to economic sociology (marriage and the family, dating, childrearing), politics (the behavior of politicians under re-election constraints), anthropology (how overuse of common property resources led to certain civilizations' downfall), and many other aspects of social science. Other areas have been used in these more expansive analyses. For example, psychologist Daniel Kahneman, Nobel laureate in economics (with the late Amos Tversky), developed what has come to be known as "prospect theory," which argues that people are limited in their choices by the information available at a given moment so that they do not necessarily adhere to the economist's view of strict rationality. This means that, for example, the price of a piece of art in an auction today may be "anchored" by a price received in a past auction— and that anchoring may influence the view of price today by sellers, buyers, and auction houses themselves, creating behavioral changes in these market participants (see, for example, Beggs and Graddy 2009). For a survey of the "new economics," see Ekelund and Hebert (2014, chapters 26 and 27).

11. See Baumol and Bowen (1966). The fundamental issue is that since substitution is not ordinarily open to performances (a string quartet requires four players), there is a cost-increasing bias through time. This notion, however, has been disputed on many margins. The pros and cons of government subsidies to the arts have also been much debated (see Ritenour 2011 for a spirited discussion of this matter).

12. International interest in cultural economics is obvious in the references within this book and in any cursory survey of the contemporary literature. Citing only a small number of important locales, see working papers and articles at CREMA (Center for Research in Economics, Management and the Arts) at the University of Zürich; Dipartimento di Economia at Universita Politecnica delle Marche; Maastricht University; the Erasmus School of History, Culture and Communication; Economic Research Southern Africa (ERSA), a research program funded by the National Treasury of South Africa; and many others.

13. Our sample of artists is described and discussed in Chapter 2, as is the matter of "schools" of artists. There are of course many methods of classifying "schools of art or artist"—and, as we will discuss in Chapter 2, ours is only one of them.

14. We note that such auction samples are biased from the beginning. First, gallery sales are omitted. And quite obviously, one mark of success for an artist is to be sold on secondary markets such as auctions. Of the literally hundreds of thousands of artists in the United States, it is probable that far less than 1 percent are ever sold at auction. That does not mean that some are unsuccessful for that reason, only that their public sales are of a limited variety, such as local or regional gallery representation (Plattner 1996).

15. Consider the following transactions by Kinsella (2016). A famous painting by Andy Warhol (*Marilyn with an Orange background*, or *Orange Marilyn*) sold at Sotheby's London in 1992 for $955,400; it was resold at Sotheby's New York for $2.3 million; resold again at Phillips in 2013 for $38.6 million; privately sold in 2015 for $44 million; and offered at Christie's in November 2015 with an estimate of $40–$60 million, but the painting only reaching $36 million. This is called "flipping," as one would flip a house, except that nothing was "improved" to the painting over the years. Often it does not work, as in the last transaction.

16. There is, in fact, recent evidence (Vosilov 2015a) that there is a "home bias" in the market for sculpture with prices higher when auctioned in the home country of the artist. The effect is more pronounced in the low ends of the market with familiarity (with the work) and patriotism as significantly related to the "home effect." Our distinction rests upon the sharp pivot of American artists after World War II with the advent of abstract expressionism in American painting and abstraction in sculpture.

17. Indeed, in Chapter 5 we show, with statistical evidence, that there are two distinct markets for American art—that produced prior to and after 1950.

18. An interesting discussion of provenance and its credence-providing properties, along with excellent information on buying and selling art, may be found in Plattner (1996: 18–19). Although the book focuses on a particular art market (St. Louis, MO) and is somewhat dated, it is highly recommended as an important introduction to many aspects of the art market and collecting.

19. Authentication and credence are also aided by the existence and publication of a particular artist's *catalogue raisonné*—a listing providing information on all *known* works by an artist. French committees exist to pass works through for verification. The process is costly to the applicant, and if a work is rejected, it is often destroyed.

20. Economist and Nobel laureate George A. Akerlof identified and analyzed this problem in 1970 (see References).

CHAPTER 2

1. The numerous excellent surveys include Goddard (1990); Stebbins (1976); Wilmerding (1973); Hughes (1997); Slowik (2006); and many more.

2. There have been recent and not-so-recent exceptions. London's National Gallery purchased George Bellows's *Men of the Docks* in 2014, expanding its collecting mission from Western European works to the broader "Western works" category. However, a visitor to European museums will not find many pre-1950 American works, despite notable exceptions in Paris at the d'Orsay (for example), which holds *Whistler's Mother* (*Arrangement in Grey and Black No. 1*, 1871) and a superb Winslow Homer of women dancing on a cliff (*Summer Night*, 1890).

3. There are many important topics that space constrains us from considering in this book, which is largely devoted to applied microeconomics. There have been, throughout American history, obsessive collectors such as Andrew Mellon, J. P. Morgan, Mrs. Stewart Gardner, J. Paul Getty, and others, who turned their collections over to the public. Such contemporary entrepreneurs as David Geffen, who has promised a gift of $100 million, carry on this tradition. The impact on American art museums (not necessarily art *produced in America*) was profound. Likewise, legendary art dealers such as Joseph Duveen and art advisors such as Bernard Berenson and their role in furthering the collection of art in the United States are topics that would take us too far from our main emphasis in the present book. These and other topics, such as public policy toward the arts in America, would require a number of books to address. All this is to say that we have selected particular aspects of the market for American art, continuing a tradition reaching back decades. We certainly do not imply that other aspects of American art and culture are uninteresting or unimportant.

4. An excellent essay on the interface between art and historical cultures of the world may be found in Iain Robertson (2016, especially Chapter 3). The book, written by the head of Art Business Studies at Sotheby's Institute of Art, also contain informative descriptions of the role of market structure in artistic success in an international context.

5. Two sources are indispensable in assessing the market for American art prior to World War II. Malcolm Goldstein's book *Landscape with Figures: A History of Art Dealing in the United States* (2000) is an invaluable source on the functioning of the US art market, particularly in the early period. We rely on it heavily in the present section, as we do a second source: Denis Michael Hall's doctoral dissertation, *Purchasing Power: The New York Market for Modern American Painting, 1913–1940* (2001). Though somewhat dated, Peter Watson's *From Manet to Manhattan* (1992) provides an excellent account of the evolution of the art market, which moved from France to the United States at mid-twentieth century. Watson focuses on the commercial aspects of the art market, as have other writers (Frey and Pommerehne 1989). Both of these works provide excellent assessments of some of the matters contained in this chapter.

6. Charles Wilson Peale (1771–1827) of Philadelphia embodied some of the great art produced in America in the eighteenth century. He was the scion of a family of artists—Raphaelle (1774–1825), Rembrandt (1878–1860), Rubens (1784–1865), and Titian (1799–1885). He opened part of his house as a museum in 1786 (which later became the Philadelphia Museum). In addition to art, the museum contained all kinds of items gathered from nature (Peale's interests in this regard were much like those of Thomas Jefferson). Several early moves, one sponsored by Peale in 1795, to support artists with exhibitions and other aid were made in imitation of England's Royal Academy. The Boston Athenaeum, a library initially and to this day, began sponsoring artist exhibitions in 1827, purchasing paintings with admission fees.

7. The first indigenous American "school" of painting was called the Hudson River school, which included Cole, Durand, Frederic Church, and a coterie of extremely talented artists. See Baigell (1996, Chapter 3) for an excellent discussion of the school.

8. The daguerreotype, invented by Louis-Jacques-Mande Daguerre (1787–1851) and introduced in Paris in 1839, was also rapidly recording American subjects. Indeed, the brilliant American painter-inventor Samuel F. B. Morse (1791–1872) led the way in the teaching and use of this early camera, encouraging the enjoyment and acquisition of American images.

9. Taste formation is a complex matter—it is well known, for example, that taste and demand for particular goods and services are formed over long periods of time. For example, when individuals are raised by their families to follow a particular religion, some 60 percent will remain a member of that religion throughout the life cycle. The same is true of artistic tastes—although malleable to an extent, they are acquired through education and time. Advertising and networking among friends and others also can change taste and demand. See Stigler and Becker (1977).

10. The following discussion closely follows Goldstein's account (2000: 47–49).

11. All three styles are related and were used by American painters of the period. Impressionism, while present in far earlier works and in "romantic" and earlier times, was a mode of painting with broad and thick brushstrokes to capture the essence or "impression" of a subject. Paintings with the use of black were avoided in favor of subtle grays produced by mixing complementary colors. Subjects varied widely, but many of the impressionists employed outdoor painting (*plein air*), often with high-toned colors juxtaposed thickly on a white or grey canvas. The great and early French impressionist Claude Monet gave the movement its name, indirectly, when he painted a picture entitled *Impression, soleil levant* (*Impression, Sunrise*, 1872). Many of the French impressionists worked in opposition to the "academic" tradition of the French academy. But that movement spread to American painters who studied abroad. That movement and

several others evolved in the United States, earlier and coincident with impressionism in the nineteenth century. Tonalism and luminism, where dark or light neutral colors were used, chiefly in landscape painting, were related to the impressionist movement. All of these styles were dominant in the late nineteenth and early twentieth centuries. Furthermore, these styles remain popular with collectors (and painters!) today.

12. Two particular companies that have come to be associated with the sale of American art are the Kraushaar (founded in 1885) and Vose (founded in 1841) galleries. Both remain in existence and continue to sell American art and to represent American artists.

13. These might include George Bellows (1882–1925); Guy Pene du Bois (1884–1958); Gifford Beal (1879–1956); Walt Kuhn (1877–1949); Alfred Maurer (1868–1932); Jerome Myers (1867–1940); Eugene Speicher (1883–1962); and many others. This art of realism continued into the 1930s and 1940s "American scene" painters, and was a source of material for the WPA art projects.

14. The term "American modernism" is an inexactly defined designation. It includes a potpourri of styles—mainly but not exclusively non-figural—that find their basis in post-impressionism. Americans studied abroad and came home with cubist, pointillist and other fundamentals of that new style of post-impressionism. Some Americans adopted a full-blown impressionist style that was adapted to American landscape and other subjects. But their more defined style is not included in the term "modernism." However, the word "modernism" has come to include many artists as diverse as Max Weber, whose figurative work derives directly from European cubism and other traditions, Arthur Dove, said to have painted the first totally abstract picture in the United States, and the kind of American realism defined by Edward Hopper. Generally, modernism does not include the ashcan artists of the late nineteenth and early twentieth centuries.

15. So many aspects of the development of American modernism deserve mention but, unfortunately, cannot be developed here. One of the most interesting characters in this development was a woman named Mabel Dodge Luhan (1879–1962) who developed salons in Italy and later in New York City, where she became acquainted with the chief modernists of the day. These included Andrew Dasburg, John Marin, Marsden Hartley, and a host of others. She moved her "salon" to Taos, New Mexico, and encouraged her artist friends—including leading artists and musicians of the time—to come to New Mexico, thereby developing an adjunct to the "Taos school" that has been extant since the turn of the twentieth century. A fascinating account of this development is found in Rudnick and Wilson-Powell (2016).

16. The roster of artists supported in this program included established artists as well as those who would meet fame in the postwar abstract-expressionist period.

Some of these were Raphael Soyer, Jackson Pollock, John Marin, Marsden Hartley, Stuart Davis, Jacob Lawrence, Philip Evergood, John Sloan, Mark Rothko, Thomas Hart Benton, and many hundreds of others. Some estimate that approximately 200,000 works were produced.

17. This group of paintings was reassembled in 2012 and toured 2012–2014 at museums in Alabama, Georgia, Oklahoma, and Arkansas with the title "Art Interrupted: Advancing American Art and the Politics of Cultural Diplomacy" (2012). See the essay by Dennis Harper (2012), "Advancing American Art: LeRoy Davidson's 'Blind Date with Destiny,'" from which this discussion flows.

18. It is curious that the "new" avant-garde pictures of the abstract expressionists were omitted. According to Harper (2012: 15), "one can only surmise that in mid-year 1946 those artists' works were unaffordable, unavailable, or simply uninteresting to the organizer of Advancing American Art." Davidson later said he excluded them because they had not done their best work by then, a dubious excuse. Most of the abstract expressionists had been part of the New Deal projects and were clearly in the avant-garde of those selected.

19. It goes without saying that the French were not ready to cede the emerging American supremacy in art. However, the French were introduced, after many quite negative reviews of the abstract painters, to a three-page spread in the 1947 issue of *Cahiers d'Art*, a prestigious French art journal. According to Guilbaut (1985: 154) this was "a master stroke. Not only were the artists [Byron Brown, Romare Bearden, and Carl Holty] covered introduced to Paris in a serious and sumptuous review, where they were surrounded by the starts of modern art (such as Picasso and Miro), but they also took on considerable importance in the United States, where the magazine was still highly respected and quite popular in the studios. They could no longer be ignored in the United States."

20. It is quite important to note that Pollock himself had serious objections to the term "abstract expressionism" when applied to his own work. He believed that he was painting in a representational manner in some fashion all of the time. He also thought that it was impossible, even when painting from the "Freudian unconscious," not to conjure up figures from the mind. See his statement quoted in Wood et al. (1993: 155).

21. Note that there is some difference in interpretations of what exactly constitutes a primary and secondary market for art. According to Robertson (2016: 23–24), the primary market is that which appears for sale by a dealer or artist for the first time. By definition, that is all contemporary art. Secondary markets or "middle markets" are those sold with prestigious galleries in international markets where some (late middle-age) contemporary artists, dead artists, or "long dead" artists (Old Masters) are represented and prices have risen steadily for such works. Tertiary markets conform to regular trades at auction or by high-value galleries or dealers. We conflate all but primary sales into secondary markets.

22. The debate over the placement of much contemporary art in some kind of pantheon of quality is contentious, as is the very "making" of a contemporary artist. Consider Paul Johnson's (2013: 730) evaluation, shared by a number of observers, of those who will not risk the intolerance of painting outside what he calls "fashion art." It is the "system" of finding new artists with commercial promise that causes many excellent artists to starve or submit. Johnson, while finding value in Johns, Rauschenberg, and Warhol, thinks that the system through which new "masters" are "discovered" is "constitutionally corrupt." (See Chapter 7 for discussion.)

23. Our work on this "Early American" portion of our sample began early on in our research, when data was available only for the period 1987–2011, so that our empirical analyses confined to these thirty-three artists does cover only a twenty-five-year period.

24. These seven include Arthur Davies and Ernest Lawson (twenty-five sales each), Grant Wood (twenty-four sales), Mary Cassatt (twenty-three sales), John Henry Twachtman (eighteen sales), Thomas Eakins (seventeen sales), and James McNeill Whistler (twelve sales). Data on these artists are included in our pooled (fixed-effects) analysis since there is no reason not to do so, but we did not include them in our individual artists' analysis for some purposes because making inferences on their individual value/age profiles based on such limited data would be too risky.

25. Some of the "modernists" listed in Table 2.4—Arthur Dove, Abraham Walkowitz, and Georgia O'Keeffe—included purely abstract paintings in their oeuvre. Dove, for example, was said to have painted the first purely abstract painting in the United States in 1907.

26. Technology and art fairs are creating vast changes in the "exhibition" model of galleries, many of which sell the work of both "new" artists and those with established records. Some believe that fairs create a disadvantage for new and innovative artists. Noah Horowitz, who directs the important Armory Show fair in New York City, sees many pluses and minuses for fairs. He writes that "while fairs have helped to create a more decentralized marketplace in which galleries from far afield can now participate meaningfully in the international dialogue, as well as a valuable sense of context for smaller and mid-level dealers looking to rub shoulders with their more established peers, they can also be precarious enterprises if risks are not well managed" (Horowitz 2011: 223). It is extremely costly to participate in most art fairs, moreover. While we do not utilize data from gallery sales in this book (they are unavailable), Horowitz's book is an excellent survey and analysis of the contemporary technology and fair-driven gallery scene.

27. Crane (1987, cited in Plattner 1996: 38) noted that "the date of origin of 290 New York galleries . . . specializing in avant-garde contemporary American art . . .

[finding] that 80 percent of them were started after 1965. She also estimates one-person exhibitions in New York at eight hundred in 1950 and almost nineteen hundred in 1985." Given the vibrancy and activity in this market, it is not unreasonable to estimate that twice as many galleries and exhibitions exist today.

28. For a detailed discussion of the emergence and characteristics of the Chinese art market, see Petterson (2014).

29. All manner of financial devices have been used to assemble first-quality art pieces for sale. Sotheby's and Christie's began guaranteeing works to assure sellers as early as the 1970s, but third parties have begun taking all or part of the risk (for a return, of course). To complicate matters, the two houses use differing arrangements depending upon whether the guarantor actually buys the work for personal ownership (see http://www.economist.com/node/21539958) or other contractual considerations. Both Sotheby's and Christie's permit guarantors to bid on the item, but, with Christie's, the guarantor receives a share of the difference between the winning bid and the guaranteed price, causing different incentives and advantages between the items at the two houses. Graddy and Hamilton (2014) analyze the impact of these differing policies, finding no differential advantage due to the differing policies. See a more complete discussion of these phenomena in Chapter 4.

30. A brand name, such as Frigidaire or Mercedes, certainly gives us some information about the quality of the good, but we will have to experience the good before determining the quality. Granted, we may spend time and effort (purchasing *Consumer Reports*, examining Internet evaluations, and so on) in order to determine quality, but our own experience is the acid test. Unsurprisingly, economists call relatively low-value, frequently purchased goods (fried chicken) "search" goods and higher-value, less frequently purchased goods (the refrigerator) "experience" goods (Nelson 1970, 1974).

31. There may be goods that are termed "meta-credence goods," such as religious promises of eternal salvation. The quality of these goods may not be discernible until after death. Since no one has returned to report on the quality of the good, it is not verifiable (Ekelund, Hebert, and Tollison 2006: 28). Faith is required for credence in this good.

32. In general, the higher the value of a work of art, the more that will be invested in determining authenticity. Some groups of "authenticators" will no longer provide bona fides on artworks due to the possibility of legal action in case they opine that the work is a fake (see Chapter 6 for details).

CHAPTER 3

1. The epitome of the (European) innovative artist is Pablo Picasso, who fits the profile established by Galenson, with Cézanne the quintessential experimental artist in Galenson's characterization. At some points, Galenson suggests (2006a: 55) that

there might be a continuum of artistic types between conceptual and experimental, but he makes no such distinction in his statistical or qualitative analyses. There is no metric provided for a continuum of artistic "types." Elsewhere (2006: 37) he suggests that the artist's method of approach (planning a painting, painting methods, when to stop) may determine or help determine the artist's "type." He persists, however, in the dichotomous relation between types of artists (2009).

2. Although Galenson studied sixteen overlapping American artists statistically (2001: 8, table 1.2) and five anecdotally (2005b) for the earlier period (those born prior to 1900), our sample is larger, contains all the artists in the sample (not simply the ones who have significant correlations between age and peak value), and uses a longer and contrasting sample of auction values. Hellmanzik's sample includes twenty artists either born or working in the United States in the pre-1900 period, with seven of them overlapping in our sample (2009: 206–209, table 1). Hellmanzik is interested in schools, so her sample includes 214 US and European artists drawn from artvalue.com. Until recently, our source (askART.com) reported data on American artists only.

3. Portions of the following section were drawn from Ekelund, Jackson, and Tollison (2013). We are grateful to the *Southern Economic Journal* for permission to use this work.

4. This study originated in Galenson and Weinberg (2000) and is repeated in other contributions (2005b, 2006a). Also see the interesting paper relating age-price profiles for a section of Canadian artists (Hodgson 2011).

5. The premise that most American artists were "captive" of their American traditional training is questionable. As noted in Chapter 2, the Parisian world fair brought American artists and dealers to Paris, where the European mode won the prizes. That affected not only dealers, but artists as well, concerning the "new" styles. Afterward it became de rigueur for Americans to study in Paris, bringing home knowledge and execution of European, mainly French, styles. It should not be forgotten that Claude Monet painted what is regarded as the first "impressionist picture" (*Impression Sunrise*) in 1872, and the influence of the Barbizon school was distinct in many of the American works painted decades before 1900.

6. Galenson provides a reference to an unpublished paper on twentieth-century American artists prior to the abstract expressionists (from the early twentieth century (2005c) in (2006a: 12), but several attempts to acquire the paper have been unsuccessful.

7. Galenson uses the value/age profile and the age of the artist at peak value to draw inferences regarding the nature of the artist's creativity. It is not clear where Galenson obtains the calculation for "the age of the artist at peak value." If he simply scanned the data for the highest-priced painting and took the age at creation for that painting, that procedure is anecdotal and not statistical. He more likely obtained age from the appropriate critical point on value/age profile. Otherwise, regressions would be unnecessary.

8. Elsewhere Galenson (2002, 2004, 2005a, 2006a) and Galenson and Weinberg (2000) studied twentieth-century American artists (again born between 1900 and 1920 and between 1920 and 1940) and found that ranking artists born in similar time periods exhibited the same creativity characteristics. This study originated in Galenson and Weinberg (2000) and is repeated in other contributions (2005b, 2006a). In short, experimental artists generally reach their peak creativity at older ages in the 1900–1920 cohort and conceptual artists born afterward, mainly those born after 1920, reach peak creativity at younger ages.

9. To be clear, our sample of artists born prior to 1900 consists of auction sales from 1987 through 2011; our sample of artists born after 1900 consists of auction sales from 1987 through 2013; consequently, when we pool the data sets, that sample consists of sales from 1987 through 2011. Thus, our statement in Chapter 2 that we collected data on eighty artists for auction sales from 1987 through 2013 remains correct; it simply is not relevant to all of our empirical analyses.

10. In a similar table, Galenson (2001) also includes the artists' ages at peak value. We do not do so here because we use an alternative, arguably more general (see note 11) approach to categorizing the artists by productivity type that does not require explicit knowledge of age at peak value.

11. Admittedly, Galenson's empirical procedure seems a bit sketchy nearly a decade and a half in retrospect. Perhaps a more econometrically advanced procedure such as spline estimation would better estimate the value/age profile. Using adjusted R^2 as a model-selection criterion is dubious at best (and probably was when Galenson did it, as well). Some sort of specification error testing seems mandatory. No attempt is made to adjust for "bought in" paintings, auction houses, etc. The list can go on and on. But we hasten to add that all of these very legitimate criticisms are irrelevant to our purpose. Our objective is to assess the robustness of Galenson's conclusions regarding age and artistic productivity by using his own procedures on an alternative data set.

12. Converting premium to hammer prices is non-trivial. The problem is highlighted in Chapter 4, and the conversion procedure we use is discussed in detail in Appendix 4.1.

13. Furthermore, one conclusion from that analysis is that there is much more variability across artists (and by date of birth) in terms of their value-age profiles than suggested by Galenson, which casts some doubt on the appropriateness of pooling the data in the manner of Galenson and Weinberg (2000), which we replicate in our subsequent fixed effects analyses. In sum, we offer both fixed effects analysis as well as that for individual artists, acknowledging that each procedure has its potential difficulties, but finding comfort in the fact that the results from each procedure broadly support the findings of the other.

14. Appendix Table 3.A1 contains not only the best specifications for the twenty-six artists listed in Table 3.1, but it also contains the best specifications found for the seven artists excluded from the individual artist analysis due to insufficient observations. We include these for the benefit of those readers interested in any of those artists, with the caveat that they may not be reliable. Those results,

however, play absolutely no role in our preceding analysis of individual artist creativity patterns.

15. In those cases where the artists' value/age profiles fit neatly into Galenson's taxonomy, this approach is equivalent to Galenson's age-at-peak-value approach. As explained in the text, a negative trend indicates that peak value occurred early in the artist's career (indicating a conceptualist or innovator), and a positive trend indicates that peak value occurred later in the artist's career (indicating an experimentalist). However, as also noted in the text, cases arise in which the value/age relationship is statistically significant in the age polynomial (presumably due to cyclical performance), but there is no significant trend in value over the artist's career. In this case, Galenson would determine age at peak value, compare that age to forty, and class that artist as an innovator or experimentalist based on that comparison. We argue that this procedure is at best anecdotal and at worst misleading since there is no statistically discernible trend in value over the artist's career. For this reason, we prefer our more general linear trend approach.

16. Our test coincides with four reported results by Galenson (Weber, Davis, Hartley, and Demuth) and obtains five opposing results (O'Keeffe, Sloan, Dove, Marin, and Stella).

17. The term "fixed-effects model" is simply a technical term for the model that results when we pool the data across artists and add time (year, in this case) and artist dummy variables to our standard regression model. In effect, the fixed effects model allows the model's intercept to vary by time and by artist but requires all slope coefficients to be constant across artists and over time.

18. While it is true that the slope of the overall trend characterizing the value/age profile for artists born after 1900 is steeper than that characterizing the value/age profile for artists born before 1900, –0.0095 compared to –0.0075, that difference is not statistically significant, as noted earlier.

19. While our data on contemporary American artists end in 2013, our data on early American artists end in 2011. Consequently, when we pool the two data sets, the resultant data set ends in 2011, excluding data for the years 2012 and 2013 since the early American artists have no observed sales in these years.

20. We refer to "a version of" equation (3.5) because the estimates in the text refer to a sample of data that includes 2012 and 2013, but those referred to subsequently refer to the pooled sample that ends in 2011. Thus the slope estimates for the age variable in the two models should be expected to be close to each other, but not identical.

21. These results do not fully comport with those of Galenson and Weinberg, however. Their sample indicated that the older artists were experimentalists; ours indicates that the older artists are also innovative, just not to the extent that the younger artists are.

22. See his correlations of peak ages of five experimental and five conceptual American painters using his statistical results (2001: table 2.2), text illustrations and works in retrospectives of the artists' work (2006: 36, table 2.5).

23. Hutter, correctly noting the truncated nature of textbook illustration, cites one of Galenson's text sources as containing 1,075 illustrations of works by 765 artists. Hutter continues arguing that "such Pareto or Power-Law distributions are well-known in all cultural sectors, and they are attributed to a self-enforcing 'superstar' dynamic, as some works gain initial attention, they accumulate further regard because there are benefits in knowing the works familiar to others. The results, then confound individual creativity with the evaluation process in social networks" (Hutter 2010: 157).

24. Two primary agencies collect fees for illustrating artists' works in books. They represent the estates of artists or artists themselves. One is VAGA, representing the copyrights of worldwide visual arts. Another is ARS (the Artists' Rights Society). Together they represent the copyrights of approximately a hundred thousand artists worldwide. These agencies use a sliding scale for fees depending on the use (commercial or otherwise), size, placement (cover or inside), distribution, and number of copies printed. A request must be made to reproduce works delineating the purpose for illustrations. Some estates may demand higher fees for reproduction, so that simple substitution may have an impact on the artists illustrated in art-history books. Such price differences would bias the particular number of illustrations an artist receives.

25. That Picasso's *Demoiselles d'Avignon*, of 1907, achieved in part through a study of African masks and Cézanne's late works, is possibly the most reproduced picture in all art texts is hardly surprising for several reasons. It is of course a benchmark artistic achievement (there were others as well), but it became so at least partly *through network, superstar effects*, which established a central part of the emerging canon of twentieth-century art. Importantly, network effects in consumption do not alter the utility function itself for individuals. They appear as an argument in the utility function. In the context of art histories and criticism, the more individuals who tout a picture or school, the more important it is to add similar credence to the painting. A textbook writer on art history may not like the painting more due to these effects, but because n is larger, it is profitable and of more utility to join the cascade.

26. Galenson clearly states that "the period the textbooks identify as that of O'Keeffe's most important work was marked by her paintings of New York and by a continuation of the series of large paintings of individual flowers that she had begun in 1924" (2009: 98).

27. Color was central to the art of some of O'Keeffe's contemporaries, especially to her friends Charles Demuth and Arthur Dove. Demuth's "commitment to color" is well documented (Haskell 1987: 51).

28. O'Keeffe taught drawing in her earlier career, and her pre-1918 output was chiefly composed of charcoal, pencil, and watercolor drawings. Her preparatory drawings for oil paintings continued throughout her life. Preparatories for

Skyscrapers (Lynes, Vol. I, plates 514–521), the Ranchos Church—St. Francis de Asis in Taos, New Mexico (Vol. I, plates 661–664), Shells (Vol. I, plates 781–788), Skulls (Vol. I, plates 798–799), and Landscapes (Lynes, Vol. II, plates 1173–1174) are only a few examples. Also see Messinger (2001).

29. The famous example is Picasso—who is identified by Galenson as the classic innovator—who painted different subject matter throughout his very productive life but in clusters of subject matter. The great and famous "blue" and "rose" colored paintings (and his "neoclassical" period) were clustered around "saltimbanques" or circus performers in the Blue and Rose Periods, figures in his neoclassical period, and on and on.

30. The argument is similar to the State Department's debacle of advancing American art with tours of art gathered in the 1940s. See Harper (2012), discussed in Chapter 2.

31. Galenson may be confusing "types" of artists with subject matter. After all, Andy Warhol, Galenson's modern exemplar of an "innovator," was swept up in photo manipulations of then-contemporary famous people (Monroe, Elizabeth Taylor, Mao), producing a *series* of them and a further series in different colors (*Orange Marilyn, Blue Mao*, and so on). Earlier in his career (1960s) he did a "shoe" *series* of drawings, a cat series, and prints that were "colored in" by assistants and his mother. Series painting is common to almost all artists—variation on themes, just as O'Keeffe's "door" or New Mexico paintings were!

32. Statistical evidence is also not without problems. An important potential problem is that, as time progresses, most or much of artists' "best work" is housed in private collections and museums. Galenson answers this criticism with more anecdotal and "selected data" from a *catalogue raisonné* (a volume listing and illustrating an artist's entire oeuvre and the paintings' whereabouts) of Paul Cézanne. In it he finds that museums' holdings of Cézanne's work are principally from the later period of this (experimental) artist's career. Galenson believes that large paintings, moreover, are a proxy for quality. He notes, from studying Rewald's *catalogue raisonné* of Cézanne's works, "The *catalogue raisonné* ... shows that it is not just late works by Cézanne that are disproportionately removed from the auction market, but that it is the best of the late works that are most disproportionately absent. If none of Cézanne's works were owned by museums, the average quality of his late paintings coming to auction would likely rise relative to the average quality of the early works sold.... Thus for Cézanne the impact of museum purchases is actually to reduce the estimated value of the works from the period the auction market considers his best—the late works—relative to the rest of his paintings" (2006a: 24). Naturally, a lowered price of Cézanne's *remaining* late works would reinforce his belief that Cézanne was an "experimental" artist who reaches peak value at auction at older ages. The value of peak-period works would be diminished due to museum holdings,

implying that if such works remained high relative to earlier periods in the artist's life, the theory would gain gravitas. Unfortunately, such argument is certainly not definitive. The auction price of Cézanne's works from all periods is the result of both *demand* and supply. The absence (due to museum holdings) of an artist's peak-valued work from auction in the most important period of the artist's life could mean that a "demand-side effect" might obtain for the remaining pieces that do come to auction. Galenson believes that the museum holdings would lower the price of Cézanne's (for example) late work. Indeed, it is just as plausible that it would *raise* the price of remaining peak-period art since it would be most desired by collectors and institutions. (The appearance of *any* painting or drawing from Picasso's Blue, Rose, or Cubist Periods brings out droves of bidders.) In this manner, museum holdings may bias results in favor of Galenson's theory.

33. Braque and Picasso (and others) learned and developed cubism together—and there was added value to each artist's creativity.

34. Museums specializing in American art were few in the period before 1950, but there were important exceptions—the Whitney Museum of American Art, for example.

35. Let us be clear that we agree with much of Galenson's proposed relations between age and productivity. We part company with him, however, in his attempt to dichotomize artistic productivity into experimental and innovative attributes of artists. Also see Ekelund (2002, 2006).

36. A broader view of the interrelationship between market and artistic factors, with the taste parameter as paramount, has been underscored by several writers. According to Frey and Pommerehne (1989: 93), who provide a model of the art market, "it has become obvious that the price of a piece of art and its evaluation through the art establishment are closely linked . . . aesthetic evaluation and its influences (e.g. the artistic capital stock, the technical variety) have explicitly to be taken into account." On cultural versus market and economic evaluation of art, see Frey (1997b, 2008a).

37. Simple marketing methods used by types of artists—salon artist, art-fair artist, for example—"offer a new perspective on artistic careers and on the speed at which some participants may find themselves front and centre on the artistic states. In particular, the increasingly early success of artists practicing researched art, the recognition of which depends largely on signals given by experts and institutions rather than the art market raises the question of the responsibility of public players in developing the market and its values" (Moureau and Sagot-Duvauroux 2012: 44).

38. The bifurcation of artists and the "classification" of working methods (planning, execution, and completion) is a central problem in Galenson's approach. For example, definitions are key, and Galenson's definitions would make no sense for

working artists—all artists "draw" in advance of a production, some on canvas; some use preparatory sketches; and some media are natural drawing tools (pastels, charcoals, oil brushes).

39. Early death (which may lead to a spike in an artist's prices) may create a "death effect" for the artist as well (see Ekelund, Ressler, and Watson 2000, and Chapter 7 of this book for examples).

40. Naturally the acquisition and "dissipation" of human capital has many dimensions. Domain-specific human capital may "warp" creativity activity in particular directions, but there are no hard and fast rules. Psychologists have revised their earlier view that creativity peaks in early or midlife and necessarily declines with age (Simonton 2000). See Lindauer (1992, 1998) on issues related to creativity.

41. Many factors affect an artist's creativity including the artist's health and the health of family and the death and health of family and friends: see the interesting paper by Graddy (2015) on the latter phenomenon. See Hellmanzik (2010) on clustered premiums for certain modern artists.

42. For European artists, there are plentiful exceptions to the older-experimental/younger-innovator designation of kinds of created by Galenson. For example, Galenson calls Vincent van Gogh, Georges Seurat, and Henri Toulouse-Lautrec (2001: 92–101) "conceptual" artists who did "high valued" work early, but these artists died at ages thirty-seven, thirty-two, and thirty-seven, respectively, and would not have had production past forty. Many artists simply do not fit his experimental/innovator distinction. Paul Gauguin is called an "innovator" who peaked out at forty-four, but Galenson calls him an exception (2009: 74) because his initial career was in banking. Monet is also an exception (peak value at twenty-nine) due to his stylistic mentor who early on introduced him to impressionism (his mentor was Eugene Boudin [Galenson 2001: 88–89]). Edouard Manet, styled as an innovator, is also an exception (he reached peak at age fifty). Statistical evidence does not comport with the theory with respect to these important artists.

43. Other factors may enter as well. For example, an interesting question arises concerning whether there is a payoff to an artist spending much of his time in preparation for the painting in lieu of simply starting to paint. As this time spent in preparation is a characteristic of innovators, one could address the question by adding a dummy variable for innovators (DPREP = 1 for the ten painters whose linear age profile was found to be negative and significant in Table 3.3; = 0, otherwise) and re-estimating the pooled-data models with it included as an additional explanatory. When this operation is performed, we find the coefficient on that dummy (DPREP) to be positive and statistically significant at the 0.01 level in all specifications. It therefore appears that there is a higher level of creativity, as measured by auction-market value, associated with more time spent in preparation.

CHAPTER 4

1. The issue of credence is discussed in Chapters 1 and 2, and fakes and frauds are discussed fully in Chapter 6.

2. Risk of legal action has caused a number of these committees to discontinue judgments regarding authenticity (such as the committee dealing with Andy Warhol's work).

3. The use of *catalogues raisonnés* does not always provide definitive credence in the authenticity of a work because these catalogs are assembled by "experts" (often dealers, family of the artist, and others) who are themselves subject to error. There are at least five such catalogs for the Italian/French artist Amadeo Modigliani, each containing an enormous variability of included works. The catalogs are only as reliable as the "experts" who composed them.

4. There is in fact indirect evidence that the two major houses employ higher-quality art experts. Bocart and Oosterlinck (2011) statistically study the appearance of fakes on the art auction market and find that *prior* to the announcement of the discovery of fakes, the faked artists appear in statistically smaller numbers at Christie's and Sotheby's. This suggests that fakes are more likely to appear at lower-level houses.

5. Sproule and Valsan (2006) show that, for abstract art, estimates by auction-house experts are as powerful as hedonic models in predicting hammer price. They do not claim that their results predict efficiency, however.

6. These results appear to be based upon the assumptions of a competitive market in auctions and on the fact that both buyers and sellers—and auction houses—want unbiased presale estimated prices. Either or both assumptions could be disproved in our test. The auction market may not be competitive, and market participants, particularly sellers, may prefer downward bias in presale estimates.

7. Condition is critical to the demander's assessment of value. A watercolor by, say, John Singer Sargent, will be of a certain value if it is torn or stained or faded but of another (higher) value if it is in excellent condition. The auction house invites potential bidders (or their representatives) to examine a work's condition, and the house publishes a condition report (with no guarantees or warranties of accuracy) itself.

8. There are other studies that show underestimates by auction houses as well. Teti, Sacco, and Galli (2014), using 333 observations (with unsold works excluded), find that the auction prices of five Italian futurist painters between 2000 and 2010 are underestimated but that aesthetics (unmeasured) often carry a higher weight than market forces in explaining price.

9. Fedderke and Li (2014), in a most interesting twist on the matter of overestimation, study the auction market of South Africa, where there is a clear market leader and one follower (where interactions are confined to two firms). They find, using 7,554 auction observations, that the follower is forced to provide

overestimates of work to attract business. It is likely that lower-tier auction houses in the United States must adjust or raise estimates to attract material to sell.

10. While Mei and Moses (2002) do not consider no-sales, they also confine their attention to only high-end masterpiece auctions. If auction houses have an incentive to overestimate these paintings' values in order to persuade potential buyers that they will indeed be bidding on masterpieces, then this alternative sample-selection issue could account for Mei and Moses's results.

11. One of the most intriguing studies of the formation of prices by all market participants in auctions (buyers, sellers, and auction-house experts) has been presented by Beggs and Graddy (2009), who introduce "anchoring effects" into the calculation. Anchoring is a type of bias first promulgated by Amos Tversky and Daniel Kahneman (1982) wherein individuals are "biased" in a current estimation of values by past value (the benchmark or anchor of value). Beggs and Graddy use heuristic prediction for current art sale and a previous sale and then regress "actual sales price on our hedonic prediction, on the difference between the actual price in the previous sale and our hedonic prediction (this expression tests for anchoring), and on the difference between the actual price in the previous sale and our hedonic prediction of price in the previous sale (this expression controls for unobservable characteristics). The test for anchoring is the extent to which the actual price in the previous sale affects the current sale price" (2009: 1027). Separating anchoring from other effects, they find that there is strong support for anchoring on the part of buyers and sellers and, possibly, on auction-house estimators. Anchoring is a reference point that influences market reactions, which, as Beggs and Graddy point out, would be expected to produce bias. However, these authors (2009: 1038) find no such bias in their sample of paired sales of forty-seven Contemporary and ninety-four impressionist and modern artists. We do not employ this interesting technique in our study. Even more recently, along these lines, Vosilov (2015b) has tested market efficiency of auction house estimates in international sculpture markets (about 10 percent of all art traded) utilizing an Adaptive Markets Hypothesis. He finds that market efficiency varies over time, with peak market inefficiency coinciding with disrupted macroeconomic and financial markets. Efficiency is driven by a variety of market forces in this approach.

12. That is not the only gap in estimation, according to a study by Campos and Barbosa (2009). In an interesting paper on Latin American art auctions at Sotheby's between 1995 and 2002, they argue, among other issues, that "the artist's reputation and the work's provenance turn out to be significantly more important price determinants than more commonly studied factors such as size, theme, and medium" and that "contrary to previous research (Ekelund et al. 1998; Mei and Moses 2005), we find that experts' opinion [contrary to virtually

all studies] is of rather limited power in predicting the sale of a work." In their regression on Latin American art, "window" is not significant, but neither is "exhibited, art books, and *catalogues raisonnes.*" In order to predict art prices, Campos and Barbosa claim that "reputation"—that is, provenance ("exhibited," "art books," "*catalogues raisonnés*")—which is reported in the auction catalogs, is more important than other traditional explainers (size, area, signed, etc.) used by most investigators. Here they find that whether the work was exhibited, in art books, or included in *catalogues raisonnés* to be highly significant, but they *do not* include a variable for auction-house estimates. The point is that auction-house estimates do include all the items listed in the presale catalogs. A painting that has been exhibited or is contained in a *catalogue raisonné* or art book will receive a higher estimate than one that has not or is not. Campos and Barbosa do not include auction estimates in their regression (OLS estimates of log price). They do not acknowledge the fact that "provenance" (exhibition record, published in art books or *catalogues raisonnés*) and whether the item came from a public or private collection are merely *proxies* for auction-expert estimates, which also include the condition of the painting. These reputational and credence characteristics may be more important than size and type of picture (e.g., landscape), but they are not as important as the auction-house estimates, which *encapsulate* these variables, including the condition of the work.

13. Building on the idea that non-pecuniary factors such as "taste" and "mood" may have an impact on prices, De Silva, Pownall, and Wolk (2012) argue that London weather had an effect on private-value but not on common-value (price) works. They show, using weather as a proxy for mood, that bad weather negatively affected purchase of low-value items at Sotheby's and Christie's. It did not have the same effect on high-value items—those dominated by common-value buyers more interested, perhaps, in investment.

14. The Heckman procedure has been used in several studies, although not in connection with "no-sales." Interesting investigations have been conducted, for example, on particular genres of paintings (symbolists in Collins, Scorcu, and Zanola 2009) or on the impact of "fakes" (Bocart and Oosterlinck 2011).

15. If, as seems likely, Sotheby's and Christie's are price leaders among US auction houses, one would expect the competitive fringe to price their services according to the fee schedule that Sotheby's and Christie's set. One explanation as to why the other auction houses appear to set their fees a bit lower is that they draw on a smaller market than Sotheby's and Christie's (i.e., a regional or even local, as opposed to a national, market).

16. A brilliant and entertaining narrative account of this price-fixing conspiracy may be found in Christopher Mason's *Art of the Steal* (2004).

17. Ashenfelter and Graddy (2011: 212) estimate the sellers' reserve at 70 percent of the low estimate. Other estimates are as high as 75–80 percent.

18. Notably, in New York the reserve must not, by law, be higher than the low estimate. Elsewhere that practice is followed by tradition.

19. Ekelund, Ressler, and Watson (1998) found 32 percent no-sales in the Mexican/Latin American art sample they studied; Ashenfelter and Graddy (2011) found up to 43 percent, and Ashenfelter (1989) found 26–40 percent no-sales in his impressionist-art sample. Clearly no-sales in substantial numbers are a part of most auctions—the exception being, of course, a "no-reserve" auction.

20. Thus if $\theta = 1.2$ and the auction house estimates a painting's value at $1,000, the hammer price would be expected to be $1,200; but if the auction house estimates a painting's value at $10,000, the hammer price would be expected to be $12,000—the percentage understatement is the same in both cases, 20 percent.

21. The Breusch-Pagan test for heteroscedasticity produces a $\chi^2(2)$ test statistic of 514.91, which is statistically significant at the 0.01 level. Heteroscedasticity is a problem; OLS coefficient estimates are unbiased and consistent, but their standard errors are inconsistently estimated by traditional OLS formulas. We solve this problem by employing White's recommended approach to compute heteroscedasticity-consistent standard errors. The t-ratios reported in the preceding are these standard errors divided into their corresponding coefficient estimates.

22. It is worth noting that we also estimated the preceding model and the ones we subsequently consider by including artist and media dummies. This resulted in no marked change in the magnitude of crucial parameters or in their statistical significance. Furthermore, all of the dummies were statistically insignificant at traditional levels in any of the models. We take this to mean that the auction houses' art experts take artist and media, as well as characteristics of the artwork, into account when formulating their assessments. In any event, these types of variables have no role in our bias analysis.

23. The Breusch-Pagan test for heteroscedasticity produces a $\chi^2(2)$ test statistic of 514.97, which is statistically significant at the 0.01 level. Heteroscedasticity is a problem; OLS estimates coefficient are unbiased and consistent, but their standard errors are inconsistently estimated by traditional OLS formulas. We solve this problem by employing White's recommended approach to compute heteroscedasticity-consistent standard errors. The t-ratios reported in the preceding are these standard errors divided into their corresponding coefficient estimates.

24. The estimation results for the dummy/interactive model are as follows (t statistics in parentheses):

$$\ln(HP_i) = \begin{array}{l} 0.5586 + 0.984\,GMAV + 1.8576\,D100K - 0.3125\,D100K * GMAV \\ (9.03) \quad (151.1) \qquad\qquad (19.89) \qquad\qquad (-15.22) \\ -1.0494\,IMR \\ (-18.32) \end{array}$$

These results can be decomposed into the following two models:

For paintings selling for less than $100,000 in nominal terms,

$$\ln(HP_i) = 0.5586 + 0.984 \text{ GMAV} - 1.0494 \text{ IMR}$$
$$(9.03) \quad (151.1) \quad (-18.32)$$

And for paintings selling for $100,000 or more in nominal terms,

$$\ln(HP_i) = 2.417 + 0.851 \text{ GMAV} - 1.0494 \text{ IMR}.$$
$$(31.5) \quad (150.4) \quad (-18.32)$$

25. If the assessed value is $10,000, the predicted price is $15,102, for a 51 percent understatement; if the assessed value is $90,000, the predicted price is $131,224, for a 46 percent understatement.

26. If the assessed value is $200,000, the predicted price is $363,380, for an 82 percent understatement; if the assessed value is $1,000,000, the predicted price is $1,431,143, for a 43 percent understatement.

27. Important variations have been made in analyzing no-sales. Ashenfelter and Graddy (2011) propose that sales rates are a function of "shock rates" from unexpected price movements and that the sale rate in period t is a function of the "shock rate" from previous auctions. Using data from impressionist and Contemporary auctions in New York and London, they calculate price indices (hedonic) and correlate them with sales rates. While they find no correlation between current price indices and sales rates, they do find that sales rates in, say, period t are a function of shock rates in period t-1. These writers use probit and random-effects probit procedures to obtain their results. (Notably, for one of their samples, bid prices were obtained for pieces that did not reach the reserve and hence were bought in.)

28. It is worth noting that in exploratory estimates of the model, we included artist and/or school dummy variables. None of these turned out to be statistically significant. We take this to imply that the auction-house experts take such idiosyncrasies into account when forming their high and low estimates.

29. The analogy of art-estimate spreads to risk (posited in Hodges 2011/2012), with large spreads indicating greater "resale risk" to buyers and smaller spreads to lower risk of this kind, is inapt. Spreads in, say, bond estimates are created by a group of evaluators. Individual sellers do not "bargain" with bond raters changing estimate ranges, as is the case in art auction markets.

30. These probabilities arise from the estimated probit equation evaluated at sample means (\bar{Z}), both with $[F(\bar{Z})]$ and without $[F(\bar{Z} - \beta_{UNSOLD1})]$ the unsold effect included. The probability of sale without the UNSOLD1 effect is $F(0.5978) \cong 0.73$, and the

probability of sale with the UNSOLD1 effect is $F(0.5978 - 0.3223) = F(0.2755)$ $\cong 0.60$, so that the difference in the probability of sale at the second auction attributable to the burned effect from the first auction (i.e., UNSOLD1 = 1) is 0.13.

31. Nor should it. When considering questions such as burning, investment returns, etc., that involve, of necessity, multiple offers or sales, paintings offered at auction only once must be excluded by the design of the experiment from the analysis. Hence their exclusion cannot bias the results.

32. This procedure is explained in detail in Anderson et al. (2015) within the context of their analysis of the effect of changing buyers' premia on early American art prices on paintings sold at auction by Sotheby's between 1987 and 2012. They also include three recession dummies (1990–1991, 2001, and 2008–2009) and a dummy for the Sotheby's/Christie's price-fixing scandal (1993–2002) in their model for conditions-of-sale variables. They found that these variables were uniformly statistically insignificant and that their exclusion from the model did not materially affect the magnitudes estimated for the remaining parameters. Consequently we exclude these variables from our earlier analysis.

33. The t-statistics in parentheses were computed using White's heteroscedasticity-consistent standard errors. The observations are ordered by painting, not time, so that no correction for autocorrelation is warranted.

34. All manner of financial devices has been used to assemble first-quality art pieces. Sotheby's and Christie's began guaranteeing works to assure sellers as early as the 1970s, but third parties have begun taking all or part of the risk (for a return, of course). To complicate matters, the two houses use differing arrangements depending upon whether the guarantor actually buys the work for personal ownership (see http://www.economist.com/node/21539958). Both Sotheby's and Christie's permit guarantors to bid on the item, but, with Christie's, the guarantor receives a share of the difference between the winning bid and the guaranteed price, causing different incentives and advantages between the items at the two houses. Graddy and Hamilton (2014) analyze the impact of these differing policies, finding no differential advantage due to the differing policies.

35. The chief executive of Sotheby's, William F. Ruprecht, believed that increases in the buyer's premium had "stabilized the business," while hedge-fund investor and now board member Daniel S. Loeb (who owned a 9.2 percent share of Sotheby's) claimed several years ago that the increase has reduced profits (Bowley 2014: 2).

36. The sample mean of PCTPREM is 20.15 percent, while the sample mean of average buyers' premia (ABP) from our previous analysis is 16.53 percent. This result also suggests a crude estimate of average sellers' premia of about 5.62 percent. This result in turn suggests roughly a 75 percent/25 percent split in profits between buyers' and sellers' premia. In principle, then, one could back

out an estimate of the effect of buyers' premia by taking 75 percent of the effect of the effect of PCTPREM.

37. *t* ratios are computed using Newey-West standard errors, lag length = 2.

CHAPTER 5

1. Academicians Jianping Mei and Michael Moses, who have produced important academic research on returns to art investment (2002, 2005), established a subscription service (ArtasanAsset.com) called Beautiful Asset Advisors to help investors make decisions concerning fine art as an element in their investment portfolios. See Questroyal Fine Art, LLC, "Art vs. Stocks and Bonds: A Comprehensive Analysis of the Investment Potential of American Art" (New York: n.d.; 2nd ed., 2013).

2. The most complete introduction to the economics of art market is found in Ashenfelter and Graddy (2003). Discussion of aspects of investment returns may be found in Graddy et al. (2012) and Graddy and Margolis (2011).

3. A seller's reserve price is the (secret) price under which she would not be willing to sell. One exception to studies that exclude transaction costs relates to collectible British stamps. Dimson and Spaenjers (2011) calculate the impact of a 25 percent transactions cost on return, concluding that the asset must be held for four years to compare with an equity holding of just three months. Frey and Cueni (2013) note that a similar cost may apply to art investments but do not formally assess that possibility.

4. Until recently, few pre-1950 American works found their way into European museums, but there were exceptions, including important exceptions. Whistler's "mother" (*Arrangement in Grey and Black*, 1871) and an important work by Winslow Homer (*Summer Night*, 1890) were included in French collections (now in the D'Orsay) in Paris and London's National Gallery, in a bid to include American works as part of their "Western European art" collection, in pursuit of which they also purchased a masterpiece by George Bellows (*Men at the Docks*, 1912) from Randolph College for $25.5 million in 2014.

5. Several galleries that dealt sporadically in American art in the earliest period remain in the American Northeast. The Vose Gallery was originally established in Boston in 1841, moving to Providence, Rhode Island, in 1850. Of four remaining galleries in New York City, with significant trade in American art, Knoedler & Company (1846) is the oldest, followed by Babcock Galleries in 1852, James Graham & Sons (1857) and Kraushaar Galleries, founded in 1885 (Fahlman 2010: 92).

6. Pop art, op art, and myriad variations on abstract and other concepts have permeated the market. Only in the latter decades of the twentieth century and in the early twenty-first century have American works achieved sufficient international

interest to be in the highest echelon of value at auction and the object of invest-ment. Of sixteen of the highest-priced artworks ever sold at auction in real terms (as of November 2013), only four were by Americans (one by Andy Warhol and three by Mark Rothko), but they were all purchased in 2012 and 2013. None was created prior to 1950 (http://www.economist.com/blogs/graphicdetail/2013/11/daily-chart-7).

7. This distinction is not different than identifying an "American" stock or bond market, although, obviously, Americans purchase stocks and bonds of other countries, as their citizens do those created in the United States.

8. American dominance of the contemporary art market is an interesting story that begins in the post–World War II era (see Guilbaut 1985, 1992). The whole art scene changed over the postwar period. According to Watson (1992: 421), "it used to be that [collecting contemporary art] took nerve and involved going out on a limb. But in the Seventies and Eighties this changed. More and more people were at home with newness and thrived on change; the shock of the new was less and less disconcerting." In 1988, for example, the primary auction houses, Sotheby's and Christie's, began selling contemporary works by artists in mid-career.

9. Only nineteen of Agnello's (2002: table 2) sample of ninety-one American artists were born in the twentieth century and none after 1935, replicating a larger but similarly composed sample as the one here.

10. New artists are often promoted by galleries at which they receive representation. Galleries (some of which use exclusive dealing arrangements with artists) will attempt to reduce the supply of an artist's work by creating a "waiting list." The lucky buyers will then attempt to "flip" the work at auction for profit. Consider an analysis of the November 2014 New York sales of postwar and Contemporary art: "In a booming market which continues to see remarkable totals for Post-War and Contemporary auctions Christie's ($852,887,000) and Sotheby's ($343,677,000) sales reports tend to highlight results for the work of hot young artists selling out at gallery shows and subsequently being 'flipped' at auction for many times a gallery price" (Pollen 2015: 30). Contemporary galleries often cre-ate waiting lists for paintings. Artists themselves help when "lists arise because of the very limited production of market-savvy artists" (Thompson 2008: 96).

11. Diversification naturally reduces risk in art as well as in all investments; hence the publicly traded art "funds" mentioned in the introduction to this chapter.

12. Picasso's work (along with Andy Warhol's) is generally considered the gold standard in modern art markets. Picasso's investment returns have been studied for both prints (Pesando 1993; Pesando and Shum 1999) and paintings (Czujack 1997). Picasso prints do better than prints in general (real return of 2.10 to 1.51 percent between 1977 and 1992), with paintings at 8.30 percent be-tween 1966 and 1994.

13. The elimination of transactions costs is probably more serious than Mei and Moses appear to believe. They note that "the return could be further reduced by transaction costs [auction fees to both buyers and sellers at auction]. We like to note, however, that return estimates for financial assets, to some extent, also could suffer from the same biases, such as lack of market liquidity, transaction costs, and survival" (2002: 1659). Transaction costs relating to art sales or purchases at auction are significantly higher than those for sale of financial assets, however. Now, the standard buyer's premium for art is 25 percent (for purchases up to $100,000) and for sellers, at least 10 percent. If art sales are through galleries, the gallery "take" may be 20 to 40 percent or more of the sale price, all attributed to the seller.

14. Like Pesando (1993) and Goetzmann (1993), Mei and Moses find that "masterpieces" (higher-priced art) underperform lower-priced art—contrary to the advice of most dealers to "buy the best that you can afford."

15. Their sample of artists was from the Annual Art Sales Index (Hislop 1971–1992) and excludes bought-ins—those works that did not meet the reservation price.

16. Agnello and Pierce (1996) and Agnello (2002) find a "masterpiece effect"—that is, higher-priced paintings do better in terms of return than low-priced paintings. These results are in contrast to other studies (for example, Pesando 1993 and Mei and Moses 2002).

17. Mei and Moses calculate fairly high returns for pre-1950 American art (Questroyal Fine Art, 2013), but their data are strictly proprietary.

18. There are a massive number of artists working in the United States, with only a small fraction of them being regularly represented at auction. This is a parallel to musicians and actors: the rewards at the top must be very large in order to compensate for high entry and large numbers of competitors in the market. Princeton University's Center for Arts and Cultural Policy Studies estimates that there are more than 2.5 million Americans working in art fields in the United States (from 2001 population survey), with 288,000 listed as primarily painters, sculptors, and craft artists. See http://www.princeton.edu/~artspol/quickfacts/artists/artistemploy.html.

19. In principle, it is possible to incorporate the buyer's premium into a hedonic model; it is simply not done. Perhaps the reason for not dealing with it is that it is not at all clear how to do so appropriately. One way might be to treat price as "premium price" and the buyer's premium as a condition-of-sale variable, but this would build spurious correlation into the model. In any event, since data on the seller's premium are not published, the seller's premium will always be a source of omission.

20. Without doubt, there are many paintings that were offered for sale *once* at auction by these artists and sold. Including these data in our hedonic analysis would surely produce more (statistically) efficient return estimates. We did not include these data to retain comparability of return estimates across methods—i.e.,

so that both hedonic and resale estimates would be based on the same basic data set.

21. For paintings that were sold three times, the first and second sales constituted one resale, and the second and third sales were taken as a second resale. Paintings offered at auction three or four times during the sample period but sold only twice were counted as one resale; the no-sales in that set of offers were ignored. This set of 105 resales constitutes our repeat-sales sample.

22. Bowley notes that the buyer's premium—which falls to a marginal 12 percent for work receiving more than $2 million hammer price—may be split with the seller. Thus to attract high-priced material, auction houses may offer an "enhanced premium" paid to the consignor or to a guarantor of the painting. Naturally, such practices reduce the overall return and profitability to the house.

23. For any painting, the premium price (PP) equals the hammer price (HP) plus the buyer's premium (BP). The 2011 buyer's premium rates were 25 percent on the first $50,000 and, for paintings hammered down for between $50,000 and $1,000,000, 20 percent on the excess of hammer price over $50,000. Thus $362,000 = HP + [$12,500 + 0.2(HP − $50,000)]. Solving for HP gives $299,583.33.

24. The results are not quite as "identical" as table 5.2 would suggest. There are differences in the arithmetic and geometric means, usually starting around the fourth significant digit. Most of the similarities in the table arise due to rounding for tabular presentation.

25. As prefatory analysis, we regressed ln(premium price) on a full set of thirty artist dummies (Inness was the omitted artist) and a constant term. Twelve of the dummy coefficients did not differ significantly from zero, indicating that the pricing of their works did not differ significantly from those of Inness. The eighteen artist dummies that were significant are the ones included in our hedonic model.

26. This is an approximation, and due to the size of the coefficient, it may contain considerable error. An exact calculation reveals that the average price of an oil painting is about twice the average price of an otherwise identical painting in another medium: i.e., $[(P_{oil} − P_{other}) / P_{other}] = (e^{0.699} − 1) = 1.012$. Thus the percentage difference is $100(1.012) = 101.2$ percent.

27. While neither study expressly states it uses hammer prices, both use the Hislop (1971–1996) data, which record only hammer prices.

28. The average (and marginal) buyer's premium prior to 1993 was 10 percent of hammer price. From 1993 on, the average buyer's premium as a percentage of hammer price was 18 percent. Hence the 80 percent increase in average buyer's premium.

29. Because of the higher standard errors, we note that the trend coefficient in model V is statistically significant at the $\alpha = 0.055$ level and that the trend coefficient in

model VII is statistically significant at the 0.065 level, both based on a one-tailed test that they are not negative.

30. One difference in the variables is that the daily time trend in our contemporary sample ended on December 31, 2013.

31. The relevant computations are: model 1: $[(1.000254)^{365} - 1] = 0.097 = 9.7$ percent; model 2: $[(1.000258)^{365} - 1] = 0.0987 = 9.9$ percent for premium prices; model 3: $[(1.000242)^{365} - 1] = 0.092 = 9.2$ percent; and model 4: $[(1.000247)^{365} - 1] = 0.094 = 9.4$ percent. The numbers in the text are averages.

32. As noted earlier, the probit model from which the IMR was derived was estimated based on the second offer of the 1,505 paired offers. The dependent variable was unity if the painting sold; zero if it did not. The explanatory variables were, as defined in Chapter 4, RANGE2, LLEST, AGE, AGE², DMED, LSIZE, % year time dummies, GR, and UNSOLD1. The estimated model accurately predicted 98.9 percent of the paintings that sold.

33. It goes without saying that alternative methods of estimation and art valuation yield different rates of return. An important evaluation of art "returns" and methods may be found in Chapter 9 in Robertson (2016). "Return" for the collector or exhibitor, moreover, may be far higher than simple monetary returns.

34. Methods of marketing and transactions costs are important to the highly competitive auction houses Sotheby's and Christie's as well. A chief strategy of Sotheby's, from 2006 until recently, was to focus on selling higher-priced material in art and in other collecting interests. Earlier (between 1999 and 2003) Sotheby's partnered with Amazon (Amazon.com) to sell lower-priced items at lower transactions costs, but incurred losses of $150 million. Now, Sotheby's (and Christie's) will again begin marketing art through the Internet. Sotheby's will partner with eBay (paying eBay a percentage) to create an Internet business selling art, mainly lower-priced material at first. Christie's will develop its own Internet site and offer art in addition to other items. It is hoped that the brand credence of the two houses will cause the value of materials sold on the Internet to rise.

35. There are other reasons for holding a portfolio of American art (as in our sample). We conducted a portfolio investment procedure (a modified Capital Asset Pricing Model) with respect to our sample of early American artists. Accepting the most likely estimates of premia for these artists produces a Beta value that is low relative to many traditional asset classes, but it is positive and significant. This means that there is a potential role for pre-1950 art in a portfolio of diversified assets. The risk-adjusted value of holding that art follows the business cycle, but does not go down as much as the market in a downturn. (Results are available on request from the authors.)

36. Art markets do not carry instant or rapid and continuous feedback as in the financial markets, but it may be that auction frequency in fact is sufficient to engage in long-term speculation. Use of the Internet may in fact reduce those

costs relative to holding other assets. Additionally, the quality of art may reduce competition, as in some studies showing "masterpieces" to give better returns over time (Mei and Moses 2002, 2005) as does our analysis of Contemporary American art and the length of holding most assets (real estate and other assets).

CHAPTER 6

1. We do not here deal with the extremely serious problems involved in the repatriation of Nazi art or the theft of cultural heritage (such as the thefts in Iraq). But these issues are assessed in interesting and important sources (see Edsel and Witter 2009).

2. Originality on the part of the artist may also become an issue. The famous and highly successful American artist Jeff Koons has been sued numerous times for plagiarism, losing at least two cases (and winning one) of copyright infringement for pieces from his "Banality" series (Forbes 2014a, 2014b). One of Koons's trademarks is the parody of other works, although the legal exclusion may or may not apply, depending on several factors.

3. What if it isn't, and "new" prints are made? In this sense, the graphic or other artist is similar to the durable-goods monopolist (Coase) in that he or she must provide guarantees that output identical or similar to a sole image will not be made. Fakes are similar to prints in this regard, as we discuss later in this chapter.

4. Without question the most informative survey on international art theft and crime is the set of essays by Charney (2009), who is the founding director of the Association for Research into Crimes Against Art (ARCA).

5. None of the stolen paintings was by an American artist, however. Indeed, only three of the top twenty-four *most frequently stolen paintings* in the Art Loss Register (ALR) are by American artists (Coombes 2013: 76). The only one in the top ten is by Andy Warhol, the others being the photographer Edward Curtis and the abstractionist Alexander Calder. That fact does not diminish the importance of the theft of American art or the theft of art in the United States, however: art theft is in the top three crimes annually reported by the FBI, along with money laundering and drug crime.

6. The Isabella Stewart Gardner theft is the most famous in modern times. The FBI now claims that the identity of the robbers is known, but that they are dead (Ngowi and Kole 2015). Attention has turned to recovery of the work, and a $5 million reward (no questions asked) is offered. In 1911 an Italian employee of the Louvre stole the Mona Lisa and attempted to return it to the Uffizi Museum in Italy as part of Italian heritage. It belonged to the Louvre and was recovered and returned two years later (see Charney 2011).

7. This marginal calculation obtains for any crime; for our purposes, it obtains not only for art theft, but also for those producing art fakes and forgeries.

8. This popular theme (art theft and forgery) is the central focus of many novels each year. Many deal with other kinds of forgeries (see Bradford Morrow's *The Forgers*) or constitute whole series featuring an art theft/forgery detective such as the expanding series by Jonathan Santlofer or Daniel Silva.

9. A recent tragic semi-exception was the accumulation of a horde of masterpieces in France. Between 1995 and 2001, Frenchman Stephane Breitwieser assembled a collection of 239 works from European museums and traveling exhibits, storing them at his home in Mulhouse, France. He had no other intention than privately to enjoy the paintings that were worth at least $1.4 billion. In 2005 he was sentenced to twenty-six months in prison. To the dismay of art lovers, sixty of the paintings were destroyed by his mother, who was trying to eliminate the evidence against her son. A young art-loving thief stole a Picasso and Léger drawings in 2011 to decorate his apartment in Hoboken, New Jersey.

10. Canada is a paradise for art thieves and black market dealers since victims have few resources to track down their property (see Quill 2010).

11. http://www.havocscope.com/tag/art-theft/ (accessed August 24, 2014).

12. http://www.economist.com/blogs/graphicdetail/2013/11/daily-chart-7.

13. Unbelievably, private sales have reached loftier records, with a single Cézanne selling to Qatar for about a quarter of a *billion* dollars.

14. An "art-crime team" was established in 2004 by the FBI, headed by Bonnie Magness-Gardiner (manager of the Art Theft Program) in connection with the theft of "cultural property" (notably the looting of the Iraqi treasures but also theft from Native American sites). This team is also charged with museum and private thefts and claims that "since our inception [up to 2008] we've recovered over 850 items valued at over $134 million," a report at variance with other statistics.

15. See https://www.ifar.org for details concerning services and the organization.

16. Nelson (2009: 199–200) provides actual examples, however: "In March 2002, U.S. officials seized two paintings, a Goya and a 1924 work by Japanese artist Tsuguharu Foujita, that were being used by a Spanish money-launderer to settle a $10 million drug debt."

17. Again, the market has responded to this difficult issue. In 2009, an interdisciplinary association, the Association for Research into Crimes against Art (ARCA) was founded by Noah Charney (see Charney 2009, 2011). ARCA promotes research in art crime, publishing a journal (*Journal of Art Crime*) and sponsoring postdoctoral studies leading to a Certificate in Art Crime and Cultural Heritage Protection. Its website also provides information on art crime and links to art-recovery registries (http://www.artcrimeresearch.org).

18. The Art Recovery Group is a private company founded in 2013 to recover stolen art and has also become a "due diligence" resource that has been creating a

database of stolen art using new technologies, including image-recognition devices for recovery purposes. This private company was founded by Christopher Marinello, formerly associated with the Art Loss Register.

19. Sometimes art-theft stories have a happy ending (Squires 2014). Two paintings, one by Paul Gauguin and one by Pierre Bonnard, hung in an Italian workman's kitchen for four decades. He had purchased the two paintings at a railway auction as "junk" in 1975 simply because he liked them. Decades later, the then-pensioner took the paintings with him to southern Italy and put them on his wall. His son became interested in the paintings and after investigation found that they had been stolen from a house in London in 1970 and abandoned by the thieves on a Paris-to-Turin train. (The theft had been noted in the *New York Times* in 1970.) English authorities were notified and found that the works had belonged to Mathilda Marks and her husband, who were now dead and who left no claimants to the works. An Italian court awarded the paintings to the pensioner in 2014, who had purchased the paintings in good faith. He is selling the Gauguin, estimated as worth up to $40 million, and keeping the Bonnard. This "rags to riches" story will enable him to take his wife on a honeymoon at last, buy a farm, and ensure a fine future for his children and grandchildren. It is the stuff of dreams. (Note that good-faith purchase would not have applied in the United States.)

20. Knoedler's very valuable archive was purchased by the Getty Research Institute. It includes a complete archive of Knoedler's operations from the 1850s through 1971. Rosales's sentencing was postponed, suggesting that she might trade time and fines for solid information on all of the transactions.

21. The Rosales-Knoedler frauds came to light when suspicions were raised at the Beyeler Foundation in Switzerland, to which some Knoedler works had been lent. A private e-mail raised doubts concerning the authenticity of a Barnett Newman. Investigations by a purchaser of that work brought the whole fraud to light. When the owner of the "Newman" demanded money from Knoedler, the latter closed its doors and legal cases proceeded rapidly, many remaining unsettled.

22. Some art professionals believe that the April 2014 decision introduces even more confusion into the market. Consider a report by Burns (2014) in the *Art Newspaper*: "The decision does not include details of what, or whom, is meant by 'forgery expert.' In today's litigious climate, 'we are already witnessing the erosion of the process of authentication, which used to be governed by experts who now seem to be driven further and further away by threats of legal action where so much financial value is at stake,' says the art adviser Allan Schwartzman. It seems unlikely that advisers and scholars would freely voice their opinions on forgeries." The decision places more responsibility on the buyer *at the time of purchase* to determine authenticity. At the same time, it creates additional reluctance to provide credence by experts.

23. American artist and sculptor Kenny Scharf created a futuristic sculpture called *Bird in Space* and chose Brian Ramnarine's Bronze Foundry and Gallery to mold four copies. When Scharf learned of additional copies in the market—obtaining the price of the "originals"—Ramnarine was prosecuted (Amore 2015: 86).

24. There are exceptions, where second, third, and fifth strikes of a plate also carry value. The works of Goya are an example, as are the woodcuts of Gauguin, whose son and others struck prints from his father's work, but *they were and are represented as such*.

25. Books detailing methods of discovering fakes and forgeries (Bell 2009) may in fact help the unscrupulous to create techniques to avoid such detection.

26. Minor forgeries on eBay may lead to a path of big-time forgery. See Walton (2006).

27. Some (McFarland-Taylor 1998) suggest that an internationally recognized "due-diligence standard" for faked art could be set up on the Internet to check for fakes, theft, and forgeries.

28. Keats (2013), for example, suggests that the faking or copying of existing art exposes the ignorance of "experts" and promotes creativity in advancing art, a dubious claim. Radnóti (1999) presents a philosophical-aesthetic argument for fakes, suggesting that the fake is the "real" work—a parody of what went before and a necessary goad to future creativity. The argument is somewhat similar to the practice of modern American artist Jeff Koons.

29. Artists who need advertising will not be the ones faked, moreover, since only successful artists are the subject of fakes and the object of illegal profit!

30. Some observers take a "philosophical-artistic" view of fakes. Part of this view is that fakes or "paintings of a painting" are deconstructions that qualify as "the great art of our ages." Warhol's painting of thirty Mona Lisas (*Thirty Are Better Than One*), per one observer, "is not really about the Mona Lisa or even about art, but rather concerns the tortuous relationship between culture and media, a relationship beginning to play out in his own life as he became the first metacelebrity" (Keats 2013: 159). Forgeries in this context cause anxiety, alienation, and attention to the "status quo" elicited by originals. Also see Radnóti (1999).

31. During his lifetime, the Mexican artist Rufino Tamayo (1899–1991) established two museums to display his artistic output in Mexico (in Oaxaca and Mexico City) for his work (very much like the land developer's parks and recreation "set asides"). Pablo Picasso's (1881–1973) legacies and endowments of hundreds of pictures in France and Spain both before and after his death also established that "non-market" part of his output.

32. Fakes and fraud may take on insidious forms. The "big eyes" paintings of the 1950s and 1960s were allegedly painted by artist Walter Keane. It has only recently come to light that they were all products of his artist wife Margaret Keane (Ronson 2014).

33. A number of works have been devoted to art forgery, an excellent survey of which is by Noah Charney (2015).

34. A fascinating story is told of a fake Heade by the expert on the artist (Stebbins 2004: 138–139). Examination of a transparency for Sotheby's-Parke-Bernet led him to conclude that a small Heade was genuine, but Stebbins began to have "nagging doubts." A trip to New York on the day of the sale (in 1980) convinced him that the work was a fake. He advised Sotheby's to withdraw the picture or, if sold, to remove his attribution. The work was removed and the Heade was exposed and discounted accordingly. One wonders how many other "Heades" are in the marketplace.

35. A synopsis of this case is given in Mooney's *Chiaroscuro Market*, but a fuller description of this case may be found in Los Angeles Police Department 2002, *Art Theft Case Files: Hidden Treasure*, 2000 ed., available online at http://www.lapdonline.org/newsroom/content_basic_view/27408 (accessed September 15, 2014).

36. Some theft-fake combinations do not come to light until the faker tries to sell the authentic works. In 2015, the theft of a collection of stolen prints by Andy Warhol (*Ten Portraits of Jews of the 20th Century* series) came to light when the owner was having some of the prints reframed (they were purchased in 1980). At some time between 1980 and 2015, fake prints were substituted for the actual prints (the Los Angeles Police Department's website portrays some of the prints as stolen). Someone tried to sell a print from the series at Bonhams auction house in Los Angeles in 2015 and there is hope that the prints will be recovered. This incident brings to light how owners, even sophisticated collectors, may not be able to identify fake materials, possibly for decades. (See http://losange-les.cbslocal.com/2015/09/08/thief-steals-andy-warhol-paintings-and-replaces-them-with-fakes/.)

37. There are of course other issues. The Dow was not in a UCLA museum but hanging in a counselor's office and, according to one account, had been there since at least 1940. The returned picture, which the thief had had "cleaned" (the fake) was not recognized as such. Other paintings stolen were placed in offices around buildings without protection—easy picking for the thief (who had other "replicas" made).

38. In October 2016, for example, a brilliant faker (unknown) came to light in England. Dubbed the "Moriarty of the Old Master," an artist of the very highest quality has been faking Fran Hals, Lucas Cranach, and other great Old Master painters, possibly to the tune of £200 million. Called the biggest art scandal of the century, Sotheby's was required to indemnify a collector £8.4 million for a "Frans Hals." So-called experts are in a tailspin, and it is believed that more than twenty-five of these fakes are in the trade. See Luck (2016).

39. An investigation revealed that the auction houses got calls from around the world from individuals asking what they were doing with their property when

offering Sakhai's wares. But Keats (2013: 27) is incorrect when he notes, in re-
spect to these episodes, that "any notion that capitalism makes knowledge more
efficient—as the conservative economist F. A. Hayek influentially claimed—
would appear to need serious reconsideration." All information acquisition
carries a cost. Hayek argued that an "optimal" level of information would be
achieved under capitalism *given* these costs. On the general issue of auction
houses and the discovery of fakes see Tancock (2004).

40. As noted elsewhere, a *catalogue raisonné* and an "authentication committee"
are two tools that give credence to an artist's work—but that is not necessarily
the case. Consider the case of Amadeo Modigliani, an Italian modernist art-
ist whose elongated necked muses are a famous staple of post-impressionist
art. Modigliani is the most faked of artists of his genre. There are numerous
catalogues raisonné of his work, some listing as few as 350 works and others
attributing thousands of paintings to him. On the heels of a record-breaking
sale of a Modigliani in 2015, a "new" work by the artist has emerged in Italy,
found by a flea market dealer near a trash bin. With no provenance, and even
with some science on the painting's side (no sign of titanium white paint, which
was only used since 1924), there is broad skepticism. That skepticism is multi-
plied due to the president of the Amadeo Modigliani Institute being involved in
authenticating fake Modigliani paintings that he knew were fakes. If credence
cannot be given by "authorities" on the artist or by *catalogues raisonné* writers
and researchers, the market is unlikely to function efficiently. The role of the
catalogue raisonne in authentication is discussed at length by Kraus (2004).

41. Many methods have been proposed to help verify art. One is to digitally assign
by using a method called "block chain," assigning each piece of art with a
badge of authenticity (Tarmy 2015). As the artwork passes through hand after
hand, the e-mail address is attached to the object. It is a money-making service
(Verisart) proposed to eventually encompass all art. One would then pay for the
verification to provide credence when purchasing a piece of art. Naturally there
would likely be problems with this method, which requires voluntary compli-
ance by present owners of art (including price paid, date purchased, etc.). It is
unlikely that individuals would be willing to provide such information without
guarantees of privacy. Further, if such an online engine acts as a "market" for
buyers and sellers, it would bypass the traditional marketplace of galleries and
auction houses.

42. The well-known expert Dr. Abigail Booth Gerdts, director of the Winslow Homer
catalogue raisonné, advises, "The stakes are just too high. I believe that we should
all get out of the opinion-giving business" (quoted in Stebbins 2004: 140).

43. Spencer describes an interesting and infamous case wherein a judge overruled a
very credible expert (Calder's dealer for twenty years) and other evidence, declar-
ing an Alexander Calder mobile to be genuine (2004: 189, 196–198). The Calder,

of course, became practically worthless. Ronald Spencer, along with other scholars, provides an excellent survey of "art law" in the United States and in France in his book (2004: 143–226).

44. This conclusion is supported by numerous anecdotal reports (Riding 1995; Hope 2006). Recovery and apprehension are increasingly important in the United States and other countries, since innocent buyers of stolen art that finds its way into the market are losers unless they can prove that they have exercised "due diligence" in the purchase (shifting liability back in the chair of ownership). Insurance companies, moreover, who pay out billions of dollars per year have clear interests in developing new methods of detection, including electronic detection devices, bar codes, and other methods of identification such as high-tech cataloging (Tarmy 2015).

45. Reports are that a startling new technology to detect fakes has been developed. It is based on the use of a "unique synthetic DNA tag," one that can be stuck onto artworks. According to Neuendorf (2015) the technology, developed at the University of Albany and Aris Insurers, over time transfers DNA to the artwork so that a missing tag would not deter identification. Naturally this is essentially a "going forward" technique to detect fakes. But it would naturally make the faking of Contemporary works more difficult, if not impossible. That would, in effect, change the "equilibrium" in the "fake market" and the art market as well.

CHAPTER 7

1. Agnello and Pierce (1996) and Czujack (1997) found that prices rise at death in conjunction with hedonic art rates-of-return studies.

2. The taste parameter is particularly prominent for demanders (Frey and Pommerehne 1989: 81–100; Baumol 1986). Tastes may change or be influenced through the action of gallery promoters and "discovery" of new and innovative styles of art (Thompson 2008).

3. Museums rarely deaccession works for purposes (e.g., working capital) other than acquiring more desirable art. That is a condition, for example, for membership in the American Association of Museums.

4. This practice is very common. However, even prints made from "defaced" plates may have value, the famous print by Edgar Degas of Mary Cassatt at the Louvre being one example.

5. According to Thompson (2008: 196), "gallery owners are happy to announce there is a waiting list, but not how many collectors might be on it (or who they are). . . . Some lists arise because of the very limited production of market-savvy artists." When well-placed contemporary galleries serve as "patrons" to early-career artists, they often limit their sales of works to half a dozen a year, thereby creating

waiting lists. Success in such endeavors often hinges critically on legal limita-
tions on contract, strategic behavior between collectors, gallery owners, artists,
and access to the auction market.

6. There might be some exceptions in contemporary art dealings. The dealers of the
high-return contemporary living artists in New York and elsewhere, for example,
will attempt to restrict the number of paintings sold over time to maintain de-
mand and high prices. This and all sorts of manipulations when the contempo-
rary artist's work is sold at auction are an attempt to reassure demanders of the
continuing (and hopefully rising) value of an artist. See Thompson (2008: 189–
99). But ultimately the "supply decisions" of owners and artists and the interplay
between auctions, dealers, and collectors will have an impact on the demand for
works by a living artist.

7. Ursprung and Wiermann (2011) find a death effect for artists. They include repu-
tation in their analysis of a death effect for artists, concluding, using a large data
set and hedonic art price regressions, that there is a "hump-shaped relationship
between age at death and death-induced price changes" (2009: 697). We discuss
their hypothesis in more detail later.

8. They note that "an examination of the art market alone cannot separate the price
effects of the 'durable goods monopolist effect' and the 'nostalgia effect' except by
noting, as Ekelund et al. did, that prices tend to rise quickly following an artist's
death and then fall back over time, a situation that is inconsistent with the durable
goods monopolist effect but is explainable by the nostalgia effect." We will show that
this outcome is perfectly consistent with one possible outcome of the Coase conjec-
ture. Interestingly, our empirical findings are quite consistent with another possible
outcome of the Coase conjecture but are inconsistent with a nostalgia effect.

9. The marketing literature has also used panel data to measure the process of at-
titude formation toward dead celebrities (see Evans et al. 2009). Extremely rare
instances of the possibility of a nostalgia effect for an artist may occur, as (for
example) Sir Winston Churchill's or the pop singer Tony Bennett's artwork may
enhance demand for their art, but this has nothing to do with the cessation of
supply, which is realized on the death of an artist.

10. As Ekelund et al. note (2000: 288) "with perfect knowledge of the exact time of
death, a smooth internalization on demanders of this anticipated 'supply effect'
would take place. The uncertainty of death, however, no matter the age, may
lead to a discontinuous increase in the price of the art—or to a 'death effect.'"

11. An imaginative study proposes yet another possible reason that would create
a rise in artists' prices. Coombes (2013) hypothesizes the possibility of a "theft
effect" whereby a major art theft creates major media exposure, which *may* lead
to higher demand and higher prices for other works by the artist (2013: 12). But,
as with the nostalgia effect, there is no real change in supply due to theft. Total
supply remains the same, whether on black or white markets.

12. According to Ekelund et al. (2000: 295): "If market participants are fully and completely rational, why would a death effect exist at all? Profit opportunities would exist and, assuming efficient markets, a 'death effect' would be eradicated. The durable goods monopoly aspects would be subsumed in these expectations, moreover. We have no good explanation for this possibility save the usual fall-back on 'information costs' among market participants and the obvious difficulty of predicting a 'time of death' for anyone, artists included. . . . It might be argued that any observed 'death effect' is mitigated as artists age beyond some life expectancy and that the effect may be applicable only at younger ages."

13. Other researchers (Coate and Fry 2012) have approached the problem in similar fashion. These researchers conduct a study of Australian artists (all Australian artists listed in Hilsop data) and suggest a death effect or, rather, that it is better to be "near death or long dead" in terms of the price of a painting at auction. Using observations for the period 1995–2003 in a hedonic regression, the authors find a positive relation between prices and life expectancy and years after death for Indigenous and non-Indigenous art. Their data show that "sales of non-Indigenous paintings by recently deceased artists have an increased price. This is consistent with the nostalgia effect described by Matheson and Baade (2004) where the death event drives up prices in the short run—in our case the first year since death—and then prices fall" (2012: 11). This, however, is a misattribution. The death effect studies the impact of death on prices, which may or may not rise or fall afterward. A comparison of "states" before and after death may mean that anticipated or expected price may change, causing a rightward *shift* in the supply curve. In short, the authors' attribution to the nostalgia effect is observationally equivalent to a Coasian conjecture—that is, the actual death effect.

14. For example, in the Ekelund et al. (2000) sample of Mexican artists and in the sample of contemporary American artists that we employ later, only three of the seventeen artists treated in each study died before the age of seventy.

15. They criticize the Ekelund et al. empirical method for using a "questionable variable for representing the death effect 'years after death' squared (i.e., the year of sale minus the year of death of the artist squared to ensure that the variable takes only positive value," attributing the results to a durable-goods monopoly. They go on: "It is not immediately clear however why the death of the artist should result in symmetric response in prices around the time of their death, nor why the effect should be identical for all artists irrespective of whether they die prematurely or survive until old age" (Maddison and Pedersen 2008: 1790). Symmetry is, of course, an assumption that can be tested empirically. Further, Ekelund et al. recognize that their sample contains artists whose average age in the sample is high, not permitting an "age test" on the death effect. They recognize that their results are "unconvincing" by showing that artists who die at

older age appear to exhibit a stronger death effect (only three in the sample died before age seventy).

16. Recall that as death approaches, YAD^2 decreases. This, coupled with a negative y_1, implies a positive price response.

17. That is, the only non-zero component of the death effect is DD.

18. In this view y_3 is the difference between the pre- and post-death year effects on price. As such, a statistically significant y_3 coefficient rejects symmetry of the death effect about the death year.

19. Polynomials in the artist's age at painting creation have been suggested as measures of artistic productivity; see Galenson (2002) or Ekelund, Jackson, and Tollison (2015).

20. The base artist (DA1) is Millard Sheets.

21. The semilog functional form is conventional for hedonic estimation; it has the theoretical advantage that, for this form, the estimated hedonic prices increase with the asset price.

22. Since the sample covers over two-and-a-half decades, we view it as essential to deflate all nominal prices for overall price-level changes. The price index we employ for this deflation is the CPI (1982–1984 = 100).

23. This result supports the earlier findings of Urspung and Wiermann (2011) that death at younger ages results in a drop in price. They explain this result by "unfulfilled reputation."

24. There are exceptions: Olivera's dummy is statistically significant in one of the models, and Resnick's coefficient, while still insignificant, turns positive in one of the models. Otherwise, the previous generalizations uniformly hold.

25. We note that it is possible, since major auctions of contemporary art take place seasonally (generally in spring and late fall), that the YAD effect may be "postponed" until the year following an artist's death. To test the relevance of this possibility, we respecified the year of death (YOD) as YOD+1 and redefined all death-effect variables correspondingly. The preceding results, both numerically and statistically, were substantively unaltered by this change.

26. The results are qualitatively similar for the hammer-price model. The after-death price effect is 0.0012 (= –0.0028 + .004) × YAD^2 with an associated t statistic of 8.48.

27. An alternative explanation is that the reputations of the various artists continue to grow after their deaths. This is entirely possible; there are many famous artists in the sample (e.g., Basquiat, Wyeth, etc.). But this is also consistent with, and arguably a part of, the rising demand explanation noted earlier. Further, the artists listed in Table 7.1 have been established at auction (and in galleries, museums, and collections) for many years. Certainly no major or second-tier auction house (e.g., Sotheby's, Christie's, or Bonhams) is going to accept consistently the work of artists who have not achieved excellent reputations and sales records.

28. We are grateful to art dealer, appraiser, and American art expert Betty Krulik for this observation (telephone interview, July 2014).

29. This model-selection criterion is based on the result that if any specification under consideration is "best" it will have the minimum residual variance—i.e., highest adjusted R^2.

30. The whole issue of "rationality" and the assumption of rational behavior was upended by the now-famous work of Tversky and Kahneman (1982) and by Kahneman (2013). They suggested that rationality does not work in the manner of *homo economicus*. Rather, they argue that individuals anchor around a decision, a price, or a bet, and mentally calculate losses as cognitively more important than gains, other things equal. We have met this idea earlier in this book and mention it here since it could be applied to art markets. Indeed it has been so applied (Beggs and Graddy 2009), and the concept may have important implications in art markets. However, we do not integrate anchoring with our discussion of "bubbles" and discuss this topic using the traditional concept of rationality.

31. Unsurprisingly, the contemporary arts sales were the largest sector of sales (46 percent by value), with modern art second largest at 30 percent, but contemporary art did not avoid a drop *worldwide*.

32. A rare Blue Period painting sold at Sotheby's for $67.5 million, ahead of the high estimate of $60 million in November 2015. It was the most expensive Blue Period painting ever sold at auction at the auction house. Titled *Nightclub Singer* (1901), from when Picasso was a late teenager, the piece is of a nude cabaret dancer.

33. It is critical to note that some contemporary artists do not experience "bubbles"—consider the work of Julie Mehretu (forty-five years old in 2015), Mathhias Weischer (forty-two years old, represented by the Saatchi Gallery in London), or British artist Jenny Saville (forty-four years old), whose stock rose in 1993 when Saatchi purchased all of her works from an exhibit. Many contemporary artists do extremely well monetarily and will stand the test of time.

34. The Austrian view is that the interest rate should be focused upon and left to the forces of the real supply and demand for money. This is a key variable that controls investment and growth in the economy (see Thornton 2014: 104–107 for an excellent discussion of these matters).

35. Further, we identify some post-1950-born artists' recent price experience later in our discussion.

36. For example, one of the eighteen paintings in our sample sold in 1989 is an $11 million Jackson Pollock. Thus the sample average gives a much-distorted picture of representative art prices for that year.

37. We could as easily have used hammer prices for this analysis. The same results would have resulted. Clearly hammer prices track premium prices almost exactly, the difference getting only slightly larger toward the end of our sample period due to increases in buyer's premiums.

38. Further evidence on the soaring nature of Contemporary art, much of it American art, is revealed by the enormous success of sales at international art fairs, with many of the participating American galleries specializing in that art. The sparkling success of sales at Art Basel (in June 2015) and London's Frieze Art Fair (in October 2015) attest to the explosive nature of interest in Contemporary art and younger artists (see Reyburn 2015; Kazakina 2015). Downturns in the stock market or lagging GDP growth have left multimillionaires and billionaires unfazed in purchasing artists in mid- or even early careers.

39. Cassandra-like admonitions that the 2011–2015 "bubble" has peaked or burst were stimulated by the year-to-year comparisons of art auction revenues. A comparison of auction revenues at Christie's and Sotheby's for the spring auctions of modern and contemporary art revealed a 45 percent decline in 2016 over 2015. That, however, was for global sales. Sales in the New York market showed no such decline. Additionally, the cause is uncertain—some observe (Robertson 2016) that reductions could be linked to the effects of guarantees by the houses on profit margins. At the very top ($1 million and up) the decline was mitigated as noted in the text. If a bubble is going to burst, we would argue that it will not be at the highest realms of the market.

40. We must indicate immediately that there are many issues concerning the economics of art museums that we do not discuss here. Among them are: Do public and private (profit or nonprofit) museums face similar problems? What would economics have to contribute to expressing the goal of museums? Should regulations affecting museums (such as those imposed by the American Association of Museums) be relaxed to better achieve economic goals of matching the supply of as much art as possible to demanders to see that art? Interesting answers are provided in many venues (see O'Hare 2015 or Ritenour 2011, for example). Our discussion in this section is limited to the problem of how "bubble prices" might affect all museums, eschewing these other basic and important issues.

41. Some, but certainly not all, private collectors create their own "museums." Denying support to existing institutions, these collectors develop "vanity museums" and direct finances and their friend's subventions to cover the cost.

42. The fact that these artists are still traded at auction is some indication of having achieved some longevity. Naturally other artists may no longer trade.

CHAPTER 8

1. There is also an intersection between aesthetic and commercial value, which we will discuss later in this chapter.

2. Returns such as these (even greater for particular artists and pictures) appear high enough to entice art investment as yielding a real return exceeding investments in stock and other investment funds.

3. It is useful to always remember that return calculations are specific to the sample period chosen and the composition of the sample as well.

4. Previous publications by the authors have dealt with investment, auction estimates and productivity for early American artists and for the so-called Ashcan school of the early twentieth century. They have been integrated into the discussion.

5. Reportage is often expensive or lackluster as well. The difficulties of getting on a stolen art registry are many, except for very high-value items. Museums, for example, often want to keep quiet about theft, fearing that announcements will reveal gaps in their security systems.

6. Artists naturally realize that fortunes and success can sometimes take a reversal. The contemporary artist Kenny Scharf reached total auction sales of more than $1 million in 2006, falling (in part due to the recession of 2008) to $100,000 in 2012, but rising to $252,029 in 2014.

APPENDIX

1. The phrase "linear in parameters" just means that, while the variables in the model can legitimately be subjected to non-linear transformations [e.g., $X_3 = X_2^2$ or $y = \log(y)$], the parameters cannot be (i.e., expressions like β_3^2 or e^{β_5} are not permitted if the relation is linear in parameters).

2. It is conventional to take the variable X_1 as an intercept, or constant term, i.e., a variable all of whose observations take on the value of 1.

3. As many authors have pointed out, there is nothing ordinary about ordinary least squares. The appellation is used simply to distinguish this method from other least squares techniques, such as generalized least squares (GLS) or non-linear least squares (NLS).

4. These assumptions constitute the standard linear model of least squares theory. In brief, they are that we have specified the true model and that it is linear in parameters; and that the theoretical disturbances [the ε_i of (2A.1)] are independently and identically distributed with mean 0 and constant variance σ^2.

5. α is called the "level of significance" of the test, and $(1-\alpha)$ is called the "level of confidence." Intuitively, α is the probability that we are willing to risk if being wrong if we reject H_0. Clearly, we would like this probability to be small, which leads to traditional levels of significance of $\alpha = 0.10$, $\alpha = 0.05$, and $\alpha = 0.01$.

6. Other F tests may be relevant for other joint hypotheses and may be reported in lieu of the F test discussed in the following. For example, some of the F tests presented in Chapter 4 relate to H_0: $\theta = 0$ and $\lambda = 1$, and the Fs presented in Tables 3A.1 and 3A.2 refer to the tests of the null hypotheses that all of the AGE coefficients are jointly zero. Our point in the subsequent discussion is that, in the absence of such topic-specific concerns, it is conventional to report the F statistic for testing the overall significance of the regression.

7. An alternative interpretation may be more intuitive. If we define the fitted value of y_i as $\hat{y}_i\ (= \sum_j b_j X_{ji})$, then R^2 is the square of the correlation between y and \hat{y}; a perfect fit implies that $y_i = \hat{y}_i$ for all i, which in turn implies $R^2 = 1$.

8. If we use Sotheby's 2014 rate structure as a numerical example, a buyer would pay 25 percent (R_1) for hammer prices < \$100,000; 20 percent for hammer prices between \$100,000 and \$2,000,000; and 12 percent of hammer price over \$2,000,000. Thus for a painting whose hammer price is \$2.6M, the total buyer's premium would be BPP = [.25*100,000] + [.2*(2,000,000 − 100,000)] + [.12* (2,600,000 − 2,000,000)] = (\$25,000) + (\$380,000) + \$72,000) = \$477,000.

References

Abra, J. (1989). "Changes in Creativity with Age: Data, Explanations, and Further Predictions." *International Journal of Aging and Human Development* 28: 105–126.

Accominotti, Fabien. (2009). "Creativity from Interaction: Artistic Movements and the Creativity Careers of Modern Painters." *Poetics* 37: 267–294.

Agnello, Richard J. (2002). "Investment Returns and Risk for Art: Evidence from Auctions of American Paintings." *Eastern Economic Journal* 28: 443–463.

Agnello, Richard J., and Renee K. Pierce. (1996). "Financial Returns, Price Determinants, and Genre Effects in American Art Investment." *Journal of Cultural Economics* 20: 359–383.

Akerlof, George A. (1970). "The Market for 'Lemons': Quality Uncertainty and the Market Mechanism." *Quarterly Journal of Economics* 84: 488–500.

Amore, Anthony M. (2015). *The Art of the Con: The Most Notorious Fakes, Frauds, and Forgeries in the Art World.* New York: Palgrave Macmillan.

Anderson, Seth, Robert B. Ekelund, John D. Jackson, and Robert D. Tollison. (2015). "Are Auction Revenues Affected by Rising Art Buyers' Premia? The Case of Early American Art." *Applied Economics* 47: 1389–400.

Anderson, Seth, Robert B. Ekelund, John D. Jackson, and Robert D. Tollison. (2016). "Investment in Early American Art: The Impact of Transactions Costs and No-Sales on Returns." *Journal of Cultural Economics* 40: 335–357.

Ashenfelter, O. (1989). "How Auctions Work for Wine and Art." *Journal of Economic Perspectives* 3: 23–36.

Ashenfelter, O. (2005). "Anatomy of the Rise and Fall of a Price-Fixing Conspiracy: Auctions at Sotheby's and Christie's." *Journal of Competition Law and Economics* 1(1): 3–20.

Ashenfelter, O. (2011). "Sale Rates and Price Movements in Art Auctions." *American Economic Review: Papers and Proceedings* 101: 212–216.

Ashenfelter, O., and Katherine Graddy. (2003). "Auctions and the Price of Art." *Journal of Economic Literature* 41: 763–787.

Baigell, Matthew. (1996). *A Concise History of American Painting and Sculpture.* Boulder, CO: Icon Editions, Westview Press.

Bamberger, Alan. (2014). "Hey Kids—It's Bubble Time!" *Art Business,* http://www.artbusiness.com/orwxb.html.

Baumol, William J. (1986). "Unnatural Value: Or Art Investment as Floating Crap Game." *American Economic Review,* Papers and Proceedings 76: 10–14.

Baumol, William J., and William Bowen. (1966). *Performing Arts, The Economic Dilemma: A Study of Problems Common to Theater, Opera, Music, and Dance.* New York: Twentieth Century Fund.

Becker, Gary. (1968). "Crime and Punishment: An Economic Approach." *Journal of Political Economy* 76: 169–217.

Becker, Gary. (1976). *The Economic Approach to Human Behavior.* Chicago: University of Chicago Press.

Becker, Gary, and G. J. Stigler. (1974). "Law Enforcement, Malfeasance, and Compensation of Enforcers." *Journal of Legal Studies* 3: 1–18.

Beckert, J., and J. Rossel. (2004). "Reputation as a Mechanism for Reducing Uncertainty in the Art Market" (in German). *Kölner Zeitschrift für Soziologie and Sozialpsychologie* 56: 32–50.

Beggs, Alan, and Kathryn Graddy. (1997). "Declining Values and the Afternoon Effect: Evidence from Art Auctions." *The Rand Journal of Economics* 28: 544–65.

Beggs, Alan, and Kathryn Graddy. (2008). "Failure to Meet the Reserve Price: The Impact on Returns to Art." *Journal of Cultural Economics* 32: 301–20.

Beggs, Alan, and Kathryn Graddy. (2009). "Anchoring Effects: Evidence from Art Auctions." *American Economic Review* 99(3): 1027–1039.

Bell, Suzanne. (2009). *Fakes and Forgeries.* New York: Facts on File.

Bocart, Fabian, and Kim Oosterlinck. (2011). "Discoveries of Fakes: Their Impact on the Art Market." *Economics Letters* 113: 124–125.

Bowley, Graham. (2014). "The (Auction) House Doesn't Always Win: Christie's and Sotheby's Woo Big Sellers with a Cut." *New York Times* (January 16), http://www.nytimes.com/2014/01/16/arts/design (accessed February 24, 2014).

Burns, Charlotte. (2014). "Small Decision, Big Impact." *The Art Newspaper* (April). http://old.theartnewspaper.com/articles/Small-decision-big-impact/32163.

Campos, Nauro F., and Renata Leite Barbosa. (2009). "Paintings and Numbers: An Econometric Investigation of Sales Rates, Prices and Returns in Latin American Art Auctions." *Oxford Economic Papers* 61: 28–51.

Case, Karl E., and Robert J. Shiller. (1987). "Pricing of Single Family Homes since 1970: New Indexes for Four Cities." *New England Economic Review* (September–October): 45–56.

Caves, Richard. (2003). *Creative Industries.* Cambridge, MA: Harvard University Press.

Charney, Noah (ed.). (2009). *Art and Crime: Exploring the Dark Side of the Art World.* Santa Barbara, CA: Praeger.

Charney, Noah. (2011). *The Thefts of the Mona Lisa: On Stealing the World's Most Famous Painting*. New York: ARCA.

Charney, Noah. (2015). *The Art of Forgery*. New York: Phaidon.

Christie's. (2012). *Important American Paintings, Drawings & Sculpture*. May 16. New York.

Coase, Ronald. (1972). "Durability and Monopoly." *Journal of Law and Economics* 15: 143–149.

Coate, Bronwyn, and Tim R. L. Fry. (2012). "Better Off Dead? Prices Realised for Australian Paintings Sold at Auction." ACEI Working Paper Series (AWP-02–2012) (February).

Cohen, Patricia. (2011). "Possible Forging of Modern Art is Investigated." *New York Times* (December 2). http://www.nytimes.com/2011/12/03/arts/design/federal-inquiry-into-possible-forging-of-modernist-art.html.

Cohen, Patricia. (2014). "Selling a Fake Painting Takes More Than a Good Artist." *New York Times* (May 2). http://www.nytimes.com/2014/05/03/arts/design/selling-a-fake-painting-takes-more-than-a-good-artist.html?.

Collins, Alan, Antonello Scorcu, and Robert Zanola. (2009). "Reconsidering Hedonic Art Price Indexes." *Economics Letters* 104: 57–60.

Conklin, John E. (1994). *Art Crime*. Westport, CT: Praeger.

Coombes, Jarrett. (2013). *The Economic Impact of Art Theft: A Quantitative Study of the Economic Effects of Art Theft on Art Prices and Returns*. Master's thesis. Rotterdam, The Netherlands: Erasmus University.

Cowen, Tyler. (1998). In *Praise of Commercial Culture*. Cambridge, MA: Harvard University Press.

Cowen, Tyler. (2015). "How Auction Houses Orchestrate Sales for Maximum Drama." *Marginal Revolution* (November 2). http://marginalrevolution.com/marginalrevolution/2015/11/buyer-psychology-in-the-art-world.html.

Crane, Diana. (1987). *The Transformation of the Avant-Garde*. Chicago: University of Chicago Press.

Crossick, Geoffrey, and Patrycja Kaszynska. (2016). *Understanding the Value of Arts and Culture: The AHRC Cultural Value Project*. Arts and Humanities Research Council. Polaris House, North Star Avenue, Swindon, Wiltshire, United Kingdom. www.ahrc.ac.uk.

Crow, Kelly. (2013). "A Geometry Guru Stays True to Form." *Wall Street Journal* (April 13–14): C20.

Currier, W. (1991). *Currier's Price Guide to American Artists (1645–1945) at Auction*. Brockton, MA: Currier Publications.

Czujack, Corinna. (1997). "Picasso Paintings at Auction, 1963–1994." *Journal of Cultural Economics* 21: 229–247.

Darby, M. R., and E. Karni. (1973). "Free Competition and the Optimal Amount of Fraud." *Journal of Law and Economics* 16: 66–88.

De Marchi, Neil. (2006). "The History of Art Markets." In V. A. Ginsburgh and D. Throsby (eds.), *Handbook of the Economics of Art and Culture*. Elsevier: North Holland: 69–122.

De Marchi, Neil, and Craufurd D. W. Goodwin. (eds.). (1999). *Economic Engagements with Art*. Durham, NC: Duke University Press.

De Marchi, Neil. and Hans J. Van Miegroet. (1994). "Art, Value, and Market Practices in the Seventeenth Century Netherlands." *Art Bulletin* 75: 451–464.

Deresiewicz, William. (2015). "The Death of the Artist—and the Birth of the Creative Entrepreneur." *The Atlantic* (January/February). https://www.theatlantic.com/magazine/archive/2015/01/the-death-of-the-artist-and-the-birth-of-the-creative-entrepreneur/383497/.

De Silva, Dakshina G., Rachel A. J. Pownall, and Leonard Wolk. (2012). "Does the Sun 'Shine' on Art Prices?" *Journal of Economic Behavior & Organization* 82: 167–178.

De Zayas. (1996). *How, When, and Why Modern Art Came to New York*, Francis M. Naumann (ed.). Cambridge, MA: MIT Press.

Dimson, Elroy, and Christophe Spaenjers. (2011). "Ex Post: The Investment Performance of Collectible Stamps." *Journal of Financial Economics* 100: 443–458.

Dobovšek, Bojan. (2009). "Art, Terrorism, and Organized Crime." In Noah Charney (ed.), *Art and Crime: Exploring the Dark Side of the Art World*. Santa Barbara, CA: Praeger: 64–71.

Dobrzynski, Judith H. (2015). "How Auction Houses Orchestrate Sales for Maximum Drama." *New York Times* (October 28). http://marginalrevolution.com/marginalrevolution/2015/11/buyer-psychology-in-the-art-world.html.

D'Souza, Clare, and David Prentice. (2002). "Auctioneer Strategy and Pricing: Evidence from an Art Auction." *Marketing Intelligence & Planning* 20: 417–427.

Duray, Dan. (2013). "Meet Art Recovery International, the New Competitor to the Art Loss Register." *New York Observer* (November 7). http://observer.com/2013/10/meet-art-recovery-international-the-new-competitor-to-the-art-loss-register/.

Duray, Dan, and Andrew Russeth. (2013). "Glafira Rosales Pleads Guilty in Knoedler Forgery Case." *New York Observer* (September 16). http://observer.com/2013/09/glafira-rosales-pleads-guilty-in-knoedler-forgery-case/.

Edsel, Robert M., and Bret Witter. (2009). *The Monuments Men: Allied Heroes, Nazi Thieves, and the Greatest Treasure Hunt in History*. New York: Center Street.

Ehrlich, I. (1973). "Participation in Illegitimate Activities: A Theoretical and Empirical Investigation." *Journal of Political Economy* 81: 521–565.

Ekelund, R. B., Jr. (2002). "Review of *Painting Outside the Lines*, David W. Galenson (Cambridge: Harvard University Press, 2001)." *Journal of Cultural Economics* 26 (4): 325–327.

Ekelund, R. B., Jr. (2006). "Review of David Galenson's *Old Masters and Young Geniuses: The Two Life Cycles of Artistic Creativity*." Princeton, NJ: Princeton University Press, 2006. *EH.net*.

Ekelund, R. B., Jr., and R. F. Hebert. (2014). *A History of Economic Theory and Method.* 6th. ed. Longrove, IL: Waveland Press.

Ekelund, R. B., Jr., Robert F. Hebert, and Robert D. Tollison. (2006). *The Marketplace of Christianity.* Cambridge, MA: MIT Press.

Ekelund, R. B., Jr., John D. Jackson, and Robert D. Tollison. (2013). "Are Art Auction Estimates Biased?" *Southern Economic* Journal 80: 454–65.

Ekelund, R. B., Jr., John D. Jackson, and Robert D. Tollison. (2015). "Age and Productivity: An Empirical Study of Early American Artists." *Southern Economic Journal* 81: 1096–1116.

Ekelund, R. B., Jr., and Edward O. Price III. (2012). *The Economics of Edwin Chadwick: Incentives Matter.* Cheltenham, UK: Edward Elgar.

Ekelund, R. B., Jr., Rand Ressler, and John Keith Watson. (1998). "Estimates, Bias and 'No Sales' in Latin-American Art Auctions." *Journal of Cultural Economics* 22: 33–42.

Ekelund, R. B., Jr., Rand Ressler, and John Keith Watson. (2000). "The 'Death Effect' in Art Prices: A Demand-Side Exploration." *The Journal of Cultural Economics* 24: 283–300.

Evans, Robert D., Phillip M Hart, John E. Cicala, and Dan L. Sherrell. (2009). "Elvis: Dead and Loving It—The Influence of Attraction, Nostalgia, and Risk in Dead Celebrity Attitude Formation." *Journal of Management and Marketing Research* 3: 1–13.

Fahlman, Betsy. (2010). *Kraushaar Galleries: Celebrating 125 Years.* New York: Kraushaar Galleries.

Farrell, Lisa, and Tim R L. Fry. (2013). "Pre-sale Information and Auction Prices for Australian Indigenous Artworks." Working Paper, RMIT University, Melbourne, Victoria.

Fedderke, Johannes W., and Kaini Li. (2014). "Art in Africa: Market Structure and Pricing Behavior in the South African Fine Art Auction Market, 2009–2013." (September) ERSA (Economic Research Southern Africa), working paper 466.

Feldstein, Martin (ed.). (1991). *The Economics of Art Museums.* Chicago: University of Chicago Press.

Finley, Michael. (2004). "The Catalogue Raisonne." In Ronald D. Spencer (ed.), *The Expert versus the Object: Judging Fakes and False Attributions in the Visual Arts.* New York: Oxford University Press: 55–62.

Forbes, Alexander. (2014a). "Jeff Koons Sued for Plagiarism." *Artnet News* (December 18), https://news.artnet.com/exhibitions/jeff-koons-sued-for-plagiarism-201510 (accessed October 25, 2015).

Forbes, Alexander. (2014b). "Second Plagiarism Claim against Jeff Koons in Two Weeks." *Artnet News* (December 29), https://news.artnet.com/exhibitions/second-plagiarism-claim-against-jeff-koons-in-two-weeks-208930 (accessed October 25, 2015).

Frank, Robert H. (1985). *Choosing the Right Pond.* New York: Oxford University Press.

French, Douglas. (2009). *Early Speculative Bubbles.* Auburn, AL: Ludwig von Mises Institute.

Freundlich, August L., and John A. Shively. (2006). "Creativity and the Exceptional Aging Artist." *Clinical Interventions in Aging* l: 197–200.

Frey, Bruno S. (1997a). "Art Markets and Economics: Introduction." *Journal of Cultural Economics* 21: 165–173.

Frey, Bruno S. (1997b). "Evaluating Cultural Property: The Economic Approach." *International Journal of Cultural Property* 6(2): 231–246.

Frey, Bruno S. (1999). "Art Fakes—What Fakes? An Economic View." Institute for Empirical Research in Economics, University of Zurich. Working Paper Series No. 14. ISSN 1424-0459 (July).

Frey, Bruno S. (2008a). "What Values Should Count in the Arts? The Tension between Economic Effects and Cultural Value." In Michael Hutter and David Throsby (eds.), *Beyond Price: Value in Culture, Economics and the Arts.* New York: Cambridge University Press: 261–269.

Frey, Bruno S. (2008b). *Happiness: A Revolution in Economics.* Cambridge, MA: MIT Press.

Frey, Bruno S., and Reto Cueni. (2013). "Why Invest in Art?" *The Economists' Voice* 10(1): 1–6. *Cultural Economics* 6: 231–246.

Frey, Bruno S., and Werner W. Pommerehne. (1989). *Muses and Markets: Explorations in the Economics of the Arts.* Oxford: Basil Blackwell.

Froidefond, Antoine. (2014). "Record-Breaking Year for Contemporary Art." *Yahoo News* (September 23), http://news.yahoo.com/record-breaking-contemporary-art-103321463.html.

Galbraith, John W., and Douglas J. Hodgson. (2014). "Aesthetic-School Effects in Artists' Age-Valuation Profiles: Evidence from Eighteenth-Century Rococo and Neoclassical Painters." *Centre Interuniversitaire de recherche en analyse des organisations (CIRANO).*

Galenson, David W. (2001). *Painting outside the Lines: Patterns of Creativity in Modern Art.* Cambridge, MA: Harvard University Press.

Galenson, David W. (2002). "Was Jackson Pollock the Greatest Modern American Painter? A Quantitative Investigation." *Historical Methods* 35: 117–128.

Galenson, David W. (2004). "The Life Cycles of Modern Artists: Theory and Implications." *Historical Methods* 37: 123–136.

Galenson, David W. (2005a). "The Reappearing Masterpiece: Ranking American Artists and Art Works of the Late Twentieth Century." *Historical Methods* 38(Fall): 178–188.

Galenson, David W. (2005b). "The Methods and Careers of Leading American Painters in the Late Nineteenth Century." *NBER Working Paper* 11545.

Galenson, David W. (2005c). "Before Abstract Expressionism: Ranking American Painters of the Early Twentieth Century." Unpublished paper, University of Chicago.

Galenson, David W. (2006a). *Old Masters and Young Geniuses: The Two Life Cycles of Artistic Creativity*. Princeton, NJ: Princeton University Press.

Galenson, David W. (2006b). *Artistic Capital*. Abington, UK: Routledge.

Galenson, David W. (2009). *Conceptual Revolutions in Twentieth-Century Art*. Cambridge: Cambridge University Press.

Galenson, David W., and Bruce A. Weinberg. (2000). "Age and the Quality of Work: The Case of Modern American Painters." *Journal of Political Economy* 108(41): 761–777.

Galenson, David W., and Bruce A. Weinberg. (2001). "Creating Modern Art: The Changing Careers of Painters in France from Impressionism to Cubism." *American Economic Review* 91: 1063–1071.

Galton, F. (1874). *English Men of Science: Their Nature and Nurture*. London: Macmillan.

Garber, Peter M. (1989). "Tulipmania." *Journal of Political Economy* 97: 535–560.

Gerlis, Melanie, and Javier Pes. (2013). "Recovery Rate for Stolen Art as Low as 1.5%. *The Art Newspaper* (December). http://recoveryvans.blogspot.com/2013/11/the-art-newspaper-quotes-arca-noah.html#.WLg8uTEiyUk

Ginsburgh, Victor. (2013). *Handbook of the Economics of Art and Culture*, Vol. 2. Elsevier: North Holland.

Ginsburgh, Victor, and Pierre-Michel Menger. (1996). *Economics of the Arts: Selected Essays*. Amsterdam: Elsevier.

Ginsburgh, Victor, and David Throsby. (2006). *Handbook of the Economics of Art and Culture*, Vol. 1. Amsterdam: Elsevier/North Holland.

Ginsburgh, Victor, and Sheila Weyers. (2006). "Creativity and Life Cycles of Artists." *Journal of Cultural Economics* 30: 91–107.

Glackens, Ira. (1957). *William Glackens and The Eight: The Artists Who Freed American Art*. New York: Horizon Press.

Gladwell, Malcom. (2008). *Outliers: The Story of Success*. New York: Little Brown.

Goddard, Donald. (1990). *American Painting*. New York. Beaux Arts Editions.

Goetzmann, W. (1993). "Accounting for Taste: Art and the Financial Markets over Three Centuries." *American Economic Review* 83: 1370–1376.

Goldstein, Malcolm. (2000). *Landscape with Figures: A History of Art Dealing in the United States*. Oxford: Oxford University Press.

Graddy, Kathryn. (2015). "Death, Bereavement, and Creativity." Unpublished Manuscript, Brandeis University.

Graddy, Kathryn, and Jonathan Hamilton. (2014). "Auction House Guarantees for Works of Art." Manuscript, Department of Economics, Brandeis University.

Graddy, Kathryn, Jon Hamilton, and Rachel Campbell. (2012). "Repeat Sales Indexes: Estimation without Assuming That Errors in Asset Returns Are Independently Distributed." *Real Estate Economics* 40(Spring): 31–166.

Graddy, Kathryn, and Philip Margolis. (2011). "Fiddling with Value: Violins as an Investment?" *Economic Inquiry* 49(4): 1083–1097.

Grampp, William D. (1989). *Pricing the Priceless: Art, Artists and Economics.* New York: Basic Books.

Guilbaut, Serge. (1985). *How New York Stole the Idea of Modern Art.* Chicago: University of Chicago Press.

Guilbaut, Serge. (1992). *Reconstructing Modernism: Art in New York, Paris and Montreal 1945–1964.* Cambridge, MA: MIT Press.

Hall, D. M. (2001). *Purchasing Power: The New York Market for Modern American Painting 1913–1940.* Ph.D. dissertation, University of Northumbria at Newcastle.

Harper, Dennis. (2012). "Advancing American Art: Leroy Davidson's 'Blind Date with Destiny." In *Art Interrupted: Advancing American Art and the Politics of Cultural Diplomacy.* Athens: Georgia Museum of Art: 8–29.

Haskell, Barbara. (1987). *Charles Demuth.* New York: Whitney Museum of American Art and Harry N. Abrams.

Hèbert, Robert F. (1977). "Edwin Chadwick and the Economics of Crime." *Economic Inquiry* 15: 539–550.

Heckman, James. (1979). "Sample Selection Bias as a Specification Error." *Econometrica* 47: 153–161.

Heilbrun, James, and Charles M. Gray. (2001). *The Economics of Art and Culture,* 2nd ed. Cambridge: Cambridge University Press.

Hellmanzik, Christiane. (2009). "Artistic Styles: Revisiting the Analysis of Modern Artists' Careers." *Journal of Cultural Economics* 33(3): 201–232.

Hellmanzik, Christiane. (2010). "Location Matters: Estimating Cluster Premiums for Prominent Modern Artists." *European Economic Review* 54: 199–218.

Hislop, R. (ed.). (1971–1992). *The Annual Art Sales Index.* Surrey: Art Sales Index.

Hodges, William Zachary. (2011/2012). "The Value of Estimating the Price of Art: A Lesson for Auction Houses." Honors Capstone (AV).

Hodgson, Douglas J. (2011). "Age-Price Profiles for Canadian Painters at Auction." *Journal of Cultural Economics* 35: 287–308.

Homer, William Innes. (1988). *Robert Henri and His Circle.* New York: Hacker Art Books.

Hope, Bradley. (2006). "Art Forgeries Are on the Rise, Testing Dealers, Detectives." *The Sun* (August 25). http://www.nysun.com/new-york/art-forgeries-are-on-the-rise-testing-dealers/38599/.

Horowitz, Noah. (2011). *Art of the Deal: Contemporary Art in a Global Financial Market.* Princeton, NJ: Princeton University Press.

Hoving, Thomas. (1996). *False Impressions: The Hunt for Big-Time Art Fakes.* New York: Simon and Schuster.

Hughes, Robert. (1997). *American Visions: The Epic History of Art in America.* New York: Alfred A. Knopf.

Hutter, Michael. (2010). "Review of David Galenson, *Conceptual Revolutions in Twentieth-Century Art*" (Cambridge: Cambridge University Press, 2009)." *Journal of Cultural Economics* 45: 155–158.

Hutter, Michael, and Bruno Frey. (2010). "On the Influence of Cultural Value on Economics Value." *Revue d'economie politique* 120: 35–46.

Hutter, Michael, and David Throsby. (2008). *Beyond Price*. Cambridge: Cambridge University Press.

International Foundation for Art Research. "Authentication Research Service." "Catalogues Raisonnes, USA," et al. https://www.ifar.org/about.php.

Itaya, Jun-ichi, and Heinrich W. Ursprung. (2007). *Price and Death*. CESifo Working Paper Series 2213, CESifo Munich.

Johnson, Paul. (2003). *Art: A New History*. New York: HarperCollins.

Jones, Benjamin F. (2010). "Age and Great Invention." *The Review of Economics and Statistics* 92: 1–14.

Kahneman, Daniel. (2013). *Thinking Fast and Slow*. New York: Farrar, Straus and Giroux.

Kallir, Jane. (2013). "Perils of Authentication." Reprinted in *ArtBanc, Market Intelligence* (Jeremy Eckstein and Lindsay Dewar), September 2013.

Kazakina, Katya. (2015). "Sotheby's Sells $1.1 Billion of Art as Shares Sink on Guarantees." *Bloomberg Business* (November 12), http://www.bloomberg.com/news/articles/2015-11-12/sotheby-s-sells-1-1-billion-of-art-as-shares-sink-on-guarantees.

Keats, Jonathon. (2013). *Forged: Why Fakes Are the Great Art of Our Age*. New York: Oxford University Press.

Kennedy, Elizabeth. (2009). *The Eight and American Modernisms*. Chicago: University of Chicago Press.

Kinsella, Eillen. (2016). "What Does TEFAF 2016 Art Market Report Tell Us about the Global Art Trade." *Artnet* (March 9) https://news.artnet.com/market/tefaf-2016-art-market-report-443615.

Knelman, Joshua. (2011). *Hot Art*: Portland, OR: Tin House Books.

Konigsberg, Eric. (2008). "Two Years Later, the F.B.I. Still Seeks the Owners of a Trove of Artworks." *New York Times* (August 8). http://www.nytimes.com/2008/08/12/nyregion/12kingsland.html.

Kraus, Peter. (2004). "The Role of the Catalogue Raisonné in the Art Market." In Ronald D. Spencer (ed.)., *The Expert versus the Object: Judging Fakes and False Attributions in the Visual Arts*. New York: Oxford University Press: 63–72.

Lehman, Harvey. (1953). *Age and Achievement*. Princeton, NJ: Princeton University Press.

Lehrer, Jonah. (2012). *Imagine: How Creativity Works*. Edinburgh: Canongate.

Lindauer, Martin S. (1992). "Creativity in Aging Artists: Contributions from the Humanities to the Psychology of Old Age." *Creativity Research Journal* 5: 211–231.

Lindauer, Martin S. (1998). "Interdisciplinarity, the Psychology of Art, and Creativity: An Introduction." In Martin S. Lindauer (ed.), Interdisciplinarity, the Psychology of Art, and Creativity, *Creativity Research Journal* 11: 1–10.

Lindauer, Martin S. (2003). *Aging, Creativity, and Art: A Positive Perspective on Late-Life Development*. New York: Kluwer Academic.

Los Angeles Police Department. (2002). *Art Theft Case Files: Hidden Treasure*, 2000 ed. http://www.lapdonline.org/newsroom/content_basic_view/27408/ (accessed September 15, 2014).

Louargand, M. A., and J. R. McDaniel. (1991). "Price Efficiency in the Art Market." *Journal of Cultural Economics* 15: 53–65.

Luck, Adam. (2016). "'Moriarty of the Old Master' Pulls Off the Art Crime of the Century: Market in Crisis as Experts Warn £200m of Paintings Could Be Fakes." *The Mail* (October 1), http://www.dailymail.co.uk/news/article-3817580/Moriarty-Old-Master-pulls-art-crime-century-Market-crisis-experts-warn-200m-paintings-fakes.html (accessed November 9, 2016).

Lynes, Barbara Buhle. (1999). *Georgia O'Keeffe, Catalogue Raisonné*, 2 Vols. New Haven, CT: Yale University Press.

Maddison, David, and Anders Jul Pedersen. (2008). "The Death Effect in Art Prices: Evidence from Denmark." *Applied Economics* 40: 1789–1793.

Mandel, Benjamin R. (2009). "Art as an Investment and Conspicuous Consumption Good." *American Economic Review* 99: 1653–1663.

Maneker, Marion. (2015). "Artprice's Top 50 Contemporary Artists." *Art Market Monitor* (October 8), http://www.artmarketmonitor.com/2015/10/08/artprices-top-50-contemporary-artists-2/.

Mason, Christopher. (2004). *The Art of the Steal: Inside the Sotheby's-Christie's Auction House Scandal.* New York: Berkley Books.

Matheson, Victor A., and Robert A. Baade. (2004). "'Death Effect' on Collectible Prices." *Applied Economics* 36: 1151–55.

McAndrew, Clare, Rex Thompson, and James L. Smith. (2012). "The Impact of Reservation Prices on the Perceived Bias of Expert Appraisals of Fine Art." *Journal of Applied Econometrics* 27: 235–252.

McFarland-Taylor, Sarah. (1998). "Tracking Stolen Artworks on the Internet: A New Standard for Due Diligence." John Marshall Journal of Computer & Information. *Computer & Information Law* 16: 937–969.

Mei, Jianping, and Michael Moses. (2002). "Art as an Investment and the Underperformance of Masterpieces." *American Economic Review* 92: 1656–68.

Mei, Jianping, and Michael Moses. (2005). "Vested Interest and Biased Price Estimates: Evidence from an Auction Market." *The Journal of Finance* 60: 2409–2435. http://www3.interscience.wiley.com.spot.lib.auburn.edu/cgi-bin/fulltext/118686414.

Messinger, Lisa Mintz. (2001). *Georgia O'Keeffe.* London: Thames & Hudson.

Messinger, Lisa Mintz (ed.). (2011). *Stieglitz and His Artists: Matisse to O'Keeffe: The Alfred Stieglitz Collection in the Metropolitan Museum of Art.* New Haven, CT: Yale University Press.

Milgrom, Paul, and Robert Weber. (1982). "A Theory of Auctions and Competitive Bidding." *Econometrica* 50: 1089–1122.

Milroy, Elizabeth. (1991). *Painters of a New Century: The Eight and American Art.* Milwaukee: Milwaukee Art Museum.

Mokyr, Joel. (1992). *The Level of Riches: Technological Creativity and Economic Progress.* New York: Oxford University Press.

Mooney, Kempton. (2002). *The Chiaroscuro Market: Art Theft and the Art World.* New York: FKM Books (2nd ed.; originally published by Stony Brook University).

Morrow, Bradford. (2014). *The Forgers.* New York: The Mysterious Press.

Moureau, Nathalie, and Dominique Sagot-Duvauroux. (2012). "Four Business Models in Contemporary Art." *International Journal of Arts Management* 14: 44–54.

Naifeh, Steven, and Gregory White Smith. (1989). *Jackson Pollock: An American Saga.* Aiken, SC: Woodward/White.

Nelson, Dafydd. (2009). "Economic Woe, Art Theft, and Money Laundering: A Perfect Recipe." In Noah Charney, *Art and Crime: Exploring the Dark Side of the Art World.* Santa Barbara, CA: Praeger: 197–204.

Nelson, P. (1970). "Information and Consumer Behavior." *Journal of Political Economy* 78: 311–329.

Nelson, P. (1974). "Advertising as Information." *Journal of Political Economy* 81: 729–754.

Neuendorf, Henri. (2015). " Can DNA Verification End Art Forgery Forever?" *Artnet News* (October 12). https://news.artnet.com/art-world/dna-verification-art-forgery-339319.

Ngowi, Rodrique, and William J. Kole. (2015). "With Boston Heist Suspects Dead, FBI Focuses on Finding Art." *Seacoastline.com* (August 7), http://www.seacoas-tonline.com/article/20150807/NEWS/150809323.

O'Hare, Michael. (2015). "Museums Can Change—Will They?: *Democracy Journal* (Spring) 36, http://democracy journal.org/magazine/36/museums-can-changewill-they/ (accessed August 9, 2016).

Peacock, Alan. (1969). "Welfare Economics and Public Subsidies to the Arts." *Manchester School* 17: 323–335.

Perenyi, Ken. (2012). *Caveat Emptor: The Secret Life of an American Art Forger.* New York: Pegasus Books.

Perlman, Bernard B. (1979). *Painters of the Ashcan School: The Immortal Eight.* New York: Dover Publications.

Pesando, J. E. (1993). "Art as an Investment: The Market for Modern Prints." *American Economic Review* 83: 1075–1089.

Pesando, J. E., and P. M. Shum. (1999). "The Return to Picasso's Prints and to Traditional Financial Assets, 1977–1996." *Journal of Cultural Economics* 23: 181–199.

Peters, Gerald, and Charles C. Eldredge. (1994). *Canyon Suite: Early Watercolors by Georgia O'Keeffe.* New York and Kansas City: The Gerald Peters Gallery and the Kemper Collection.

Petterson, Anders. (2014). "Booming Art Markets." *Telegraph* (June 20), http://www.telegraph.co.uk/art/barnebys-auctions/booming-art-markets/.

Plattner, Stuart. (1996). *High Art Down Home: An Economic Ethnography of a Local Art Markets.* Chicago: University of Chicago Press.

Pollen, Susannah. (2015). "The Post-War and Contemporary Art Market." In Jeremy Eckstein and Lindsay Dewar (eds.), *ArtBanc Market Intelligence* 9 (January).

Preston, Andrew. (2013). "Art Theft: Who's in the Frame? Why Steal a Priceless Masterpiece When It's Almost Impossible to Sell?" *London Mail* (February 9). http://www.dailymail.co.uk/home/moslive/article-2274998/Art-theft-Whos-frame-Why-steal-priceless-masterpiece-impossible-sell.html.

Pringle, Heather. (2013). "The Origins of Creativity." *Scientific American* 308: 36–43.

Questroyal. (n.d.). "Art vs. Stocks and Bonds: A Comprehensive Analysis of the Investment Potential of American Art," www.questroyalfineart.com.

Questroyal. (2013). "Art vs. Stocks and Bonds: A Comprehensive Analysis of the Investment Potential of American Art," 2nd ed., www.questroyalfineart.com.

Quetelet, A. [1835] (1968). *A Treatise on Man and the Development of his Faculties*. New York: Franklin.

Quill, Greg. (2010). "Canada Dumping Ground for Stolen Art." *Toronto Star* (March 26). https://www.thestar.com/entertainment/2010/03/26/canada_dumping_ground_for_stolen_art.html.

Radnóti, Sándor. (1999). *The Fake: Forgery and Its Place in Art*, translated by Ervin Dunai. Lanham, MD: Rowman & Littlefield.

Reitlinger, Gerald. [1961] (1982). *The Economics of Taste: The Rise and Fall of Picture Prices 1760–1960*, 3 Vols. New York: Hacker Art Books.

Renneboog, Lue, and Christophe Spaenjers. (2013). "Buying Beauty: On Prices and Returns in the Art Market." *Management Science* 59: 36–53.

Reyburn, Alan. (2015). "Art Basel Confirms Buyers' Enthusiasm." *New York Times* (June 19), http://www.nytimes.com/2015/06/22/arts/international/art-basel-confirms-buyers-enthusiasm.html?_r=0.

Riding, Alan. (1995). "Art Theft Is Booming, Bringing an Effort to Respond." *New York Times* (November 20), http://www.nytimes.com/1995/11/20/arts/art-theft-is-booming-bringing-an-effort-to-respond.html (accessed August 25, 2014).

Ritenour, Shawn. (2011). "Economists' Arguments for Government Arts Subsidies." *Regent Journal of Law and Public Policy* 3(1): 95–117.

Robertson, Iain. (2016). *Understanding Art Markets: Inside the World of Art and Business*. London: Routledge.

Ronson, Jon. (2014). "The Big-eyed Children: The Extraordinary Story of an Epic Art Fraud. *The Guardian* (October 26), https://www.theguardian.com/artanddesign/2014/oct/26/art-fraud-margaret-walter-keane-tim-burton-biopic.

Rooney, Ben. (2013). "Is There a Bubble in the Art Market?" *CNNMoney* (November 15), http://money.cnn.com/2013/11/15/investing/art-market-boom/.

Rose, Barbara. (1997). "O'Keeffe's Originality." In Peter H. Hassrick (ed.), *The Georgia O'Keeffe Museum*. New York: Harry N. Abrams.

Rosen, Sherwin. (1981). "The Economics of Superstars." *American Economic Review* 71: 845–858.

Rudnick, Lois P., and Ma-LinWilson-Powell. (2016). *Mabel Dodge Luhan and Company: American Moderns in the West*. Taos: Museum of New Mexico.

Salerno, Louis M., and Brent L. Salerno. (2015). *Essential: Important American Paintings* (Fall). New York. www.questroyalfineart.com.

Salisbury, Laney, and Aly Sujo. (2009). *Provenance: How a Con Man and a Forger Rewrote the History of Modern Art.* London: Penguin Books.

Simonton, D. K. (2000). "Creative Development as Acquired Expertise: Theoretical Issues and an Empirical Test." *Developmental Review* 20: 283–318.

Simonton, D. K. (2014). "Creative Genius in Literature, Music and the Visual Arts." In Victor A. Ginsburgh and David Throsby (eds.), *Handbook of the Economics of Art and Culture*, Vol. 2. London: Elsevier: 15–48.

Singer, Leslie P. (1988). "Phenomenology and Economics of Art Markets: An Art Historical Perspective." *Journal of Cultural Economics* 12:20–40.

Skinner, Sarah, John D. Jackson, and Robet B. Ekelund, Jr. (2009). "Art Museum Attendance, Public Funding and the Business Cycle." *American Journal of Economics and Sociology* 68: 491–516.

Slowik, Theresa J. (2006). *America's Art: Smithsonian American Art Museum.* New York: Harry N. Abrams.

Spaenjers, Cristophe, William N. Goetzmann, and Elena Mamonova. (2015). "The Economics of Aesthetics and Record Prices for Art since 1701." *Explorations in Economic History* 57: 79–94.

Spencer, Ronald D. (ed.) (2004). *The Expert versus the Object: Judging Fakes and False Attributions in the Visual Arts.* New York: Oxford University Press: 143–216.

Sproule, Robert, and Calin Valsan. (2006). "Hedonic Models and Pre-Auction Estimates: Abstract Art Revisited." *Economics Bulletin* 26: 1–10.

Squires, Nick. (2014). "Italian Pensioner Awarded Ownership of Gauguin Stolen from London Flat." *The Telegraph* (December 12), http://www.telegraph.co.uk/news/worldnews/europe/italy/11289980/Italian-pensioner-awarded-ownership-of-Gauguin-stolen-from-London-flat.html (accessed October 27, 2015).

Stebbins, Theodore E., Jr. (1976). *American Master Drawings and Watercolors: A History of Works on Paper from Colonial Times to the Present.* New York: Harper & Row.

Stebbins, Theodore E. (2004). "The Art Expert, the Law and Real Life." In Ronald D. Spencer (ed.), *The Expert versus the Object: Judging Fakes and False Attributions in the Visual Arts.* New York: Oxford University Press: 135–142.

Stein, John Picard. (1977). "The Monetary Appreciation of Paintings." *Journal of Political Economy* 85(5): 1021–1035.

Stigler, George, and Gary S. Becker. (1977). "*De Gustibus est non Disputandum.*" *American Economic Review* 67: 76–90.

Stigler, Stephen. (1986). *The History of Statistics: The Measurement of Uncertainty before 1900.* Cambridge, MA: Harvard University Press.

Straus, Dorit. (2009). "Implication of Art Theft in the Fine Art Insurance Industry." In Noah Charney, *Art and Crime: Exploring the Dark Side of the Art World.* Santa Barbara, CA: Praeger: 87–106.

Tancock, John L. (2004). "Issues of Authenticity in the Auction House." In Ronald D. Spencer (ed.), *The Expert versus the Object: Judging Fakes and False Attributions in the Visual Arts*. New York: Oxford University Press: 45–54.

Tarmy, James. (2014). "In Art the Safest Bet is the Biggest Bet. *Bloomberg News* (July 23). https://www.bloomberg.com/news/articles/2014-07-23/in-art-the-safest-bet-is-the-biggest-bet.

Tarmy, James. (2015). "A Tech Startup Is Trying to Catalogue Every Piece of Art on the Market." *Bloomberg News* (July 21). https://www.bloomberg.com/news/articles/2015-07-21/a-tech-startup-is-trying-to-catalogue-every-piece-of-art-on-the-market.

Teti, Emanuele, Pier Luigi Sacco, and Tecla Carlotta Galli. (2014). "Ephemeral Estimation of the Value of Art." *Empirical Studies of the Arts* 32: 75–92.

Theil, Henri. (1970). *Principles of Econometrics*. New York: John Wiley and Sons.

Thompson, Don. (2008). *The $12 Million Stuffed Shark: The Curious Economics of Contemporary Art*. New York: Palgrave Macmillan.

Thompson, Earl A. (2006). "The Tulipmania: Fact or Artifact?" *Public Choice* 130: 99–114.

Thornton, Mark. (2014). "The Federal Reserve's Housing Bubble and the Skyscraper Curse." In David Howden and Joseph T. Salerno (eds.), *The Fed at One Hundred: A Critical View on the Federal Reserve System*. New York: Springer: 103–114.

Throsby, David. (1994). "The Production and Consumption of the Arts: A View of Cultural Economics." *Journal of Economic Literature* 32: 1–29.

Throsby, David, and C. D. Throsby. (2001). *Economics and Culture*. New York: Cambridge University Press.

Throsby, David, and Anita Zednik. (2013). "The Economic and Cultural Value of Paintings: Some Empirical Evidence." In Victor Ginsburgh and David Throsby (eds.), *Handbook of the Economics of Art and Culture*, Vol. 2. Amsterdam: Elsevier/ North Holland: 81–100.

Tijhuis, A. J. G. (2009). "Who Is Stealing all those Paintings? In Noah Charney (ed.), *Art and Crime: Exploring the Dark Side of the Art World*. Santa Barbara, CA: Praeger: 41–51.

Towse, Ruth (ed.). (2005). *A Handbook of Cultural Economics*. Cheltenham, UK: Edward Elgar.

Towse, Ruth (ed.). (2015). *A Handbook of Cultural Economics*. 2nd ed. Cheltenham, UK: Edward Elgar.

Tully, Judd. (2000). "An 'Immense Hoax'? O'Keeffe's Soured 'Suite.'" *Art News* (February): 22, 24.

Turner, Elizabeth Hutton. (1999). *Georgia O'Keeffe: The Poetry of Things*. Washington, DC: The Phillips Collection; New Haven, CT: Yale University Press.

Tversky, Amos, and Daniel Kahneman. (1982). "Judgments of and by Representativeness." In Daniel Kahneman, Paul Slovic, and Amos Tversky (eds.), *Judgment under Uncertainty: Heuristics and Biases.* Cambridge: Cambridge University Press: 84–98.

Ursprung, Heinrich W., and Christian Wiermann. (2011). "Reputation, Price, and Death: An Empirical Analysis of Art Price Formation." *Economic Inquiry* 49(3): 697–715.

Valsan, Calin, and Robert Sproule. (2008). "Reservation Prices and Pre-Auction Estimates: A Study in Abstract Art." *Economic Interferences* (June) 24: 257–272.

Veblen, Thorstein. [1899] (1934). *The Theory of the Leisure Class.* New York: Modern Library.

von Zuydtwyck, Freiin Monika Heereman. (2014). *Nobody Knows—But the Auction House? A Study on Pre-Sale Price Estimates of Online Auctioneer Auctionata AG.* Thesis, Erasmus School of History, Culture and Communication. Rotterdam: Erasmus University.

Vosilov, Rustam. (2015a). "Art Auction Prices: Home Bias, Familiarity and Patriotism" (August 3). Available at SSRN, http://ssrn.com/abstract=2686527 or http://dx.doi.org/10.2139/ssrn.2686527.

Vosilov, Rustam. (2015b). "Sculpture Market Efficiency and the Impact of Auction House Art Experts" (August 3, 2015). Available at SSRN, http://ssrn.com/abstract=2686516 or http://dx.doi.org/10.2139/ssrn.2686516.

Wallack, Todd. (2013). "Prized Stolen Art Frequently Surfaces after Decades." *Boston Globe* (May 10), https://www.bostonglobe.com/metro/2013/05/09/prized-stolen-art-frequently-surfaces-after-decades/M220VQCJiQwQvHl3lCjJCN/story.html

Walton, Kenneth. (2006). *Fake, Forgery, Lies and eBay.* New York: Simon Spotlight Entertainment.

Watson, Peter. (1992). *From Manet to Manhattan: The Rise in the Modern Art Market.* New York: Random House.

Wilmerding, John (ed.). (1973). *The Genius of American Painting.* New York: William Morrow.

Winfield, Nicole. (2016). "Hoax? Rome Firm Claims New Modigliani but Offers No Evidence." *Associated Press* (June 18), http://bigstory.ap.org/article/61044b74fe014a018126e5d7929a2240/hoax-rome-firm-claims-new-modigliani-offers-no-evidence.

Wood, Paul, Francis Frascina, Jonathan Harris, and Charles Harrison. (1993). *Modernism in Dispute: Art since the Forties.* New Haven, CT: Yale University Press.

Worthington, A. C., and H. Higgs. (2006). "A Note on Financial Risk, Return and Asset Pricing in Australian Modern and Contemporary Art." *Journal of Cultural Economics* 30: 73–84.

Zausner, Tobi. (1998). "When Walls Become Doorways: Creativity, Chaos Theory, and Physical Illness." In Martin S. Lindauer (ed.), Interdisciplinarity, the Psychology of Art, and Creativity, *Creativity Research Journal* 11: 21–28.

Index

Note: Page numbers followed by t or f indicate tables or figures, respectively. Numbers followed by n indicate notes.